AFTER NIHILISM

In *After Nihilism,* Wilfried Dickhoff examines the art work of contemporary European and American artists, including Joseph Beuys, Marcel Broodthaers, Gerhard Richter, Cindy Sherman, and Philip Taaffe. Questioning Adorno's concept of negative freedom in the autonomous work of art, he demonstrates how the works of these artists, in which the contradictions and paradoxes of deconstruction/reconstruction, beauty/ sublime, difference/indifference, affirmation/negation, authenticity/cynicism, subject/nonidentity are never resolved, thus creating images of competing complexities. Tracing the development of the (post)avant-garde through the 1980s to the present, this collection provides in-depth analysis of particular works of art and demonstrates the author's close engagement with and understanding of the contemporary art world.

Wilfried Dickhoff is an independent critic and a curator of contemporary art. He lives in Cologne, Germany, and New York. The author of numerous articles, catalogues, and books on aspects of contemporary art, he is also editor of Nabe Press, New York, and editor of the book series Kunst Heute (K & W Verlag, Cologne). Among the exhibitions he curated are "What It Is" (New York, 1986) and "Ars Pro Domo" (Cologne, 1992). Wilfried Dickhoff is the artistic director of "InBetween," EXPO 2000 (Hannover, Germany).

CONTEMPORARY ARTISTS AND THEIR CRITICS

Series Editor:

Donald Kuspit, *State University of New York, Stony Brook*

Advisory Board:

Matthew Baigell, *Rutgers University*
Lynn Gamwell, *State University of New York, Binghamton*
Richard Hertz, *Art Center College of Design, Pasadena*
Udo Kulturmann, *Washington University*
Judith Russi Kirshner, *University of Illinois, Chicago*

This series presents a broad range of writings on contemporary art by some of the most astute critics at work today. Combining the methods of art criticism and art history, their essays, published here in anthologized form, are at once scholarly and timely, analytic and evaluative, a record and critique of art events. Books in this series are on the "cutting edge" of thinking about contemporary art. Deliberately pluralistic in approach, the series represents a wide variety of approaches. Collectively, books published in this series will deal with the complexity of contemporary art from a wide perspective, in terms of both point of view and writing.

Other Books in the Series:

Beyond the Mainstream, by Peter Selz

Art into Ideas: Essays on Conceptual Art, by Robert C. Morgan

Building-Art, by Joseph Masheck

Surrealist Art & Writing, 1919–1939: The Gold of Time,
 by Jack J. Spector

*The Exile's Return: Toward a Redefinition of Painting for the
 Post-Modern Era,* by Thomas McEvilley

*Looking at Art from the Inside Out: The Psychoiconographic
 Approach to Modern Art,* by Mary Mathews Gedo

Signs of Psyche in Modern and Postmodern Art,
 by Donald Kuspit

WILFRIED DICKHOFF

After Nihilism

Essays on Contemporary Art

CAMBRIDGE
UNIVERSITY PRESS

PUBLISHED BY THE PRESS SYNDICATE OF THE UNIVERSITY OF CAMBRIDGE
The Pitt Building, Trumpington Street, Cambridge, United Kingdom

CAMBRIDGE UNIVERSITY PRESS
The Edinburgh Building, Cambridge CB2 2RU, UK http://www.cup.cam.ac.uk
40 West 20th Street, New York, NY 10011-4211, USA http://www.cup.org
10 Stamford Road, Oakleigh, Melbourne 3166, Australia
Ruiz de Alarcón 13, 28014, Madrid, Spain

Translated from the German by Jeanne Haunschild
except:
"Pre-Setting": translated from the German by Rosanne Altstatt
Chapter 19: translated from the German by Camilla Nielsen

Excerpt from Paul Celan, "Meine Dir zugewinkelte Seele," © Suhrkamp Verlag, Frankfurt am Main, 1976.

Publication sources are listed on page 285, a continuation of the copyright page.

First published 2000

Printed in the United States of America

Paperback cover design: Wilfried Dickhoff and Mikco+ Ltd., New York
Paperback cover: Front, Cindy Sherman, *Untitled (No. 299), 1994.* Color photograph.
©1997 Monika Sprüth Gallery, Cologne; Ross Bleckner, *Middle Sex of Angels* (detail), 1988. Oil on canvas, 274.5 × 183 cm. ©1997 Mary Boone Gallery, New York. Spine, Marcel Broodthaers, *Je,* 1967. ©1997 Maria Gilissen. Back, Rosemarie Trockel, *Justine & Juliette* (Collection *Désir*), 1990. ©1997 Monika Sprüth Gallery, Cologne; Albert Oehlen, *Am Ofen,* 1996. Oil on canvas, 190 × 160 cm. ©1997 Max Hetzler Gallery, Berlin.

Typefaces Sabon 10/13 pt., Futura, and Kunstler Script *System* QuarkXPress® [GH]

A catalog record for this book is available from the British Library.

Library of Congress Cataloging-in-Publication Data

Dickhoff, Wilfried.
 After nihilism : essays on contemporary art / Wilfried Dickhoff.
 p. cm. – (Contemporary artists and their critics)
 ISBN 0-521-59294-1 (hb). – ISBN 0-521-59698-X (pb)
 1. Art, European. 2. Art, Modern – 20th century – Europe. 3. Art,
American. 4. Art, Modern – 20th century – United States. 5. Avant-
garde (Aesthetics). I. Title. II. Series.
N6758.D53 1999
709'.04'07 – dc21 99-14941
 CIP

ISBN 0 521 59294 1 hardback
ISBN 0 521 59698 X paperback

For Alexa and Sarah

CONTENTS

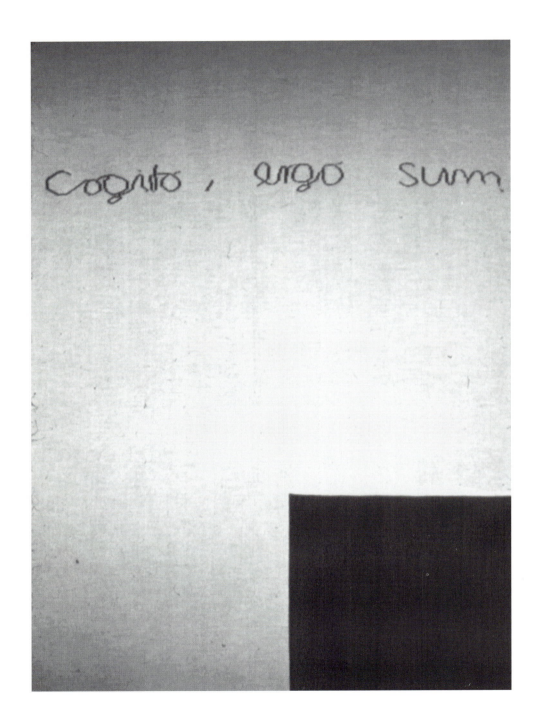

Rosemarie Trockel. *Untitled (Cogito, ergo sum)*, 1988. Wool over canvas.
220 × 150 cm. © 1997 Monika Sprüth Gallery, Cologne.

PRE-SETTING

> There is no understanding, there are only various levels of humor.
>
> Gilles Deleuze

"Today it goes without saying that nothing concerning art goes without saying, much less without thinking. Everything about art has become problematic: its inner life, its relation to society, even its right to exist."[1] Adorno's *Aesthetic Theory*, written in the 1960s, began with this sentence – and it still holds true today. Furthermore, in the realm of art criticism, in the realm of the discourses on art – be they philosophical, art historical, sociological, or psychoanalytical, or be they structured within attempts to integrate different sciences – and in the realm that is insufficiently labeled with the term "public," the talk of the end of art mounts. It is talk of the interchangeability of art's forms of expression, of its sociocultural arbitrariness, and of an increasingly generalizing indifference that drives the necessity, the autonomy, the irreducibility, the critical potential, and the "objection" tied to art's subjectivity ad absurdum. There is much to be said for these critical points of view and the economic situation of the 1980s that blessed art with an unprecedented economic "success" and seemed to have confirmed once more the disappearance of art into an advancing culture of mere decorations of power. Correspondingly, in the current discussion of art and in the art of the nineties, we are experiencing a multitude of deconstructive discourses on art and nonart that more frequently take art's place, putting art in a role as a supplementary illustration of the theoretical development of the end of art.

The essays in this book are based on the self-evidence of the irrefutably questionable nature of contemporary art. But they are not content with theoretically confirming this with artworks as examples. Instead, they question this questionable nature once again. They do this in view of specific works by artists with specific attitudes in specific situations, institutions and contexts. These works do not serve as an illustration and confirmation of previously decided theories. The self-fulfilling

prophecies of art theory that are served only by art itself as material for art theory's self-affirmation do not interest me. On the contrary, these essays are a product of the uncertainty that even the most advanced theories on contemporary art repeatedly experience through art as art, meaning through artistic thought, which is a living concept, and through its nonverbal, analogical language – which is a language of sensations.[2] Yet, I am also not interested in rashly putting in the last word on the fetishization of art as the last bastion of the unspeakable, intangible, absolute and sublime. Before one is taken in by these and all other formations of art myths, perhaps one should first strip off everything that is expected of art as spiritual masturbation. Today, quite a lot of what is unfulfilled and even unfulfillable within political, social, personal, sexual, erotic, and altogether interpersonal life is "aesthetically" demanded of art. Certainly, art presents itself as a projection surface, and, therefore, the resulting compensatory fetishization – in view of its questionable nature – is also often approvingly accepted by art. But can art really bear this, much less redeem it? How much religious, philosophical, and other types of yearnings for meaning, coherence, satisfaction, and harmony should art represent as a last stand-in?

While the fetishizations, ascriptions, and formations of art myths mount, now and then art still takes other paths that question its questionable nature. On these other paths art often starts out from its own impossibility. Accepting this, and not playing it down, art repeatedly opens unexpected possibility where impossibility was long thought to have become the norm. Roland Barthes once said that to make art means to consider the desire for the impossible reasonable. That is a fitting formulation because it has always understood art, not only from the perspective of seemingly impossible desires but also and precisely from the perspective of the impossibility of redeeming art's own standards and essentiality, from the perspective of the impossibility of art as art. In view of specific artworks, I am often reminded of Adorno's remark that art is "the possible, as promised by its impossibility."[3] Could it not be that the memory of unredeemed difference – which single works of contemporary art here and there evoke – draws attention to the unsatisfied nature of this paradox? And could it not be that art which opens possibility by starting out from its own impossibility is very close to the counterpole of the so-called irrational in the tradition of the ideas of reason as Kant understood it?

These are some of the questions contemporary art raises in these essays, which the essays do not answer but conceptually pursue. I consciously say "some" of the questions because even with negative dialectic the impossibility of art is no longer so easily overcome. The essays accordingly strive for an openness toward the formation of concept, which incorporates features of what Barnett Newman once called "impassioned criticism."[4] This openness toward the formation of concept might be appropriate in the moments of unredeemed difference in contemporary art. And correspondingly, these essays also reflect the process of the reciprocal uncertainty between art and art theory. They expose themselves to this double uncertainty and even start from there. These essays make an attempt, which is certainly not new but is as yet unfulfilled, to establish a dialogue with what makes itself visible as art, with what Plato called "ecphainestaton," what appears outward

from within. What this dialogue might look like, linguistically, depends greatly upon the language that one could find for it. The attempt to bring the language of art up for discussion is naturally tied to the demand – again, neither new nor unredeemed – to work with terms against terms. Essays on art that expose themselves to this are put to a linguistic endurance test. Its result, even its possibility, remains open. While writing these essays, I was always preoccupied with the question of whether or not this endurance test of attempting to still use language without undoing the achievements of deconstruction is adequately described in reference to art. In the best case – and this case came up more often than I had dared to hope – these essays will have been polylogues that turn out to be female.[5]

But what is the subject, if there can even be one? The title of this book indicates a tendential direction. It is a paradoxical line of flight because "after Nihilism" may be a desirable impossibility, but it still is an impossibility. Nihilism is not an attitude that we can change at will. Here, good will accomplishes nothing. Nihilism is not an attitude – nihilism is still the contemporary human condition. And let us not forget that the director of its realities and virtualities and even of the imaginary scenarios of nihilism's (im)possible overcoming is still *das Kapital*. This condition is still about seeing, coping, and surviving through[6] – before we delude ourselves that it has been overcome when, in fact, we have confirmed it by protesting against it. The title of this book still emphasizes a seemingly paradoxical insistence on a *Nevertheless* (Dennoch), on the impulse of non-affirmative affirmation that is visible and perceptible in contemporary art. This impulse is not in opposition to a critical or anti-illusionistic motivation. Rather, it is based upon such a motivation. It can arise only there where an artist has sensed and thought of the degradation of art myths. Placing this tendential direction at the forefront of the reader's expectation was intentional because the essays are dedicated to the attempt to set free this moment – a moment that might correspond to the moment of beauty. Art that is suitable to this non-nihilistic impulse – and art is rare – is always more than a mere expression of a gesture of the degrading of the lies and illusions they no longer can or want to be. As blocs of sensations that stand up on their own, art works – the self-consciousness of their impossibility is also conveyed (even if it could be understood as the degradation of art myths sublimated to form) – have always shared a nonetheless melancholy hope that I would like to call the *degrading of the degrading*. The essays in this book are in solidarity with this hope.

Art as beauty without beautification, as negativity without negativity, is it conceivable, can it become visible? This idea touches upon the question of beauty, the question of mourning for a beauty that bears the legacy of the sublime within it. The montages of such an art would also always be demontages, for instance, of all illusions of purity, absoluteness, and sublimity. But the deconstructions of such art would also always be constructions. Art would turn the execution of its deconstruction toward what is constructive in a non-affirmative affirmation. The art in question here is de-montage and de-construction, namely, concurrently related to what art, in each case, is about and with reference to itself as art. Art today is a degrading in which its anti-illusionistic motivation prospers and, at the same time,

a degrading of the degrading. That is art's *Nevertheless* as an (im)possible figuration of possible freedom. Art is negation (death lives a human life, according to Hegel) and, at the same time, affirmation. A yes devoid of conviction. Could it not be that an art which nevertheless arises from a will for beauty as truth enters into the legacy of the sublime in that it does not play down its own and art's contradictions but instead presents beauty as a paradox? Were I to assert that this is the subject of this book, I would already be off the subject because this question unfolds into a multitude of thematic relationships that are grouped around a thematic core, which is contradictory in itself. But does the legacy of the sublime not lie in the unfolding itself? Does it not lie precisely in not playing down, harmonizing, and reconciling the contradictions it left behind but instead in struggling with and bringing them out? And could it not be that the language of art – as the language of unreconciled contradictions – resists the impossibility in everything in the name of what was once called freedom.

The art that will be in question in this book does this with results that were unhoped for. In many cases these results hardly bear any features of the dualisms that seemed to structure what one calls modern art. Beyond all harmonizing decoration and beyond all "either-or," "as well as," "on the one hand–on the other hand," and other evasions of unavoidable paradoxes, many works of contemporary art appear as though they were formed into surprising gaps. Between form and content, autonomy and *fait social,* subject and object, ratio and irratio, visibility and invisibility, outer and inner, art and nonart, abstraction and figuration, beauty and sublime, riddle and clarification, myth and demystification, as well as other contradictory pairs, these artworks appear as settings for an oscillation and/or a raising to a higher power and/or a going between and through.[7] They are intermezzi of an intangible, nonetheless sensuously experienceable hope, a hope that springs forth from the trace of memory of a lost human (without identity), which becomes apparent when faced with such intermezzi. Can the open wounds of unredeemed difference that flare up in moments of the presence of our lost memory still be claimed?

The generation of artists the main portion of this book addresses were imputed, mainly during the 1980s, to have reactivated something like a new subjectivity. Certainly, these artists first searched for the consequences of the failing standards of the sociopolitical will power of art – as it hopefully reappeared in the sixties and seventies – with a focus on what is reflected in the mirror and in the eyes of the other. But that onto which one is thrown back upon is no longer the identity of the subject. The human being as a subject who is aware of its presence, who freely identifies itself with itself, is now truly long dead. That may be simplistic, but we cannot avoid finally drawing the conclusions that go along with it. Rimbaud's formulation "The self is an Other" already historically marks this decisive point of the lost (bourgeois) self that has since set at least every advanced artistic movement in motion. These movements have set free potentials of nonidentity that were, however, repeatedly undone in the course of establishment, institutionalization, and integration. Nonetheless, the stories of the so-called avant-garde have accumulated unredeemed difference that is claimed again and again in precisely those works by

the generation of artists that developed its attitude in the 1970s. This happens with perhaps less illusion than ever before – which may at times seem cynical. But does not the absence of belief set free an openness of another sort that is more honest as well as more responsible than the eternal reproduction of art utopias that, in the end, really serve only the affirmation of illusions of identity and the soothing of the moral conscience? Certainly, in the eighties and nineties we have experienced how an art dedicated to the scattering of the subject has very rarely demanded nonidentity. It normally happened that art quickly disappeared, as though it had been handed over to the art industry on a platter. As a piece of merchandise among merchandise, it enacted – not always against its will – its own interchangeability and arbitrariness. It functioned as the interchangeable material of an indifference that was accelerated to the point of dizziness and seemed to water down every *Nevertheless* of art.

Nevertheless, there were and are deviations from the tendency toward global indifference. And I believe to have seen them here and there: first, where failure and impossibility are no longer concealed; second, where the de-territorialization of identity and, correspondingly, an opening of the non-identical is allowed; and third, where the shattering of identity (of the subject, the self, the artistic self, the artwork, the artistic concepts, the discursive reinsurance of "art"), where a basic disagreement with oneself is experienced as a non-indifference toward the Other,[8] toward what is foreign to me (toward me and others), what is not identical to me and/or itself. Could it be that a *Nevertheless* of art could prosper today where difference cannot be separated from non-indifference, from non-unconcern toward other existence ("human beings," animals, etc.), precisely where both are articulated at once? And accordingly, could not an art of difference formation be an art of nonindifference? There is much to be said against this. Some works by contemporary artists, however, speak for this. These shall be spoken of here.

The questions I address in this introduction, in an extremely shortened form, revolve around something specific in contemporary art that I would like, as a trial, to call *responsibility of form*. This "phenomenon" as it is addressed and touched upon in very different manners, especially in European and North American contemporary art of the eighties and nineties, and as it is realized within the specific artistic perspective of each artist, could have been the leitmotif of this selection of essays. With this term, I attempt to address the specific artistic responsibility that precedes every moral or sociopolitical conception of art – that, furthermore, is based on a radical openness which claims difference but also undermines it and exposes the "identity-addicted," security-conscious state of mind of every ideology of art. Because this responsibility is due to the experience of difference as nonindifference, it takes a big risk. It is openness as unprotected vulnerability. An unrestrained, tragic desire, whose necessity is nourished by the demand for freedom, a freedom that is bound solely to the art of difference formation. Said in a very shortened form, I would like to assume that such an amoral responsibility of form comes from a desire, from an intention of desire that turns nothing into an object of its own desire and that is also not aimed at loving something and lovingly becoming

"one" with an other. Jacques Lacan brought my attention to this when he spoke of the desire of painting – as distinguished from the subconscious desire he called "the desire of the Other" – as a sort of "desire *on the part of* the Other (désir à l'Autre)," which respectfully desires the Other as an (unreachable) Other and "at the end of which is the *showing* (le donner-à-voir)."[9]

Showing the gaze of the Other as art. What is that? How does that look, how does that appear outwardly through a picture painted in 1997, for instance, at a time when no one who takes a brush in hand can seriously believe in the possibility of painting? The same is true, by the way, for all other media when they are approached from the perspective of possible art. What is art's perspective today? A perspectivism (Nietzsche) that wants to give ideas of reason (Kant) as showing gazes? With this, in the end, the question of presence is raised again. I find myself asking this question when I stand before a work that seizes the point of view of my perception and conveys a moment (Augen-Blick)[10] that can be articulated only in this manner and in no other, a moment when, for instance, an image is truly relevant to me. Neither the fetishism of essentiality nor of inessentiality matters to me. I have survived the Heidegger school as well as the Adorno school. I am also well aware of the danger of fetishizing difference. And in this book one will find enough countermeasures against every form of illusionism, mysticism, metaphysics, and transcendence, through the content as well as through the efforts to find an appropriate language. But there are compositions from nonrepresentative blocs of sensations that do not express difference but develop difference and show real differences. *Real differences,*[11] naturally, do not exist unadulterated. In art, there is no longer anything unadulterated. There are only the impossible paths that go between and through the dualisms. And there is the paradox of a presence of difference that meets the eye as a gaze of non-indifference.

In a word: The art of nonindifference, as presence of difference, is a desirable impossibility that I would like to draw attention to in view of some contemporary works of art. But look for yourself.

Theoretical Prelude

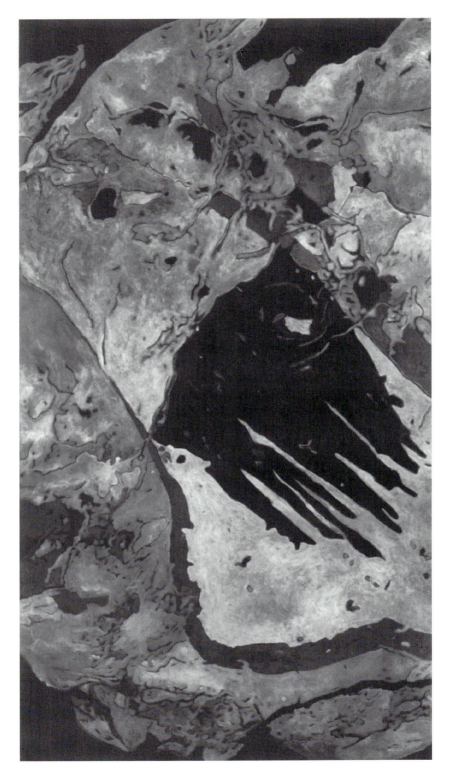

Haralampi G. Oroschakoff. *Jasenowac*, 1989. Pigment, varnish on canvas. 200 × 160 × 8 cm. © 1997 Diana Hohenthal Gallery, Berlin.

INBETWEEN BEING (T)HERE: A SCENARIO OF THOUGHTS ON THE (IM)POSSIBILITIES OF ART

THE PREREQUISITES

Adorno's last words were: experience in the Hegelian sense (the realization of intellect [*Geist*] in history) ends with Auschwitz; we have no choice except to accompany metaphysics to its demise; and, since there is no longer any one great narrative of emancipation, let us multiply the micrologies. An alert ear will be able to glean the following from the essays at hand: in the aftermath of Auschwitz, and thanks to the revival of capitalism, experience in the Hegelian sense has come to an end; the age of experimentation (the age of satire) is flourishing, so let us multiply the paralogisms.

≈

In doing so, the experimental mode of behavior is balanced on a razor's edge: undecided as to whether it should keep to the rule formulated by Valéry (dating back to Mallarmé), which states that the subject should prove its aesthetic energy even while it abandons itself to heteronomy, or whether this latter act ratifies its abdication.

≈

On the one hand, art as micrology, a self-contained entity, a fragmentary "whole" that attempts to redeem and accompany the dissociated subject by aesthetic means. On the other hand, art as paralogy, an aimless experimentation with intensive fragments no longer guided by fossilized and fossilizing instrumental rationality. On the one hand, hermetic form as "determinate negation." On the other, the unqualified affirmation of intensities. It is the oscillation between these two poles – between a paralogic dissipation of the subject and a sublimation of form –

which, expressly, holds fast to the disintegrating subject – that characterizes the present state of art. It should be the job of art to accept, yet counter, this situation through form and work it out in the artwork without defining it in a unilaterally ideological-fetishistic way. Art is either the resistance to reality and a spiritual guide rolled into one, or it evaporates as a reflex or camouflage of power.

❧

"What is to be done if we have no horizon for emancipation; where do we put up resistance?" This, for me, is the essential question. When Zola intervened in public affairs, he knew what he was talking about; he was in full possession of his "emancipatory horizon." The same is as true of Voltaire as it is of Fourier, who was also a politician; it even applies to Sartre. Even if Sartre was mistaken. As intellectuals, we can no longer intervene. But where are we to draw the line of resistance if there is no longer any emancipatory horizon? I think this question has much to do with artistic and art-philosophical activity. It ought to be fully explored; we must pose the question of what is happening in contemporary art at the level of time, space, and society. . . . Today we need to think successfully about what art ventures, what's at stake in art, where its true place is, and what art indeed is. Such a drawing of boundary lines is omnipresent.

❧

WHAT IT IS

. . . The utopia, whose language is that of art but which is at odds with the collective human neurosis, is the utopia of being able to produce one single affect: neither Eros nor Thanatos, but life-death, in a single thought, in a single gesture.

❧

A Tintoretto paints the Creation of the world as if it were a marathon, with God himself in the first row and firing the start gun from right to left. Suddenly, a painting by Lotto appears, which could just as well have originated in the nineteenth century. And surely this de-territorialization of streams of painting, these schizoid vanishing points – which create machines of desire on the horizon – are worked out in fragments of the old codes or inserted in the new one like a pure axiomatic of painting, which cuts off the flight, which closes the units via the transversal relationships between lines and color and applies the old or new territorialities (for example, perspective). Just as it is true that the movement of de-territorialization can be grasped only as the opposite of residual, artificial, or imi-

tated territorialities. Yet something has always appeared that broke open the codes, tore down signifiers, and flowed beneath the structures, thereby setting currents in motion at the border to wishing and initiating disruption: a break-through.

The explanation that the nineteenth century was already present in the fifteenth is not sufficient to explain this, for the same could be said of the nineteenth century, and in any case, such a concept would also apply to the Byzantine code, beneath the surface of which strangely liberated currents were already in motion. We can see this in Turner, in his most perfect paintings, which are occasionally classified as "imperfect": the moment this true destiny is revealed, something becomes evident, something that no longer belongs to any school or epoch, that fully completes the breakthrough: art as a process without a goal, which nonetheless in this manner becomes complete and realized.

∼

Painting upsets all our categories by revealing its dreamworld of carnal essences, actualized resemblances, and mute meanings.

∼

What is a gesture? It is similar to the encore at the end of an act. An act is transitive: it wishes to generate an object, a result. Gesture is the undefined and inexhaustible sum total of reasons, instincts, and indolence that surround the act with an atmosphere (in the astronomical sense of the word). I shall therefore distinguish between the message that is intended to create information, the sign that is meant to create insight, and the gesture that produces the rest (the "encore"), without actually wishing to produce anything. The artist (to continue to use this somewhat kitschy word for the time being) is by nature a maker of gestures: he wants to generate an effect and yet at the same time does not want to. The effects he produces are not necessarily intended; they are effects that have been led back, turned around, or broken off; they come back to him, evoking modifications, digressions, making it easier to stay on track. Thus, in a gesture, the difference between cause and effect, motive and goal, expression and appeal are eliminated. The artist's gesture – or the artist as gesture – does not break the causal chain of actions (what the Buddhists call Karma – the artist is not a holy man, or an ascetic), but he shakes it, casts it out until he loses its meaning. In (Japanese) Zen, this unexpected (occasionally quite fine) breach in our causal logic is called (to simplify here) a *satori*: thanks to a trivial, absurd, far fetched, bizarre condition, the subject awakens to a radical negativity (which is no longer a negation).

A diagram is the operative ensemble of strokes, lines, and zones. Take, for example, Van Gogh's diagram: it is a mélange of straight and curved hatches, which lift and lower the floor, twist trees, cause the sky to quake, and, especially after 1888, take on a particular intensity. You can not only differentiate between diagrams, you can also date the diagram of a painter, for there is always one moment when the painter confronts it most directly. The diagram is truly a kind of chaos, a catastrophe, but also a source of order and rhythm. It is violently chaotic in relation to the figurative facts, but it is also the germ of rhythm with respect to the new order of painting: it "opens up the realm of the senses," according to Bacon. The diagram signals the end of the preparatory work and the beginning of the act of painting. There is no painter who has not experienced this germ of chaos where he can no longer see anything and is in danger of ruin: a breakdown of visual co-ordination. This experience is not psychological but specific to the art of painting, even if it does have a great influence on a painter's psychological life. It is here that a painter faces the greatest danger, both for himself and his work. It is a kind of experience that is constantly being reinitiated among very different painters: the abyss or the catastrophe of Cézanne, and the chance that this abyss will make room for rhythm; the chaos of Paul Klee, the lost gray dot and the chance that this gray dot might "leap beyond its limits" and open up new dimensions of the senses. . . . Of all the arts, painting is surely the only one that necessarily, "hysterically," incorporates its own catastrophe and from whence it re-creates itself by going on the offensive. In the other arts, catastrophe is merely an association. But a painter strides through the catastrophe, ties up chaos, and tries to leave it behind. However, what actually distinguishes painters is the way they tie up nonfigurative chaos and then assess the emerging pictorial order and the relationship between this order and chaos.

⚘

How is it possible to draw a line that is not mindless? It is not enough to wave it a bit to bring it to life. You must – so to speak – outsmart it: intelligence always involves a bit of trickery.

⚘

The artist does not have any morals, but possesses a kind of morality. In his work there are the following questions: What do others mean to me? How shall I desire them? How shall I present myself to their desire? How must one behave among

them? By each time expressing a "subtle vision of the world" (as the Tao says), the artist composes what is generated (or rejected) by his culture, and what his own body insists upon: what is left out, exclaimed, repeated, forbidden-desired: this is the two-legged paradigm that gets the artist going, insofar as he produces anything.

꽃

Only the true artistic entities persist, in other words, those that possess a soul (content) within the body (form).

꽃

When works are not fully developed, not formed, they forfeit precisely that expressiveness for whose sake they attempted to dispense with the work and effort of form. As a result, the supposedly pure form, which denies expression, rattles hollowly. Expression is a phenomenon of interference, a function of how one proceeds, and is nothing less than mimetic. Mimesis, for its part, is conjured up by the density of technical procedure, the immanent rationality of which seems to work against expression. The compulsion exerted by integral works is equivalent to their eloquence and their manner of speech and is not merely a suggestive effect. Suggestion for its part, by the way, is related to mimetic processes. This brings us to a subjective paradox of art: to produce something that is blind – the expression – by means of reflection, that is, via form; not to rationalize what is blind but to create it aesthetically in the first place.

꽃

If, in the belief that with these words I hold the key to the problem, I speak of "presence" in relation to a work of art, do I not then have – if not the explanation – at least the right criterion? Or is this not quite simply the case if I state that this object – as the fruit of imaginative powers that work with materials originally designed along the usual lines of experience (forms, colors, volumes in the visual arts, tones and rhythms in music, language in literature) – that this work, created on every level by human means but whose effect nonetheless remains a secret, gains a reality that for me not only goes beyond that of its processed materials but also seems to be more intense than most everyday realities? It escapes the ghetto of the imaginary and firmly announces that it exists. In its totality it takes over space in life, instead of coming down to just a game that, amidst all the bravura, remains hermetically sealed.

THE BASIS

Humanity is now merely a state-humanity and for centuries, that is, since the state has existed, has lacked an identity, as I see it. Today, humanity is non-humanity, known also as the state, as I see it. Today a human is only a state-human and is thus an annihilated human, and the state-human is the only humanly possible human, as I see it. The natural human being is no longer even possible, as I see it. When we look at the state citizens packed together in their millions in the major cities of the world, we feel sick, because we also feel sick when we see the state. Every day, upon awaking, our state makes us feel sick, and when we walk along the street, our fellow citizens who inhabit this state make us feel sick. Humanity is a huge state, which, if we are honest, makes us feel sick every time we wake up. Like everyone else, I also live in a city that makes me nauseous when I wake up. Our teachers teach the state to the people, and they teach them all its horror and ghastliness, its mendacity; what they do not teach is that the state is this horror and ghastliness and mendacity. For centuries, teachers have been ensnaring their students in the tongs of the state, torturing them over the years and the decades and crushing them. These teachers, employed by the state, take their pupils through the museum and with their dulled sensibilities spoil art for them. But what kind of art is this on these walls other than state art, as I see it. Reger, when he speaks of art, speaks only of state art, and when he talks about the so-called Old Masters, he is speaking only of the old state masters. For the art hanging on these walls is, after all, nothing other than an art of the state, at least here in the picture gallery of the Kunsthistorisches Museum. All the art on its walls is nothing more than pictures painted by state artists. Pleasing Catholic state art, nothing more. Time after time only a countenance, as Reger says, but never a face. Time after time just a head, never a mind. All in all, always just the front side with no reverse side, always just the lie and the mendacity without the reality and the truth. All these painters were nothing more than thoroughly deceitful state artists, who played up to their employers' epileptic fits; even Rembrandt was no exception, says Reger. Look at the Velásquez, nothing more than state art; the Lotto, the Giotto, always only state art, like that awful Dürer, the primordial and prototype Nazi, who placed nature on the canvas and killed it, that dreadful Dürer, as Reger often said, because he truly hated Dürer to the depths of his being, that engraver from Nuremberg. Reger describes the pictures hanging on the walls here as art commissioned by the state, to which even the white-bearded man belongs. The so-called Old Masters served only the state or the church, which comes down to the same thing, as Reger once again says: an emperor or a pope, a duke or an arch-bishop. Just as the so-called free person is a utopia, so has the so-called free artist always been a utopia, madness, as Reger often said. The artists, the so-called great

artists, according to Reger, and as I see it, are moreover the most unscrupulous of all people. They have even fewer scruples than the politicians. Artists are the phoniest, much more so than the politicians; thus the art-artists are much phonier than the state-artists, I once again hear Reger say. This form of art always turns towards the Almighty and the powerful and away from the world, as Reger often says. This is what makes it so truly despicable.

Wretched indeed is this art, and nothing more than that, I now hear Reger say yesterday while I observe him today from the Sebastiano Hall. Why do painters even paint, when we have nature? as Reger yet again wondered yesterday. Even the most extraordinary work of art is still just a wretched, meaningless, purposeless attempt at imitating nature, at aping it, he said. What is the face of Rembrandt's mother compared to the actual face of my own mother? he asked again. What are the meadows of the Danube across which I can wander while observing them in comparison to the painted ones? he said. I find nothing more repugnant, he explained yesterday, than painted sovereignty. Monarchist painting, neither more nor less, he said. Set it down, people say, document it, but, as we know, it all becomes nothing but deceit, untruth; only the untrue, the lies are set down and documented. Posterity will have only untruth and deceit hanging on its walls; only untruth and lies in the books the so-called great authors left behind for us, only untruth and lies in the pictures that hang on these walls. The person hanging on the wall is never the one painted by the artist, said Reger yesterday. The one on the wall is not the one who actually lived, he said. Of course, he continued, you are going to say that it is the view of the artist who painted the picture. That's right, although that view is a deceitful one. In reference to the pictures in this museum, it is always only what the artist in question sees from his Catholic state view. For everything hanging here is nothing but Catholic state art and therefore, I have to say, a common art. It can be as great as it wants, but it is nothing more than common Catholic state art. The so-called Old Masters are, above all when you examine several alongside each other, enthusiastic liars, who have ingratiated themselves with and sold themselves to the Catholic state, which means with and to Catholic state taste, says Reger. As such we have here a thoroughly depressing Catholic history of art, a thoroughly depressing Catholic history of painting that has always found its subjects in heaven and in hell, but never on earth, he says. Painters have never painted what they should paint but rather what they were commissioned to paint or what brought them riches and fame, he said. The painters, all these Old Masters, who for the most part disgust me and have always made my skin crawl, have always served one master, never themselves and therefore never humanity. They always painted a hypocritical world from the inside, which they hoped would bring them wealth and fame. They all painted for this reason, that is, out of addiction to fame and fortune; not because they had wanted to become painters but because they wanted to become famous or rich, or both famous and rich. In Europe, they always painted in the hands and on the head of one Catholic God, he said, one Catholic God and his catholic gods. Each brushstroke of these so-called

Old Masters, no matter how ingenious, is a lie, he said. Yesterday he called them world decorators, these painters whom he, deep down, hates quite profoundly and yet who have simultaneously fascinated him throughout his entire miserable life. Religiously deceptive decoration-assistants to the European Catholic ruling class, that's what these Old Masters are, and nothing more. You can see it in every spot that these artists once daubed onto their canvas without showing the least embarrassment, my dear Atzbacher, he said. Naturally, you are obliged to say that it is the greatest art ever painted, he said yesterday, but do not forget to mention, or at least to think – at least to think for yourself – that it is also infamous painting. What makes this kind of painting infamous is at the same time its religious aspect; this is what is so disgusting about it. If you stand for an hour in front of the Mantegna, as I did the day before yesterday, you will suddenly feel the urge to rip it down from the wall because you suddenly perceive it as one great painted meanness. Or if you've stood in front of the Viliverti or the Campagnola for a time. These people painted only to survive and for money and in order to go to heaven and not hell, which they feared throughout their lives more than anything else, although they had quite sharp minds but in fact very weak characters. Painters in general do not have a good character, in fact, always have a very bad character, which is basically why they have always had very poor taste, Reger explained yesterday. There is not one single so-called great painter, or let us say so-called Old Master, who had good character and good taste. And when I say good character, I quite simply mean one that is incorruptible. All these artists as Old Masters were corruptible, and that is why I find art so disgusting, said Reger. I understand them all, and I find them deeply disgusting.

Everything they have painted and is hanging here is repugnant to me is what I often think, he said yesterday, and yet for decades I have been unable to stop studying it. That is exactly what is so horrible, he said yesterday, that I find these Old Masters deeply disgusting and yet I continue to study them. But they are repulsive, that is quite clear, he said yesterday. The Old Masters, as they have been called for centuries now, can withstand only a superficial examination. If we contemplate them at greater depth, they fade, and in the end, if we have truly and honestly studied them, which means as fundamentally as possible over the longest time, they disintegrate. They crumble before us and leave only a stale, mostly very bad taste in the mouth. In the end, the greatest and most important work of art lies heavy in our head like a great clump of meanness or lies like an oversized chunk of meat in our stomachs. We are fascinated by a work of art, and it is, in the end, ridiculous.

❧

. . . Yet to cowardly eyes, art lay like the joyful domain of unrealized wishful thinking in which the trivialized personality evaporated, stank and prevaricated.

Art is at once the greatest and the most repulsive, he said. But we must convince ourselves that there is high and highest art, he said, otherwise we will despair. Even if we know that all art ends up in ineptness and absurdity and on the dustbin of history just like everything else, we must all the more self-assuredly believe in high and highest art, he said. We know what it is, namely amateurish and ineffective, but we daren't always admit this, because we will then be inevitably destroyed, he said.

≈

MASTERPIECE

The thing one gradually comes to find out is that one has no identity that is when one is in the act of doing anything. Identity is recognition, you know who you are because you and others remember anything about yourself but essentially you are not that when you are doing anything. I am I because my little dog knows me but, creatively speaking, the little dog knowing that you are you and your recognizing that he knows, that is what destroys creation. That is what makes school. Picasso once remarked I do not care who it is that has or does influence me as long as it is not myself. . . . The manner and habits of Bible times or Greek or Chinese have nothing to do with ours today but the masterpieces exist just the same, and they do not exist because of their identity, that is, what any one remembering then remembered then; they do not exist by human nature because everybody always knows everything there is to know about human nature; they exist because they came to be as something that is an end in itself and in that respect it is opposed to the business of living, which is relation and necessity. That is what a masterpiece is not, although it may easily be what a masterpiece talks about. . . . It is not extremely difficult not to have identity, but it is extremely difficult the knowing not having identity. One might say it is impossible, but that it is not impossible is proved by the existence of masterpieces which are just that. They are knowing that there is no identity and producing while identity is not.

That is what a masterpiece is.

And so we do know what a pasterpiece is, and we also know why there are so few of them. Everything is against them. Everything that makes life go on makes identity, and everything that makes identity is of necessity a necessity. And the pleasures of life as well as the necessities help the necessity of identity. The pleasures that are soothing all have to do with identity, and the pleasures that are exciting all have to do with identity, and, moreover, there is all the pride and vanity that play about masterpieces as well as about everyone, and these too all have to do with identity, and so naturally it is natural that there is more identity that

one knows about than anything else one knows about, and the worst of all is that the only thing that anyone thinks about is identity and thinking is something that does so nearly need to be memory and if it is, then, of course, it has nothing to do with a masterpiece.

But what can a masterpiece be about? Mostly it is about identity, and all it does and in being so it must not have any. I was just thinking about anything and in thinking about anything I saw something. In seeing that thing, shall we see it without it turning into identity, the moment is not a moment, and the sight is not the thing seen and yet it is. Moments are not important because, of course, masterpieces have no more time than they have identity, although time like identity is what they concern themselves about; of course, that is what they do concern themselves about. . . . There are so many things to say. If there was no identity, no one could be governed, but everybody is governed by everybody and that is why they make no masterpieces, and also why governing has nothing to do with masterpieces; it has completely to do with identity, but it has nothing to do with masterpieces. And that is why governing is occupying but not interesting, governments are occupying but not interesting because masterpieces are exactly what they are not.

<div align="center">✍</div>

CLAIMS

In every true work of art there is a place where the person who can imagine himself in that place is buffeted by a breeze as cool as the wind of an approaching dawn. This means that art, which was often regarded as refractory opposition to every relationship to progress, can serve to define genuine progress. Progress does not consist in the continuity of time passing by, but is more at home in its interferences: there where something truly new makes itself felt for the first time with the sobriety of dawn.

<div align="center">✍</div>

A work is valid for us insofar as it defines its age or is molded by it. In this case, someone will inevitably attempt to examine the creations, the extent to which they approximate our own mentality – in other words, how they can subsequently be integrated into a preformed universal view and into our own lives, or how they contradict, upset, or influence these things. In so doing, the question of technical management or execution is relegated to studio discussions of craftsmanship. A work of art is valid for us as a living force and practical tool, whereas it, as a specifically aesthetic phenomenon, strikes us as unimportant and dead. We are scornful when works of art are appraised as precious or rare bibelots; the technical aspects hardly interest us,

since technique and its reactionary media mislead us into adapting a new or extraordinary event to the bias of craftsmanship, whereby all traces of originality are destroyed. One could almost say that the paintings themselves and the technique only perceive biases. The demoralizing and despiritualizing aspects of virtuoso craftsmanship should at long last be investigated. Usually works of art are unabashedly overrated, as if one could unmistakably read the whole face of an era or generation from them. We notice that, on their own, works of art are clearly inadequate for defining an epoch. A considerable portion of art can run quite counter to the popular currents of an era, or embarrassingly compensate for or conceal an intellectual movement. For instance, the greater part of all so-called modern art is very much reactionary in orientation. We are concerned with works of art only to the extent that they contain the means to revise reality, to revise human structures and a picture of the world [Weltbild]. In other words, the main question is how works of art are to be integrated into a picture of the world, or how they destroy and transcend it. This turns the position taken by art historians upside down. Now it is art's biological sense that must be examined; that is, it cannot be enough to offer a descriptive history or to evaluate aesthetics in classroom terms and then hand out grades. A sociology or ethnology of art must be attempted, whereby art is no longer judged as an end in itself but as a living, magical medium. Then pictures will once again take on the significance of vitally functioning energies.

‰

This is the line that offers the solution to the question of aesthetic truth: art is a laboratory just as much as a feast of executed possibilities, together with their encountered alternatives. Here, the execution, like the result, emerges in the shape of a well-founded semblance [Schein], namely, that of a worldlike, fulfilled pre-semblance [Vor-Schein]. In great art, exaggeration, like confabulation, is the most visibly presented, as are tendentious consistency and concrete utopia. However, whether the call for fulfillment – one could call it the godless prayer of poetry – will also become practicable at least to some degree and not simply remain part of the aesthetic pre-semblance is something that will not be decided in poetry, but in society. At first, history dominated, with an invasive ploy to counter inhibitions, with an authoritative promotion of tendentiousness, which ensures that essence, in its distance to art, increasingly enjoys an appearance in life. However, this then resembles iconoclasm – not as the annihilation of artistic works but as an inroad into them – for the purpose of fructification of that which they contain that is not just typical but paradigmatic, that is, exemplary. And everywhere where art does not gamble itself away to illusion, beauty, and even the sublime is what conveys a notion of future freedom. Often rounded out, never sealed off: Goethe's maxim for living is also a maxim for art, with the accent of conscience and substance put on that which is still open, still unsealed.

As much as art was marked and enhanced by universal alienation, and here it is least alienated, everything having to do with art passed through the intellect and became human without violence. Art oscillates between ideology and what Hegel regarded as the native realm of the intellect, the truth of the certainty of itself. Though the intellect in art may continue to exercise further mastery, in its objectification it frees itself from its authoritative goals. By forming a continuum that is pure intellect, aesthetic entities become the semblance of the blocked per se, in whose reality the intentions of subjects can potentially be fulfilled and extinguished. Art rectifies conceptual knowledge because, split off, it completes what this knowledge vainly expects of the nonvisual, subject-object relation, namely, that something objective should emerge from a subjective achievement. Art does not infinitely postpone this achievement, but wrings its own finiteness from it in exchange for its semblance [Schein]. By spiritualization, by the radical domination of nature, that is, of its own self, it corrected the domination of nature as the domination of the Other. What there is in the artwork that is alien to the subject as a constant, as a rudimentary fetish, does not stand in for the alienated; but that which acts in the world as if it had survived as nonidentical nature becomes the material for the domination of nature and a vehicle for social domination, and now truly alienated. The expression with which nature most deeply permeates art is at once purely and simply its nonliteral aspects, a memento of that which is not the expression itself and yet does not become concrete other than through the How of its existence.

"All reification is forgetting." Art struggles against reification by getting fossilized people and things to speak: to sing, perhaps also to dance. Forgetting past suffering and past happiness makes life easier under the repressive reality principle: memory wants suffering to pass and desire to remain forever – in opposition to the reality principle. Its will is powerless; happiness itself is linked to suffering. But when memory is preserved throughout the struggle for change, a revolution is being fought over that is still being repressed in revolutions.

FORE-SIGHTS

. . . So much for the ideology-critical attempt to get around the objectiveness of the object in that its further development is prevented by an a priori declaration

of distrust. As plausible as such a maneuver might seem for a time, what follows (precisely when it succeeds) is a surfeit of criticism's rapid victories over that which is criticized. To go even further: criticism for its part will soon fall victim to new criticism because the spiral of increasing distance and denial can in principle be followed to infinity – until, in the end, criticism finds, and accommodates itself to, a common ground of misery with that which is criticized. . . . In this context, it is easy to show why high-ranked modernist art so often revolves around an aesthetic of aridity, rejection, and negativity. For in an era of devastation, great art cannot simultaneously believe in itself and in the applause of a multitude that is a conspicuous agent of devastation. It cannot seek a consensus with people who approve of the absolute embodiment of horror that constitutes modern everyday life. The fact that important modern art rejects such reconciliation means that the utopian anthropology of artists is in revolt against the realistic anthropology of the positivist sociologists with their cynical teachings of compensation. Nothing less than a new universal constitution is being sued for here, for only a world that truly did not require any more prettifying lies or aesthetic compensators, or star rejecters or the negativist elite, would be bearable to the sensibilities of great artists (or all people who are positive and childlike). Instead, a world is required in which the most hypersensitive aesthete could go home again like someone returning from exile to a liberated country, in order to forthwith create beauty without lies and legitimately compose harmonious songs: about a second innocence and unpressured reconciliation. This is why the greater part of important modern art is rightly an art of discontented consciousness. But, in essence, the art of negation wants to end; it must ultimately have the will to negate itself and render itself superfluous. For everything that is merely an answer to pain and wrongdoing falls under the very correct Mephistophelian motto that it were better if nothing emerged in the first place. If, from this basis, we inquire into the future of art, we are also inquiring into the future of the painful in society. The answer is to be found in the social suffering and the social struggle themselves. I believe we can see that the future of life in society as a whole is becoming increasingly dependent on the development of therapeutic, compensatory reservoirs and on living islands of warmth – in short, what more recent jargon refers to as alternative lifestyles. The further the crisis in the military-industrial society proceeds, the clearer we see how deep the alliance goes between modern currents of aesthetic and therapeutic practice. It is an exaggeration when it is claimed that a future for Western societies will be decided in this alliance of art, holiness and the art of living.

≈

The style of the future will be a robotic style, assemblage art. The human being we have known to date is at an end; biology, sociology, family, theology are all in ruin and drained, all prosthesis wearers. The ado made in novels is nonsense, as though

there really were continuation and something still going on that merits the old-fashioned concept of fate or the new-fangled concept of an autonomous social movement. Things are not continuing, and nothing is happening. People falter and have to work – it is the artist who must continue, who collects and groups – rural and grandfatherly with the help of spatio-temporal categories, contemporary and neurotic through the formation of absolute, transcendental focal points. Enthrallment, the constitution of pivotal points – only thus can the artist create something beyond relations and ambivalence. It is this technique that is itself the problem, and we should note the fact. A lady, clearly intelligent, wrote to me about a picture by Gauguin in the new Folkwang Museum, now in an old moated castle in the Ruhr valley; all around the house, as she emphasized, there was an atmosphere of *jardin-sous-la-pluie:* "An island dweller, on her own, mirroring the expression of being painted even to the gracious manner in which she holds up her fan; only her eyes are dreaming." That is it exactly: the expression of being painted always has to be visible; one must seek and know what goes together, what truly goes together, and take it. If you once think about it, you will arrive at the conclusion that we move about far more in our cerebral sphere than we do in our sexual or intestinal or muscular spheres. We are interested in thoughts that burn. We go back to these thoughts even when we are being active practically or commercially. We start up out of a deep sleep and they are there again immediately. It is questionable whether this was always the case, but it is at any rate the case today.

The human being must be reassembled from idioms, proverbs, meaningless references, sophistry via a broad base: man in quotation marks. His depiction will be kept alive through formal tricks, repetitions of words and motifs – ideas will be driven in like nails and suites hung from them. Origin, the course of a life – all nonsense! Most of them come from Jüterbog or Königsberg and, since time immemorial, people have been ending up in some Black Forest or other. Now, thought processes will be categorized, geography brought into play. Reveries be spun in and then let fall again. Nothing more is woven materially or psychologically; everything is alluded to, nothing carried out. Everything remains open. Anti-synthetic. Stalled before the irreconcilable. Need for the greatest mind and the greatest encompassment, otherwise all is mere childish play. Need for the greatest tragic meaning, otherwise unconvincing. If the man has it in him, then the first verse can be from a handbook and the second a stanza from a songbook, and the third a Mikosch joke and yet the whole is poetry. But if the man does not have it in him, then husbands can rhyme stanzas for their wives, mothers for their sons, grandchildren for their great aunts, in armchairs or in the peace of the evening, so that even a layman will notice that this is no longer lyric poetry. (Names: Perse, Auden, Lautréamont, Palinurus, Langston Hughes, Henry Miller, Elio Vittorini, Mayakovsky [without Bolshevism], a number of young Germans from the Freiburg circle.) I have coined a term for the style: PHASE II, namely, Phase II of the expressionist style, but also Phase II of post–ancient man. "Interesting" – now that is a significant word! Interesting – it does not lead to that impenetrably tor-

tured familial "depth," not directly to the "mothers," that popular German place – interesting is in no way identical to entertaining. Translate it literally: inter – esse: between being, namely between its darkness and its shimmer – "Olympus of illusion *[Schein]*." Nietzsche. Eternal things, the so-called timeless that leaks into everything is matter of course, but it is the phenotype we must work on: God is form. We will never recognize the gene, but the phenotypical can be worked into an image. According to my theory, you have to do something astonishing, at which you yourself will laugh in the end. ("I call it poor wisdom if it didn't involve one single bout of laughter," Nietzsche.) You must again suspend everything yourself, then it will begin to float. Charlatan – not really a bad word, there are worse: historic and ridiculously profound.

<center>⤳</center>

But do you have any idea who is now so forcefully effecting Phase II in so many geographically separated brains?

<center>⤳</center>

The world of seduction is pure illusion [Schein] and not a world of signs: Schein is not a sign. Signs can be decoded, unlike Schein. Seduction embodies the world of Schein and thus is in contrast to power, master of the sign world. Signs still belong to the world of sense and profundity. They are subject to law, while what is illusory is bound only to one game rule. There is not only a material basis to things but also a profundity to sense, which we zealously guard with our entire order; we thus eliminate all supposedly calamitous appearances. . . . The present system of dissuasion and simulation is successful in neutralizing all finalities, all references, and all meaning; but it fails to neutralize Schein. This is our last chance. The system has all the procedures for generating sense under its control, but not the seduction of the illusory. This manages to elude all interpretation, and no system can eliminate it. It is in this sense that the problem of seduction is so decidedly contemporary – not in the lax sense like the seduction of the masses by the media, etc. . . . Seduction presents itself as a final breaking out, an unlimited recourse to artistic devices of the body, as a survival strategy, a concealment of truth and a camouflage for the body, as a fading of references. The system presents itself primarily as a system of absolute surveillance, registration, and deterrence, with a so-to-speak terrorist relationship to truth (even genetic information is recorded). In opposition to all this, seduction opts completely for the unlimited distribution of illusory images, of forms of disappearance and subterfuge, in other words, a form of dissuasion that is even superior to that of the system. Today, seduction is again able to muster all the sinister forces mobilized against God and morality, all the

might of trickery and the devil, of dissimulation and absence, of challenge and the metaphysical inversion of semblance to be used against the terrorist act of appropriating truth and verification, against all the methods of recording and programming that rein us in.

❧

It is time to replace cowardly stylizing interpretation with the spiritual fact of reality. Applied to pictures this means pictures are not fictions but rather practically effective energies and facts. The moral position of pictures is thus changed and the merely artistic standpoint and the indifference of the artist done away with: it is no longer valid to varnish pictures like bibelots but rather test them as real and practical forces and mediums. Thinking and viewing flow into us as a means of creating reality.

❧

RIDDLE

The most extreme figure we can think of for the enigmatic character is whether meaning itself exists or not. For no artwork is without its context, even if it is diversified in whatever way into its opposite. However, through the objectivity of the configuration of the artwork, this context lays claims to the objectivity of meaning per se. Not only can this claim not be redeemed, it runs counter to experience. The enigmatic character looks out of every work of art in a different way, but in such a way as if the answer were, like that of the Sphinx, always the same, although this occurs only through the different, not as identity – an identity that the enigma (perhaps deceptively) promises. Whether the promise is deception or not, that is the enigma.

❧

Praise in darkness. Toward seeing.

❧

And in another dark or in the same another devising it all for company. Quick, leave him.

Actors in order of appearance:

Jean-François Lyotard, Theodor W. Adorno, Wilfried Dickhoff, J.-F. Lyotard, Roland Barthes, Gilles Deleuze, Maurice Merleau-Ponty, R. Barthes, G. Deleuze, R. Barthes, R. Barthes, Kandinsky, T. W. Adorno, Michel Leiris, Thomas Bernhard, Carl Einstein, T. Bernhard, Gertrude Stein, Walter Benjamin, C. Einstein, Ernst Bloch, T. W. Adorno, Herbert Marcuse, Peter Sloterdijk, Gottfried Benn, G. Benn, Jean Baudrillard, C. Einstein, T. W. Adorno, Botho Strauss, Samuel Beckett.

Paths of a Different Presence

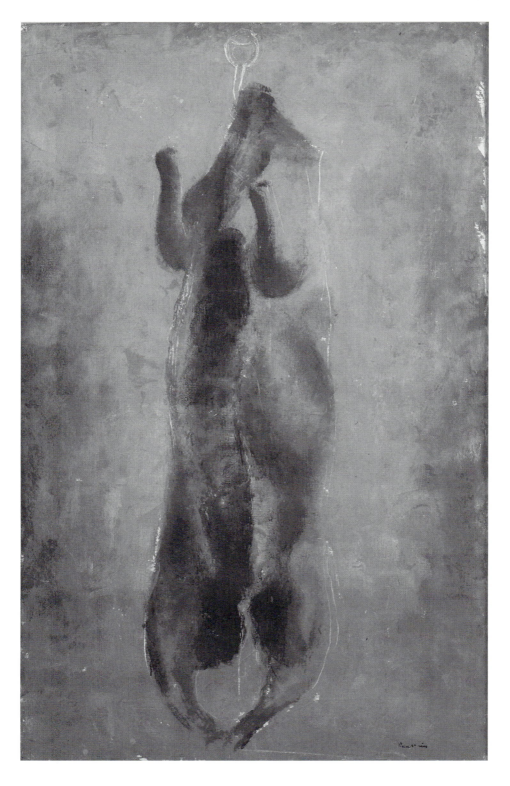

Jean Fautrier. *Le Mouton Pendu,* 1926. Oil on canvas. 131 × 81 cm.
© 1997 VG Bild-Kunst, Bonn.

THE FAUTRIER YARDSTICK

And even if forms are nothing without the light of the world, they nonetheless themselves contribute to this light.

Albert Camus

At the beginning of the forties, Fautrier painted anonymous portraits of the hostages mutilated by the fascist henchmen of the German occupying forces in France. These pictures are characterized by a supreme beauty that, as painting, have nothing more to do with the reason and necessity of their origin. The pictures were engendered by the artist's confrontation with horror, and this horror is acknowledged in the pictures. But their beauty disassociates itself, stands for itself alone, without so much as a whiff of fair illusion [*schöner Schein*]: "Horror and beauty have merged into one in the statement," as Francis Ponge wrote of the *Otages*. The transformation of unbearable injustice into something beautiful (yet not glossed over) is Fautrier's undeniable achievement. Here, the continuum of the catastrophe is for a moment actually interrupted, a moment in which it becomes clear that the greatest achievement of painting can consist only in the creation of beauty in face of whatever (in)human reality may be present, irrespective of the level of misery in which painting is, for the moment, vegetating.

Fautrier sets before our eyes what a painting can look like when it parries the situation at hand. To see, in other words, to look at something in the sense of enduring it, neither ignoring, nor overlooking, nor looking away, nor disregarding it. An incorruptible gaze that withstands reality with all its falsity and misery is the first prerequisite for a kind of painting that wishes to come into its own. This is what good painting always wants to do, for only in its separation from reality can it become its own reality. And it can do justice to its own reality only

when it is satiated with experience, thought, and other forms of working through reality.

In his pictures of animal cadavers and the truncated nudes of the twenties, Fautrier had already started to develop a way of painting existence, which reached its first climax in the *Otages*. This high point was repeated in the paintings of the partisan heads that rolled as the Soviets put down the Hungarian uprising in 1956. In this context it is characteristic that the invention of *art informel* – which is attributed to Fautrier – coincided with an espousal of the object. Fautrier knew that everything in art "that arises from reality is more imaginative, more magical than that which systematically rejects it." Those who disregard reality ultimately become ingrown within the ridiculous melodrama of the Ego. Reality provides the raw material (content) that sets form on the right track. But Fautrier also knew that it (form) must go down this track on its own – without referential crutches, assurances of meaning, and any art-to-life transference illusion. However, when it comes to art, one can accept only "that which possesses no reality of any kind, nor which shows any kind of link to any abhorred real thing," as he says. Fautrier sets up a standard for this self-evident nonsynthesis that is found in all great painting, behind which painting can no longer go back, unless it contents itself with fabricating artificial frills to decorate power with. Fautrier transformed the split between injustice and loneliness, on the one hand, and the beauty of form, on the other, into physically present perception. He allowed the traditional surface to cave in, like thin ice under a skater, and he re-created it as if it were blocks of earth. In the *Hautes Pâtes,* he succeeded in creating a geology using slabs of flesh, overlappingly layered and then dusted with the colors suitable for naked existence when it lies there skinned. Fautrier painted the membrane of existence. His paintings go behind the abstract and the figurative. They are closer to the cerebral cortex than to any discourse. And he showed that this can succeed only if one is aware of the limits of painting, if one is clear about its ineffectiveness and, above all, about the fact that its social purpose consists simply in, as he says, "decorating a wall."

To unreservedly expose the gaze to reality in the knowledge of painting's area of jurisdiction (always in need of fresh demarcation) – and then, by stating what is existentially what, to create pure painting that evokes forms that, by virtue of their pure physical presence, resist reality. Painting as a proof of existence in the force field between beauty and horror: this is the standard, the yardstick, that Fautrier has bequeathed us in his ideograms.

Jean Fautrier. *Tête d'un Partisan de Budapest,* 1956. Oil on canvas.
27 × 22 cm. © 1997 VG Bild-Kunst, Bonn.

THE UNREDEEMED IN JOSEPH BEUYS'S EXPANDED ART

I

With every attempt to deal posthumously with the work of Joseph Beuys – whether it be in the form of an exhibition, a book, a documentation, or an action – the question of the expanded art concept comes up, and it does so not only as regards its theoretical requirements but above all as regards the form its material works take. Via his drawings, sculptures, objects, installations, lectures, discussions and theoretical writings Beuys placed the concept of form within the prospect of social responsibility. He wanted to expand art beyond the self-referential limitations of art for art's sake. Art was to be the all-encompassing activity. From its vantage point, the social and the political were to be reinvented, and art was to become a trans-political practice. As a matter of principle, this prospect should never be lost sight of.

Any subsequent attempt to saddle Beuys's works with a picture frame in order to enjoy them "purely aesthetically" or, equally, any effort to derive from his ideas a kind of simpleton "political" program à la "anyone-who-tinkers-at-something-has-always-been-a-socially-effective-artist," all in order to avoid the question as to form, leads irrevocably to a narrow reductionism.

In the case of Joseph Beuys, the unity of aesthetics and morality must be seen and understood within the form. Art for him was, for one, a demarcated experimental field for working toward the radical transformation of the body of society, up to and including human blood circulation. In this context he understood himself to be someone who via his works enters into the form and feel of substances, which he always understood to be simultaneously physical and spiritual. To comprise in forms "the life principle of things as living matter" (J.B.), to unleash forces that

Joseph Beuys. *Stuhl mit Fett,* 1963. Background: Fettecke aus *Das Schweigen von Marcel Duchamp wird überbewertet,* 1965. © 1997 VG Bild-Kunst, Bonn. Photo: Wilfried Dickhoff.

Joseph Beuys. *Tierfrau und Tier,* 1956. Pencil on paper. 11 ½ × 20 ½ cm.
© 1997 VG Bild-Kunst, Bonn.

actually modify forces – that was his ambition: to breathe life into forms that then work like "dynamic medicine" (J.B.).

That such a pretension is inevitably programmed to fail does nothing to change the fact that its necessity remains unresolved, and the implicit hopes for freedom and social change remain unfulfilled. In 1988 I dedicated an exhibition and a book to this need.[1] It was an attempt to learn to see and to show the "parallel process" (J.B.) of conceptual and material work, of free thinking and formal magic in the work of Joseph Beuys.

The book's illustrated section, for example, was not preceded by any interpretation. It seemed to me preferable to let the drawings, sculptures, and objects speak for themselves and to avoid any discursive appropriation in view of works that are articulated out of the very avoidance of stereotyped discourses. In the discussion that follows in the book, the questions that arise in dealing with Beuys – with which we were ourselves confronted in preparing the book and the exhibition – were at least briefly made the theme. In a third section Johannes Stüttgen undertook to treat the responsibility of the form in Beuys not as an external block of theory that is cast over the works but as something that evolves from them. This took place using the example of Joseph Beuys's stamp, that is, of seemingly marginal works that a closer look proved have a key function, such as: *Identity card of the Plastic Order, by which the innermost is to be turned outward and the outermost inward* (J. Stüttgen). [For "plastic" read "three-dimensional": translator.]

With the example of the stamps and their use it becomes clear that for Beuys form was the criterion for a political action not meant in any traditional sense, and

that he, precisely in his commitment far beyond any institutional artistic framework, did not stray a single step from the path of radicalism and beauty.

It is here that Joseph Beuys remains a yardstick for what plastic [three-dimensional] work can be: "the embodiment of places that, by opening up an area and preserving it, keep assembled around them something free that allows each thing a place to stay and allows the human being to take up residence in the midst of things."[2]

II

At the beginning of 1987 I talked with Johannes Stüttgen about "dealing with Joseph Beuys's work a year after his death."[3] Much of what we spoke of then has come true. At the center was and is the question – for example, within the framework of an installation – of how you conduct yourself in feeling and thought toward a work that operates from a formal concept that intends to transform the body of society as a whole. Beuys had always insisted that the pretension of expanded art was "dynamic medicine" and had therefore placed the "life principle of things as living matter" at the center of his work. The question is, How do you bring yourself into relation with Beuys?

In view of the visible attempts to exhibit Beuys's works after his death, the familiar platitude was given new life that every exhibition is an interpretation and every interpretation a construction of the exhibited works. Which means that in these last years all those who tested themselves on Beuys's work have always brought in their own personal perspective, consciously or not, which is noticeable in the installation. Whether agreeable, disagreeable, or whatever. Thus, the continuation of the works by other means is actually already in progress. From the first contact, you cannot not do this. Which means that there is no question here of any sacred fidelity to the work – which would be a lie anyway – but of becoming aware that an encounter with Beuys, perhaps more than in other cases, is an encounter with yourself, with your own way of seeing, feeling, and aesthetically thinking.

That is, in the very moment that the expanded art concept can no longer be personified in Beuys's person, it becomes a demand on all those who deal with his work. We must therefore – quite in the sense of the expanded art concept – proceed from the assumption of a multiple responsibility. This means, among other things, that the attempt to deal with Beuys's works in the form of an exhibition would necessarily require the curator himself to incorporate his own person in the formal and thematic context.

Joseph Beuys's work provides an installation potentiality, a whole field of possibility for hands-on art interventions into social spaces, an offer to transcend boundaries aimed at all who wish to (and can) open up for themselves the possibility for change that is present in material and spiritual form in art. This potentiality is what Beuys understood to be art's accumulated capital, a reservoir of art competency to be expended in order to modify society in the name of a

social concept of freedom that stems from art: its "expanded art concept." This is how his equation "art = capital" is to be understood. And in this context, his statement "Every man an artist."

The expanded art concept places the question of form at the crux of human activity. This shifting of the question (up until now reserved for art for art's sake) into the space of human existence does not mean that everyone is an artist who produces something that is seemingly nonfunctional. Quite the contrary. What is meant is that human activity cannot unfold to its full potential if the question of art (the question of *HOW I* do something, that is, the question as to form, which comes up simultaneously with the question of *WHAT I* do) is not satisfied along with every task that arises.

For Beuys, it was important to unleash a political, or better a trans-political, momentum into the art context and, vice versa, to ignite an aesthetic momentum within the so-called political context. A new integration of aesthetics and morality is what he, his entire lifetime, was working toward.

In my opinion Beuys's sculptures, objects, installations, and also the drawings are in themselves effective as the carrier or medium of ideas – emanating from the magic of the form that Beuys was capable of giving them. And they possess this function to the same degree as the concepts with which he operated, though they no longer stand before us in their purity but are packed to overflowing with simulated refuse and have undergone an unpleasant materialization in the blind, feel-good present of especially the last decade, whose overseer – as we know – is capital, and that is meant in Karl Marx's sense. I would therefore like to stress the medial character of the form. For Beuys, art was a demarcated experimental field for his work on the incursive transformation of the social. And the pretension bound up with this is that the "Fettstuhl" [grease chair] is the idea as substance. Accordingly, "an olive leaf [can be] an insight in image-form," as Beuys said. Whereby it remains an open question as to where and how and if at all the idea as energy is able, from the form, to interact with trans-political energies.

Naturally, we are also dealing with a phenomenon here that still takes place in the institutional framework of the so-called art system and, naturally, also gets caught up in the usual pull of appropriation. Parallel to this we have for some years had an accelerated development toward an aestheticizing of reality where Beuys's idea is negatively fulfilled, and this happens everywhere where the social imagination projects things purely aesthetically. Along with advertising and fashion, among others, all forms of the art of survival share in this process of total aestheticization. Yet, there is a latent potential in Beuys's work to counter its own appropriation. For example, because of the "Darmstädter Zyklus" and its problematics people suddenly came together and, owing to a feeling of dismay or of being addressed, felt the need to commit themselves, although they otherwise shared few common interests. At least once, the integral momentum provided by the question of materialized essence did really work. What I do not see, however, is that this could ever suggest a possibility for a transference into the real, which then spreads as energy into the social fabric. I note only failure. Beyond this, I do see art here and there that artic-

ulates and simultaneously contests its own failure with form. But the norm is "the well intentioned" that is taken in by the art-to-life transference illusion. Politics as a means of instigating change is no longer feasible; the same is true for political art. The idea that political art exists is a favorite illusion of art criticism, an illusion that very often serves only as moral self-gratification. Whether art, by radicalizing its own means and possibilities, can still be (or at all become) a stand-in for nonidentity as a source of real change or of a change of the real, I would like to leave open.

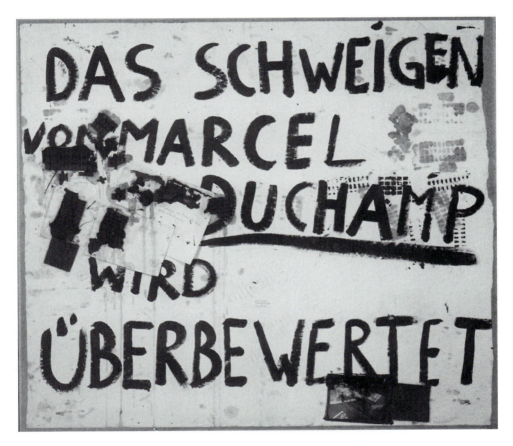

Joseph Beuys. *Das Schweigen von Marcel Duchamp wird überbewertet*, 1964.
© 1997 VG Bild-Kunst, Bonn.

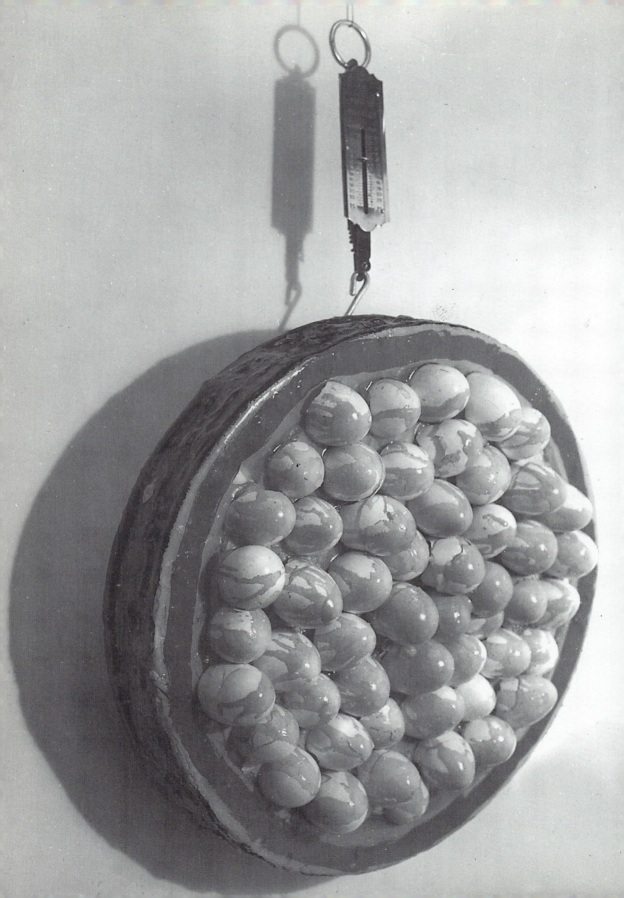

MARCEL BROODTHAERS'S DETERMINATE NEGATION

> As weak as my voice may be in the internal domain of
> art, I insist on manifesting a choice under the pressure
> of events. Pure or impure, fiction is logical. It still
> remains to be discovered whether art exists in another
> form and in another place than at the level of negation.
>
> Marcel Broodthaers

I

Marcel Broodthaers died on January 28, 1976, on his fifty-second birthday. He left behind an immense body of work, consisting of films, books, photographs, sculptures, objects, drawings, prints, installations, relics of installations, and a theoretical and literary oeuvre that, in particular, includes poetic texts. Until well into the sixties, Broodthaers lived as a freelance author, writer, and journalist in Brussels and, on occasion, in Paris. He created one of his first three-dimensional objects at the end of 1963. By halfway encasing in plaster fifty copies of *Pense-Bête*, his volume of poetry, he made it impossible to read the books, thus transforming them into "sculpture." He himself remarked: "Here the book cannot be read without destroying the sculpture."[1]

This gesture constitutes the beginning of a wealth of three-dimensional ("plastique") works inscribed with what Broodthaers terms the plastic quality of language ("la valeur plastique du langage"), a space between art and poetry. As late as 1974, he said; "I still think I have come to the point of expressing myself at the borderline between things, where perhaps, although I would not say necessarily, the world of the visual arts and poetry may meet, but precisely on the boundary line at which they both coincide."

Marcel Broodthaers. *Le poids d'une œuvre d'art*, 1965. © 1997 Maria Gilissen.

In April 1964, Broodthaers exhibited *Pense-Bête* together with other newly created objects in his first solo exhibition at the Galerie Saint-Laurent in Brussels. A pamphlet was published to accompany the exhibition, and in it he articulates the reasons for becoming involved in the fine arts: "Moi aussi je me suis demandé si je ne pouvais pas vendre quelque chose et réussir dans la vie." ("I too wondered whether I couldn't sell something and succeed in life.")

In the years that followed, Broodthaers made various "sculptures," which determined his image in the art world, objects in which he focused on the references and reference systems between egg shells, mussels, coal, and so on, and their supports (table, chair, shovel, etc.) and took them as his theme. "In fact I was trying to re-establish a link between this object and the image of this object by means of banal everyday objects and to insert it, this dual idea of image-object, that is, planar space and volume, into one and the same entity."

From the very beginning, Marcel Broodthaers put the idea before the sculpture. His background was that of language, and he deployed his objects like receptacles (for words), an extension of language by means of object-images (and vice versa) and text-images (and vice versa). In his objects, which he used like "zero words" ("mots zero," M.B.), Broodthaers organized what he termed "the encounter between various functions which point to the same world – to the table and to the egg, to the mussel and to the pot on the table and to the art, to the mussel and to the chicken."

He proceeds first and foremost by coming to terms with the language of images and the language as images in René Magritte's work, asserting that "In Magritte, there is a contradiction between the painted word and the painted object; the signs of language and painting are subverted in order to narrow down the meaning of the picture-object" (M.B.).

Broodthaers takes the subversion of the sign even further. He liberates Magritte's work from its surrealistic interpretation and, as evidenced in a photograph, accepts Magritte's bowler as a sign of an "art of thinking."[2] As early as his first objects, but especially in his installations, he staged surprising variations on the triad of image-object-writing by performing, playing out, unsettling, and shifting the relations and oppositions between sign systems that convey reality to us and thus produce (social) reality, on the one hand, and the reality of the sign systems themselves, on the other. The egg shells and mussels are empty forms that, for example, allude to the act of eating, to its social reality, and to a(n) (im)possible link between the object and the image of the object. However, they are also an image for the empty form of art, which reflects on itself and its form/content problem. And what is more, "the deviation which the material adds to the representation" (M.B.) is realized in the empty receptacles.

Marcel Broodthaers. *Marcel Broodthaers: Magie, Art & Politique*, artist book. Edition of 400 copies. Paris, 1972 (cover and pages 22–23). © 1997 Maria Gilissen.

Marcel Broodthaers

MAGIE

Art et Politique

Magie

Being Narcissus.

1 sleeping – Plains of sleep. Dreams – etc.–

2 reading – The book as it transforms itself into images. Let everything literally become mirrors.

3 drinking – After the acid wine, the gentle wine. And then the sea. May the glass find the clearest of springs and fill with a water saltless and full of alcohol.

4 eating – Cobras, vipers, boas, grass snakes... ...later on to be fascinated with one's own image as with a snake. Later again, naked.

Being an Artist.

1 sculpting – To drown like the son of a god ! What glory!.. It's better to fake. Properties : A diver's outfit. Several fish. Flowers.

2 painting – Witnesses appearing on stage, the merchant with his friend, the art lover. Swearing allegiance.

3 drawing – The artist's writing complements or replaces his images. He signs.

4 engraving – Market study.

22

The writing slate is based on the following principle: each inscription can be wiped off just by pulling out the plate. Yet it remains invisibly engraved on a film inside the device.

23

Broodthaers was familiar with the writings of Jacques Lacan. Lacan's texts on the mirror stage as the creator of the Ego function, on the unconscious as language, on illusion and truth in the triangle of the symbolic, the real, and the imaginary all served to buttress Broodthaers's own view of things. He understood these views as being an application of Mallarmé's language in order "to circumscribe a reality structured according to a psychoanalytic, philosophical order" (M.B.). That he read Lacan is legible in Broodthaers's works. In the *Ardoises Magiques,* for example, the magic slate signed by the artist is an image of the narcissistic reflection of the bourgeois artist-ego in the name of the Father, an image that can barely disguise the fact that its uniqueness is institutionalized self-deception. Broodthaers states that the role of the artist serves "the fabrication of a myth" that "has a narcissist foundation": "It seems to me that the author's signature, be it of an artist, *cinéast* or poet, is the beginning of the system of lies which all poets, all artists attempt to erect in order to defend themselves against I know not exactly what."

Broodthaers purposely used his works as what he called "pedagogical objects" in order to "reveal the secret of art" and "to erode the falsification inherent in culture." But he was always mindful to avoid dishonest pretensions of unequivocalness, pedagogical presumptiveness, and nonart delusions: "The fact that the mussels surge from the pot does not follow the laws of water boiling over but the rules of creative action, in order to arrive at an abstract form."

Broodthaers was active on the margins of modern art. He played games with the traps that the representatives of all "is·ns" and fashions naively tended to fall into. He kept his distance from surrealism, Pop Art, Conceptual Art, Minimal Art, and New and Socialist Realism and from all romantic postures, including all the well-intended but hardly well-conceived political, intellectual, spiritual, and anthroposophical hopes for social change by means of the magic of art.

Many of his sculptures and installations are organized like chains of signifiers that constantly displace each other, that constantly subvert the attributions of meaning and identity and thereby attract attention to the signifiers' structure of social reality and of art institutions: "a kind of social novel" (M.B.). The language that is spoken and the sign systems that structure art and society are at the center of the installations which Broodthaers realized in connection with his *Musée d'Art Moderne* (1968–1973) and in connection with the term *Décor* (1974–1976) in various museums and galleries, especially in France, Germany, and Switzerland. At the center of his *Musée d'Art Moderne* is the question: "What is, after all, the role of the institution which represents artistic life in a society, namely, that of the museum?" The institution of the museum – organizing the organization of art as a representation – appears here in two ways: as fiction and as an institutional site. *Décor* plays, among other things, on the function of the artwork as a decorative object and on fashion as a trademark of the fine arts. Thus, for example, to quote Broodthaers, it furnishes "a perfectly bourgeois domicile in which words float freely."

With these installations Broodthaers has created a standard for an art that not only reflects on itself but also contains the negation of the contexts which consti-

tute art, that intrinsically develops this contradiction and even co-formulates the questionability of its own forms. Art made into a determinate negation in the hope "that the viewer will be prepared to run the risk, for a moment at least, of no longer feeling so at ease with his own sense."

Broodthaers refused to offer us redemption in the form of a clear message. Instead, he positioned his works at the interface between image and text. Throughout his life he was concerned with an art of withdrawal, of omission and elision. One could interpret it, to use Jean-Paul Sartre's phrase, as a "hermeneutics of silence" at the boundary of visibility. This position goes back to Stéphane Mallarmé's poetry of the hiatus, a tradition in which Broodthaers expressly felt he belonged. His works invariably revolve around the impossibility of linguistically and visually communicating the gaps in the structure of signifiers. The critical self-reflection of art, which is often at the center of his work, was also one of the paths he took in order to further (i.e., to take somewhere else) Mallarmé's radical architecture of the linguistic form.

Here again we are back at one of art's endpoints. Marcel Broodthaers lived out an artistic stance that involved a political reaction but also kept its (aesthetic) distance from politics. His works offer a lesson in the responsibility of artistic form that provides a look at the conditions under which a new beginning for art could become possible. Broodthaers fulfilled one prerequisite to an extent almost unparalleled in this century, namely, that the artist should no longer feel so at ease in his own non-sense. Social nonconformity is the artist's conformity. Broodthaers was familiar with this form of appropriation. In 1969, of all years, when asked whether he believed in the sincerity of socio-critical intentions, he answered: "Certainly I believe in the sincerity of these intentions, as I believe in the sincerity of my own intentions, but it is smarter to foresee that we will be capitalistic, be it as collectors and artists or as directors of a new kind of gallery, that we will be steam-rollered by the deep structures of the system and that we will, of necessity, reinstate the capitalist structure."

Broodthaers's answer was art as an "authentic form of calling art in question," which for him justified a broadened view of artistic production. He stated that "what remains is art as production," although he was very careful to ensure that, in his words, his productions "simultaneously contained in themselves the negation of the context" in which they were not only embedded but that also served to constitute their meaning. Perhaps he succeeded as few other artists did, because in the final instance his output remained – in his words – "this side of the fine arts," but has articulated everything with the means provided by a (social) space that was simultaneously real and fictitious:

. . . RIEN . . . N'AURA EU LIEU . . .
QUE LE LIEU . . . EXCEPTÉ . . . PEUT-ÊTRE . . .
. . . UNE CONSTELLATION . . .
 Mallarmé[3]

II. CLOSED LETTER TO DORE ABOUT TRYING TO BE OPEN

Dear Dore,

When mirrorings raised to the second degree flicker in the tragedy of the *Hôtel du Grand Miroir*, then it is quite all right to take refuge in Descartes and play chess (poor Duchamp). But it does not suffice as an answer to a system that easily swallows this too whole. To this extent, Beuys was right when he said that Duchamp's silence had been overestimated. Whereas Beuys was "thinking with his knee" (and he meant Elvis's knee and pelvic movements), Broodthaers dared the experiment of not salvaging Mallarmé's hiatus into the visual age of interchangeability but of transposing it – as a resistance that considers itself unnecessary. A gesture that shines all the more in relationship to the clouded view the artist as a structural unity has at the end of this century when he unreservedly eyes the arbitrary, while the poor rich people have to search desperately to enhance their identities by engaging in halfhearted commitments to social causes, because they can no longer be caught dead at a party with the picture they last acquired.

Broodthaers risked his livelihood in exchange for a possible form of authenticity, as if it were only natural to do so, knowing full well that such a form was a necessity he experienced in the face of its impossibility. Yet he knew that normality involves the social and economic appropriation of the artist and/or the mechanism of reversal, by dint of which each alleged subversion and/or avoidance strategy ultimately reproduces the very thing that the subversive agent (the person who believes she or he is acting, while in fact she or he is only (re)producing mechanisms of reversal via active passivity) thinks can be avoided. Suffering was not the only essence of his forms. The great Belgians, who disdain the great Frenchmen's addiction to bon mots, take the philosophy of the profane too seriously for that. In this respect, Magritte's nonsurrealist humor cannot be valued highly enough. When Magritte says, "A picture seems valid to me when it is neither absurd nor incoherent and when, like the world, it has the logic of mystery,"[4] he had "more the feeling of finding the world again than of bringing something into it."[5] Mallarmé, on the other hand, believed that he possessed the linguistic tools with which to ensure the sublimity of nonbeing over being when he said, "The fact is we now possess what are precisely the reciprocal means that correspond to those of the mystery."[6] For Mallarmé, the poet's only task was "the Orphic explanation of the world . . . and the literary game."[7] In other words, on the one hand, absolute negation and, on the other, the careful creation of nonbeing: the flower that is "absent from all bouquets."[8]

Dear Dore, do you still remember how we were talking about Sartre and how he is not now being discussed in New York because post-structuralism in all of its variations dominates all the theoretical discussions? There is no better description of the two-sided figure of the absolute poet (caught between negativity and nothingness who is irrealized in the real in order to be realized in the irreal) than the one provided by Jean-Paul Sartre in *The Family Idiot*:

On this level, curiously, the writer, by contesting reality in each of his perceptions or behaviors, once again comes across negativity, the real basis of literary autonomy, which will *in fact* give him the power to write; yet he exercises it in the name of absolute negation. So he does not acknowledge it as a pure freedom of transcendence which lays the foundations for the sign and demands no foundation itself, rather he designates one of its products, nothingness, as a necessary foundation, which is itself hypostatized and reified. Indeed, the false relation between negativity and nothingness, the radical inversion that makes nonbeing as the surpassing of everything (hence as the surpassing of nothing, or as the surpassing surpassed and consequently *realized* as being) into the meaning and justification of an annihilation *in progress*, which is none other than existence, praxis as producer of instruments and work. This subversion lived as life's allusive relation to absolute nonbeing, this *false* illumination of life by death, or, if you like, this way of grasping life as the analogue of a continuous death is the objective neurosis itself insofar as the contradictions in the literary imperatives compel the artist, merely by living, to fashion the servile work of prejudice as the permanent expression of the lofty stoicism of the masters.[9]

Broodthaers knew this. And through the realist gap that Magritte had opened up, he presented himself as a poet of sociological reality by means of real/fictitious space (stating: "I now know what that is, a color and a volume [spatiality]"), without abandoning the literary climate that he was convinced was also the key to the current responsibility of artistic form. The idea of a poetic and political de-realization of Mallarmé's Easter eggs[10] of irrealization may follow in the tradition of French lovers of impossibility (Mallarmé opines: "To suggest, that is the dream"[11]). And what perhaps remain are a few "shipwrecked allusions."[12] But it was, certainly, not only worth the attempt. The spaces Marcel Broodthaers opened up create the conditions for the possibility of what he called "art as production." By doing so he set out on a path he followed through to its very end, an end at which painting could venture onto new beginnings, the first results of which are now slowly emerging. The artwork as a game of allusions taken to the second power with the effect of a supposed non-Being is not my cup of tea. I am interested in painting, a painting that creates mental images, constellations of color and form that function like painterly conceptual formations. Fautrier's *Otages,* for example, or Albert Oehlen's post-nonfigurative paintings. Art of this kind does not exist (solely) at the level of negation.

Dear Dore, I would like to answer the question at the end of your text in the following way: In 1969, I was in London on a school-exchange trip. Although I was almost exclusively interested in Jimi Hendrix, skinny girls with long blond hair, shaggy sheepskin jackets, my long hair, and marijuana, I did see the Magritte exhibition at the Tate Gallery (compulsory for students). I was fascinated by it. My favorite picture was *Le Viol,* the body of a woman as a face, as a gaze. These pictures functioned on the same simple and realist level of intensity as *Purple Haze* or *Little Wing.* Today, it is clear to me that Magritte had such a strong effect on me at that time precisely because he was not surreal, precisely because his images did not

exude dreaminess or some narcotic high but took the mysteries of reality by the balls with purely visual means so that I could see something that only a picture can express. If you ask me today whether Broodthaers was on a tragic quest, what may have played itself out in the tragedy of the *Hôtel du Grand Miroir,* and what I think of it all, I would like to answer with a picture by Magritte. It is called *L'usage de la parole* and shows two arbitrary forms, obviously replacements for the picture of an object; the forms bear two words, and, as is well known, have the same status in a painting as do the images. In this case they obviously refer only to themselves. So much for the picture on the "use of speech." The words are: MIROIR (mirror) and CORPS DE FEMME (female body).

Lacan could help us here, but I want to spare both you and myself the details. Roland Barthes once said that writing a text is the same as playing with your mother's body. I would like to add to this:

I hang up Broodthaers's "mirror of countersense" (M.B.) in the tragedy of the *Hôtel du Grand Miroir.* Then I again descend from the stage and go to my love, where I, too, try to speak:

> MY
> soul angled toward you
> hears you
> thunder
>
> In the crook of your neck
> my star learns how to slacken
> and become true,
>
> I finger it back out –
> come, speak to it,
> still today.
>
> Paul Celan[13]

Marcel Broodthaers. *Machine à poèmes,* 1965–68. © 1997 Maria Gilissen.

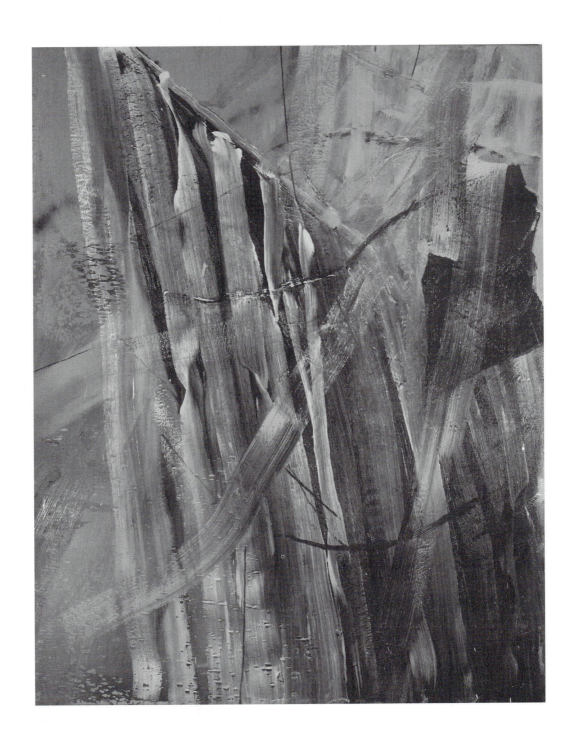

Gerhard Richter. *Mauer,* 1984. Oil on canvas. 260 × 200 cm.
© 1997 Gerhard Richter.

CHAPTER FIVE

GERHARD RICHTER: PAINTING'S RESPONSIBILITY

The hallucinatory interval in contemporary painting has passed. So-called neo-expressive figurative painting has proved to be an affirmative form of Conceptual Art; the idea of gut painting has mostly produced mere imitations of the soul's refuse, and the attempt to make expressiveness and figuration into an agenda has left us with only simulations of passion. What remains is a more or less embarrassing "parody of brightly colored corpses" (as Walter Benjamin once described fashion), which wets itself in pictures throughout galleries and museums.

But this interval had hardly faded away when the eternal return of the new (the law of motion for artistic fashions) had already completed its next turn. Alongside a tentatively emerging aesthetic Renaissance of the political in art, what is again increasingly emerging is what is called the constructive, the conceptual, and the abstract. A conceptual hemorrhaging is being followed by the constructive excrement of the brain. Exhibitions on this tradition's older and old classics have become more frequent in galleries and museums; younger conceptual painters have increasingly appeared in public, and thus, after the pleasant return of Palermo's poetry, attention has turned with all the more intensity to Gerhard Richter.

After his polychromatic abstract pictures had become the abstract climax at the "von hier aus" exhibition in 1984, Richter almost inevitably was in the news again. However, this was not because his abstract paintings from the past few years had been supported by the noted fashion-based art trade. On the contrary: his most recent works in particular persevere in their gaze, offering the presence of poetic abstraction in a manner that is at present almost without equal. Thus, for example, in the picture *Die Mauer [The Wall]*, a black-and-white caesura invades the polychromatic lightness-of-being of the layered forms, colors, and painting styles, which ties the picture together to a thematically charged and intense moment, an unexpected harmony made up of disharmonies. A break-in of thematic harshness into a nonfigurative, transparent, and impasto action on the canvas has the effect of an enclosed contradictory order that brings out painting's contradictions.

But not only the newest pictures by Gerhard Richter are of current interest. It is

also worth having a renewed look at his works from the sixties and seventies, in particular because they stand for a responsible reflection on painting by painting. If just a number of years ago nothing in painting could be taken as a matter of course, the matter-of-courseness of today's painting is exactly what is itself again in question. This renewed sense of questionability is one of the themes painting cannot dodge. A reflection on the (im)possibility of painting is imminent, which as early as the beginning of the sixties was a central concept of Gerhard Richter's painting. Starting with *Picture No. 1,* his works have been consistently numbered in order right up to the present and are concerned, to use his own words from 1968, "to test what can be done with painting, how, and, above all, what I can paint today. To put it another way, the constant attempt to make a picture for myself of what is going on."

It all begins when he crosses out with a broad paintbrush a table he had painted with imitative accuracy. The picture seems to say no to painting as a representation of reality. In fact, it says only what it is. This means that the negation of representation functions not only on the semantic level but also primarily aesthetically; it is in itself painting. Even this first picture is characteristic of what has distinguished Richter's painting over the past twenty years: it is an artistic self-reflection on painting, whose possibility and necessity must always be won anew.

Thus, confronting the illusion of reproduction inherent in painting yields photographic pictures that are no longer related to a purported reality, but, of reality conveyed to us by our senses. In a kind of ready-made painting, Richter makes use of amateur photographs and in doing so also avails himself of a photographically conveyed, stereotypically imagined reality as the basis for producing photos by the means of painting. He does not paint with photographic realism but makes "photographs by other means" (as he noted in 1968), which distract the gaze from the representation of some reality or other to focus it on the presence of painting as such – something he accomplishes in particular through the technique of smudging. The "blurriness" attained is, in fact, not blurriness. It makes the picture visible as such: "What we see here as blurriness is imprecision, and that means being unlike the object portrayed. But since pictures are not made in order to be compared with reality, can they not be blurred or imprecise or different (different from what?). How are, for instance, colors on a canvas supposed to be blurred?" (1967).

If his photographic paintings represent anything at all, then it is painting as painting, despite the fact that the stereotypical perception of the socially generated view is, at the same time, brought into the picture by concentrating on painting the subjects from holiday and family photo albums. Here, Gerhard Richter has succeeded in a form of pure painting that does not break off its relationship to reality, but in its form points to a restricted and alienated perception of the universal petty bourgeoisie; "I would like to have contents without sentimentality, but as human as possible" (1985).

Gerhard Richter. *Onkel Rudi,* 1965. Oil on canvas. 87 × 50 cm.
© 1997 Gerhard Richter.

At the end of the sixties, Richter's painting concentrated more and more on the possibilities of painting beyond all evocations, possible meanings, and interpretations. A kind of painting arose that disappoints artistic deceptions, that leaves nothing to its external shape. For example, the color fields that are nothing more and nothing less than a matter of presenting the essential medium of painting – color – as a simple factuality. The painting here is simply the site of color multiplicity per se and dashes all the observer's hopes for interpretative froth, although it is well known that no picture is safe from interpretation, which is at once a construction of meaning and an appropriation of art's subversion of meaning.

Richter's artistic self-reflection on painting reaches its peak in the series of gray pictures, in which the impossibility of painting – as was politically obvious, particularly in 1968 and the following years – is artistically parried by the monochrome gray of paintings that function as a symbol, or better, as an analogy for unpretentious negation. Here, Richter has painted an endpoint of painting that is at once its new starting point, because the formalization of negation is already beyond negation and therefore a determinate negation. All the individual and collective experiences that made these pictures necessary are – as is nearly always the case with Richter – sublimated to form. But even from within their autonomous construction of form, they still speak as essence. In their formal hermeticism, the gray pictures (begun in 1968) are, in fact, a determinate negation of the social situation to be found at the end of the sixties and the beginning of the seventies. It is just by this (seeming?) indifference of pure painting that they fulfill Richter's maxim from 1966: "It is not a question of painting good pictures, because painting is a moral action." In other words, he does not follow an ideological didactic theory but a morality of form, which is redeemed anew in every picture, that is, formally clarified. His paintings are guided by a responsibility of form, which, as Roland Barthes once said, can alone tie the forces of freedom to art, something that neither the so-called message of a picture, let alone the political lip service paid by a (petty) bourgeois artist personality, can accomplish. The politics of the picture – if it can even be a question of such a thing – takes place in the constellation of colors and forms to a picture language, for which the canvas acts as the stage. That which speaks as content from within the formal structures of a picture is still what decides the truth of the picture. Painting perhaps derives its fundamental necessity just from this occasionally hermetic morality of form that takes up the lines of a probable possibility for painting. It is essential to this possibility that it cannot be defined because it is a negation of definition. It is best paraphrased as a zone between coping with and surmounting nihilism. Gerhard Richter paints in this in-between zone. His paintings provide evidence of this, because they have always found their way to new possibilities for painting in face of its impossibility.

Does this then also apply to the gestural, abstract paintings that were to be seen for the first time in 1978 in Halifax, and that, since that time, have become the center of Richter's work? In 1976, these pictures formed the turning point of his artistic stance, which he described in 1981 as follows:

After the Gray Pictures, after the dogma of a "fundamental painting," which fascinated me to the point of self-abnegation with its purist, moralizing aspect, the only thing left for me was a completely new beginning. Thus the first color sketches emerged to uncertainty and openness under the premise of "multicolored and complicated," in other words, the opposite of anti-painting and of painting that doubts its own legitimacy.

What Richter accomplished here corresponds to the affirmative *volte-face* in painting that took place on a major scale at the end of the seventies in Italy, Germany, the United States, and other countries and was tied in with the fact that painting became unreservedly open to a manifestation of intensities, for which all the available media were called up. Richter's polychromatic abstract pictures exhausted the entire spectrum of gradations of color, strokes, streaks, enlarged brushstrokes, paint spray, and various ways of painting (from extremely impasto applications of color to the clear transparency of varnish). His abstract pictures are, in the first instance, diagrams, in other words, operative ensembles of all the non-significant and nonrepresentational artistic strokes, lines, and zones, which are nevertheless in the end brought into a constructive arrangement of form by means of a dialogue with the painting process during which the compositional expectations of the painting confront the painter. Their sometimes extreme tensions are brought on because Richter "plays out" the antimony between abstract expression and mathematics, between inner necessity and a tectonic pictorial order, without deciding the issue one way or the other. Put another way, the nonfigurative chaos on the canvas is gathered into a pictorial and self-contradictory order. Without the contradictory spaces and layers of the pictures being harmonized in any orderly way, they implode into a unity, to a poetic density of a different presence, a presence of difference.

In 1985 Richter stated:

The composition of various forms, colors, structures, proportions, sound patterns, etc., are shown to be an abstract system that is comparable to music; it is then an artificial structure and, in itself, as logical as any natural structure, but not in a figurative way. This system exists by virtue of its similarities to natural appearances, but would be instantly destroyed if an object were recognizably portrayed within it. Not that this object would then say too much, but rather its one-dimensional nature would limit the statement made by the contents and degrade everything around it to props.

Thus, the tension between the reality (of painting as such) and the illusion (of representation) in Richter's work becomes immobilized in an instant but without being dissolved in favor of some kind of figurative or abstract unequivocalness. Painting is always visible as such in its media and methods but, on the other hand, is not afraid to open itself to what is illusionary in all "references to nature," which, vice versa, are disappointed by Richter's painting as painting. Any viewer of Gerhard Richter's abstract paintings finds himself in the fade-in/fade-out between the reality and semblance [*Schein*] of this diagrammatic pictorial order, for it never

allows him to quietly contemplate the pictures. Richter's abstractions leap before the eye in such a way that the eye can hardly grasp them. They convey the fascination of an eye's glance in which the glance overflows and the form unfurls its magic, in other words, its direct, pictorial speech. But as I mentioned before, the abstractions do not exhaust themselves in the revelation of an artist's suggestive power. They always direct the gaze back to the simple material fact of "oil painting on canvas," which Richter presented once again in 1981 in an explicitly conceptual way in his work *Zwei gelbe Striche*. Two yellow strokes – which came about as a work commissioned for a school entrance hall in Soest – are, down to the last detail, an extreme enlargement of simple brushstrokes on a 1.9 × 20 m format, which presents the gesture of the artistic hand in a nearly mathematical exactness of hyperdimensional proportions: a gigantic demonstration not only "of" but above all "for" Richter's controlled act of painting, which also plays a role in the paintings whose abstraction at first seems to be expressive. Also in Richter's (not just) abstract paintings, the question arises as to the possibility and necessity of painting, as well as misgivings as to its media and methods. Only it seems to be suspended in the pure, nonexcessive presence of the picture, in the "music of the picture," which "conveys" painting's self-reflection. It appears to me that Richter is increasingly successful at staging a convergence between morality (of form) and amorality (of the chaotic, nonsignifying activity on the canvas). What most characterizes the polychromatic, abstract pictures is a responsible, pure realism of painting as painting, which for Richter is as ever a moral action – one, however, that achieves results, or formal clarification, only through the unrestrained diagrammatic manifestation of the painter (who of necessity is amoral [immoral being something else again!]) And what else is formal clarification other than creating clarity with pictures: the constant attempt to form a "picture" of what is going on.

Gerhard Richter. *Betty,* 1988. Oil on canvas. 102 × 72 cm.
© 1997 Gerhard Richter.

Brice Marden. *Couplet IV,* 1988/89. Oil on linen. 108 × 60 inches.
© 1997 VG Bild-Kunst, Bonn .

BRICE MARDEN: ENSOULED FORM

These paintings are not "abstractions," nor do they depict some "pure" idea. They are specific and separate embodiments of feeling, to be experienced, each picture for itself.

Barnett Newman[1]

For Brice Marden, real painting has always begun where collages and illustrations end. There is no solution in painting that has itself not been worked out through the painting process. The result for him is not restricted to formalist fact. "There is more than that" (B.M.). The question as to the "more" is that of transcendence and the spiritual, issues on which his painting has been centered since the 1960s. His contraction of the image to the picture plane never becomes formalist reduction in his paintings. "The indisputability of the Plane" (B.M) was and is for him a focus on the reality of painting, that is, on the rectangle, line, proportion, plane, structure of the picture support, light, and paint application. However, he does not stop at the point at which many Minimal painters confused the utmost reduction with purity. To him, work on the surface is work on a spiritual resonance box: "The rectangle, the plane, the structure, the picture are but sounding boards for a spirit" (B.M.). For Marden, this condensed restriction must coincide with a poetic opening. The presence of poetic energy in the form of painting – that is the ambition here. The qualities of the surface are directed toward the radiation of the visible that finds itself here. At issue is ensouled form, embodiments of feelings that have not been felt (yet), that are not affections or perceptions a "person" might have (had) but affects and percepts, embodied in and as a picture plane, in other words, non-abstract and nonpure painting, for example, ensouled form.

To believe that with ensouled form transcendence and/or something spiritualized has been achieved is a fatal delusion that many (abstract) painters fall prey to. This delusion leads to a phony transcendence and mock-ups of spirituality and ersatz sensation. Marden is here more modest and more focused. Asked about the spiritual nature of abstraction, he once replied,

I don't think there is. . . . Maybe it's just aesthetics and maybe I am confusing the aesthetic response with the spiritual response. But I'd just like to believe that there could be some kind of transcendence. That's one of the things about the possibility of art . . . I would rather keep it open and say that there are magical, spiritual possibilities in painting rather than be cynical about it.[2]

Marden's insistence on the possibility, or at least the necessity, of a magic of the ensouled form is a rejection of both cynicism and formalism in art. His painting revolves around a concept of energy that is neither reductionist, illusionist, nor conceptually illustrative. To him, an absolute criterion for painting is that it not only be "right" intellectually but – above all – optically. A condition for the possibility of good art is, as always, that it visibly manifests the content that speaks from its form structures. During the course of a conversation in 1986, Marden explained his conception of a picture as an aggregate of energy – a concept that exhibits surprising parallels to Joseph Beuys:

In Maynard Solomon's book *Beethoven* he defines a work of art as "being instilled with a surplus of constantly renewable energy – an energy that provides a motive force for changes in the relations between human beings because they contain projections of human desires and goals which have not yet been achieved. (Which indeed may be unrealizable.)" That's true. Whenever anybody goes back to it, there is the potential for that energy to start going. And, it's my theory that that's why the rich try to control it – because the rich control energy. In a way that kind of energy is dangerous because anybody is open to it. It can be used by anybody who can get to it – it can't be owned.[3]

In the mid-1980s, Brice Marden reacted to the fashion for the geometric illustration of social structures and for the nostalgic return to geometrical abstract painting. He increasingly had doubts about collages with rectangles because they seemed more and more easily readable. The vocabulary of geometrical painting had become both generalized and generally understandable; it had also become available for use in illustrations of mostly only "half-baked" paraphrasing of semiotic theory. Neo-geometric pictures circulated in the distribution system of hypermodern art effects. In contrast to the (in the meantime) widespread collages made up of exchangeable picture-plane fragments, Marden began to work on the possibility of "setting up rhythms across the entire plane" (B.M.). For example, of the drawings he completed at the beginning of the 1980s in Sri Lanka, he said, they are "drawings with nature not from nature" (B.M.). These drawings, his studies of Chinese and Japanese calligraphy, his subsequent interest in hieroglyphic communication, his attention to the structural surface of seashells, as well as changes in his vision (owing to the simple fact that eyesight deteriorates with age) – all of these factors formed the basis for his new paintings. They come about from a process of a stratified drawing in oils. Marden works according to the organizational structure of calligraphy, namely, from right to left and from top to bottom. Triangular shapes breathe in and out, dissolve and contract, forming a painterly weave of structure and gesture, light and space. Marden stages and interplays between evocations of the organic and inorganic: painting as the evocative presence of crystallization in which the "molecular energy of colors" (B.M.) are both effective and

visible. With lines that mesh and superimpose on and run alongside each other, he furnishes his imaginary rectangle in a manner that announces and promises more than it avoids and retracts. The gestural opening up in his recent paintings is, in fact, an energetic concentration. The paintings reveal the skeletal framework of abstraction in that they "allow the lines to dream" (Henri Michaux). In his *Couplets I–IV*, he creates a visual analogy to contradictory units of couplets in modern poetry: ensouled ideograms of poetic vision. A formal confrontation is formulated here that is closer to the strict rules of far eastern calligraphy than to any personal gesticulation. With these paintings, Brice Marden has once again attempted to call to life forms that escape the ghetto of the imaginary and will perhaps at some point find use as energy aggregates.

It's a cynical time. But maybe one of the most positive things is that a belief in art does exist and in some way maybe that will loosen things up a little bit. Maybe by just keeping the possibilities of the idea open, something else can happen.[4]

We shall see.

Brice Marden. *Couplet Painting Study III*, 1988.
Ink on paper. 22 × 10¼ inches.
© 1997 VG Bild-Kunst, Bonn.

Howard Hodgkin. *Like an open book,* 1989–90. Oil on wood, 24¾ × 20½ inches.
© 1997 Anthony d'Offay Gallery, London.

HOWARD HODGKIN: THE CARNAL PRESENCE OF EMOTION

In his paintings, Hodgkin would like to provide a link to the "glancing, slightly dematerialized quality that one does actually see in reality,"[1] "the sort of evasiveness of reality."[2] He knows, however, that he can achieve this only if he manages to create an autonomous picture-object that comes into its own when "the subject comes back."[3] In the process he pursues a kind of realism that "depends also a lot on illusionism."[4] Trompe-l'oeil effects and figurative allusions in his pictures serve the purpose of translating emotional situations into an autonomous pictorial reality. By contrast, making the deliberately placed brush strokes anonymous, even those that evoke the figurative and the illusion of space, serves the purpose of expressing a specific emotional situation. Hodgkin has worked out a reservoir of brush strokes that he executes with large, wide brushes in such a way that they remain discernible as such. Even the view of the nude blonde with spread legs in the picture *None But the Brave Deserves the Fair* tilts your view toward a perception of the brush strokes from which it is made (and back again). Hodgkin's picture-objects set up a circulation between brush stroke and figure, between picture plane and spatial illusion and in this way produce an emotive expression that sets off memories which are then disappointed by the abstraction that provokes them. He is working on a reformulation of classical painting "where all emotion, all feeling turns into a beautifully articulated anonymous architectural memorial."[5] Hodgkin's picture-object is indeed experience sublimated to form. It bears the memory of emotive experience like a sediment (who would not find the sight of the clothes she has taken off familiar?) and is itself a fabricated affect. This simultaneity is also realized in Hodgkin's line: on the one hand, as consciously placed signs – that is to say, part of an impersonal reservoir of brush strokes, an ideographic dictionary for producing in-sight (into emotional realities) – and appears, on the other hand, to be a direct "gesture" that produces the remainder, the atmospheric bonus. Through his work on presence Hodgkin gains expression, and through his work on expression he gains presence. He has worked out for himself his own brush style through his de-personalization. He comes by his use of the brush *[Duktus]* via its codification ("I want to make

marks that are anonymous as well as autonomous"[6]). These signs are the means by which he constructs his *paintings as affects* in contrast to the affection you feel. He uses the gesture as a sign with no loss of its specific energy, without which the controlled, that is, the formalized, affect (classicism) no longer is one. Hodgkin imposes the figure rather than "pure" form on the viewer. And he does this by using the gesture ideographically (for example, as a conductor of graphic energy or by means of lines in quotation marks) and also as the painter's gesture (the correspondence between brush/body, which is the way his own body insists). On the one hand, the interior depicted serves to transform the composition into colored surfaces and ornaments, whereas on the other, the *realistic* furtively steals into decorative form. The picture is thus manifest as an interplay of colored surface and figuration in the sense of a still-life repertory. From the friction between these two *gestures* (the ideogrammic and the line as a carnal strand from the body), the abstract picture emerges as a trace of the figurative, as a carnal presence of emotion. Thus, taking our distance from things leads us back to them, without our having to pretend we ever left abstraction.

Hodgkin has in mind a classical nonsignificant language of magical presence: an autonomous brush-stroke ornamentation whose effect is an analogue to emotion. His painting evolves in accordance with the necessity that is a brush stroke and in accordance with the painterly necessity that follows in its wake. But the aim is the production of a simple-as-possible constellation of brush strokes, in which the subjectivity of the figure, the objectivity of the object, and the legitimacy of space create a plane of convergence. Ultimately, a metaphoric picture-object hangs on the wall, which represents the proof of its coming into its own but without relinquishing any tie to (possible) inter-human realities. Hodgkin's paintings (re)present recognitions that bring (back) into art all the lost emotions on whose physical experience we build relations to other human beings in reality . It is not enough for him to make visibility visible. Hodgkin settles at picture-plane level the contradictions that painting gets itself into when, not content with the visibility of visibility, it makes likeness its goal and the imaginary tissue of reality its theme:

Quality, light, color, depth, which are there before us, are only there because they awaken an echo in our bodies and because the body welcomes them. Things have an internal equivalent in me; they arouse in me a carnal formula of their presence. Why shouldn't these correspondences in turn give rise to some tracing rendered visible again, in which the eyes of others could find an underlying motif to sustain their inspection of the world?[7]

Howard Hodgkin. *Discarded Clothes*, 1985–90. Oil on wood, 31¼ × 36¾ inches.
© 1997 Anthony d'Offay Gallery, London.

A. R. PENCK: THE IMPORT OF THE REAL

> It wasn't easy to leave the lowlands of constant simula-
> tion and neither get caught in the metaphorical quag-
> mire nor wither in the desert of mere facticity.
>
> A. R. Penck, 1988

A. R. Penck is a painter, sculptor, semiotic theorist, and jazz musician, but primar-
ily a researcher of images. As early as the beginning of the sixties, in the former
German Democratic Republic, he broke away from traditional art – including
Socialist Realism. He wanted to create something to set against the illusion-gener-
ating machinery. He was interested in a presentation of the systems in East and
West Germany that was as factual as possible and of the difference in the relations
between people and their institutions within the two systems. By reducing and
abstracting the way in which structured human behavior reveals itself through ges-
tures, he wished to arrive in his pictures at a representation of the complexity of
social relations.

His original name was Ralf Winkler. Since the mid-sixties he has called himself
A. R. Penck, after the geologist and ice-age researcher Albrecht Penck (1858–1945).
The writings of the original Penck led him to discover cave painting. It was in partic-
ular its character as a signal and the energy it radiated that interested him. But in addi-
tion, the idea for the pseudonym was inspired by the analogy between the earth's lay-
ers and stored information and between a chronology of the ice age and his attempt
to shed light on the logic of cold war relations. As A. R. Penck, he has set about devel-
oping an elementary vocabulary of pictorial signs that allows him to work in a lexi-
cal way with the images. The product is "Standart," A. R. Penck's form of political

A. R. Penck. *Standart-Identitätsmaschine,* 1972–73.
© 1997 Michael Werner Gallery, Cologne and New York.

A. R. Penck. *l: Go Go Gorbatschow,* 1988. Oil on canvas. 285 × 500 cm. r: Reaktor, 1990, 90 × 320 × 400 cm, installation-view Monika Sprüth Galerie, Cologne 1990, © 1997 Monika Sprüth Gallery, Cologne, and Michael Werner Gallery, Cologne and New York.

Conceptual Art, conceived at the time as a constructive contribution to socialism. The Standart pictures are intended to function as images that are understandable to everyone and that everyone can use. With a program of reducing the picture to signals that control and structure behavior ("Signals select us," he says), he wishes to elaborate a model of communication that is free from repression and dominance.

In 1968, this bubble of hope burst. The realism of Standart foundered on a new ruling order in Eastern Germany. "Who has blocked the path?" A. R. Penck asked in 1974. Even in 1989, the correctness of his answer has not changed at all: "That generation – the ones with their demagogic lie of state consciousness that was only

an arrangement made by a particular group in order to ensure its well-being . . .
they were the ones who obstructed the path," he avers.

The experience of the ongoing perversion and defrocking of Eastern-bloc socialism
is also reflected in his pictures. They become more aggressive and expressive,
although without losing the priority of content characteristic of his work. He always
wanted to be at once expressive and realistic. And unlike Picasso, of whom John
Berger once said his only theme was sexuality, sexuality is not A. R. Penck's only
theme. He has always understood himself as a thematic artist who arrives at a picture
by starting with the political, economic, sexual, linguistic, and artistic themes that are
important for him and for others. Even by using expressive and surreal means in
paintings such as *Mike Hammers Geburt (Der Ursprung des Faschismus) / Mike
Hammer's Birth (The Origin of Fascism),* or *Der Wahnsinn der Vergangenheit ist
irreparabel / The Insanity of the Past is Beyond Repair,* he also remains close to an
analysis of the situation (not only) in the German Democratic Republic. And with the
End in the East pictures, he reacted to the breakthrough of irrational reality by a
unique blend of rationality and irrationality.

In 1980, A. R. Penck moved permanently to West Germany, where he achieved
world fame in the course of the eighties. Confronted with the contradictions of late-
capitalist reality and its corresponding machinery for creating illusion, he con-
sciously pressed ahead with an archaic tendency in his painting, in which he saw a
possible counter movement to the return to a new barbarism. However, he also wit-
nessed the misery caused by the waves of nostalgia, illusion of authenticity, and the
seeming subversions of the leftist movement in West German art and politics. He
watched them be swallowed up by an art culture of emphatic consumer and logo
fetishism. Aware of the possibility that counter movements perhaps do not impact
at all, and aware of the platitude, often perilously ignored, that a picture is a pic-
ture and not *not* a picture, he continued to work on pictures that counter rather
than hide what is considered to be reality and dominates as such. He presented the
proliferation of unfounded and deceitful symbols and the exchangeability of all
contents and attitudes in large-size pictures in which the contradictions and the con-
flict between being and consciousness typical of the victims of contemporary life
appear as ornamental figurations.

In 1988, on the occasion of a retrospective of his works in the Berlin National-
galerie, he formulated once again his artistic program in a brief, pithy manifesto:

Against color – for form's sake
Against mood – for shape
Against feeling – for system
Against fantasy – for reality
Against resolution – for tension

A. R. Penck's research into images still focuses on dealing with the complexity of
the structures of social relations by using world pictures that bring out the contra-
dictions (instead of playing them down) that make them necessary. Of all the

important contemporary artists, it is he who fights for the analytical within the irrational, for an awareness of art that takes up the analysis of broken identities, for magic that promotes knowledge, and for the import of the real within abstraction.

In 1912, Marcel Duchamp painted *Nude Descending the Staircase*. It was both the Cubist solution to Futurism and at the same time a picture which expressed that it is the task of the artist to instruct painting on the essence of its being. A. R. Penck is currently working on a Futurist solution to Cubism, and thus on the future of a kind of modern painting that does not allow the strands to lose contact with human reality: in the name of change, that is, the reality of difference.

A. R. Penck. *Der Übergang,* 1963. Oil on canvas. 94 × 120 cm.
© 1997 Michael Werner Gallery, Cologne and New York.

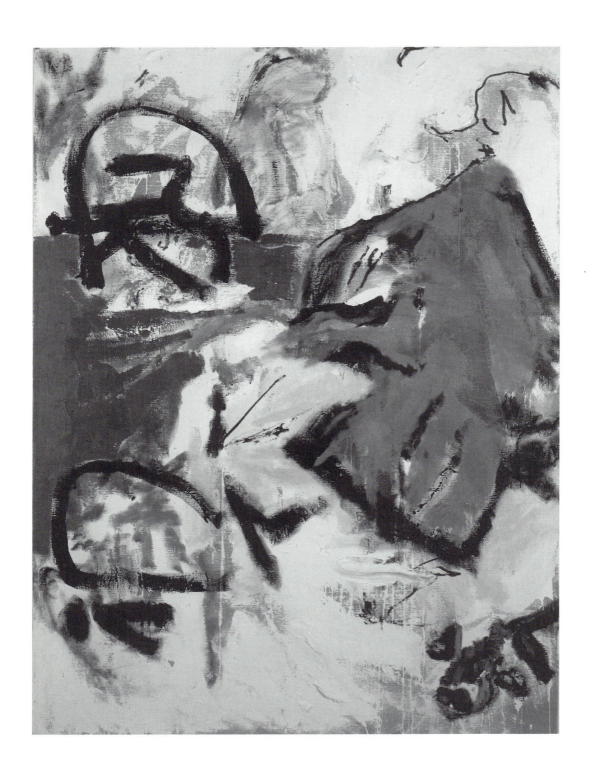

Don Van Vliet. *Parapliers the Willow Dipped*, 1987. Oil on canvas.
198 × 147 cm. © Michael Werner Gallery, Cologne and New York.

DON VAN VLIET: COHERENT DEFORMATION

The fact that children, if they are not conditioned to keep to a regulated harmony very quickly stop drawing beautiful pictures has in the past helped maintain the hope of a renewal for painting. This hope, however, has recently been discredited by the trendy mannerism of warped body parts. And those who considered the strategy of bad taste to be the right road now find themselves on the wrong track of affirmation. Don Van Vliet's pictures go back to before this development and once again remind us of the chance that still exists in the art of neither being able to see nor to hear very well and of playing it wrong. Nothing really comes together in his pictures, and he does not speculate on mistakes brought purposely into play, not even by way of the back door. The contrasts are simply and agreeably opposed in an imaginary rectangle. Everything seems pushed into a tight corner, with no room, beset by obtrusive color planes, which let the figurative skeletons they keep in the closet shine through. Contorted faces, animals, women's bodies, and other figurative allusions remain unrelated to each other. Either they peer through the cracks and crannies in the surface or they remain ambivalent, hybrids between abstraction and figuration that materialize through the smears: an appearance and disappearance of shadowy beings haunting the gaps between presence and absence. Demons of the revolt (a revolt long since appropriated as an aesthetic) maintain their survival in the pictures in the form of picturesque deformation. For example, in *The Shiny Beast of Thought* Don Van Vliet depicts the theme of the contradictory unity between order and disorder, death and nondeath by means of, on the one hand, a disagreeable white color, which like an unavoidable zone of death (a "skeleton breath," D. Van Vliet), constitutes the background for everything else and, on the other, by means of the enchantingly beautiful blood-red color, which appears in varying shades (e.g., in *Zebra Bees*). It is a theme that every painter for whom a picture is there to incarnate the necessity of freedom works to show: *Treed, But Not Crow*, which amounts to saying: It is true that we were driven up a tree, yet there is no reason to crow.

This paradox is the expression of the coherent deformation by which painting

evolves and by which art, in following its happy demon, suggests the contingency in a too self-assured world.

In the name of a more genuine interrelation between all things, the artist destroys their usual relationship and substitutes a new, unrehashed system of equivalence by means of an organized disorganization of the painting. A good picture portrays the present that is striving to be seen. And by his work on the possibly visible, which exists before and behind the regulated visible, the painter struggles toward an unadulterated view, toward the visibility of holding one's ground in the midst of a time of great indifference to everything visible, a time in which capital acts as the grand supervisor of all sounds and silences.

In contrast to the widespread waves of nostalgia in art, whose relationship to history is less marked by remembrance than by a narrow-minded forgetfulness of historical abuse, Don Van Vliet's paintings, by coping with art's necessary failure, are mindful of this as-impossible-as-it-is-necessary mission that every genuine painting must fulfill, namely, to destroy the order of things and, in the unbearable sense-full world, tear open the rectangular hole through which "the light from the other side" (Egon Friedell) falls through the crack in the door and makes the ass of the world visible. I speak here of the shaping of a silence that is not an empty one, where painting can be the stand-in for the nonidentical. Everything else is neither silence nor pure painting but pure bullshit.

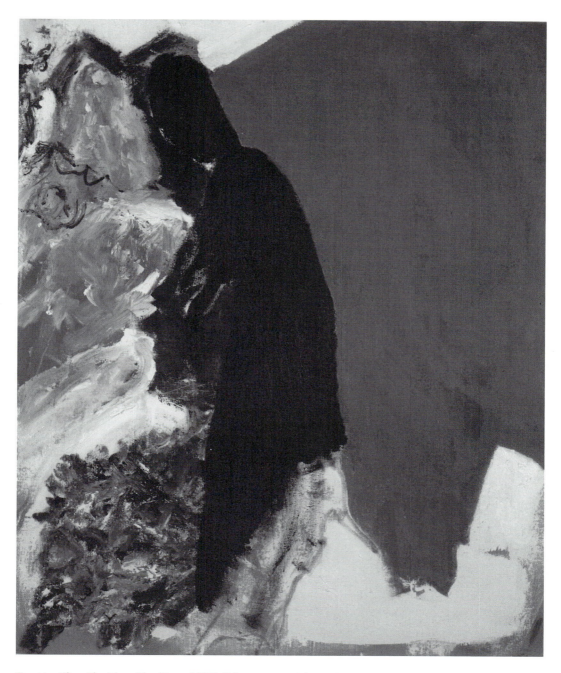

Don Van Vliet. *The Navy Blue Vicar,* 1987. Oil on canvas. 147 × 122 cm.
© 1997 Michael Werner Gallery, Cologne and New York.

Theoretical Interlude

Fisch

火車

Vochem

五 第 四

Heide

Benderkloster

Grube Gruhl

Roddergrube

Rodder

Grube Brühl

Johannishof

Ringsdorf

T

130.c

133.c

65

66

62

63

56

57

69

64

43

39

40

35

36

30

29

24

72

25

26

19

20

44

34

32

AFTER NIHILISM

Seeing everything properly means thinking in pictures in such a way as to see how pictures, hermetically sealed off from their position in the expressible, mute to the degree that they are visible to the annihilation of nothingness, show their knowledge visibly. In order to see what they know, that time must be examined whose eyes are pictures, which in the shadow of cadavers see nothing other than death and yet in the margin now see non-death, calculable according to the formula of the new picture world.

Rainald Goetz

Tintoretto paints the Creation like a cross-country race, in which God himself is sitting in the front row to give the signal to start. Then a painting by Lotto suddenly appears that could just as easily be from the nineteenth century. What happened? Something has appeared that surely was painted out of remnants of old painting codes, but which have been infiltrated by a virus of an altered perspective that undercuts the dominant style. What happened is a breakthrough, something that no longer belongs to any school or age – even if this should be nothing other than a gesture of concession toward the age out of which it arose: art as a process without a goal, but which in this way perfects and realizes itself – art as experiment. . . . In the moment of such a breakthrough, art is an experiment, the experimental conditions of which consist in rupturing codes, tearing down the signifiers, making incisions into the continuum of discursive mendacity, undermining the

Curtis Anderson. Untitled (detail), 1990. Lacquer, silver leaf on aerolam panel. 122 × 244 cm. © 1997 Curtis Anderson.

structures, and setting currents in motion at the boundary of desire. . . . The result is new diagrams, new operative ensembles of strokes, lines, and zones in the painting, new diagrams in which the painter works out for himself a specific way of doing things in order to bind together the non-figurative chaos he has created for himself as a basis that is authentically non-authentic. . . . We experienced such a breakthrough at the end of the seventies and the beginning of the eighties, above all in the painting of a generation that was born into the fifties and lived through the development of the sixties and seventies with all their hopes, failures, illusions, political misery, and especially their musical highpoints viewed from its early to postpubertal perspectives. . . . This generation's perceptual seismographs set to work when it became evident that the political bards of Minimalism and Conceptual Art were imperceptibly caught up in society's appropriation vortex and failed to notice that they were reproducing only that which they thought they were fending off. These political bards were not in a position to counter the resulting contradictions; that was reserved for the generation for whom ambivalence was and is its self-evident mode of existence and for whom conflict is the horizon of its visions. . . . Whether we reflected on it or simply saw it as evident, it was already clear, even at the beginning of the eighties, that our task would consist in redefining responsibility without any emancipatory horizon, and that the (im)possibility of art is a deciding factor in fulfilling this task. . . . Art as the staging of its own disappearance had come to an end, the hymn of purity on its way to purgation through reduction had been unmasked as narrow-minded pseudoautonomy. The hermetic self-reflection of art and its context had evaporated in the incessant iteration of masturbatory linguistics. It also became clearer what in addition was no longer possible: logocentrism, the myth of the Ego, all varieties of identity lies, all the blah-blah about meaning, the idea of unity, holistic illusions or simulations (with which many still believed they could establish a small corner of authenticism for themselves), every form of the ideology of linear progression, and, not least of all, the one truth, to which more than enough people still fall victim. . . . Perhaps at this moment, it was the nihilist's inconsistency to create art. It was a rejection of formalism and aestheticism, which is what nihilism in art always boils down to. It was a rejection of decay and ruin, a rejection of resignation, apathy, plaintiveness, psychologism, and the cult of angst, a rejection of the misery of all art flea markets and the emotional worlds associated with them, a rejection of the increasingly watertight immanence of a system that absorbs everything, that affects all terminologies – in particular, critical terminology – making any possible critical or post–critical ambition become irrelevant through interchangeability. . . . In contrast, an art of intensity arose (from paintings to display cabinets, from photography to drawings on paper), but with an insistence on content, an art of fascination, but one aware of the dubious nature of pathos, an ideogrammic art that generates paralogical and analogical references, but without falling prey to talk of a newly awakened myth. Where such a myth was believed in, art quickly ran out of breath and blood-letting simulations of expressionism piled up in galleries and museums.

... And, in fact, the very first mistake made was to elevate the features of a nonarbitrary breakthrough in painting to a programmatic level and, in the process, assume that factually impossible things, such as immediacy and authentic expression, were real and possible. Such idiocy quickly showed up in the wishy-washy phoniness that went quite against the will of the pictures that were only well meant. . . . At the turn of the decade, there was, in fact, a diffusion of the Ego and of identity deceit; there was a liberation of the marginal in society and in one self, a loosening of references and a nomadism of the imaginary in a quarry of vapid styles and broken references. There was the emphatic production of symbols at the endpoint of meaning, and there was an involuntary concentration on what remained when you fall, ideologically and semantically, flat on your ass of expressive powers: coming down to the fact that what really counts in a life not yet lived is to counter alienation by painting it. . . . Aware of the miserable art-to-life transference illusion, you opted for a presence free of illusions. Pictures were seen once again as vitally working energies. A revival took place of what Carl Einstein formulated in his major essay on Braque: "It is time to replace cowardly stylizing interpretation with the spiritual fact of reality. Applied to the pictures this means pictures are not fictions but practically effective energies and facts. The moral position of the pictures is thus changed and the merely artistic standpoint and the indifference of the artist is done away with: it is no longer valid to varnish pictures like bibelots but rather test them as real and practical forces and mediums." . . . But just as Carl Einstein later dissected the fabrication of fictions, so at the beginning of the eighties, people (if not stupid) very quickly grasped that all this existed only in a painting diagram at the moment of the breakthrough; that expressiveness can be achieved only on the road toward construction (and vice versa); and that, for example, whether a line is not stupid is dependent upon whether the painter is intelligent enough to trick his intelligence. . . . What followed was express(ive) ideology, which fatally served the market. It was able to do so because the purported aesthetics of openness functioned as an optimal foundation for expanding the exchange of artistic goods, since it created an atmosphere of "anything goes," in which the same indifferent equivalence of all forms and contents made the works exchangeable to an unprecedented degree. The pluralism of the pictures force-fed the capitalism of the art market to such a degree that aesthetic judgments vanished, their only value being as commodities and objects of speculation. The pictures' lack of references was reversed to their becoming interchangeable within an ecstatic circulation of goods. . . . What emerged from the reproduction culture was the "degré xerox." Where a thing disintegrates and disappears, it doubles in trappings of its self, and a frenzy of eclectic form arises, a delirium of more or less superficially glittering fragments: that which is artistically ruinous, as could be observed as long ago as in the Baroque. . . . However, the baroque glitter of the fractal surfaces is now accompanied by its flip side, which is the indifference of all forms and substance within the increasingly universal economic discourse, a discourse that absorbs everything and allows nothing outside of itself. . . . This not only applies

to the distribution of art as a commodity but also affects the thought and action of art producers in the form of inevitable strategies for behavior, sales, presentation, and production, which are the prerequisites to what then is considered and then sold as contemporary art. . . . In this sense, the development of artistic currents in the eighties was not actually an artistic development at all, but an economic one. The succession starting with "expressive painting" and continuing through sculpture, "geometric painting," and "postconceptual art" to the return of "art photography" illustrates a simple compulsiveness in the circular structure of fashion, taste, and status values: the eternal return of the new. . . . The only thing that counts is the communicative commodity value of pseudo-isms. So-called post-expressionism had four years of hype, the "Neo Geo" had two years. "Post Pop" in the United States needed only a half year to go from $5,000 to $100,000, only then to run the danger of being boring: as long as the illusion of progress and of the new could be sold. . . . The "what's new" aspect of (say) collectors shopping around for art to fill their own identity gaps echoes through the stage play of art like the Ninth Symphony in *A Clockwork Orange*, used as an instrument of torture. At issue are plastic ecstasies, compensation pills, distinction orgasms. The principle of hopeful speculation reigns supreme. . . . But let us not forget the following simple fact: capital is the stage director of all images and non-images. To paraphrase the words of Gordon Gecco in the film *Wall Street:* Everything is a game that comes down to zero. What one person wins, the other has to lose. After all, money is not produced new for the occasion, it simply changes hands. Like a miracle. This painting here I bought ten years ago for $60,000. Today I could sell it for $600,000. The illusion has become reality. And the more real it becomes, the more it is desired – capitalism at its finest. . . . No one who has anything to do with art nowadays can avoid the omnipresence of economic discourse even within the crypts of the soul. Here, you have to pin your colors to the mast. . . . A happy expression, incidentally, since, taken literally, it alludes to the importance that pictures could have as pictures. What is required here are ways of reacting to the system, pictures that counter the system and not illustrations of purportedly critical concepts that have long since belonged to every party's program of lies. . . . At a German liberal party congress on the theme "The Art of Creating Art in Germany," for example, the foreign minister gave a talk in which the art concept of a Joseph Beuys, expanded to include the social, was turned into the basis for liberal democratic politics. That something was fishy became apparent the moment examples were cited. Here, truth and verisimilitude became obvious again as a question of the concrete form. Asking oneself this question in the face of over-inflated indifference could be an approach to artistic responsibility. . . . No obsession without obligation. But the responsibility of art is not a directly thematic one, nor a matter of discourse or even ideology; rather, it is a responsibility of form. I would like to have this concept of "form" understood in this context as the objective organization of any appearance within a work of art to a (dis)harmonious articulation of nonidentity. Form is the nonviolent synthesis of what is dissociated, preserving it for what it is in all its divergence and its contradictions, and therefore form is, in

fact, an unfolding of the authentic nonauthentic. In this sense, truth can also justifiably be understood as work on the form. . . . In art, the only thing that counts is what is brought to the surface and speaks by dint of this visibility. If I see a picture, I must be able to see what it has to say. Everything else is merely everything else, namely, ideology, illustration, half-baked contextual commentary, or some other form of ingratiation with the economic universe of the petty bourgeoisie. . . . If one refuses to cater to the situation by providing exchangeable pictures – and the true necessity of art involves challenging just such exchangeable images – then the task at hand is form sublimation. Only if art can completely unfold its laws of form, for example, its physical sensations, (dis)similar similarities and mute meanings, can it do justice to a responsibility of form. Its thematic radicalness is a question of form. . . . This has indeed, in the meantime, become an overused platitude, and one that I will not cease to overuse as long as there is a growing mediocrity of artists/performers who sometimes babble about it but, when it comes down to it, try to sell as sublime formalisms of private fetishes, eclectic architectural fictions, and melodramatic atmospheric bluffs. Even with apparently critical (i.e., glorifying) collages of cultural garbage or with satirical and ironical (i.e., beautifying) illustrations, the concept designer is doing nothing more than talk up the situation. . . . The art-ersatz signs circulate in the domain of public taste in which the myth of power directs the hermaneutics of silence (art). . . . One should always, just for a change, pose the question about power, for it purges the criteria for quality. . . . However, exactly because there is no way of being outside of indifference and power, the question becomes all the more acute: How can we redefine responsibility (of form) without possessing some kind of system of references that provides a continuum of meaning including an assurance of a future? . . . The status of art in this context is no longer quite so evident as it was at the beginning of the eighties. We also cannot speak of something as a real possibility that art would already have. But there is a necessity to create possibilities. Don't cry, work. . . . Much depends on whether art will succeed in coping with its transition to the stage of industrial production without mutating into the "pure" production machinery of hyper-modern special art effects, which, within the rhythm of recycling, repeat memories of the memory of the future in an endless loop. . . . However, propagating the ultimate end of art and its culmination in the design of hyper-reality, as Jean Baudrillard does, is wrong. Art does not have to inevitably exhaust itself in the (re)staging of its disappearance. Just as a potentiated void does not forcibly become an event. We must be clear here only that in its best manifestation, this void embodies the underlying contradiction in contemporary (in)human reality. What is required are pictures of an unsentimental kind of humanism. . . . Art is caught in the paradox of being a mendacious luxury on the one hand, but of simultaneously being able to be beautiful and truthful and thus a carrier of nonidentity on the other hand. It succeeds only where it plays out this paradox within itself and retains it as the tension in its form. This is equally true of the antinomy that all this talk about modernism and post-modernism is constantly bypassing. I am speaking here of the paired opposites, micrology and paralogy. On the one hand,

art as an entity sealed off within itself, as a fragmentary "whole," that attempts to redeem the dissociated subject at the aesthetic level and accompany it (micrology). On the other hand, art as paralogy, as a random experimentation with intensive fragments in a manner no longer beholden to the fossilized and fossilizing force of instrumental reason. On the one hand, the picture as definite negation. On the other hand, the unrestrained affirmation of intensities. . . . Oscillating between these two poles, between a paralogic dissociation of the subject and of an experience sublimated to form, in which the disjointing subject is retained: this is where good art today is at work bringing this antinomy out in the picture. . . . Attempts to make a one-sided decision in order to escape it lead to naivety and/or cynicism, and the danger is immediately at hand that the artificial art of an abstract society of mock-ups will be enriched by one more decoration. . . . Nowadays, a good picture is neither a complete rejection nor a complete affirmation of that which is. It is at once both affirmation and rejection, and this is why it can be nothing other than a constant being torn this way and that. It moves between numerous snares, between recklessness and propaganda, between formalism and the semblance of the authentic, between "pure" abstraction and "pure" expression, between illustrating bad translations of French philosophy and the romanticism of "pure" bullshit. . . . The picture comes into its own in the tension between negation (questioning the whole) and affirmation (sympathy with what is against death, the final goal of all forms of dominance). . . . It possesses truth only in the manifestation of its contradictions; therefore, it always pays the price of illusion [Schein] in exchange for its truth content, which it gains by dint of illusion. Its share in deceit must be visible as such. This means, for example: no painting without enchantment, although its magic comes about on the path toward artistic disenchantment. No painting without beauty, although the painter finds beauty only when he jettisons it, with the knowledge that for beauty's sake there can be nothing directly beautiful any more. . . . Making such antinomies come to the surface in a work of art and in this way formally countering the situation is not necessarily a matter of self-lacerating pathos. After the breakthrough at the beginning of the Eighties, the march through the realm of artificial signs, and the flood of simulated Conceptual Art with logo stickers, we can now see the consequences of a generation that, as I stated at the outset, takes ambivalence as its mode of existence and contradiction as the horizon of its visions. What does such a thing look like? Like the Procrustean paintings and the drawings of Albert Oehlen, all the works by Rosemarie Trockel, the great constellation of failure in the pictures by Julian Schnabel, the other side of beauty in Cindy Sherman's photography, Walter Dahn's continuation of painting by nonpainterly means, the new paintings by Axel Kasselböhmer and Siegfried Anzinger, Reinhard Mucha's installations, the fresco magic of Francesco Clemente, Georg Herold's counterillumination of meaning, the artificial irrealism of George Condo, Martin Kippenberger's malicious furniture, *Sardinen erwachet, ich male (Sardines Wake Up, I'm painting)* and *Akt eine Treppe hinaufgehend (Nude Mounting a Staircase)* by Georg Dokoupil, the text forms of Jenny Holzer, Richard Prince's *Girlfriends,* Andreas Schulze's box pictures, the displaced pre-

sumption of Haralampi Oroschakoff, the most hackneyed metaphors in the works of Günther Förg, and so on: beautiful, evil, and torn. . . . As different as these works are and as mutually exclusive as their basic attitudes may be, these artists nonetheless have a common artistic quality that takes the situation into consideration – a magic quality of form as ideograms of the knowable. . . . A prerequisite for this is that all deeply deceitful tales of coherence be thrown overboard. For example, tales told from a cowardly critical distance in the name of a communication that never takes place except as the negative fulfillment of a utopia within the above-mentioned xerox culture; the guilty conscience of the old leftists; the source of insincerity and cynical stratagems, the germ-free substitute for the soul in post-conceptualism. . . . In contrast to this, it would be important to first allow things the leeway to appear as they present themselves, with all their contradictions. A veritable opening up of perception to a state of steady attention, which Freud recommended with regard to everything the patient had to say, would be an additional precondition for being able to call forms to life that would not merely be "capitalism at its finest." . . . During the eighties, there were widely varying attempts to overcome the late-capitalist plague of ornamentation in art. There was the attitude that we should use the canvas as a platform for presenting everything that happens within a culture, to the tune of "truth can look at whomever it wants," as W. Büttner puts it. There was the attitude that insisted, and to hell with the losses incurred, on the significance of the pictures as vital, working energies. There were various efforts at potentiation [Potenzierung], for example, in the early Romantic sense of Novalis, who considered Romanticism to be nothing other than a qualitative potentiation. And, of course, there was also the attitude which consisted in saying that there aren't any more attitudes, so as to reintroduce the hope of a poetic moment by way of the back door, by way of formalizing the visible reasons for its impossibility. But at the basis of every attempt that led to good art was the awareness that today every effort to break out is as necessary as it is necessarily condemned to failure. . . . In ever newly planned and poetically sublimated failures and in the wonderful errors of artistically researched results undertaken by the above-mentioned artists, the conditions are worked out for the possibility of a beauty that is nondeath – after nihilism. . . . The results of the first ten years: ideograms of known untruthfulness and the first steps toward a language of images – neither death nor life, but rather life-death in one single thought, in one single image. . . . To bring the contradictory unity of death and non-death into the image is a task that painters in particular must face repeatedly, once they have grasped the fact that their necessary failure doesn't change the necessity for freedom. It is the expression of a coherent deformation through which painting develops further, and, by following its happy demon, lets contingency resonate in this objectionably smug world. . . . In the name of a more sincere relationship between things, the painter destroys their (un)usual relationships and replaces them with a system of equivalents that has not simply been chewed over and warmed up: the organized disorganization of the painting. . . . A good picture still portrays a presentness striving to become visible. In the work on the possibly-visible in front of and

behind the visible that is regulated by a web of signifiers, the painter is struggling for an unobstructed way of seeing, for the visibility of holding his ground in a time indifferent to obviousness. . . . Today's widespread wave of nostalgia in art has a relationship to history characterized less by its memory than by a bigoted forgetting as part of its abuse of history. In contrast, the above-mentioned works, by way of their materially processed failure, enact a recollection of painting's demand, one as impossible as it is unredeemed: a demand to destroy the order of things on the canvas and tear open that square hole in the unbearable, meaningful/meaningless world, through which, for a moment, "the light from the other side," as E. Friedell calls it, falls through a crack in the door and the ass of the world shows itself up for what it is. . . . I speak here of the formulation of silence – the obverse of the discourse on injustice – that is precisely not empty. Here, art can stand in for the nonidentical. Everything else is not silence but rather mendacious bellyaching, mendacious design, or mendacious architecture. . . . Whether everything is just the blue haze from one's own smokestack or a still life of the unsayable. Whether the pictures die as the extenuation of power and a late-capitalist plague of ornamentation or light the way to more freedom. Whether art is blown away in the metaphoric flurry of second-hand culture and must restrict itself to functioning as a symbol of distinction in the system of coordinates of prevailing taste or whether a revolution suppressed in all real revolutions will be fought after all in the ideograms of "my generation." This is the questionable per se, and art today should work out the images and figurations of this basic questionability. But art is rare. . . . Its best representatives (see earlier) provide fragments of questionability, which express quite sharply the ambivalence that is the stuff human beings are made of, right down to their psychosomatic bones. However, they then leave the beholder alone with fascination, that is, with an absence that is present because it dazzles us, and the presence of this absence confronts us with the gaze of the loneliness that is us. . . . Where someone does in fact succeed in "letting loose into the world something pure that we cannot let vanish so easily," to take up A. Oehlen's phrase, the picture suggests that the aesthetic event is the impending revelation that never does take place. . . . "Art is the promise of happiness, a promise that is constantly being broken," as Adorno once said. That is art's import of reality. . . . How much of happiness and its broken remnants affect our unlived life is – as Rushdie's case proves again – an existential question of being (t)here and of realpolitik (t)here.

Is There a Presence of Difference?

Francesco Clemente. *Analogy*, 1983. Fresco on heater.
© 1977 Francesco Clemente.

FRANCESCO CLEMENTE:
BE A CURTAIN AND TEAR YOUR SELF APART

Francesco Clemente, born in Naples in 1952, is a painter of the younger generation, whose works, by the end of the seventies, were already known far beyond the borders of Italy. During the eighties he developed into one of the most important international artists of today. His work began at a time when it had become clear that ideologies were interchangeable and the process whereby society appropriates everything to its own ends stops at nothing to do so, not even at criticism. Clemente experienced the failure of the avant-garde's political aspirations in the sixties and seventies in Italy and observed how the forms the art took lost critical power, became institutionalized, and thus slowly but surely sank to the level of the conventional "art norm" and, as such, came to dominate the academies. The artists who had come on the scene in the sixties in order to tear down the boundaries between art and life, art and politics, art and revolution began to reproduce exactly what they thought they had been working against. Their claim to offer the one truth in art and life has been standing around, amputated and seedy. And the much loved unequivocal differences between left and right, good and evil, right and wrong as well as the seemingly indispensable illusions of uniformity – of lifestyles and art styles, of political parties and the (lost) sense of Ego – disintegrated to irrelevance. The emancipatory obsession has sprung an irreparable leak. And its falsity has come to light.

Clemente belongs to a series of artists – particularly in Germany and Italy, but also in the United States and Switzerland – who were aware of the altered situation and have responded to it in their works. They applied their lever at that point where it was previously believed that the reactionary was discernible – in figurative painting. By a stress on its thematic possibilities, the flood gates were opened onto all that was repressed by dogmatic hippiedom. Making art at the beginning of the eighties is no more and no less than a rejection of apathy and resignation. "Don't cry, work!" is one slogan that attempted to put an end to fat-cat ideologies, holistic doctrines, art's "isms," and the coherence of individual identity. At issue was, among

other things, the ability to bear the parallelism of things and to work out the subsequent contradictions in pictures.

Clemente started out on this road by first welcoming everything that came to mind in the way of thoughts, wishes, insinuations, ideas, desires, dreams, analogies, and logical conclusions. The method consisted in evolving a passive mode of action that sets currents in motion beneath the codes, bursts open identity systems, and distorts the systems of signifiers. He followed the strategy of acknowledging everything that an uncensored, aimlessly drifting imagination finds along the way as being pictorial material of an equal value. His ambition was, within his own thoughts and feelings, to turn loose the reference systems that produce one-dimensional meaning and thus to provoke an unsentimental, poetic opening in painting.

In his pictures, Clemente stresses the fragmentary and allows the fragments to stand next to one another without any link. He lets the famous-infamous dissociation of the Ego take its course ("Be a curtain and tear yourself apart." Carl Einstein) and begins working with the fragments. In his pictures, he stages an imaginary journey from one Ego to another, from one possible means of perception to its opposite. The loss of political or private identity is realigned into an artistic position, partly bluffed and partly suffered. Dissociation is employed as a micropolitical strategy that is intended to take the wind out of the sails of "new" illusions of uniformity and patchwork systems to compensate for its loss. And in the loophole left by indifferent aesthetic and political perspectives, Rimbaud's imaginary "deregulation of all the senses" appears on the scene: the program of intensity as both beginning and end.

The body as the meeting point of the symbolic, the real, and the imaginary is Clemente's main theme. He himself constitutes the platform upon which he paints the dissociation of identities in which he lets himself drift. Above all, his own physiognomy and that of his wife are for him not only the subject of transfiguration and the deformation of the irritatingly personal, they are also the platform for "masks of the personae" (E. Pound), behind which there is no longer a genuine face to be found. Multiplying the masks appears as the authentic articulation of the nonauthentic. He uses parts of the body as building blocks for a pictorial language, for its liberation from the straitjacket of psychoanalytical sense attributions. His pictures often begin where suffering and passion are not far removed from one another: between the legs of both sexes and of the one in the other. On the human body – which Clemente views as a film between the inner and outer world – erotic scenarios are played out for which there is no longer room on the psychoanalytical couch: for example, a nonoedipal circle consisting of a childbearing woman, a hankering child, and a man/father who appears incapable of closing the circle, an androgynous dilemma, an inner landscape or the most diverse picture puzzles of death, perception, man-woman variations, shoe fetishes, impossible contacts, fuck scenes, self-portraits, discharges, and other convolutions of the brain. Clemente himself says: "For my part, I want to see the body wake up again, since I come from a tradition of the resurrection of the flesh."

Clemente works on pictorial parallelograms that play between the skeleton of

the body and the skeleton of our experiences. In so doing, he often links up with places where nonart beckons. He helps himself to Indian film poster painting or resorts to artists whom the ideologically progressive faction of modern art happily excluded. The romantic visions of a William Blake, for example, or the terra-cotta reliefs of the della Robbias, which still today are frowned upon as religious kitsch. And Clemente even regards the use of classical techniques as a possible new start for a painting that had been pronounced dead, whereby the tradition of Italian Renaissance frescoes plays a major role. The pastel, the watercolor, and the fresco are his favorite media, as is the book. His self-designed catalogues and especially his books of illustrations on texts by Alberto Savinio, Allen Ginsberg, and John Wiener are among the finest artists' publications of the time.

The goal of the entire undertaking is to forge a new form of objective poetry. For Clemente, this begins where formulation and decoration end. First, let the associations and allusions take their course, then bring them together, turn them into a riddle, condense them, and throw away the key, so that the pictures are weaned from their creator. The figurative and the corporeal become the material for constructing signifiers without a history. He himself calls the results of this poetic strategy Ideograms, in keeping with Ezra Pound's texts on Chinese characters. Much in Clemente's work has its roots in the poetic writings of Pound – for example, the intention of giving birth to an image that is not an idea but rather functions as a radiant center or "vortex" (E. Pound). An irreducible image that stands for itself has no meaning but is its meaning. Clemente himself says: "The pictures, however, are real links between thoughts which, from the energy of chaos, go along other paths of rationality, of reason, of the poetry of sensation."

Clemente romanticizes the cracks in the physical, political, and (ir)rational systems of illusions, but without giving them any soft focus. His Ideograms for our hypermodern psychosomatic entrails constitute an attempt to counter the euphoric indifference of late capitalism. Which means coping with this without imagining that you can seat yourself safely removed on a bough of authenticity, in a pub of critical distance, or on a hunting blind of pure form. Clemente tosses the weight of reality (which harsh poetry could bring off) onto the scales of art, where power structures and instruments of suppression – however real or irreal they may be – still carry too much weight.

Francesco Clemente. *Hermaphrodite*, 1985. Gouache on handmade paper.
© 1997 Francesco Clemente.

Donald Baechler. *Priceless, Wordless, Loveless,* 1987. Acrylic and collage on canvas. 111 × 66 inches. © 1997 Donald Baechler.

DONALD BAECHLER: ON LINE

> How is it possible to draw a line that is not mindless?
> It's not enough to wave it a bit to bring it to life. You
> must – so to speak – outsmart it: Intelligence always
> involves a bit of trickery.
>
> Roland Barthes

For days I've been walking around in the mercantile thicket of the Cologne art fair,[1] without being able to really follow the oddly mannerist, commercial mediation of so-called art. "You are dislocated," the psychologist would say, whose function in the art trade is, in the meantime, practiced by and for everyone, so that we all can get by, especially yourself. And, of course, nothing is more questionable nowadays than this "self," which we have, accord-ing to so-called post-structural philosophical pronouncements, somehow in the course of this century lost in an unremarked dissociation of the subject. And indeed: who could claim for himself that he is him-self, that is, a subject in identity with himself, a coherent personality that flourishes in an active self-realization?

I myself, for instance, tend more toward an accommodation with dissociation, that is, with a loose bond between partial egos, or, quite sincerely, to keeping my head above water. To tell the truth, we are all walking around these days with open skulls. It doesn't help to take on the pose of holding our heads high (which Bertolt Brecht calls the aristocratic posture) because we think the water is up to our necks. The water is actually up to the brink of our open skulls, in which an eddy whirls us into a mental delirium resembling a state of being infatuated that we cannot possibly realize. Sometimes the cup runneth over, but usually we do indeed walk the tightrope quite artistically despite the interpersonal breaks in communication. Logo-causality tells us identity is all a question of your aesthetic outfit (Nietzsche calls it style), even cognition and so-called truth are. This illusion of the one truth concerns all painters, even when they claim the opposite. Thus, once again, Gilbert & George: "All we ask is to be with art." And after the curtain falls, the eternally fundamental question: Is it beautiful? Or what else would you expect to find at an art fair? Sex? I doubt it. Pictures that make sense of the world? Seldom to be found at a vernissage. Perhaps at issue here is art that has stopped trying to make sense.

But this is tough eye work that presupposes the (above) open skull (an acceptance of the dissociated personality). The painter's vision is that of a continuous giving birth, and the pregnant gaze is like a placenta one later discards after inspecting it to see if the newborn has suffered from calcium deficiency because the mother smoked too much. But then who is capable of being permanently pregnant?

I, personally, am presently trying to shed excess baggage like the concepts of the last fifteen years, ones I grew up with. Does this perhaps predestine me to answer questions about art, which time and again aims at this latent manifestation of physical sensations?

So, it's back to the art fair for me tomorrow. For there are at least three pictures I can't get out of my overcrowded skull: next to a flesh-colored jet fighter by Gerhard Richter from 1963 and a black trinity of a skull, a cross, and a self-portrait against a monochrome yellow background by Walter Dahn, I was especially struck by a painting by Donald Baechler. A painted linear self-portrait surrounded by red Suprematism. One of those attempts at a closer encounter with a picture of oneself, more explicitly of the dissociated "self" that, in turning into painting, leaves the self behind.

What distinguishes this painting from the interchangeable standard fare at this optically impertinent "art fair" is the fact that it simply possesses a raison d'être that leaves no doubts. Contrary to the many pallid gags of current compensatory gratification, perception here is accompanied by a feeling of necessity, by evidence that the picture itself "is." It allows an eye blink of fascination during which the seen determines the way it is seen. Content plunges into form; the picture no longer represents but simply is present: "It escapes the ghetto of the imaginary and firmly announces that it exists. In its totality, it takes over space in life instead of coming down to just a game which, amidst all the bravura, remains hermetically sealed" (Michel Leiris).

Presence in this sense is perhaps one of the few criteria for art that we can still cite nowadays. And it is decided neither in the head nor the gut but more by the way a mental figuration turns into (non)figurative painting. Along the body's traces the painter follows the thread of gestures with which he furnishes an imaginary square.

Donald Baechler is a painter of presence, that is, of a literal painting that simply says what it is and "is" what it says: meaningless but full of non-sense. He accomplishes this through his line. "Everything you see is just the most recent set of lines in a particular field," Baechler once said, knowing – like Cy Twombly – that art is altered through the displaced line. This line is the inimitable uniqueness in Baechler's paintings, despite the fact that, and because, he often finds it in the graffiti in public toilets. The lines in these graffiti are close to the body traces, parallel to the stream of urine left behind. "That which cannot be imitated is, in the end, the body," Roland Barthes stated, because the line that tracks the body's contours is the materia prima of painting, that is, that which precedes the split in meaning and therefore is essentially sly and awkward. In Japanese Zen this unintentional break in causal logic (e.g., in script, structure, and meaning) is called *sartori*. Donald Baechler is the painter of a calculatedly awkward *sartori*. He is the mannerist of the threads of lost identity. His painting of proper names and lost Ego floats on the surface as a pure sign of the hiatus that we "are." The innumerable layers of indistinct attempts that constitute his

paintings develop toward completion whose grief is for the unachieved masterpiece, of which Gertrude Stein said: "It's not exceptionally difficult to know that one has no identity. One could say it is impossible, but that it is not impossible is proved by the existence of masterpieces which are exactly that. They are knowing that there is no identity and creating, while identity is not. That is what a masterpiece is."[2]

Baechler's paintings are will-ful forms toward a masterpiece in this sense. They shine through the flurry of metaphors of what is understood as so-called reality like apparitions in the universe of simulation, this universal fairy tale that narrates us into it.

And still the eddy whirls in the opened skull, but what remains is the picture, if it is a masterpiece. And a masterpiece is that which it is not.

Donald Baechler. *Selfportrait*, 1985. Acrylic and collage on canvas. 150 × 150 cm.
© 1997 Donald Baechler.

JULIAN SCHNABEL'S INTENSITY PROGRAM

> When it (art) does not brutally invite us to die ecstatically, it at least has the virtue of dedicating a moment of our happiness to a concurrence with death.
>
> Georges Bataille[1]

I. THE LITTLE DEATH

After seeing St. Jean Vianney on the Plains of the Curé d'Ars, Eulalio Epiclantos finds himself reduced to the form of his own death mask in the middle of an irreal landscape in the most artificial theater in the world. It is here that Sukeroku and Agemaki must have fallen out of love and the great Kabuki actor Danjuro V. Ischikawa refused to eat rice during a meal on stage, insisting on eating a ball of white cotton instead.

Eulalio's mask stares at a forest of recognitions, a greenhouse of symbols reduced to their magical essence, an atmosphere of "nevermore" leaks from the cracks in a discarded theater backdrop, like veins from a long-lost time ("Ah, you were in days of old my sister or my wife." Baudelaire). The arias are hushed, empires have fallen, and tragic loves been suffered. The opera is over. Everything is concentrated within this ambivalent mask that seems as frozen as if a theater curtain, its velvet laden with memory, had dropped. It is a static emblem behind which the chaos (that is us) grins. For everything unpredictable is concealed behind a mask.

A mask suffices to throw "homo sapiens" back into a world about which he knows nothing. It is present before me, like a fellow-being staring at me, and this fellow-being staring at me has assumed the face of my own Death.[2]

Julian Schnabel. *A.D. (Wreath for Tennessee Williams)*, 1987. Julian Schnabel's studio, New York, 1991. Photo: Wilfried Dickhoff.

The painting of *Eulalio Epiclantos after Seeing St. Jean Vianney on the Plains of the Curé d'Ars* is an *aprèslude* on the other side of our life, like a night spent with a death of gleaming ash and gushing blue.

But the trail of associations leading from the painting are dead-ends as regards content; theatrical allusions turn to nothing, become other correspondences that merely lead to another question mark, as does the dancer in the painting *Indecipherable Narratives*. This painting is a double image *[Vexierbild]* of a river bed that vanishes in the distance. Here again, nothing is narrated. Every narrative illusion is a trick that merely serves to intensify the painting's pictorial forms. Like Flaubert in *Salambo*, Schnabel creates a shimmery web out of recollections that dissolve the world into the imaginary, so as to resurrect it in the irreal all the closer to "nature." Indecipherable narratives are in fact not narratives. They function like a battery for the painting that is charged with everything imaginable that can never be realized. We are carried off to a forest filled with symbols, as in the painting *Stella and the Wooden Bird*, which opens a view onto a yearning for something from "afar." This irreal scene shines like an opera of our fragmented ego.

The correspondences that Baudelaire speaks of were possible only within the cultic, which is no longer accessible to us. Even in Baudelaire's day they had no cultic validity, only beauty. Schnabel's imaginary echoes are the drive behind the lyricism of painting, that is, "the servile imitation of that which is indefinable in things."[3] He offers concrete painted equivalents of the imaginary texture of reality. And that is what these paintings effect, what our recollections united with the feeling of familiarity relate to. This also serves their theater of irreality. They leave the existence of the nonaesthetic behind them, for example, by derealizing space; foreground and background stand spaceless vis-à-vis one another or collapse into one another; perspectives are fragmented and resist the viewer's need for orientation. Nature is not really nature here, but completely artificial opera staging. These indecipherable narratives distance themselves through time leaps and spatial disjunction from an existence beyond the aesthetic in order to approach the essence of existence. We are thus drawn into the imaginary, which these pictures set the stage for, on the track of a kind of (re)cognition.

. . . the world is nothing and the world is everything – this factor is what determines the double, untiring call of each true artist, the call that sustains him, keeps him ever alert and which from time to time in the lap of the sleeping world awakens everyone to the fleeting and impressive image of a reality that we recognize without ever having encountered it.[4]

Schnabel's Rebirth works are exactly contrary to paintings of ideas that lose themselves in the imaginary. They also have nothing in common with the cultivated, hyperartificial aesthetics of Japan. The backdrops of Kabuki theater are unreal screens used for a completely different atmosphere, like that of the dry, southern climate in Bizet's *Carmen*, of which Nietzsche said:

It has from Mérimée the logic found in passion, the shortest line, the "hard" necessity; it has, above all, the dryness, the "limpidezza" of the air that belongs to a torrid zone. Here from every perspective the climate is different. Here a different sensuality is at work, another sensibility, another gaiety. The music is gay, but is not a French or German gaiety. Its gaiety is African; it has an air of doom; its happiness is brief, sudden, without mercy.[5]

This is exactly Schnabel's position and painting style: the logic found in passion as well as happiness without mercy. As much as his paintings provoke a discerning gaze, the hard composition and, above all, the harsh brush stroke of his usually thick paintbrush disappoint it. A spell is cast and is simultaneously lifted. That is their tension. Schnabel achieves harsh poetry by throwing it away. He achieves intensity by the hard logic of a composition that comes about from a calculatedly awkward brush stroke, from displacement and disrupted harmony.

In *L'amour (Carmen Iris Rivera 1967–1986)* a completely flat phallus has fallen, as if struck from its pedestal, before a background whose horizon is marked by pedestrian row houses. The phallus is checked, however, by the minimal spatial illusion in the form of two precisely set and deliberately ungainly brush strokes. This, in turn, is broken by the manner in which the mask of an iris is hung in space. And a rope erect in the air – like a fist pounded on an absent table – brings the whole into a new balance. A balance of displacements. The unity in the painting is an atonement of incompatibilities. Schnabel's intensity program is the opposite of an expressionism of emotional myths. It is based on the radicalism of form, on the logic with which passions are sublimated to form. Its mainstay is passion, form, soul. Correspondingly, love speaks from the painting not as harmonious sentimentality or as a simulated tragic myth. "But love as fate, as fatality, cynical, innocent, terrible – and thus Nature."[6]

A fatal black phallus crashes to earth. From an iris – the double image *[Vexierbild]* of a mask – the face of death stares. As an allegory of suicide, a rope stands in space and cannot be denied; it requires an answer. And the title relegates *l'amour* to the semantic field of an irretrievable loss. As in most of Schnabel's paintings, so in *L'Amour (Carmen Iris Rivera 1967–1986),* death is also present. But, and this is decisive, death appears in the painting as an acknowledged and accepted death. It is not ignored, repressed, or excluded as the great dreaded Nothingness. On the contrary, it is manifest as an integral part of life and in this picture of love is beautiful, evil, and broken.

In the Rebirth paintings death is affirmed, but it does not have the last word. A painting that aesthetically parries yet accepts death is nothing other than an attempt to sharpen our awareness of existence and intensify life. The resolve all great art has, to tear a living image from death of our passion and our misery, is for Schnabel an "explicit" semantic orientation for his painting. His understanding of a "modern image" he once described as a personal experience after seeing a Van Gogh drawing:

Julian Schnabel. *Eulalio Epiclantos after seeing St. Jean Vianney on the plains of the cure d'ars,* 1986. Oil and tempera on muslin. 137 × 176 inches.
© 1997 Julian Schnabel.

I had a sense of my own twilight. That drawing made me feel like I was already dead. That's what I call Modern. Something that's appropriate, that approximates the recognition of your consciousness. . . . For a moment, you have an acute realization of your own transience and your own explicit perception of being. This affords you the luxury of dying with a grin on your face. . . . We have no choice. We didn't invent this situation, but in the act of making love sometimes one can get that same clarity of being that makes you think it was worth all the trespasses of being here.[7]

A painting is modern when artistic freedom asserts itself and laughs death in the face. This poetic fending off of death as a visual analogue to freedom – that is the modern image à la Schnabel. A kind of renaissance of the hard form and its alchemist magic, comparable to the experience of the smaller death of orgasm, where the Ego loses its self-control and experiences ecstatic being. Schnabel creates visual sketches of an inner equivalence for this paradoxical correspondence between death and eroticism in the "little death." With his new painting we set off on the road with Eulalio Epiclantos, Camilliano Ciens Fuegos, and Carmen Iris Rivera. It is an imaginary voyage toward a liberated laughter emitted by one's own death mask. This laughter is, at the same time, amusement at one's own pompous identity. Also here these paintings are comparable to the "little death," in that the irreal is the irrealization of the Ego on the plains of the Curé d'Ars: "My death and I waft in the wind of externality where I open myself up to 'selflessness'."[8]

And it is at this point exactly that these paintings are a poetic event. A "poetic" event insofar as so-called life can only offer us such an experience "sometimes in the act of making love." What we have here is a performance of the imaginary. But is this instant of a happy illusion not a moment of liberation from the self that, in its renunciation, for the first time finds itself? "In the halo of death and only there does the 'self' found its realm," says Bataille, and identifies an aesthetic affirmation of the dissociation of the Ego, a born-again factor in the same realm of the imaginary that Schnabel reproduces in his Rebirth paintings. In *Rebirth III* the painted lines move like emotional ornaments in an artificial between-zone. Lines that have a sly intelligence like those Roland Barthes found to be the case with Cy Twombly, a lush spray of blossoms in an unreal garden. The red box is like a rebirth of Joseph Beuys's honey pump transferred to the category of painting, a geometric heart whose aorta turns to wood between artificial branches. The picture is a light and amiable one, but at the same time hard and logical. It is a sensation, an affect per se, no longer a feeling or an affection: artificial and alive, dynamic and static at one and the same time.

When Schnabel speaks of the fact that painting can be constructed only out of displaced love, he means the undirected, homeless yearning that knows not where to go. In every "true" painting there is this aimless desire that finds no object for its craving. It is the potential out of which the painter releases his very own ensemble of strokes, lines. and zones onto the canvas. The result is paintings like Rebirth I–III, triggered by the will to real presences, in the knowledge that they no longer exist. Could it still be possible to create a magic of forms that would influence the

process of transforming reality? "The task of arriving at an essence of what in the future should be poetry must consist of forms that affect forces, that actually transform forces."[9]

This is also Julian Schnabel's ambition in his intensity program. His art alludes to a counterfactual profusion of sparks from the Other (e.g., the other ways of displaced love). This is what makes up their "love note" quality. And although this is absolutely and completely part of our own sociocultural situation (i.e., characterized by interchangeability, cynicism, simulation, indifference), it thrives in the depth of the enigma that Georges Bataille discovered in the wall paintings of the Lascaux cave, the enigma of the elementary and paradoxical coincidence between death and the erotic that has touched us since the dawn of history.

II. BEYOND SIMULATION?

Now let us talk about death, about freedom, love, transcendence, magic, and soul – about all the things that seem to have been lost in a time of postmodern simulation culture, but that, as ever, constitute the thematic and spiritual core which is played on by the "visible presence" of painting. When I see a picture, I want to "see" what it has to "say." That is, I want to "take in" an experience sublimated to form. The constellation made up of color, composition, line, and light must stay in my pupils like an abstract heart. This visual analogy to spiritual and magical (re)cognition is what is still at issue. It is already clear that all of this is impossible, that art is now merely a structured nexus of artificial signs, that the artist is merely an art performer, and, thus, that the whole thing is a simulation model which serves as its capitalistic exchange rate. This is the situation from which today's artist must proceed. S/he must also understand that there is nothing outside the structure of the signifier and the omnipresent simulation of identities. But if art has any meaning at all beyond fashion, that is, beyond the eternal recurrence of the new as a parody of colorful corpses, it is when art begins where the affirmative garbage of nostalgic products of simulation ends.

It is no longer enough to be satisfied with the fact that everything is a mere mock-up of itself, in order to then reproduce (with a halfhearted, intelligent, concept-design aesthetic) just that art-replacement sign from which one fancies oneself to be at an oh-so-smart distance. What is called for is a certain anachronistic unreservedness, a displaced autonomy, a putting oneself at risk, a spiritual and formal venture: pictures that hold the presence of death at bay, that speak from love, a spiritual and formal gamble: the pictorial presence of an individual universality that is quasi deduced from the structure of the signifier and in this way attests to a difference, a deviation. At issue is the picture as a "formulation of silence,"[10] full of "life," existing in between the system of language that we do not speak but that speaks us. At issue is the art of painting that doesn't imitate the visible – especially not the hyperreal – but "renders visible" the imaginary texture of reality by making an emotional fact visible. Whenever this kind of painting is attempted today,

there is the danger that it will get screwed by its own simulation. That is, today every kind of painting is "romantic," since it must feel that to desire the impossible is perfectly rational. An art of authentic visibility is imaginable only as a paradoxic simultaneity of simulation and the romantic strategy of raising it to a higher power:

The world must be romanticized. In this way you again can find its primeval meaning. Romanticizing is nothing but a qualitative raising to a higher power [*Potenzierung*]. In this operation the lower self is identified with a higher self. Just as we ourselves are such a qualitative series of potentiation.[11]

That is, a doubling of illusion [*Schein*], a potentiation of the number of art signs, a multiplication of allusions, a diffusion of the self, and a perfecting of seductive art until this series of potentiation shifts to a simple, formally clarified, non-signifying utterance of magical presence. Where such romanticizing succeeds, the hyperreal interchangeability of the exchangeable art-ersatz is not invalidated. And even the autonomous artwork remains today in paradox.

Julian Schnabel's painting is no more and no less than a small alteration in this paradox, a counterfactual romantic breakthrough in painting, which from the beginning stood at odds to every aesthetic discourse, especially to modish postmodernism. Paradox in his pictures is accomplished in the facial structure. Simulation is in no case cached behind the illusion of pseudosubjectivity. On the contrary, it is openly visible. Material filled to bursting with potential meaning such as truck tarps, linoleum floors, or theater backdrops are used, for instance, to build up the backgrounds and foregrounds. Chains, bronze ornaments, picture quotes, antlers, and found objects of all kinds are only some of the means Schnabel helps himself to in order to construct a counterfactual magical surface. His large formats and sculptures arrive on the scene as if it were no problem to re-create the magic of African sculpture from "the mysteries in our culture." In other words, the simulacra are there, but so superficially and offensively overdone as to withdraw behind the (ir)real presence of the picture. Schnabel's battleground of materials breaks through the modish handiwork of the ingratiating, epigonic art now found everywhere, as well as through the conceptual design of postmodern paint appliers. All the talk about the impossibility of any positive placement [*Setzung*] in painting is serenely left behind by his pictures. By driving the picture as a "panel of meaning" to the extreme, he ventures onto the terrain of romantic yearning, where nothing looks like art anymore and everything becomes a question of the poetic (dis)harmony of soul and form. The involuntary methodic basis of these pictures is made up, on the one hand, of an irrealization of all meanings and, on the other, of a deliberate form sublimation and a calculatedly "ungainly" displacement. There are systems of irreconcilabilities that draw your gaze in fascination, such as I have experienced with few other painters these last years. The instant [*Augen-Blick*] of fascination is that in which content rushes into form, in which the seen realizes the point of view of its perception and the picture raises its gaze, so that you no longer see it "before you" but see "with it." The crucial factor is then not so much in the forms and

themes as such but in the forces, densities, intensities by which the inner equivalent of things gains a visible existence. Painting functions as a soulful and soul-inspiring magnet from which a rational idiocy rings out like willful self-determination *[Eigen-Sinn]* in the (heart)beat. It avoids the reality impact of themes and contents and acquires the reality impact of the imaginary. Schnabel's artwork thrives on the magic of painterly "visibility" for invisible spiritual realities. Like all great painting, it celebrates the riddle of visibility "in that it unfolds its dream world of carnal essences, actualized resemblances and mute meanings."[12]

But not only the presence of essence and existence, the imaginary and the real, the visible and the invisible forcefully "passes before our eyes." We are dealing here with "spiritual pictures" not least of all because they oscillate in paradox and because they play out the contradictions that constitute every picture today. Which means not a one-sided palliating or recollective harmonization but a shoring up of the inner tension in the picture. This is the case not only for the contradiction between simulation and truth, rationality and irrationality, but also, for example, for the antinomy between expression and construction that – through artificial frills or pompous doubling – runs the risk of missing an experience sublimated to form. "This leads to a subjective paradox of art," as Adorno states, "the production of a blind quality (expression) on the basis of reflection (form), not so as to rationalize this blind quality but to produce it aesthetically in the first place."

If this does not succeed, the pathos becomes hollow, the form formalistic, the content illustrative, and the picture shrinks to the skeleton of a down-at-the-heels art sign. Paintings like *Rest, The Mud in Mudanza, Maria Callas No. 2, Griddle, The Walk Home,* or *The Wind* work because the paradox of contemporary painting is mastered in a uniquely ungainly, flickeringly intense way. Without knowing it, Jean-François Lyotard has described this paradox in his attempt to demarcate his affirmative aesthetic from Adorno's *Aesthetic Theory:*

Adorno's last words were: experience in the Hegelian sense (the realization of intellect *[Geist]* in history) ends with Auschwitz; we have no choice except to accompany metaphysics to its demise; and, since there is no longer any great narrative of emancipation, let us multiply the micrologies.

An alert ear will be able to glean the following from the essays at hand: in the aftermath of Auschwitz and thanks to the revival of capitalism, experience in the Hegelian sense has come to an end; the age of experiment (the age of satire) is flourishing; so let us multiply the paralogisms.[13]

These two poles are naturally not alternatives to each other, as Lyotard believes, but designate a paradoxical simultaneity that is present today in good painting as oscillation. That is, on the one hand, art as micrology, as a closed configuration, as fragmentary "whole" that seeks to aesthetically accompany and free the dissociated subject. On the other hand, art as paralogism, as aimless experimenting with intensive fragments that no longer follow fossilized and fossilizing rationality. On the one hand, the hermetic form as a "specific negation," on the other, the unreserved

affirmation of intensities. This oscillation between these two poles, between a sublimation of form that the disintegrating subject "holds to in expression" and a paralogistic diffusion of the Ego, is what marks the striking presentness and flickering intensity of, above all, Julian Schnabel's plate paintings. For these paintings do not mean or represent this: they are this. They speak from the broken, fragmented surface of the dissociated images. They are painted archeologies of the lost Ego that – at the same time – they leave behind like a curtain torn to pieces from inside. Paintings like *The Sea, The Patients and the Doctors,* or *Spain:* totem fragments of the single universal, modern-day Grecian vessel of the subject. Or the painting *The Walk Home:* diffuse perspectives with ornamental flames at the road's edge out of which home speaks as a place no one ever visited.

In other words, Schnabel's pictures are micrological paralogisms. Their fascination is the gaze of the irreal texture of inner nature that is available only in traces. "I am making a synonym for the truth with all its falsehoods, oblique as it is. I am making icons that present life in terms of our death,"[14] he says, and addresses what today the language of painting could be, namely, the production of a single affect that is neither pathetic expression nor frozen construction, neither negation nor affirmation, neither hermeticism nor banal statement, neither the illusion of reason nor the illusion of irrationality, neither death nor life, but death and life in a single gesture or in the abyss of a surface: pictures whose eroticism wards off death.

Schnabel is the formalist of displaced love who produces dislocated units out of incompatibilities. His work depicts romantic provocation in the midst of our hyperreal cultural wasteland. He knows that, in the end, what he too produces is an illusionist image. But he belongs to those few who – from their experience of the necessity of displaced love – have got hold of the strand of an art whose illusionist images celebrate the last allusions to our truth(s).

Something like a painting of the soul today exists always on the brink of failure, always on the margin between the soulful image and the bankrupt mock-soul. But it is this tension that provides its heartrending surfaces. Schnabel's paintings offer poetic images from the cracks in the contemporary Parthenon of simulated identities. They cope with the everyday and parry eccentric death, a specific language of painting, a magic of form that "is" simply passion. Schnabel's paintings celebrate the romantic will to a yet unseen picture, the artistic will to a unique pictorial energy (Nietzsche's will to power). Painting as a unity of both irrealization and spiritual care, in a *salto mortale* of surface intensity. "A kind of love note" (J. S.) scattered over a shoreline turned to desert.

Julian Schnabel. *L'Amour (Carmen Iris Rivera 1967–1986)*, 1986. Oil and tempera on muslin. 142 × 132 inches. © 1997 Julian Schnabel.

WALTER DAHN: BLOCS OF SENSATIONS

I

Walter Dahn was born in St. Tönis on the Lower Rhine in 1954. He was the youngest member of Joseph Beuys's master class at the Düsseldorf Academy of Art until he went his own way at the end of the seventies. This took him to Cologne, where he lives and works today. At the age of twenty-six, he had already made a name for himself on the international scene as a member of the artist group Mülheimer Freiheit at the beginning of the eighties. The Mülheimer Freiheit was probably the first resolutely nonideological association of artists since 1968. There was no manifesto, no utopia, no process for acceptance or rejection, and no membership. It defined itself as a group simply through the places where it appeared, which were not limited to galleries and museums. Hans-Peter Adamski, Peter Bömmels, Walter Dahn, and Georg Dokoupil set up a joint exhibition for the first time at the Hahnentorburg in Cologne. As the Mülheimer Freiheit, they debuted at the Paul Maenz Gallery in Cologne in November 1980. Meanwhile, Gerard Kever and Gerhard Naschberger had joined the group's ranks. The Mülheimer Freiheit was a "fusioning" group; not an organization but rather an open practice, supported by a shared attitude that enabled them to prevent even the lack of a program from becoming a program. In the works and actions of the Mülheimer Freiheit, a radical openness – not linked to an "ism," an illusion of truth, or a self-righteous discourse – regarding the so-called content and form of the works went hand in hand with the humorous, joyful deconstruction of all norms, ossifications, and preconditions that dominated art at the end of the seventies. The result was an artistic practice that was surprising in all respects.

Walter Dahn. *Abandoned House,* 1996. Mixed media on pedestal.
© 1997 Monika Sprüth Gallery, Cologne.

Here indeed a breakthrough was realized, during which, as a side-effect, both the mendacity of critical art, which had long since been institutionalized, and the hypocrisy of the left-wing artistic dogmas, which had long ago been appropriated, were visibly dismantled. Here something took place in the field of art, something the French philosophers Gilles Deleuze and Felix Guattari have described in their book *Anti-Oedipus* as deterritorialization: the radically accelerated tearing down of the boundaries between clearly outlined artistic identities along with a liberating momentum, and a dismantling of all obligations to what is considered valid as modern art. At the end of the seventies, this related to the various types of Minimal Art and to a progressively dogmatic Conceptual Art as it was "taught" at the art academies. However, the Mülheimer Freiheit's deterritorializing intensity program found ready victims in the numerous taboo themes, forms of expression, and attitudes, as well as procedures for inclusion and exclusion, all of which had been established by an avant-garde that, not so long ago, had entered the scene with the intention of changing and transcending art.

Now – ten years after the group broke up – it is slowly but surely becoming apparent that the Mülheimer Freiheit sailed under a flag whose potential is far from exhausted. Its reception in the eighties was characterized by an expressionist misunderstanding and by visual prejudices influenced by the market that were both stupid and hypocritical. This attitude was more often than not exhibited by people who felt that their own "avant-garde," "progressive" understanding of themselves was called into question by the practice of the Mülheimer Freiheit, or who feared coming up short in precisely this market. The way in which the Mülheimer Freiheit activated "traditions" such as situationism, Dadaism, or Happenings under altered conditions, or practiced the dissolution and dissipation of the pseudoindividual "creative" artist Ego – with humor but without pathos – was hardly noticed, and not just by bourgeois art criticism. This means that the reception of what the Mülheimer Freiheit was about (in between and beyond so-called modernism and postmodernism) still needs to be written. For the greater our distance to the turbulence of the eighties, the clearer we can see the key role the artistic attitude of the Mülheimer Freiheit had over and above the concrete works of its "members" on the art of an entire generation.

The end of the Mülheimer Freiheit is just as difficult to define as its beginning. In fact, the whole movement was a becoming, which includes its beginning and its end, a becoming intense and thereby creating difference (not only artistic difference). One final point was certainly set by the participation of Walter Dahn and Georg Dokoupil as "artist individuals" at the "documenta 7" in Kassel in 1982.

It was at the very latest at this point that all these associated artists started to go separate ways, although from time to time Dahn and Dokoupil still collaborated on common works. In the same year, Walter Dahn participated in the "Zeit-

geist" exhibition in Berlin. In 1983, he exhibited his work in New York for the first time, and, during the eighties, completed an extensive opus that was to be seen in solo exhibitions in many internationally acclaimed galleries and museums in the United States, Germany, the Netherlands, Italy, Australia, Japan and Switzerland, among others.

Right from the beginning, his works have not been limited to painting as painting in the traditional sense. For him, photographs, drawings, sculptures, videos, and installations are equal means to artistic ends. However, he does not consider artistic ends as being limited to art for art's sake. For Dahn, art is not only a framed panel decoration, but a demand for freedom that also necessarily implies an expansion of the term "art," which Joseph Beuys had already developed in the tradition of early Romanticism and Rudolf Steiner's anthroposophical convictions. Art as the work of transforming the social body, as the work toward a form for (inter)personal practice and organization – that was Beuys's ambition.

Walter Dahn has always seen his oeuvre against the background of an expanded concept of art and called it into question. In doing so, however, he has concentrated on an intense poetic condensation of pictorial content, a quality specific to Dahn. After Beuys's death – unlike many other "Beuys pupils" – Dahn agreeably refrained from filling large pseudomagical spaces with materials saturated in fake myth, materials not at all equal to the "great" ideas they were supposed to convey.

Since the mid-eighties, he has worked on small-sized silkscreen prints, in which he reduces the image to a figurative skeleton and allows only the awkward break in the so-called authentic line to appear through the technical reproduction, but without giving up its existential element. Walter Dahn is working on a continuation of painting using all the available materials, but especially those not related to painting. And he insists upon the pictorial magic of form as a contribution to a possible politics of signs. To accomplish this, a certain calculated naivety is required and a virtuosity in working with theoretical blinkers while intellectualizing perception. This is the tactic of screening out one's knowledge of the impossibility of a picture as a political sign, for example, in order to even work in the first place at this counterfactual activity that goes by the name of art.

Dahn understands his pictures as proposals for a dialogue that artistically avoid communication. He understands them as nonsignifying signs that would like to open up human relationships as an intercourse of differences. Walter Dahn's image operations at the limits of panel painting are displaced "traffic signs," which, in view of the situation, have the effect of naive pretensions to apparitions long since vanished. They concentrate a pure revolt "void of ideas," an insistence on difference, and a yearning for something perhaps once covered by terms such as "liberty," "justice," and "brotherhood," long before our time.

For Walter Dahn, art is still "a possible model for freedom," to use John Berger's phrase. And more still: during our conversation, he spoke of "eliminating capitalism through art." He is one of the artists well read in the fields of philosophy, art, and social theory who, from all of this – and in particular from his resul-tant knowledge as to the impossibility of painting, as to the death of the author/originator and of the bourgeois individual, as to procedures for reversal, appropriation, and identity, as to a dependence on context, as to processes of constituting meaning, etc. etc. – draw no consequences for art that would be a only well-meant illustration of theory.

The contents of the pictures are often images from the third world, of the destruction of ethnic differences, or the longing for material modesty, spiritual purity, and the wealth of dreams and picture worlds that no longer vegetate in the oedipal triangle. But Dahn does not play the role of artistic stand-in for the underdog. He is concerned with a thematic recharge of the picture, which, in the end, either speaks by way of its form, that is, as a picture, or does not. The remoteness of the thematic references either turns into pictorial proximity or it does not. A very personal not not-to-revolt is articulated in his pictures, and it stems from an intentionally impersonal – but intellectually and spiritually tested – "painting after painting's end."

For a number of years, Dahn has based his work more and more on found objects to which he adds almost nothing: dilapidated canvases, boards, glasses, and other things. The perception of what is repressed and rejected in things is foregrounded here. A roar of undefined references is inscribed onto the possible flip side of late-capitalist "rubbish." A meshwork of thematic references without any system. However, as stated above, this is not about the well intentioned but about the condensation of a different energy in the beauty of a gesture, of an off-placement, which in a happy moment invokes the memory of a loss of the human.

I met Walter Dahn for the first time in November 1979 at a birthday party for Rosemarie Trockel, where he showed up with Georg Dokoupil, carrying extremely tastelessly painted kitchen towels as a birthday present. As long as I have known him he has been working on precisely this art of off-placement from dawn to dusk and the other way around, drawing, taking pictures, telephoning, grouping and regrouping things, mixing and spreading paint on things, reading books and CD brochures, and spreading them out in strange combinations, making women he loves (loved) into active participants, uninterruptedly listening to music, talking about music and planning, preparing and not seldom also realizing records, experimenting in the lab with developer and fixer, abusing silkscreen sieves, holding belligerent monologues at every opportunity, roping in other people who actually

Walter Dahn. *Untitled (Ex Voto)*, 1988. Acrylic on canvas.
© 1997 Monika Sprüth Gallery, Cologne.

just wanted to look on, attaching pieces of paper, paintings, and found objects experimentally on the wall, observing for hours and changing around, overexerting his body, attending to its sufferings, holding a video camera up to the world, seeing the beauty of things that obviously no one else sees, and – like every other good artist today – incessantly dealing out contradictions in the name of change. One could read into his works the fact that in these works a homeless revolt, which used to have its home with the left, has found a temporary refuge.

II

In April 1933 the paintings of Georges Braque were shown in the Kunsthalle Basel, where in 1986 paintings by Walter Dahn could be seen. At that time Carl Einstein wrote the introduction. What he – probably the greatest German author on art – said about Braque's pictures takes us straight to the crux of Walter Dahn's paintings; for him, too, it is important to bring to life painting as a creator of form over and above anything merely formalist:

It is time to replace cowardly stylizing interpretations with the spiritual fact of reality. Applied to pictures this means: pictures are not fictions but rather practically effective energies and facts. The moral position of pictures is thus changed and the merely artistic standpoint and the indifference of the artist done away with. It is no longer valid to varnish pictures like isolated bibelots but rather test them as real and practical forces and mediums. Thinking and viewing flow into us as a means of creating reality.

꙳

Early autumn of 1981: met Walter at Rosemarie's, an atmosphere of affection and jealousy. But there was still coffee and cake and talk about Paul Celan while a tape played of the Talking Heads together with Earth, Wind & Fire. A typical Walter Dahn mixture that is also very important for the sound of his pictures: a simple, direct vibration of the art of painting, on the one hand, and then this simultaneous reduction of the subject down to the persistent root of its figurative skeleton, this conflict over a nonpersonal voice for the picture as image, over the crystallization of a nonsignifying language of magical presence.

꙳

Late autumn of 1985 in New York, opening season, vernissage fever in jetlag high, the blue hour of lingerie-lusting character masks and of the sincere wear-

ers of tits and cocks, idiocy and merchant wit, commerce and hallucinations, cocaine in the restroom, but otherwise fashionably coifed neuroses dance with stiff pelvis to black music, the main thing is the done business deal and the pictures let one hope for their speculative future; the food is expensive, but all the other vital accessories are dirt cheap – sunglasses, taxis, and Rolexes from the fifties, for example; the gallery is today's temple of the muses, only those who don't need an entry have perhaps a good one. Chewing-gum manufacturers, style swindlers in borrowed Gaultier suits, euphoric student intellectuals, but also tennis sponsors, beautiful people, critics, models, musicians, the rare nonartists, and all the other authentic liars, they all look for peace and consolation before the picture that oozes on the wall, in the cleansing atmosphere of mythical clouds of perfume and the sublimity of visual butt kicks: "the mental pretenses for a change in scenery as well as for a change in the diva's outfit commence" (G. Benn).

That evening, dinner at a good collection. (Too, the woman collector with sunburned gout has her right to happiness; she shall have it, for many a painter and other participants live off her pounds of yearning. And who knows the weight of one's own yearning that is pretty hard on the stomach.) Gerhard Richter provided the candlelight for an excellent salad, which was, however, followed by American chicken, for which the sauce and dessert amply compensated, not to speak of the liquid refreshment on offer. Afterward a view of the jam-packed walls. Most fell flat, with the usual exception of Richter and Polke. But really just one picture stood out. Rather modest in color, a self-portrait of the painter as a curly cubical head, bending forward out of the frame into a life, of which it is uncertain if it is one at all but of which we know it is our only mission, even when it repeatedly makes pictures necessary that not only express and flagrantly repeat its misery but also, above all, survive poetically. Like this picture by Walter Dahn from the year 1981. What differentiates this from the many pallid gags over the past days is that it simply has its own inherent raison d'être, an unquestioningly evident presence that hits you in the eye. Its perception is accompanied by a feeling of necessity that "is" the picture per se. You don't see it, you see *with* it; it conveys an enlivening moment of fascination. Of course, the necessity of the picture corresponds to some psychosomatic condition, which makes it personally necessary and possible for Walter Dahn, but what I call the picture's necessity begins just where one cannot "penetrate through any spiritual gap," as Carl Einstein says. And the perception, in tandem with the feeling of necessity, presupposes that the seen (the picture) captures the way of seeing (of the viewer); the content rushes into form; the picture represents nothing but is simply "present." That is, a spiritual figuration becomes a diagram. Walter Dahn is in this sense a painter of presence, a painter of literal pictures, which say what they are and are what they say. Presence in this sense is perhaps one of the few qualitative criteria we can cite today. This is precisely the difference between painting that apes the visible, comments on, exposes or

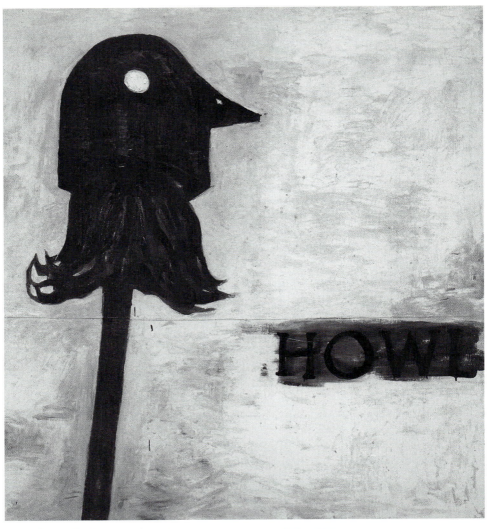

Walter Dahn. *Trophy with Howl,* 1984. Acrylic on canvas. 250 × 250 cm.
© 1997 Monika Sprüth Gallery, Cologne.

lampoons it (no matter how enlightened it tries to be) and painting that (for the discursively corrupted perception) makes what is invisible *visible,* between painting that loses itself in a metaphorical flurry of objective spirit and vanishes along with it (no matter how critical and seemingly reflected the position is) and painting that speaks from its diagram, surface, form, stroke – yes, especially the brushstroke as it is found in Walter Dahn's painting. His painting is thought out

through and through, although he does not illustrate thought but is a painter who "thinks in painting" (Cézanne).

≈

A few weeks before the opening of "documenta 7" in Kurfürstenhof in Cologne with Monika Sprüth, Rosemarie Trockel, and Walter Dahn. Once again the questionability of painting and the art system becomes evident. What to paint? Why paint at all? Is there any real reason to paint – beyond any modern/postmodern express(ive) art? Where has the political perspective gone that was a part of the hallucinatory and liberated conceptual activity of the wishing machines during the time of the Mulheimer Freiheit? More and more Fernet Branca and then one more Fernet Branca and a conversation on the possibility and impossibility of painting, of the responsibility of the artist, of morality and form, of the beautifying, compensatory, and speculative functions of art. We know that there is nothing outside the world of commodities, and there is no language but that frozen in social meanings. But that does not at all exclude working against this cynical reality while at the same time catering to it with pictures. We flutter in contradiction, we live in ambivalence. That is the situation. We can neither deny it nor simply bypass it. It is a matter of countering it with pictures and actions. Perhaps – and here our conversation ended – it is precisely the radically romantic in Walter Dahn's pictures that offers a possibility of subverting the general cynicism of simulation. When Novalis describes the method of romanticizing as being an interplay between elevating the low and abasing the elevated, it becomes clear how close Walter Dahn's painting is to this romantic art of revitalization, for it, too, is founded on elevating the simple and abasing the inflatedly complicated:

The world must be romanticized. In this way one finds again its primeval meaning. Romanticizing is nothing but a qualitative raising to a higher power (*Potenzierung*). In this operation the lower self becomes identified with a higher self. Just as we ourselves are such a qualitative series of potentiation (Novalis 1797).

≈

Sometime during the winter of 1982: an Artaud reading in the bookshop where Walter Dahn also buys his literature. The editor of Artaud's work in Germany presents a recording taped for a radio broadcast shortly before Artaud's death, one Artaud never got to hear. As always, terrifying poetry of the oppressed soul, which was, for Artaud, only stuck "in the ass." But then this forced half-cult of oh-so-sensitized pseudoconcern in the room. Sickening. Walter Dahn

hates the phony fashion for the irrational exteriority for which Artaud has to serve as representative. But he also knows – for himself and for painting in general – that only that picture has value to which the painter has given his soul.

᷍

The telephone conversations with Walter Dahn in the summer of 1983 always begin with a musical introduction. Before an exchange of information has any chance at all, the turntable is tortured. A base line is dragged backward, impossible breaks without end, in between sounds from the depths of hell and at the same time spray pictures from behind a gas mask. What results, however, is just the opposite of any kind of fashionable zeitgeist actuality. It is with unrestrained presence that Walter Dahn places his bets on the pulsating here-and-now, on things with no glorification. This presence, is, of course, a decisive affirmation, but a yes without any conviction – "it defends itself against death, that telos of all domination, in sympathy with that which is. Doubting this would mean paying the price that death itself were hope!" (Adorno). And the spray pictures whose results do not bear witness to any burning actuality, but rather to an actual burning. They are concerned with the image as a positive, enlivening unit of intensity, which is after all anchored in life, that is, the game in which the painter also puts himself at risk.

᷍

January 1, 1986: Telephone conversation with Georg Dokoupil on Tenerife, where he is plagued by his text on Walter Dahn because nothing seems suitable and good enough. We begin talking about the line he believes present-day painting will be decided by and about Walter Dahn as being one of the very few who have a clear and unique line to offer. And, indeed, the quality of the picture is decided by the line taken, since it is the translation of attitude and thinking into an image. Through the linear stroke, painting displaces itself, through the line it breaks the modish slickness of all conceptually excreted consumer aesthetics and introduces an inimitable deviation into the world of perception. The line is what is unique in Walter Dahn's pictures. "But that which is inimitable is ultimately the body," Roland Barthes correctly states. However, not the superficially fashion-crazed, squashed-steeled, new-wave bodies of the pseudo-fauve expressive brush, but rather the effecting and present body; a unity of she or he who sees in tandem with what is seen. And that is precisely Walter Dahn's line: the ways and means by which the act of seeing, made up of both body and soul, becomes painted surface. Walter Dahn's line

follows the inimitable, visible music in which body and soul "join hands" on the canvas.

<center>⚬</center>

The painter is the one who introduces the involuntary body that transcends the commercial dealings in which he finds himself, as Valéry says. But how does he do that? What does such a transformation in painting look like? At first, broken, oblique, almost inept and awkward. But this deliberate awkwardness is the quality of the line. It is a nonintentional, simple shift in the conventionally logical placement of the line. Subject and painter become one through the left-hand line, comparable to the experience called *satori* in Japanese Zen: an enlightenment triggered by strangely illogical behavior that deviates from the religious rituals, possible only through a simple, seemingly senseless act in which a person blossoms as though in a state of sublime stupidity. That is exactly this artist's line: an almost anachronistic *satori*, a simple, inimitable "wind stroke" in a land of cynical simulation painting.

It remains to be asked, where does the painter bring in the body? For urgent intestinal voidance has nothing to do with this. On the contrary: it is always a mental figuration that is transferred into a flow of lines and strokes. The lines that follow along the traces of the body are not an obsessive procedure but a deliberate furnishing of the canvas' imaginary rectangle. Without losing sight of body-soul and intellectual necessity, Walter Dahn takes the complicated issue of spiritual figuration so far back as to touch the border of his own radically romantic-political naivety, along which he leads the brush until the simple, clear, flat picture takes on form: the ensouled image. Voilà!

<center>⚬</center>

January 6, 1986. I call Walter Dahn in order to clarify last-minute annotations to the catalogue. He sounds like a long-distance runner who doesn't know if he has made it or has collapsed before reaching the goal. "I've begun something new. Somewhat similar to before, yet different. But maybe it's nothing at all, we'll see." An hour later I see him and two large-sized pictures. Thinly painted but rather monstrous configurations. Colorfully painted backgrounds, mathematically dripped grids, fingerprints, and footprints and in the middle the unmistakable, minimally painted figurations of lines. Before my eyes have understood at all what it is, he begins to wipe it away. A watercolor-like background results. Tomorrow he wants to treat the whole thing with liters of shellac. But before we go out to eat, he has already dismissed the idea. The next day there are two clean, white-primed canvases in the Klapperhof.

1962 is the title of one of the last pictures Walter Dahn completed in 1985. One of those figurative skeletons on a many-layered monochrome background, painted with Walter Dahn's hard, mobile line, which works the figure into an implied abstraction. An almost impersonal, general image. Only the title reveals that personal experience and memories have also gone into it. What you see is a child or, better, the human child per se on a swing with a globe on his lap. A simple, clear, flat picture with a lot of truth, "or, in order not to say too much, a probability that one can love" (Rilke). To me, he put into the picture no less than all our memory-addicted yearnings for that fulfilled moment that Ernst Bloch calls something "that shines into everyone's childhood, but where no one has ever been yet: home."

III

In the mid-eighties, Walter Dahn undertook a fundamental self-criticism of painting as painting. This was not only carried out on the fakeness of seem-ingly reference-less expressionist paintbrush gushings, as many art critics mistakenly claimed. Dahn and his friends from the Mülheimer Freiheit had counterfactually insisted that painting have a content in order to trust painting with an import of the real that it could probably not handle. This was one of the many authentically inauthentic sources of energy for his nonexpressionist renewal of painting in the first half of the eighties. But, after he had granted his eyes (and ours) painterly experience in his romantic paintings of crystallization and, parallel to this, used painting as an instrument to express unbearably concrete alternatives (one poignant example being the picture in which he reverses accepted modes of extermination and drops houses onto bombs), he came to the realization that painting for painting's sake was not enough to cope with the contradictions (e.g., subject/object, form/content, good/bad). He remembered his antipainting impulse, which, when applied nonspecula-tively, leads to the best painting results. Starting in 1984 he again began working more intensively with photography, the medium with which he had originally entered the scene in the seventies. A medium whose alchemist components he, by deliberately integrating the mistakes that occur in the lab, allowed to take its freely intuitive course. His "loser photos" are the result of these nonscientific experiments. Dahn works with photography like painting in a laboratory.

Parallel to this he did his first silkscreen prints, in which he at first printed drawings on monochrome backgrounds, later, increasingly in photographic form on painted backgrounds, partly in multiple-layered serigraphs. Reversing Andy Warhol's factory principle, however, Dahn did all the silkscreen printing himself. As when he prints his own photos, his printing by hand turns into a painter-like activity. He systematically committed his favorite gestural mistakes and mucked up the screens in a way he thought the contents he wanted to print from them demanded; the printing

thus becomes a meditation on, among other things, the diagram of painting by technical means. Dahn's silkscreen essays on truth and lies in an a-painterly sense relate back to Nietzsche's essays on truth and lies in an a-moral sense: a self-reflection on painting via the printing press.

As always with Walter Dahn, however, his subject matter always sets the standard for its outward form in the picture. And that is: the relationship between the industrial and the third world, nonlogocentric scientific models from a Ptolemaic view of the world up to the micropolitics of the psychophysical de-territorialization centers, Walter Dahn's "imaginary ethnology museum," the sociocultural allusions that follow, and his specific meditations on the (also in our time) multiple artistic mediations on the (as always) unavoidable nature/culture problematics (see the gridwork pictures modeled on Brazilian ex-voto objects). There are the radical-naive alternative proposals (see the pictures in which a soldier melts his tank with a sunglass or diseased trees chase down cars). There are also the blatantly true political platitudes (see the picture in which big fish eat smaller ones), photos of friends or personalities important to him like Palermo and William S. Burroughs, the films of Jean-Luc Godard, scenes of all-too-human daily misery, and not least of all himself, which means that he uses his own body to artistically study multiply broken self-identity.

This painterly misprinted, thematic complexity he sets off against backgrounds that he allows to assemble on their own by leaving canvases for long periods on the studio floor so that anyone who comes in (and the door is almost always open) leaves his traces behind. Added to this are random color samples, rejected paint remnants, trash, and dirt. Thus, a casual, unintentional patina is formed: an anonymous painting as floor.

As inadvertent as these paint traces are, their placement as picture ground and the displacing of silkscreen images on them are artistic. The deliberate selection of cut-out dirt rags as well as the thematic silkscreen composition is for Dahn more than a further variation on the fashionable draining of and the de-personalization in painting but is work toward substantial future steps in non-abstract painting after pure abstraction.

Walter Dahn tries to meet this not at all modest pretension, among others, by continuing the thought and the intuitive drive behind the contradictory concord between Warhol and Beuys. Both artists exemplarily carried out the most profound and most superficial paradoxes in their art and were not simply opposites but two sides to one coin. The works of Warhol and Beuys form that kind of complementarity that we perhaps should consider the condition for any possibility of any further step in art: a complementarity of depth and surface, of enchantment and disenchantment, of the void and the full, of Europe and America, affirmation and negation, of a political magic of form that penetrates the genes and works into the essence (Beuys) and of a radical potentiation of reproducibility, of a supraindividual factory principle and the artist as artistic stage on which the most contradictory things can be allowed to exist as they are (Warhol).

By avoiding involuntary epigonism, Dahn focuses his experiments on the (still today) repressed sides of these artists – the sharp, double-edged analytical humor of the *Fluxus* Beuys and the side of Warhol that is painterly and religious, where he is on the road to taking affirmation, artificiality, exchangeability, and surface (as projection screen for the desires) to the second power. Via his hypermodern re-animation of orthodox icon painting (Marilyn Monroe is exactly this – in blue on a gold ground, produced by artisans with no personal signature), he recreated *the blue flower of Romanticism* in the land of hyperrealist late capitalism.

With the intention of beginning with these reverse sides so as to get to more than just artful cover versions, Walter Dahn became engaged in the demand for an artistic practice in which the first steps toward a political magical form like Beuys's are made. Meanwhile, it is clear to him that this practice's future will be decided upon by how far it succeeds in not aesthetically harmonizing the ambivalence in which we all putter daily or not in a rehash of cynical conceptual mannerism as a design of simulation, but how far with all the artistic means at hand that a person's abilities, his inner necessities, and his (even including, and all the more so, moralist necessity and the situation-related moral right of radically immoral art, etc.) insights is capable of putting him in a position to work out a beauty *without cosmetic palliation* and thereby to hopefully bring about art's reality as a return of the real. Art as a stand-in for the loss of the political?

At issue is calling *forms to life* (see Ezra Pound's Vorticism program from 1914) whereby the contradictions – for instance, the constant oscillation between affirmation and negation – are made visible or become experienceable by what there is to see of present absence in the form. Art is at least potentially predestined to do so, because it is essentially still a *composition of becoming different,* that is, at once preservation, elimination, and alteration of the bases from which it has gone forth, the *reproduction* of everything *against* which it (for example, out of the need for a gut revolt of the depersonalized Ego or the dissociated subject) or *for* which it has been mobilized (for example, out of a hyperrealist longing for a career and/or out of an illusory mission for the [political] cultural struggle) and, simultaneously, the *production* of an hermeneutics of silence. This silence is not an empty or quiet one; it does not stage any self-pitying disappearance, but *parries* the omnipresence of power by articulating the "cracks in all the Parthenons" – from the soul's crypt of the disassociated subject to the institutions of communication – in the form of an artwork that avoids "communication," that bourgeois link between people per se.

In this sense, one can speak of Walter Dahn's art as deconstructive, whereby he underlines the constructive element of de-construction, a thought central to Jacques Derrida's concept of deconstruction, misunderstood for the most part. Dahn tries to do right by this by initiating parallel processes. Thus, for example, the attraction and repulsion movements of presence and representation in the

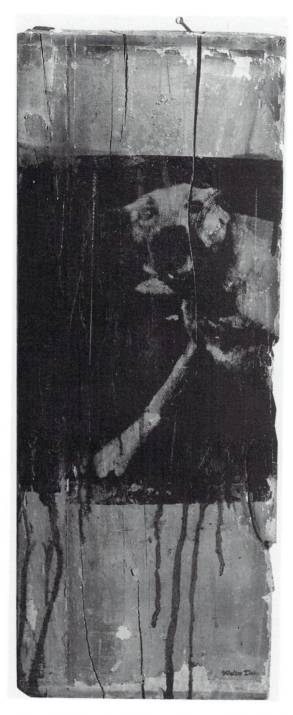

Walter Dahn. *The Hound Dog,* 1990. Acrylic and silkscreen on wood. 67 × 24 cm.
© 1997 Monika Sprüth Gallery, Cologne.

picture. In the painting *Doppelteufel [Double Devil]*, he projects Malevich's paradox – suprematist square and figurative devil drawing (the latter printed as serigraphy) – onto a formica panel (a material often used by Artschwager) that he had found in the rubbish and that had taken on a wonderful patina. By its use as a picture background, Dahn transforms it into a statement of abstract presence and thus allows it to reply to Malevich's paradox. Another example of parallel process becomes clear if you recall that art is constantly an answer to art but is also an answer to what there is in reality that is not art. Dahn reacts to this by overtaxing the picture with the nonaesthetic and burdening it with the import of the real until this nonartistic overexertion of art becomes art: until it pays off as an increase in intensity of form and, in turn, as a resistance to that which reigns as reality.

He consciously confronts the contradictions that are bound up with such parallel processes and remains active in the midst of the antinomies of art and society that the death of his former teacher had left open. Knowing that his work is maintained by a standpoint that "holds the desire for the impossible to be reasonable" (R. Barthes), he works with conscious naivety on the necessity for counterfactual change not only in the pure arts but also in the *forms* of the real.

Even in this area that is threatened by potential failure, Dahn runs the risk inherent in parallel processes: with his music (he played with the bands Die Partei, Die Hornissen, The Jewellers, and Dig Down Deep), with his films, his music videos, his readings, his television appearances, with his financial support of the Romany initiative in Cologne, and with his active participation in the Action to Save the Elbe *(Fluxus Elbe)* in the East and West German states separated at the time, he hoped to contribute to a comprehensive cultural struggle against injustice and power.

That such a *speech act* like that of the "Open Letter to the German Bank"[1] is a part of what his revolt is against did not escape him: art, too, vegetates in a quite unbroken immanence of power discourses in which all forms of critical and/or conceptual-aesthetical pseudodistance only confirm the system, obvious at the very latest when viewing today's much loved production of aesthetic meanings qua context design. But this does not change the necessity to play out this contradiction between an immanent system and a paradoxical art that acts as resistance to a reality which it, at the same time, caters to it with exchangeable pictures and, at one with this, creates possibilities for parallel processes that do the paradox justice.

The question remains *how* the continuation of working on the "social sculpture" (Beuys) with altered (and altering?) means is to rub off on the continuation of painting by nonpainting means (and vice versa). This question is identical to that of *where* the parallels meet.

But does this not leave us once more with the good old longing for "mystic participation"? And is this not, in the end, the question as to the impossible imma-

nence (Georges Bataille)? Does this not bring us, in turn, to the artist's wish to have the experience of this impossible immanence sublimated to (art) form? And isn't this the how and why of a realization of possibilities for the impossible? Art today, if it still wants to be in contact with the lost and refound real, is a counterfactual possibility promised by its factual impossibility.

Since, however, the unsolved antagonisms of the real reappear only in artworks as the immanent problems of their form, these questions, and all talk of them, will continue to remain open here.

Marx once said that all philosophy did was to interpret the world differently, but what was the real issue was to change it. In our altered situation, applied to the altered situation of art today, I would like to say: art in our century has, most of the time, only avoided the real, but what is the real issue is to regain the real by first of all coping with (hyper)reality.

GEORG DOKOUPIL: THE TRIVIAL POSITION

I

Jiri Georg Dokoupil was born in 1954 in the then Czechoslovak Socialist Republic and spent his childhood there until he fled to Germany with his family in 1968, when the Warsaw Pact troops invaded Prague. For him, the sudden immersion in a different culture and language during puberty came as quite a shock, from which he recovered only very slowly. During this period of his life, he had already begun to develop an aesthetic attitude toward the world that was not impaired by any ideology, one that made him the key figure in a new movement in painting at the end of the seventies.

Dokoupil's works and those of his fellow artists of the Mülheimer Freiheit at the beginning of the eighties were characterized by openness, intensity, and the humorous reversal of all the hardened norms of modernist art. He believes that in art there can be neither an a-personal style nor an a-political stance. Unlike any other contemporary artist, he changes styles as if they were shirts, and in so doing gives a radical edge to the tradition of a Francis Picabia, who, not least of all through artists like Dokoupil, has again become of great topical interest. Just as he is not bound to any particular style or attitude, neither can he tie himself to any particular place. He lives and works in Madrid, New York, Cologne, and Tenerife, often changing his place of residence even within each of these cities. The same with women. The same with his own partial-egos. The same with his works?

Jiri Georg Dokoupil's oeuvre is scarcely the place where the various perspectives of an individual are realized. It is more the venue of what Novalis called a *dividuum,* onto the stage of which a polyphony appears. The changes in style that he continually executes are changes in his overall attitude:

Georg Dokoupil. *Partner Z,* 1984. Buttons and zip on terrycloth. 81 × 61 cm.
Photo: Wilfried Dickhoff.

It is, I believe, really not only the perspective that changes, which would imply a fixed standpoint, but the entire person. "I slip into a different role and then I am that," I once said. The thing that changes is perhaps the overall attitude, the proximity, the warmth and the coldness of the pictures. (G.D.)

Art as non-preconditioned drifting in contradictory directions, as an attempt to become repeatedly and totally immersed in something completely different so that every individual phase exhausts a possible mode of expression. What takes place here is "a theatrical multiplication of the Ego," as Michel Foucault terms it. To my mind, the issue is nothing less than the attempt to counter the exchangeability and arbitrary nature of values, contents, and identities – the parallel ranking of hyper-realities of all simulation models – by taking simulation to the second power, which opens up all (im)possible forms of expression, yet without taking these forms seriously. As a medium of this multiplication, perhaps the gay plagiarism on the grave of the bourgeois individualist author is a sincere form of painting. For what is this but copying pictures from the partial-ego, which is what we are when beyond all simulations of identity. Certainly, the entire thing is an art event, whose necessity stems from the fact that it seems to be more intense and more present than the life not lived within that which rules as reality. Dokoupil says:

Catch phrases such as "art becomes reality," etc., those are poses. Art is what I'm concerned about. Which means, I know one thing for sure – that I will invest in art with all my energy, with all my thinking, with the last cell in my body, with hide and hair. And I believe that is much more lived than all the talk about art as life. To live art as art, that is my commitment. . . . Every kind of motivation, of inner mission like "making the world a better place" or "exposing what is wrong" is all the same to the pictures themselves. They have to stand for themselves, in a hermetically sealed world that does not stand above anything, but alongside it; alongside the reality.

Dokoupil's theatrical multiplication is aimed "alongside reality" as a purposeful *a-topoi*, a pictorial displacement of the self *(se déplacer)* that constantly seeks out the unclassified, "a-topical place." The artist who has graphically set the stage breaks with expectation and finds himself, as Roland Barthes puts it, "in a 'trivial' position in relation to the purity of doctrines. *'Trivialis'* is, etymologically speaking, the attribute of prostitutes who wait for customers at the intersection of three roads." The artist in a trivial position is a participating observer at the intersection of intense trivialities and all other discourses. This means that he no longer destroys the hardened metaphors and stereotypes but instead he finds that, to quote Dokoupil, "going against these rules means playing with them, exaggerating them, shifting them." It is no longer a question of a discursive break or a certain negation, but more of an incessant digression, in other words, playing out the interwoven metaphors and the signs rather than destroying them. In this way, art plays illusion [Schein] off against the illusory worlds that rule as realities. They bring what Baudrillard calls "the brilliant surface of non-sense" into play against the "interpreta-

tion stakes," which finally in the name of the one truth (which we do not have) simulates meaning. This truth is not Nietzsche's "seductress to life" but the seductress to unlived life. From the doubling of illusion comes the phantom images that tempt and disappoint the world of signs that is ruled by power. Phantom images that tempt rather than deny the fossilized metaphors and appear as the allusion to many singular truths: is this not what sets the works of Georg Dokoupil off from the life of conjurers and obsession simulators?

Georg Dokoupil. *Untitled,* 1996. Ink and watercolor on paper.
© 1997 Georg Dokoupil.

An excerpt from a conversation between Wilfried Dickhoff and Georg Dokoupil on current ostensible forms of theatrical multiplication:

WD: Is there at all any difference between so-called art and fashion? Don't the two coincide as regards the eternal return of the new?

GD: What has been of great interest to me lately – and here the more traditional boundary lines become truly uninteresting – is the attempt to create pictures that would be universally applicable, pictures of faith that would be common to everyone. At the moment, the question is about creating international icons.

WD: To do that, art would have to be advertising that is even better than advertising.

GD: And "kitsch" that is better than kitsch. Kitsch raised to the power of two, an extreme exaggeration.

WD: Art, then, no longer as a shower of sparks of the other, of what society has excluded, but a potentiation of normality that would take it beyond itself?

GD: Michael Jackson's most recent album, *Thriller,* comes to mind. You can be in New York or in the Philippines, in Cologne or on the Ivory Coast – you can hear it everywhere, and there is a communication taking place. Here everything that has happened in music in the last two or three decades comes together, but, over and above this, something is getting through, some relatedness, some intensity.

WD: Then we're talking about art as a collective passion?

GD: Something like a picture of faith has the precondition that you dedicate your inner enthusiasm: a sunset is great, sitting in a boat and looking out at the sea is marvelous, suntanned people playing on the beach are really great. And I mean the whole thing just the way it is. And the pictures I recently did in Spain were the attempt to expose myself to these impressions without any ulterior motive, without any recantation, by saying, for example, "You can only do that if no one is watching you." In other words, the attempt to step before nature quite naively and to paint it as if all these meanings attached to it did not exist.

WD: To paint as if one had opened up one's eyes for the first time, whereby, it seems to me, that this is just the wish that has been brought into the picture. So, knowing that it is impossible to let your wish run its course, as Barthes puts it, to "hold the desire for the impossible to be reasonable" – is this what makes it art?

GD: Yes, perhaps. A bank robbery is definitely uninteresting by comparison. Yes, perhaps I attempt it exactly because it seems to be impossible; perhaps that is the adventure of art. Yes, I think art is humanity's last adventure.

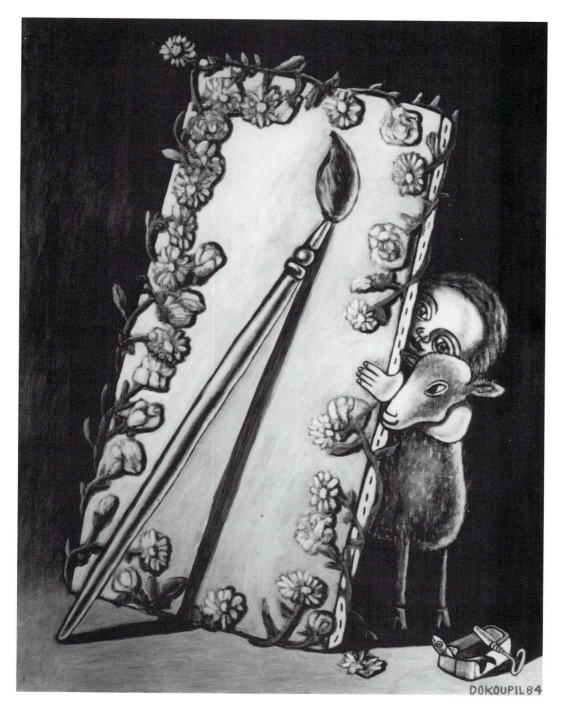

Georg Dokoupil. *Sardinen erwachet, ich male,* 1984. Acrylic on canvas.
116 × 89 cm. © 1997 Georg Dokoupil.

WD: An adventure that owes its existence – so it seems to me – to what Gottfried Benn calls the "inconsistency of the nihilist" who sets his stakes yet again on passion. But not because art reaches out across emotions and other such things – for example, into an ironic and/or reflective distance – but by painting its way through every kind of enthusiasm, it could set an affirmative density into the space at hand, a density that simply "would" be passion. Isn't that what it is?

GD: Yes, but perhaps this passion "would" also be a construct.

III*

. . . Apropos the inner necessity of form: of course your pictures are always theoretical pictures, because in them something is being conceptually condensed or inflated, in other words, shifted and dislocated. It's all the same whether it's a matter of genitalia or the loftiest values, portable radios or the universe. But at the same time – and this is where the continuity in the discontinuity of your work lies – this obsession with displacement is also in play and it obviously drives you from one a-topical place to another. We have already spoken about the fact that for you – like for Antoine Roquentin in Sartre's "Nausea" – everything is actually immersed in poetic vagueness. This aesthetic distance to the world can be traced back to a deep discursive break after your flight in 1968 and has a psychosomatic basis. It was finally your mother's stories that made it clear to me that also and, in fact, especially, your option for art began with a primal strategy of aesthetic modernity, with a "he who loses, wins" that Sartre so splendidly developed in the case of Flaubert.

Applied bluntly to you, I offer the following psychogramme, knowing that it is a conscious narrative. A boy, still in the throes of Eastern-bloc *real*-socialist puberty, with a high IQ, finds himself an apathetic nothing on a capitalist boarding-school bed in West Germany and experiences a deep discursive break with depersonalization symptoms. The attempt to make something of the state he finds himself in leads him finally to art. Which is at first nothing but a pre-neurotic generalized attack of bottomlessness in which the discursive Ego dies, the rationally pragmatic, interpersonal hold on the world is profoundly in doubt and a slightly segregated state of derealization sets in. The world increasingly appears to him as being merely an aesthetic phenomenon. He exists in this world to an ever lesser degree at a practical level, but maintains a relationship of aesthetic coexistence, which enables him to avail himself of it as material for art. His small death as a man among men leads to his resurrection as an artist, from a "real" individual to an "unreal" *Dividuum* : the poet gains what man loses (Goethe's Tasso).

The whole thing is of course just another proof of the fact that only passionate construction is "true" expression. Which compulsive neurosis, perverse lust or radical normality acts as the motor here is at most a constitutive factor in the final result, never an adequate condition. The psycho-magical is probably at best suited to rous-

*Excerpt from a letter to Dokoupil dated July 21, 1984.

ing a dull party atmosphere, to satisfying all obsessive fetishists in the art system or as a personal contribution to a museum catalogue. In the search for a clear consciousness of painting's mission in the year 1984, more help is likely to be found in Schiller's letter to Goethe of September 14, 1797, which we spoke about shortly before your departure for Tenerife: "The reduction of empirical forms to aesthetic forms is a difficult operation, and it is normally here that either the spirit or the flesh, truth or freedom is lacking."

Enough of theory. How's the love life? I hear from Rainer that despite the heat you are working all day on "Children's Pictures," a work that picks up where Morillo left off. So you seem to be resolutely continuing on the path of extremely exaggerating non-art or kitsch and raising it to the power of two. Is this helping you get closer to your idea of a profane icon? . . .

Walter Dahn and Georg Dokoupil. *Gedanken sind Feuer,* 1981. Acrylic on canvas.
200 × 150 cm. © 1997 Walter Dahn & Georg Dokoupil.

DAHN & DOKOUPIL: MASKS OF (DIS)ENCHANTMENT

> Picture – neither allegory, nor symbol of the alien: the symbol of itself.
>
> Novalis

> Simulation creates disenchanted indifference, but there is one possibility – possibility of course sounds too much like utopia. There is I don't know what, but there must be something else that happens in an enchanting way. Everything is a question of rhythm, of velocity, of acceleration, of potentiation, of intensification. The end is always the same. The end is "death" in the neutralized sense of the word. But the question is whether this death takes place in a manner that is enchanting or disenchanting.
>
> Jean Baudrillard

I

It began with Walter Dahn and Georg Dokoupil standing opposite each other at a Turkish fast-food stand in Cologne and drawing portraits of each other: Walter first drew Georg and then Georg drew Walter; then the paper was turned around and Walter drew on Georg's picture of Walter and Georg drew on Walter's picture of Georg, so that in the end portraits of a multiple (personality) emerged.

The collaboration that then ensued did not merely consist in the two creating pictures together. But it could also be the case that Walter commissioned Georg to create a picture of himself with one ear in the shape of Africa, or Walter pressed Georg to produce ideas that he then worked up into pictures, and so on. Herr Head

and Mr. Belly exchange views. But beware of the one-sided classification of these parts of the body. Needless to say, Walter Dahn's pictures stem from an inner necessity, as well as a search, for stability that in the picture – that is sublimated to form – becomes an expression of instability. But, as this kind of aesthetic transformation, these pictures leave their rationale (e.g., their inner necessity) behind them. It is no coincidence that Arthur Rimbaud appears in one of Dahn's drawings, for the latter knew full well that the poetic "deregulation of all senses" must be carefully calculated.

And irrespective of the fact that impassioned pictures are also always the result of a nonimpassioned construction, Georg Dokoupil's works are, in terms of aesthetic distance and transformed authenticity, more contemporary and more "authentic" than the numerous hollow simulations of expression and obsession. The intensity of Dokoupil's pictures consists precisely in the fact that they constantly change to a different pictorial topoi.

What distinguishes the joint pictures by Dahn and Dokoupil from Feuerbuch (Firebook) and the works surrounding *Treppenkopf (Stair Head)*, to the Duschbilder (Shower Pictures), the Afrika-Bilder, and the Tierbilder is that an interplay between expression and construction is brought out in extreme form. Oscillating in this way between leaps of the mind and of the body, pictures emerge as constructed affects that signify and symbolize nothing, but simply are passion. The issue still is the possibility of presence – form and content, passion and suffering, life and death in one single gesture.

II

Making Africa the subject of a series of pictures was not a mere random thematic decision on the part of Dahn and Dokoupil. For what distinguishes African art (of living) – and in particular traditional African sculpture – is nothing other than this magical form, also of concern to Dahn and Dokoupil. Of course, the pale-faced painters from Germany are worlds apart from an African, who, with an attitude of distant adoration, makes a sculpture that serves as a tool for capturing and warding off spirits and gods. This artist is the servant of an artwork that is an hermetic and complete mythical reality into which divinity is conjured to earth. A piece of African sculpture is mediator to the invisible forces of life, not a symbolization but the magical presence of invisible spirits. This means that African sculpture is the divinity whose idea it embodies. Even if the paintings by Dahn and Dokoupil have nothing further in view than to create dwellings for invisible spirits in order to satisfy the heart of the gods, they are linked to African sculpture by an elected affinity of form, as can be seen in Cubism and in a different way in the work of Picasso. This affinity consists of extreme condensation, of an unambiguous formal clarity and a reduction to the essential, which lends the picture the hallucinatory density and presence that allow it to become a sugges-

tive sign. It signifies nothing, it symbolizes nothing, it represents nothing; it simply has permission to be present.

In other words, whether in the African savanna or in Cologne on the German Rhine, art as quality is a question of an intensity beyond the dualist issue of form and content. In this way, intensity is form/content, meaningless and direct. In their best pictures, Dahn and Dokoupil succeed in bringing this presentness into the image, something a picture of import must today fulfill. They stage the *Augen-Blick* [instantaneous gaze] of fascination. This is the instant in which content precipitates into form; what is seen appropriates the way it is seen and the picture opens its gaze, so that we are no longer instructed, but instead seduced, abducted, or horrified.

III

The universalization of simulation has for some time now also affected art. And in its course, illusion, ossified into facticity, counts and rules as "reality," which has been replaced with global ersatz systems and simulation models. After the different varieties of anti-art have served their time as survival forms for art and after its infinite reflective reiteration in Conceptual Art has vanished in tautological negation, art survives as its own simulation. Everyone is invited to participate in the accumulation of this survival form of art: art is dead, long live its artificial sign.

However, simulation cannot replace art. It is art's most recent guise. And art is not something that is played at, for a mere game could not produce one single good picture. In contrast to a game, simulation is a halfway house between existence and semblance: he who simulates the flu always has a slight fever. Thus, we are talking about a game in which the player has to put himself in jeopardy so that he finally "is" what he seems to be.

The majority of art performers, who have in the past years been labeled "wild," "vehement," "postmodern," and "trans-avant-garde," have exhausted themselves by more or less cheery or hollow plagiarisms, and the flood of pictures of apparently authentic desire has ebbed. In their works Walter Dahn and Georg Dokoupil, in contrast, drive simulation beyond itself while executing varieties of simulation to the second power. This can be seen with particular clarity in the Afrika-Bilder from December 1983:

The first picture in this series, *Das Aussteigerbild (The Drop-Out Picture)*, graphically enacts the process of dropping out of the white and entering into the black race. It expresses very strongly their own ideas of, and points of contact with, the African world of forms, something that, in subsequent pictures, is gradually abandoned in favor of a retraction of their own themes. Just as "African sculpture" conforms to very set, stereotypical, and conventionally religious principles of design, so do Dahn and Dokoupil help themselves to the formal principles

of "African sculpture." Symmetry, shifts in body-to-head proportions, frontal presentation, static poses, and so on, are all strictly adopted. But the result is no longer merely a cheerful plagiarism on the grave of the bourgeois artist's Ego, for in this case their own expressive needs are excluded and simulation is taken to an extreme. All imaginable means are used to create a "copy that is as true to nature as possible." These range from African motifs, fetishes, and mythical pictures to the use of earth-mud pigments to the minimal texts that imitate African fairy tales and legends, as, for example, those passed down from Togo and by the Bakuba, Dahome, and Ababua. Just as someone simulating asthma sometimes "really" cannot get any more air, Dahn and Dokoupil obviously appear to "really" have been burned by the African sun while painting, and "really" seem to have offered their mud-covered mirrors for sale at a marketplace – somewhere between Dahngo and Dokoupilanga.

They enforce simulation not only through this exaggeration but also through doubling and taking it to the second power. Thus, in the case of the Afrika-Bilder, art itself is simulated, insofar as African art (of life) is graphically simulated. And a doubling of form can also be observed that consists in bewitchment via African magical forms, that is, the imitation of African forms becomes the contents of the pictures, the sense of which is nothing other than this appropriation of magical forms. The whole is then enriched with religious signs and seasoned with sexual ones. And voilà, the constructed affect.

What is, in the end, still at issue are pictures of pictures created by the African artist about the invisible (spirits and gods). Here, "phantom Africa" comes into play in an evocative manner, something that has served since the end of the last century as an imaginary refuge for the dying white race, for its retrogressive yearning for originality, immediacy, ties to nature, and so on. In brief, Dahn and Dokoupil potentiate the simulation that then no longer fakes anything, that no longer pretends not to be simulation. Here, obsession, veracity, resistance, and so on, are no longer acted out in order to pretend to themselves and the viewer that the pictures are counterfactually signs of some kind of truth and genuineness.

The Africa Pictures are not false. They are even falser than false, and this is the source of their most intense presentness: seduction. This is no longer a sign world, it is pure illusion [Schein], which, unlike the sign, cannot be decoded but only symbolizes itself and is simply what it is: fascination, enchantment, intensity.

Those who place their bets on resistance and negation in art merely reproduce what they think they are resisting. Their negation is therefore no longer negation, and the majority of postmodern artist-performers participate in the general neutralization and indifference of so-called reality. While all this is going on, I/eye see seduction in the paintings by Dahn and Dokoupil as a potentiated simulation that is differentiated by its decisively affirmative execution: the illusion of illusion (also raised to the second power) that breaks through the randomness and indifference of simulation art because it seductively undermines power, the master of the world of signs.

In a time when the realistic, world fairy tale of simulation spins us in its web and immanence finally appears to be total, nothing remains other than the way in which we differentiate between the structural elements of symbolic order. For art, it is a question of whether one carries out simulation in a disenchanting or enchanting way. What remains is seduction within art, masks of (dis)enchantment, the red arrows from Dahngo and the mud-spattered mirror from Dokoupilanga.

MARTIN KIPPENBERGER: ART'S FILTHY LESSON

> He who confronts the abyss, should not be surprised if he can fly.
>
> Martin Kippenberger

For Martin Kippenberger, the problem with painting in view of the dead mother (i.e., reality) is as follows: "How am I to come to terms with an apartment painted brown? Certainly not by painting it over white" (M. K.). Thus, the thing is to come to terms with the "brown" as it is, without whitewash, without compensation, without cosmetic remedies. Correspondingly, the painter moves not in the realm of sensuality – that neoexpressive simulation – "but rather in the realm of mealy worms" (M. K.), according to Kippenberger, in the everyday mythical dung that defines us all: "In the mouth there is decay; in the socks something similar, and on top the good mixture" (M. K.). His subject is what the poet Gottfried Benn termed "the pinnacle of creation, the swine, the human being," who chases his shitty soul around in a circle and pants for identity, while his psychosomatically knotted-up viscera relieve themselves only while peering at horny fetishes.

Martin Kippenberger. *Artauds Kreuz (Pour enfinir avec le jugement de Dieu)*, 1987. Wood, acrylic, rubber band, cassette. 200 × 180 × 89 cm. © 1997 Gisela Capitain Gallery, Cologne.

From the backyard window of a well-known Cologne brothel, which pallidly faces onto the motorway to Düsseldorf, the hygiene is hung out in the form of an orange-colored terrycloth towel. The view is obstructed by a crude "screen" so that what the passersby would like to see cannot be seen. The picture reflects on the viewer's anticipation of what might go on behind the window: the misery suffered by all those cock wearers and hobby whores. *Heil Hitler Ihr Fetischisten (Heil Hitler You Fetishists)* is the name of the picture, and the initials H.H.I.F. are painted into the picture. Put differently, the erection of the fetish makes the fetishist into a disappointed lover or into the viewer of the products of Kippenberger's Mirror Program who – as is correctly indicated in *Wahrheit ist Arbeit (Truth Is Work)*[1] – depends on being reflected in the pictures, whereas the pictures by no means depend on reflecting him.

This painting belongs in the series which Kippenberger called the I.N.P. Pictures. I.N.P. stands for *"Ist nicht peinlich,"* which translated literally means "it is not embarrassing," but, in fact, the pictures show exactly the embarrassing in everything, for example, being caught in an act of stupidity, of lying, of pretentiousness, of meaning well, in art and life. The I.N.P. Pictures confront us with ourselves in this sense. They permit no arbitrary projection. Kippenberger takes them to the outer limits of embarrassment as to what is painted and the way it is painted, offending every kind of good, bad, and indifferent taste. And when they get to us, they do so at exactly the place where "you" imagine your identities to be and where you cling to your personality, your future, and your art fetishes. For example, *Selbstjustiz durch Fehleinkäufe (Self-administered Justice via the Wrong Purchases)*, the primal scene of commodity aesthetics.

However, if in Kippenberger's *Mirror Program* you merely see the cynic at work, who shows us what we look like without underclothes and make-up, without our masks – then you have missed the point. For knowing full well what also he the painter splatters is nothing but the mud from his own puddle, he does not ironically distance himself from what he paints. Neither is he concerned with staging the expression of destroyed identity so as to generate identity for himself or with a dissecting exposure of all myths of life (and survival) in order to place the physician in a positive light. That would be a very stupid move, in any case, because medicine has long been associated with disease.

Thus, if we can speak of cynicism at all with regard to Kippenberger, then at most in the sense of a moral form of painting's standing its ground in the midst of bankrupt "man." Perhaps it will one day become clearer that this attitude is simply a means of beating a spark of humanity out of the appalling arbitrariness of things. A spark that perhaps makes it a bit worthwhile. The pictures are not limited to drawing a bottom line – something the dead mother does on a daily basis – instead, they are maintained by an unreserved affirmation of life and death.

Martin Kippenberger. *Wer sich dem Abgrund stellt, muß sich nicht wundern, wenn er fliegen kann,* 1983. Oil on canvas. 160 × 133 cm.
© 1997 Gisela Capitain Gallery, Cologne.

Although someone puked in my face
And shat into my head,
I certainly would be missing something
Had I merely stayed home in bed.

(M.K.)

In other words, affirmation of the world as an error and of life as the might of
the false, the doubling of illusion *[Schein]*, which for the artist is not a negation
of what is real in the world but exactly this yes to art as a part of life to the
degree that it is the incorporation of an affirmed *Schein* in practice. Truth is
work. It is this affirmation that, associated with an incessant moral state of
arousal, gives Kippenberger's pictures their strength, their nonugly blatancy, and,
as Rosemarie Trockel remarked, their "bitter aftertaste." "Do you really mean
well by people?" one of his pictures asks.

The whole thing is supported by what Kippenberger calls radical "courage
towards filth," or more precisely the filth of truth, for, he says, "there is
only filth and the beauty in filth." And such "beauty," free of any pallia-
tive beautification, inevitably involves a sense of horror as well; indeed, the
horror is even a constituent element because it is not won beyond the unlived
life but only smack in the midst of the filth of truth. The truth ("one of
the dirtiest birds in the world"[2]) drops its filth on the heads of those who
want to know what truth feels like from inside.[3] These include the shat-
upon-by-filthy-truth Kippenberger, whose pictures cope with the horror in
truth without covering up the "brown" with bright colors and simulated
expressivity.

Here, the specific moralist duct (i.e., vessel for excreting glandular fluids = inner
need) is brought into play with the following *Duktus* (characteristic style of giving
artistic form) of many I.N.P. Pictures:

The background is formed by a great deal of "modern art" (Polke) in the
form of a shifted geometrical and/or a contradictory composition with spatial
intimations in different directions, made up of continuous, "tastefully" colored
oils. Against this background, small and major scenes from the everyday myths
of what Kippenberger terms the "German Bronx" emerge, scenes that life does
not write but paints.

In the end, these two levels are supplemented with the lyrics of "that's just
the way it is," lyrics applied with spermlike glue, that is, with a material that
corresponds to the mental ejaculations of that which gives itself up to the filthy
bird of "truth." Taken together, this results in the I.N.P. Picture – the preserv-
ative skin of things in the light shed by the shat-on soul that looks like a bloody
membrane when the identity foam is skimmed off and he who has been sullied
with the truth's filth reaches for the paintbrush in order to extend it in the form
of a picture.

If truth is the mother and the dead mother is reality, then reality is the death of truth as a permanent condition and the truth of reality is death (see Céline's "Journey to the End of the Night"). But the mother of the picture is the horror at the gaze of the dead mother, because the horror in truth is the truth of art.

Dear Martin, keep it up.

THE ART AND LIFE OF THE PAINTER M.K.

I

Silent the truth stays
and nothing emanates
A fiddler plays
A woman masturbates

II

So, off with your pants and spread your thighs
Is this how the inner swine survives?

III

The painter paints
The swine does not cry
We do know what for
But we do not know why.

Martin Kippenberger. *Untitled*, 1992. Oil on canvas. 180 × 150 cm.
© 1997 Gisela Capitain Gallery, Cologne.

DAVID SALLE: ON STAGE

> There is no emptiness and no fullness. There is only the
> possibility to fill the emptiness, here, right now, at the
> window, by means of soundings and transformation.
>
> Gottfried Benn

I

David Salle's new paintings are more theatrical than ever. Not that they haven't always been theatrical; now it is just more explicit. The atmosphere of a stage setting is especially apparent in his two large-scale paintings *Théâtre des Amis* and *Theater for One*. In *Théâtre des Amis* figures from traditional Japanese puppet theater are on show. An actual ballet costume of Karole Armitage hangs in front of the painting as a part of it, integrated further by a flow of thin paint. It is suspended in such a way that suggests the "dancer" could almost fly across the stage. Actual chairs like props with dustcovers are standing ready to be sent to the cleaners. Many allusions to puppet shows turn up. Salle uses fake tapestries in his pictures as background and/or foreground staging for the various pictorial elements, and his manner of painting the tapestries is itself suggestive of scene painting. He designed these tapestries after those beloved by the Russian nobility, who had attempted to capture the atmosphere of French tapestries from the eighteenth century by imitating them in the nineteenth century. Salle doubles this ersatz not only through his altered imitation of the (appropriating) imitation but also by the painting technique itself. By scraping a wide-toothed comb through the paint when still slightly moist, he achieves a horizontal linear structure that looks like the texture of woven material: painting becomes the illusion of illusion *[der Schein des Scheins]*. This strategy of

David Salle. *Theater for one* (detail), 1989. Acrylic and oil on canvas.
94 × 136 inches, two panels. © 1997 Gagosian Gallery, New York.

doubling the image mock-ups can be traced throughout David Salle's entire work and makes reference to all possible forms of compensative expressions of the social imaginary (from stylish furniture to sex styles). Independent of this, however, the picture has here become a stage, a platform upon which the most disparate picture worlds make their appearance. It evokes the slightly dusty atmosphere behind the stage where props stand around as if they had been ordered and never claimed, waiting around to be able to put their illusion (offstage, their fakeness is foregrounded) of a factual theatricality to good use – these seemingly dead hermaphrodites between papier-mâché and illusion, between memories (of past performances) and expectation (of future ones).

The fictitious quality of theater props is quasi overlaid with that of the individual images in Salle's paintings. He thus achieves an effect he values so highly in Douglas Sirk's films: to superimpose various levels of reality onto one another so that one becomes transparent through the other. Salle proceeds analogously with his pictorial dramaturgy. The simultaneity of mutually exclusive phenomena has been the ambition of the painter working as a stage director of the heterogeneous from Picabia to Polke. Today it is debatable whether non-synchronicity is present at all and has not yet been muted to indifference by a culture that, possessing total information, forgets difference. This alters

the issue of pictorial complexity as well, because if there are no more references to be established, then complexity turns into an endgame formalism or a means to actually produce strands of difference. David Salle's paintings operate somewhere at the border between these poles. For example, in the painting *Imprudence,* an unnaturally posed model holds up a picture to the viewer like a vaudeville numbers girl. The picture she is holding is revealed close-up to be a copy of a portrait by Alex Katz of his son Vincent. Salle both builds up and breaks down such fictitious references between authentic artificiality and artificial authenticity. This can also be seen in the painting *Flat Puppets, Shadow Puppets,* in which Salle replaces the head of his numbers girl with two clasped hands that form a figure in a shadow show and is, at the same time, reminiscent of a sculpture by Lipchitz; in the other half of this diptych, a hand dangles an anatomical illustration of the human body as if it were a puppet. There is artificiality to the second power on the one side and a remote reference to a Faustian will to knowledge, illustrated like an ersatz Goya, on the other.

Salle proceeds in a similar manner with the traces of "ensouled form" in the history of art. Giacometti sculptures appear, simultaneously, as no longer possible, and thus as fakes, but also as a memory of what existential art once meant. And when, in the painting *Théâtre des Amis,* Salle lets a ballet doll hang from a rope in front of the painting on the left side while on the right a nude model lies on her back manipulating a jointed doll (the kind traditionally used as an artist's model), connotations become just as commonplace as they are complex. The viewer becomes a stray dog who wanders about in Salle's semantic courtyard sniffing at everything the artist has laid out in the line of deceptive maneuvers. The viewer's eye fluctuates

David Salle. *Theater for one*, 1989. Acrylic and oil on canvas. 94 × 136 inches, two panels. © 1997 Gagosian Gallery, New York.

in his paintings between would-be realism with exchangeable signs of reality and the attempt at a specific constellation of (ir)real picture-world fragments. Salle knows this requires things that are acted out as they are: ". . . the Sirk mode of tragedy, which some people would call melodrama, where characters act out their fate no matter what they think or no matter what they try to do, because that's the way the world is. Things are because of the way people are."[1] The first step to a painting is just to let things be, to let them come across with all their inherent falsity. The kind of perception operating here can be compared with "the impartial attentiveness" recommended by Freud toward a patient's every utterance. Just because Salle from the outset does not blend the elements of the painting into a pseudounity but first lines them up with all their disparity, they work like the design of a psychoanalytical "scene." One can perhaps misunderstand David Salle as the film director of visual scenes of identity simulations, sexual yearnings, taste aberrations, and art expectations.

Where no superficial accordance of all the pictorial elements are cosmetically primed to a feeling of the tasteful, the single components come forward with a blatant air of "that's just the way the world is." Salle simply lets the viewer withstand the objects' juxtaposition, which, however, soon provokes the viewer to take up some (non)figurative bait of meaning and reduce it to an analogue

for a sign of reality. This gets him bogged down in an overidentification with his own wishful thinking, where he emphatically runs into a dead-end street of meaning and is forced to conclude he has fallen prey to his own projections. I think it is Salle's virtuosity in handling the figure/ground relationship that causes such a reaction. Salle's picture units pop up and recede like the latent and manifest contents within our psychic apparatus (e.g., Sigmund Freud's oedipal triangle).

Whoever remains at this level of the paintings – whether fascinated, repulsed, or just baffled – will be taken for a fool by his own "self." Painting has always been the blind spot of a manner of perception that was happy enough to see its onanism in front of the painting as an image of culture (of the self). Salle describes one of the bases in his works to be viewing everything in this world as "simultaneously itself and a representation of the idea of itself."[2] However, his goal is not just to illustrate the antinomies of representational culture. They only supply the material for his work, as do the artificial ruins of memory, the doubled fakes, his quotes of sublime art forms, or "his" nude models, which he sets up as "angels of vision."[3] If we consider Salle's description of Karole Armitage dancing, his own goal becomes apparent: "It wasn't simply the fact that Karole's dancing was extreme, which it was, that made it interesting. She is very long-limbed and had amazing extensions and the ability to appear as

David Salle. *Théâtre des Amis*, 1989. Oil, acrylic, fabric, and wooden chairs on canvas. 115 × 190 inches, two panels. © 1997 Gagosian Gallery, New York.

though all four limbs were working in contradictory ways, but also with complete visual harmony."[4]

What he is working on is a construction of a broken whole, a unity of the irreconcilable, by means of a dramaturgy of fascinating paradoxes: an interplay between the valuable and the worthless, between pornography and vision, between the emptied and the exalted, between representation and forms of presence, and between psychological despair and mathematical poetry. There is an attempt in operation to make the structure of signifiers – the inevitable rules of a language that "speaks us" – and their structural components blatantly and unpleasantly visible by means of a specific composition, so that at least the possibility of a sincere picture will be left glowing in the ashes of discarded (world) images.[5]

Salle puts on a show of pictorial ambivalence, which he neither negates nor confirms. He simply shows it up for what it is: a paradox. He acts the paradox out, that is, the extremes intersect, enter into the painting, yet do not merge, and the opposites are not resolved. The whole of the painting is a nonsynthesis. He sets his ambivalence-dolls to dance, sets up referential chaos, and includes in the picture the stage itself on which his production takes place. The result is painting as noncoherence. Yet there is a certain logic to it, the logic of disjunction.[6] This consists in the logical contrariety of mutually excluding images – images that are "right" just because of their polarity. In short, David Salle is the formalist of discontinuity and the dis-contents and disharmonious harmonies that go with it.

II

A major characteristic of great art in this century has been the construction of micrologies – closed-off configurations that as fragmentary unities provide an aesthetic accompaniment for the dissociated subject in hermetic form. In contrast to this it is J. F. Lyotard's thesis that, at a time in which no standard history of emancipation exists, experimentation flourishes and art is conceivable only as a multiplication of paralogies. Lyotard places an affirmation of intensities in opposition to "determinate negation." This, however, makes no sense. It would be more accurate to see micrology and paralogy as parallel processes that today should be played out in art. The oscillation in the picture between both poles would be more adapted to the contradictions in our situation. The experiment on which David Salle is working could be viewed as an attempt to cobble together a (modern) micrology from (postmodern) paralogies. Whether this succeeds or not is a question of the orchestration of paradoxical images, namely, the how and why of orchestration. Which brings us back to the problem of originality, novelty, and pictorial invention. Success or failure hinges upon whether it is possible – from a constellation of the old, the new, the other, the wagered, and the suffered – to create something never before seen in quite this way.

David Salle. *The Tulip Mania of Holland,* 1985. Oil on canvas. 132 × 204¼ inches, three panels. © 1997 Gagosian Gallery, New York.

Rooted in the tradition of the New York School of Painting, Salle insists upon the possibility or at least the necessity of "absolute specificity." He explicitly views his art as a further development of Frank Stella's formalism by present-day (non)figurative means. He considers formalism to mean that it does not matter what a particular painting stands for but what it is; a painting does not illustrate meaning but is itself a construction of meaning. For Salle, formalism is the consequence of the interchangeability of emptied contents. It is the attempt to create forms that are deviations from the immanence of the technical world of images that controls our lives. The single image components – ranging from the girl with spread legs to a Giacometti sculpture, from an African sculpture to *Nude Descending a Staircase*, and from a highly refined design by a Carlo Mollino to a sketchbook drawing by Jackson Pollock – are all applied in a calculated manner in Salle's stage sets and, according to the painting style, are also indirect participants, clothed in Salle's costumes. He works in detail with an aesthetic retraction of the images and signs that then become quasi-abstract picture material of their composition as *Gesamtbild*. These devaluated and simultaneously highly charged objects serve as building blocks for a new nonfigurative painting. Lévi-Strauss called this procedure of combining disparate fragments "bricolage."[7] In reference to nonfigurative painting he described this method as a realistic imitation of nonexistent models. The formal constellation of existing models of image-mediated desire is David Salle's nonexisting model. In a conversation with Peter Schjeldahl, Salle describes his painting as linking two traditions:

There has been painting for hundreds of years that wanted to see the interior or workings of human beings, in a physical sense. And there has been painting that wanted to examine the exterior mannerisms of human society. Both kinds of paintings have existed side by side for hundreds of years, and I think my paintings have something of both."[8]

Thus, on the one hand, the surface of the picture acts as a stage, as a battlefield for the images of the social imaginary and for all the resultant mannerisms. His frontal depictions of taste inanities belong in this category. He introduces them, empties them, yet only in order to bring them in through the back door via his particular composition. A carousel of taste traps that apparently has a magnetic attraction-and-repulsion effect on the viewers on the American side of the Atlantic. Part of this is the superficial pointing out of semantic relationships that are immediately disappointed, a building up and tearing down of neutralized references – the theater of meaning. On the one hand, he is playing out the signifying structures and visually invalidating the picture fragments of our ersatz culture. On the other hand, there is a form sublimation of the human/all-too-human as it operates in the cycle of internalization and externalization. To this purpose Salle uses the (female) body as an excellent place to graphically examine human nature, something no one seems to know what it is exactly.[9] This lack of knowledge is particularly visible where reified female bodies in mock-lascivious poses are lined up and, upon closer

inspection, shown to be curiously nonerotic. They are more a question of models who suffer under the tortured poses of an artificial experiment (except for the fact that they are closer to Niele Toroni's painting than to any porn photo). Using the female body and chairs from the 1950s, Salle fabricates networks of references made up of sex and design that destroy themselves only to be charged immediately with other pictorial effects. To interlock visual construction and deconstruction is central to David Salle's strategy of (de)constructing his paintings as (de)composed paradoxes. Salle names Breughel and Bruce Nauman as eminent examples of artistic research into the (in)human and names Watteau as an example for a disenchanting art of enchantment. If we view Salle's paintings as being a mixture of Nauman and Watteau and if we attempt not to lose sight of Salle's claim of continuing Frank Stella's Black Paintings by other present-day means, then we are witnesses to a very specific high point of American formalism that originates from a play on sign-mediated longings that are repressed by the dominant ersatz art of our ersatz culture. David Salle is at work on a paradoxical experiment of a non-irreal formalism that sublimates the phenotypical to form. In the fractured planes of his brilliant surfaces, he offers enough tragedy and comedy for every taste: "The surface that Sirk possessed that contributes to your feeling that there's something terrible going on underneath the surface."[10]

Ross Bleckner. *Deathlessness,* 1987. Oil on linen, 213½ × 152½ cm.
© 1997 Mary Boone Gallery, New York.

ROSS BLECKNER: TRACES OF DEATHLESSNESS

I

In the past, reason revealed itself to man as his capacity to resist the omnipotent power of nature. The things that allowed man, in view of his state of powerlessness, to become conscious of the might of reason were called *sublime*, "since they raised the strength of the soul above the norm."[1]

Today, nature is seldom the object of such an experience; instead, the reactions of a nature that has been crippled by mankind – and quite certainly the forms in which the second nature (culture) and third nature (virtuality) for which man is responsible – are directed against him, in other words, against his inner nature (subjectivity). The symbolic order of supraindividual power structures, the institutional mechanisms of identity assignment that invade our very psychosomatic guts, the fatal correlation between gluttony in the first world and starvation in the third world, cancer as the physical, deadly disease of cell proliferation and as a metaphor for the ecstasy of our squalid culture of interchangeability, arbitrariness and indifference, AIDS, nuclear contamination, and catastrophe as normality – all are but a few manifestations of the present situation that confronts us overpoweringly because we are determined by it.

Depending on the extent to which our situation is distinguished by a real artificiality with disastrous consequences, it is perhaps art, despite its modest and restricted impact, that can still convey to us a feeling of resistance. It is precisely the limitation of aesthetic distance – which art only at the price of self-deception can think itself capable of overcoming (compare the art-to-life transference illusion in modern art) – that predestines art to do so. The sublime, as defined by Kant for the eighteenth to nineteenth century, took place only where the observer of a tempest or earthquake was in a position of safety. The mixed feelings of pleasure and terror, joy and fear, enthusiasm and depression, which one also calls the sublime, occur only where there is at least the possibility of experiencing one's own power of resistance [*Gegen-Macht*] in the face of a superior power [*Über-Macht*]. Art, however, can no longer generate the possibility of such an experience. The pure presence, with which painting hoped once again to trot out evidence of its autonomy, has evolved into a design of late-capitalistic discourse. Even Barnett Newman's paintings express only the memory of an absolute presence that has long vanished in the theater of its restaging. There is now no unbroken purity in art. More-

over, there are also no purely authentic, constructive, expressive, or even conceptual spaces. The cult of purity, just like pure cultures (e.g., pure races), has come to an end. However, the answer does not lie in an art of the pure illustration of this fact. So it is that, for instance, within the fashion for so-called Post conceptualism, precisely that stage of art production is lustily reproduced which is claimed it should visually reflect: the mass production of hypermodern art effects.

Where no full risks are taken with form, nothing of significance can come into art. The possibility for an art that still has something to say, that is in a position to formulate a countermove in form, is identical to the necessity not to bypass the contradictions but to play them out. Everything else is unavoidably a naive or cynical confirmation of the omnipotent power of the system. Only where the contradictions, antinomies, and paradoxes – which we are – are brought out as such can paintings come into being that parry the situation, which means take it as it is without any palliative, while at the same time holding its sublimation to form up to it.[2] For every question in art is related to that of the how in art (form), to how questions can be directed toward more exact questions. Perhaps paintings, which speak through their formal structures of a reflected experience of hypermodern technology and speak in such a way that they really touch something that is not completely swallowed up in the omnipotent system of signifiers, could become affects that might have the capacity to generate ensouled forms of resistance. Could it be that at this point in contemporary art we are in touch with the legacy of the sublime? The sublime is not to be confused with its legacy. It can be found today only in latent form. Sublime art is not sublime but at best a synthesis of religious substitutes, something which art that copes with the above avoids. Art is the antithesis of every kind of illusory redemption. The latent sublime walks a narrow path; the risk of slipping into affirmation and of falling into the arms of the system (of signifiers) is a constant one. Wasn't it Napoleon who said that the sublime is only one step away from the ridiculous? Sublimity was once supposed to be the greatness of man as a spiritual being and as nature's tamer. But today, "man" as such has become nothing but the tragic-comic figure of being per se. This also applies to art. In contemporary art the sublime and the playful are mutually complementary, each to the other's identity (problem). Art's latent sublimity can be attained only in a comedy on the tragic (individual). For example, perhaps by (playfully) degrading the ridiculousness of "pure" sublimity and, in the process, winning over the latently sublime? The art of degrading the sublime is the art of underlining and articulating its fundamental contradictions. But above and beyond this, is the art of degrading the sublime not the art of coping with and acting out our social and existential situation, which is still that of nihilism? "Doubts are stirring as to whether such images are suited to illustrate the overcoming of nihilism, that is, the restoration of the oblivion of Being."[3] Art's contribution may be the articulation of difference in the cracks of identity, metaphysics, the (social) body, the gender, and so on, and, in the end, of unredeemed difference in our being (t)here and in the oblivion of Being.[4] Art as aesthetic resistance cannot not work at this coveted impossibility: the real presence of real difference. Naming names: Cindy Sherman, Rosemarie Trockel, Albert Oehlen, George Condo, Günther Förg, David Salle, Richard Prince, Sigmar Polke, Gilbert & George, Philip Taaffe, the list could (and I hope will) go on.

Ross Bleckner. *Middle Sex of Angels,* 1988. Oil on canvas. 274½ × 183 cm.
© 1997 Mary Boone Gallery, New York.

II

Once we have ventured onto this path, we are able to discover Ross Bleckner's paintings. Ross Bleckner was born in New York City in 1949. He first studied at New York University (where one of his instructors was Chuck Close) and later, at the beginning of the seventies, at the California Institute of Arts (CalArts) where mainly Conceptual Art was being taught and the curriculum was governed by a critical self-reflexive approach to art within its social context. Photography, video, film, installation, and performance art were the dominant media at the time – media in which an adequate articulation of critical art seemed possible. Painting was hardly taught and was seen as obsolete, outdated, and reactionary and as having reached an endpoint with the demise of modernism. This negative view of painting was rampant in the seventies. Within the international art scene it was generally accepted that painting had become impossible once the possibilities of a contemporary painting seemed to have been exhausted once and for all and painting had been revealed as mystical and pretentious. The surprising rediscovery of painting at the beginning of the eighties and its emergence, in particular in Germany, Italy, and the United States, as an international art movement was not just accidentally set off by a generation of artists whose background were the diverse rock-pop-hippie countercultures of the sixties and who had been confronted with political Conceptual Art during the early years of their artistic development. In the United States a number of them were CalArts graduates, for instance, Troy Brauntuch, David Salle, Eric Fischl, and Ross Bleckner. As different as their respective approaches to painting were, they had all experienced the co-optation of Conceptual Art, which had lost its subversive and critical force as it became institutionalized. The realization that the art of political opposition was insincere when it reproduced precisely what it had opposed was certainly one of the reasons that these and many other artists of this generation in the United States and Europe sought to redirect their energies. They focused on a medium that perhaps precisely because it had been "conceptually" marginalized by Conceptual Art and declared to be regressive per se seemed to be an appropriate means: painting. The fact that these artists opted for painting was certainly not a regressive, conservative choice. It grew out of a need to resume the thread of lost veracity at a point where one did not expect it and from a medium one no longer believed in. That this was initially revealed in a program of "intensity" that reactivated all sorts of things, for instance, also the vanishing lines of expression, content, images, ironies, and pseudo-affirmations, was proof, albeit not always one reflected on, of this need to transform the desire to revolt into a revolt of desire. Yet desire is not clear-cut, is not always fitting and proper. It is also contradictory and different. Wherever it is expressed in intense form, it transcends boundaries, is deviant and incisive. It creates differences[5] informed by intensity proceeding from the body, which cannot be altogether grasped, neither conceptually nor "artistically," except at the price of an aesthetic translation and of inclusion and marginalization, the motivations and consequences of which remain dubious. Yet how is desire articulated in or as painting, and why? Doesn't such a need already demonstrate that it is impossible? Couldn't it be that a painting which generates differences, which exposes itself

to the contradictions of desire, be indebted to an (existential?) humor, one based on an awareness that it is impossible for a painting of desire to be an act of opposition. And couldn't it be that such a painting, at the same time and for this very reason, could incorporate the desire for this impossibility as being reasonable?[6]

This vulnerable point was where Ross Bleckner's paintings emerged in the mid-seventies. As opposed to most painters of his generation, his paintings are not based on conceptual figurations, references, and images. Instead, he opened up painting proceeding from within painting itself. It presupposes the apex of its self-reflection, as can be seen exemplarily in Barnett Newman's work. It does not use it as a point of departure. Bleckner no longer believes in a pure purity of abstract painting. He is deeply suspicious of an absolute geometric abstraction that seeks the culmination of its idea of freedom in the excesses of sublimity. Apart from the fact that a painting of pure purity had long become degraded to an institutional doctrine of pure theory, the social and contextual implications of such an approach to the absolute were too transparent to him. It is only one step from the sublime to the ridiculous, as is best exemplified by the Op Art of the sixties. Ross Bleckner based his stripe paintings on its psychedelic optics in an attempt to break open abstraction in a different way. He was interested in opening up the other dimension of geometric abstraction. These were the fields of association it could open up and reinforce, feelings it could evoke and create, a corporeality that it could allude to and actually be, a score of semantic possibilities to which it could invite the gaze. Everything that comes to bear in the game of desire when something or the other triggers an echo of something in us that does not correspond to anything in reality. Could this really exist, a visible sketch of the internal network of equivalences of desire (of the Other)?

One stripe painting is titled *The Forest*. The play of green and yellow tones extends into the black-and-white stripe structure. A forest appears, with smells, underwood impenetrable, and light incursion, but also a forest that cannot be seen for all the trees, in art and life. Another stripe painting is called *Wreath*. As strictly geometrically abstract and self-contained as it is, it assimilates everything that appears: the band worn in one's hair, the band used to wrap a present (a reading that makes wrapping paper out of the stripe pattern), or the band that tries to (symbolically?) bind a state of being hopelessly in love to the other (a pictorial reading that lets the stripe pattern represent the iridescent spectrum of strands triggered in us by the state of infatuation). A stripe painting showing, in ever greater intensity, a fit of "being in love" bears the title *Infatuation*. Yet as much as these paintings remain open to all feelings and perception, they are also nonfigurative and nonabstract at the same time. In connection with all of painting's conditions of possibility, Bleckner sees his works as paintings. He is no longer willing to give up this insight for a superficial and by necessity glib play of authenticity related to figurative expression. On the other hand, he sees affirmation unwittingly appearing in Minimal Art and Conceptual Art. In reading Jacques Lacan's nonreductionist expansion of psychoanalysis he found ideas that accommodate his desire for a nonaffirmative painting.[7]

In particular, he was interested in the intangible complexity of desire that can be

grasped neither from the oedipal triangle nor in terms of an alleged dialectic between the so-called I and the Other, not as a subject of painting but as painting. According to Lacan, the difference of desire in painting consists not in proceeding from the Other as in erotic desire but in intending the Other as gaze, as gaze that is active in an intention of desire. Painting could have to do with "a sort of desire for the Other, at the end of which giving something to see."[8] One question could be, Which gaze is gesturally inscribed in Ross Bleckner's paintings? If one views his paintings from this perspective, there is perhaps the possibility of opening someone's eyes to a painting in which differences are created. For instance, difference paintings of a desire that is not identical, that does not just merely represent a phallic function. In his essay "Transcendent Anti-Fetishism"[9] Bleckner writes: "The problem of artistic creation is the problem of madness and death."[10] In this text he expresses his desire for a painting that assimilates the vanishing lines of death and madness in desire, a painting that is open to a possible transcension of its material nature without becoming a fetish object for whatever compensation. Since then he has been seeking a (his own) subtle blend of abstract and social reality,[11] but without illusions, without allowing these two "worlds" to appear to be merging. Bleckner stages a semantic opening of abstraction as an irreducible paradox of what appears to be a dialogue. He stages an "interface."[12] If one translates this word literally (from English to German), one comes quite close to what he means. His paintings are *Zwischengesichter* (in-between faces), in-between space pictures, paintings of an open, in-between space between the self-assertion of painting as painting, as an "abstract" reality standing for itself and the vanishing lines of possible references that are deliberately provoked and admitted. The paintings are ultimately paintings that stand for and by themselves, paintings that do no follow through with the references they trigger. They do not sell illusions of something present, but they also fail to satisfy any expectations of what is represented. Bleckner exposes them to the risk that accompanies any deliberate drifting of references, but at the same time claims pictorial autonomy, a contrafactual autonomy in which he does not believe (yet). His paintings, however, could well assume this autonomy since he does not cling to it but rather abandons it by tracing the marginal paths and vanishing lines of desire and capturing them in painting.

In a text on Ross Bleckner, Peter Halley writes of "Bleckner's simultaneously ironic and transcendental content."[13] Here Halley is alluding to a specific quality of his painting, namely, the simultaneity of a spiritual opening and distancing as is exemplified in the stripe paintings. On the one hand, an art of disillusionment, of demystification of an abstract art on the wane (which is not meant ironically), and on the other, the painting of light that could perhaps be more than what it appears to be: an irreducible addition, which adheres to the body, imaginary, symbolic, and real (as painting). Yet given all romantic intensification of an intractable light, Bleckner's paintings are always anti-fetishist. They stick to the body, proceeding from it and returning to it. The light dots of the sky architectures are nipples. The irregular, nonfigurative circular surfaces in the painting *Clinical Trial* are body cells, cell tumors, x-rays, "images of illness" all in one.

Ross Bleckner. *Architecture of the Sky,* 1989. Oil on canvas. 106 × 92 inches.
© 1997 Mary Boone Gallery, New York.

Carefully taking into account the possibilities of painting, Bleckner allows unex-
pected impossibilities of a painting expressing the desire of the impossible to be
assimilated. The hard core of such painting is light, not light in represented form
but rather light that emanates to the extent that it exists. One stripe painting has
the title *Unknown Quantities of Light I.* From the dark background, behind stripes
oscillating between white, gray and yellow, white sources of light and small yellow
light dots emerge. An intangible, glistening light so intense that even the bars could
appear to be light rays, if the inevitable impression were not suppressed by curtains,

shades, window bars, fences, and other means of separation and delineation. I see the light in Ross Bleckner's paintings as visualizing a desirable impossibility of painting (after painting?), which I would like to first describe with the paradox notion of the presence of difference and accept as such. Take, for instance, Bleckner's light domes (he refers to them as "architecture of the sky" or as "Blue Dome"), geometric, abstract constructions of skies and domes consisting of precise constellations of light dots/nipples. Optical illusions of inside and outside space, microcosms and macrocosms, transcendence and body: a painting of the counterillumination of a preconceptual, abysmal void.

In the paintings of the late eighties and early nineties, darkness becomes foregrounded, along with thematic allusions to death and mortality. Light remains present but not pervasive, indeed, more like something added to indicate that the subject is not just death even if it dominates. Even if the paintings from this period seem to be painted from the end, from the nightside of life, from the sublimity of death and harbingers (e.g., AIDS) of life and desire of death. But precisely in these paintings that appear to come from the night of death, Ross Bleckner's light is the oppositional element of a painting of desire where certainty on failure has long existed as something normal. Something unexpected that can still take place in the normal darkness of the impossibility of painting, in view of death, mortality, failure, and futility. A counterlight of the "dark sponge" into what, as Gottfried Benn writes, everyone must once hold his or her face. Symptomatic of this are also the flower still lifes from the eighties, dedicated to the mainly homosexual victims of AIDS, of the not just physiological but also sociopolitical pseudofatality. Here Bleckner also accepts figurative symbolisms which he had strictly avoided up until then. In the painting *Mantle* he makes extreme use of symbolism. Here he literally designates what his light painting touches on by itself. An unsurpassable wall of night, a holy vessel (an eternal light?) from which an unfathomable light flows, out of which the head of an owl emerges looking straight at the viewer from a spiral-shaped tunnel on the other side of the wall. I do not wish unnecessarily to reproduce the symbolism of this painting in words in which an already existing pathos would inevitably become oppressive. I would like only to recall Hegel's unfulfilled claim that the owl of Minerva begins its flight at dusk and thereby point to an act of desire that is inherent in Ross Bleckner's painting: a way to counter the unbearable and intangible in the guise of a painting consisting of a contrafactual presence of light.

The most recent paintings made by Ross Bleckner since his retrospective at the Guggenheim Museum in New York dispense with symbolism (of mortality) and avoid the puzzling presence of darkness, scenes of death, images of illness, the nightside of light. Especially in the Middle Brother series, Bleckner resumes a nonabstract approach and takes up the nonfigurative structure of the stripe paintings and of the "architectures of the sky," pursuing this as a sort of dual reversal with regard to the two earlier groups of works. On the one hand, he replaces the (seemingly) abstract quality of the stripe paintings with almost figural motives, with flowers. These flowers are only almost motives. Their flower character is disrupted by what cannot be flowerlike in them, namely, their light source quality (they could also be seen as lumi-

nous jellyfish), and by their serial, almost geometric arrangement. On the other hand, the light dots/nipples of the sky architecture paintings are replaced by an almost "purely" optical abstraction, with a composition of color field dots that appear to be floating in front of the painting. With this intense reversal, Bleckner once again focuses on the point of indifference between abstract light and figurative geometry. The quasi geometrically centered vanishing lines of intangible light confront us with something detached, with something freed from the load of darkness. Could it be that Bleckner is playing out beauty against sublimity here? The Middle Brother paintings clearly present us with beauty, which means that they no longer provide a network of the unfathomable. They refrain from letting themselves be perceived as an oppositional gesture by those who wish them to be such. The stripe paintings are directed against the vapid pathos of a seemingly absolute sublime art. The nightside paintings opposed the seeming sublimity of mortality. Both groups of works documented as a pictorial optical illusion what their light and allusions opposed. The nonflower paintings avoid any opposition and thus run the risk of being "beautiful" with all its connotations (something that is decorative, ornamental, seemingly binding and affirmative, and seems to gloss over something). They no longer rely on conceptual, critical crutches. The negative thrust of against now yields to that of without.[14] Bleckner thus sets his stakes on the oppositional quality of an impossible, unassuming beauty. The danger of elaborateness inherent in such beauty is played out by Bleckner without glossing over the contradictory nature of a painting that enables this. Instead of a cynical, illustrative, and (allegedly) political correctness, and instead of a vapid, pretentious art, he allows the geometric constellation of what are almost motives to become light painting. This no longer involves something oppositional in pictorial references. It articulates more than a directed protest: more and ever more light. Light appears to be unfocused and to transcend all confines. Bleckner's light painting (a nonphallic encore?) is a tightrope walk on a nonsentimental thread of emotion. Following the narrowily winding path of beauty without anything to gloss over, could it be that this painting, when confronted with death and mortality, yields something that could be described as the desire to desire (*der Wunsch zu wünschen*)? And assuming this were true, would not such a light of oil and wax be nondeath? And assuming this, again, were true, would one still need the reference to what it opposes? Ross Bleckner's recent paintings pose this question but leave it unanswered. As self-contained as they are, their light extends outwardly, while also touching on what is questionable about its own possibility. Could it be that the paintings derive their beauty from mourning[15] beauty: is it a mourning of a negativity without negativity?

ANDREAS SCHULZE: THE FAMILY IDIOT

Strange biomorphical worm forms gather around a carpet and a Meissen china coffeepot for a picnic. Scattered peas and a few pieces of wood add to the scenery like a cozy coming together of things that, in this nebulous landscape, seem completely de-realized, even abstract. The objects seen here are not objects. Their reference, their relationship, to an object of perception in existence outside the picture is highly precarious. They have lost almost all correlation to reality. They have become form, that is, a formal, aesthetic link in a composition that moves to the threshold of "abstraction." And yet the abstract forms in this picture seem to be alive. Their inquisitive, interested attitude lends them a certain simple humanity and the lovable playfulness of abstract sea lions. In a word, content is turned into form, and constructive elements of form are charged with allusions to content. The result is an altogether curiously irreal scenery of shapes that invite the viewer into a comfy atmosphere which exudes an uncommon sense of space. The same mood prevails in the other pictures Andreas Schulze painted in 1985. For example, he formed an abstract duck's head out of different color fields onto which he placed fruit, vegetables, and quails, so that close-up the planes look like individual garden plots. In another painting he shoved two planes, painted in distorted perspective, into each other so that they look like disarranged pool tables bearing small colored stones, which give the impression of being gummy bears. It is always this fade-in and fade-out between de-realized reference with a disintegration of meaning toward the irreal and a recharge of the purified forms with a very positive, familiar, intimate, even touching atmosphere. Footstools and popular sweets like Bounty and Mars invite us to spend a comfortable TV evening in front of a picture screen in the style of the sixties, while looking out onto a serene blue sky where abstract birds are enjoying their sense of space.

However, this has nothing at all to do with any so-called neosurrealism. Surrealism at least believed it referred to the reality of the unconscious and of dream images, in other words, always understood itself to be the reference point for the real imaginary. Andreas Schulze no longer bothers to boast any meaning at all. With him, the objective neurosis called zeitgeist does not lead to the usual postmodern, simulative inflation of

Andreas Schulze. *Installation-view: wallpaper and lamp, Kunstverein Hamburg,* 1993. © 1997 Monika Sprüth Gallery, Cologne.

Andreas Schulze. *Untitled,* 1985. Acrylic on canvas. 200 × 400 cm.
© 1997 Monika Sprüth Gallery, Cologne.

all interchangeable, emptied contents. On the contrary, he reacts to a general popularity of the neo-isms by initially retracting the pictures to a minimal, simple, formal principle. Andreas Schulze brings the "brilliant surface of non-sense" (J. Baudrillard) into play against the interpretation stakes; he paints purified form that no longer feigns sense but simply is what it is: presence that is meaningless but full of sense(s).

But neither is he satisfied with the currently fashionable nostalgia for minimalism and geometrical abstraction. He is concerned with a positive, modern presence of painting that is necessarily misconstrued as the presumed emptiness of pseudopure construction. In a conversation about the emotions he would like to see embodied in his paintings, he mentioned "vehemently mild friendliness." This sounds both radically positive and intentionally naive. But naivety in this case is not the inability to reflect; it is an artistic concept. "The artist has to be dumber than the art market permits," Andreas Schulze once said to me after we had talked half the night away about the merchandising of art production in the institutionalized network of "gallery-museum-collector-critic," which is subject to so much aesthetic blindness, simple-mindedness, and stupidity that it constantly boggles the mind. Is this calculated stupidity a strategy of quality? It certainly is, but the pictures transcend this intentional recantation of the fashion in art of flaunted pseudointellect. They continue to amaze by the autonomy with which Schulze goes about disarranging the extroverted vapidity of German petit-bourgeois *Spitzweg*-Romanticism – simple, flat, gemütlich, touching, friendly, harmonious – in the imaginary rectangle of painted construction. The humor of this attitude is obvious and cannot be overlooked. But there is no irony involved. Schulze explicitly avoids this way of creating a distance to what is said/shown in a painting. The critical aspect of his humor goes deeper than irony, which always remains ambivalent. The level of humor offered by Andreas Schulze corresponds to Deleuze's insight: "There is no understanding, there are only different levels of humor."

Andreas Schulze's paintings are unique and willful. Profane poeticizing and minimal abstraction join forces on the surface of a painting style that is light and thin; "We never did it that way before," as Sigmar Polke put it. Schulze's is a specific blend of the irrealized, the meaningless, the gemütlich, and the minimal, a paradoxical formalism in that it explicitly sees itself in line with the tradition of German Romanticism and the romantic German. "The world must be romanticized," Novalis said in 1798. "It is the way to find primeval meaning again. Romanticizing is nothing but a qualitative raising to a higher power *[Potenzierung]*." This is precisely the approach Andreas Schulze takes in the way he copes with contemporary nihilism, for example, by confronting it with paintings whose vehement honesty and sincerity withstand the cynicism present in today's art and in the way it is seen. Schulze's paintings hurt cynicism's feelings.

A lovable, silly dog is sitting on an elegant minimal carpet à la Schulze while a long, mysterious path of romantic yearning fades into the distance without, however, any melodramatic exaggeration of the purified form of the picture. Schulze's smile is a condescending one toward the shallow bathos and stupid self-adulation of contemporary art. But although the surface impression of Schulze's pictures is very formal, decorative, and conceptually artificial, his works are also counterfactually authentic. Their distinctiveness is due not only to Schulze's romantic concept. Andreas Schulze is the aesthetic position that he paints. His art is based on his idiocy. But idiocy is not to be misconstrued. Not until the bourgeois acquisition of this word did it become a synonym for pathological deviation, for insanity that deserved exclusion and punishment as something divergent from the norm. In ancient Greece, *idiota* meant private person, the person as singularity, the individual. Elaborating on this meaning, Sartre understood the idiotic[1] to be the moment that alters the systems of determination (institutions, the structure of the signifier, etc.), which becomes effective only insofar as the "individual" tries to make something out of what he has been turned into by the systems. The "idiotic" thus refers to the individual forms of acquiring our social constitution. And in this sense, Andreas Schulze is indeed a great idiot in the postmodish uniformity of the art business. It is the idiotic that lends his poetic formalism its distinct and unique substance. And yet the quality of his pictures consists in sublimating himself, that is, his lifestyle, to form, to a minimalism of his own idiosyncrasy. In fact, many themes that he portrays in his pictures convey his lifestyle, the atmospheric identity he lives. But they enter the picture in the formal-aesthetic transgression of privacy, in an irrealization of content per se. Private fetishism becomes form. The picture stands for itself and is simultaneously a romanticized self-portrait of a fortunate kind.

Schulze's works are informed with "idiocy" and the familiar, with cozy lyricism and piquantly mannered formalism, abstract irreality and the picturesque being of nothingness – all of which are clothed in the semantic "aura" of a German-romantic yearning. This should suffice as a provisional commentary on paintings that say so much for themselves, especially if one does not want to raise the ante of interpretation to the brilliant surface of non-sense. This is, after all, what these pictures have just succeeded in leaving behind. What remains is the family idiot in the shape of a romantic, ironic silence whose richness may some day culminate in the amiable intensity of paintings that lead the way to overcoming nihilism. We shall see.

Andreas Schulze. *Untitled*, 1983. Acrylic on canvas. 200 × 450 cm.
© 1997 Monika Sprüth Gallery, Cologne.

GÜNTHER FÖRG AND PHILIP TAAFFE: WE ARE NOT AFRAID

The sound engineer and the director of photography tried to obstruct my way of seeing. They wanted this mystery to continue because for them the film is a mystery with rituals, which it has finally stopped being for me. I am no longer afraid.

Jean-Luc Godard

My work serves the exclusive purpose of inventing new ornaments.

Georg Baselitz

Günther Förg and Philip Taaffe embody two opposing positions within contemporary abstraction. I use "opposing" intentionally because they tend to repel more than to attract each other. Any apparent common ground between the two artists merely underscores their differences, especially as to how they arrive at their conclusions. Here there is no question of citing common ground (from whatever strained discursive angles) in order to continue writing about cheerful German-American amity à la Koons and Kippenberger. Instead, I would like to present a kind of parallelogram on the sequel to abstract painting as seen from two diametrically opposed poles.

Günther Förg/Philip Taaffe. Günther Förg: Wallpainting; Philip Taaffe: *Stewardess*, 1990–1991. Mixed media, 435 × 80 cm. Installation Galerie Max Hetzler, Cologne, March 1991. Photo: Wilhelm Schürmann. © 1997 Galerie Max Hetzler, Berlin.

One of the reasons for this impossible comparison is that both artists approach art by concentrating on surface and form[1] and – from the standpoint of the *reason* of form – will not acknowledge anything that does not speak through the constellation of line, plane, color, proportion, layering, material, and spatial conception. No matter how contrary and mutually exclusive their attitudes may be, both Philip Taaffe and Günther Förg are at work on a continuation of abstract painting through non-painterly means (photography, installation, printing techniques, the introduction of cinematic ways of seeing). But neither do they eschew reflected and calculated spontaneity, that is, painterly means (doodled drawings, flat paint application, diagram and nonstyle). This continuation of abstract painting by painterly and nonpainterly means is work on the conditions of the possibility for real abstraction in difference to the abstract realities.

I

Förg redirects the art of painting by varnishing picture surfaces like a house-painter, by composing rooms like a workman, by taking photographs à la Titian and *painting* photographs à la Godard.[2] His work is both abstract and concrete (in situ). Working directly on the conditions within a concrete spatial situation is, for Förg, not simply a concept but a perceived necessity. He makes art only for concrete situations. "Making a virtue of necessity" – necessity consists of having no reasons and virtue of the need to create some – is Förg's method of forcing himself to develop a perspective (in situ).[3] Förg creates a sense of space by *writing* a perspectivist installation as a *gesamt* picture: "There is no emptiness and there is no fullness; there is only the possibility of filling the emptiness. Here, right now, at the window, by means of soundings and transformation."[4] The motif is generated from the process of production. The practice of the three-dimensional picture is its own theory. Consequently, Förg does not show systems but systems being generated. A Förg installation is an *in-between space,* comparable to the temporal space produced by a stopover at an airport. It thrives on dual focal directions and potentiated inside-outside *Vexierbilder,* staged so that the viewer is "in the film." Förg opens a sense of space to us and invites us to take a walk in it, from his artist's eye-view.

In the individual pieces (bronze reliefs, lead paintings, drawings), the procedure is reversed. Here he eliminates the imaginary rectangle and with his inimitable, matter-of-course lack of illusion, throws open the *widowed* (Duchamp) black window so that out of the surface shadows (reflections of Förg's line) "the light from the other side"[5] may or may not be perceived. Förg subjects perception to the tension between transcendence and immanence.[6] This tension is disengaged and clicked back into position with stubborn insistence until something is seen, or not. That, however, is the viewer's problem, whose visual acuity is incorporated into Förg's scenarios.

Günther Förg. *Melnikovs Atelier,* 1995. Photography, 150 × 100 cm.
© 1997 Günther Förg.

The look you give is the look you get in return. The viewer consumes him/herself vis-à-vis a Förg work. In this way Förg caters to the art-mind market, but lets the consumer go hungry in foreplay, a characteristic he foments professionally from work to work. Förg's works first offer themselves as analogues to everything that might and can be seen in them, but then they leave the viewer on his own in a sea of interpretations. What the viewer sees is the reflex of his or her level of perception and "library."[7] The act of seeing itself becomes the theme of the viewing process in the midst of an atmospherically elegant space, letting its flip side, the staging of prostitution, rise to the surface. Förg knows that along with a work of art, the artist's body is on sale and that the deal is nothing short of a hypermodern contract of prostitution. The market is the true scenario. Godard once said, "If I can ever say I have 400 million dollars (for a film), the story will follow on its own."[8] This is exactly Förg's perspectivism.

Whether, however, the body that painting writes can rise above just being the deal into which it has been drawn, I find even more questionable in Förg's case than Roland Barthes does in Cy Twombly's.[9] Förg raises the question everywhere he lays his hand. This can be seen in the deceptiveness of the body traces in his works. To the same extent to which he introduces a gesture, he redeems it from the lie that these traces could be authentic: *Förg's line crosses out the gesture* and thus sets out to walk the path of disharmonious harmony.

Förg runs the body like a machine. (He could even let others *take his place*, because the making itself is more important than the question of who made it.) He does not produce variations on or appropriations of that which was, at the heights of abstraction, celebrated as the sublimated forms of absolute emotion or utopian longing, but rather surrogates of these apotheoses of emotional analogues (of the sublime and/or the beauty of nature or artifice). By placing his body in the service of surrogate production, he creates a distance to the aesthetic reception that his works provoke. At the same time, he creates a distance to this distancing through the *bonus* provided by the deliberately displaced line into which he inscribes the knowledge of the gesture's abysmal questionability – a gesture foolhardily considered inimitable according to the motto "the clumsier, the more authentic." Förg succeeds because the death of the artist and of the subject has been and still is the premise and substance of his forms. It is the almost unsustainable acceptance of this death *in the line* by which he gains this (poetic) toughness inscribed in his forms. This emotional toughness in the midst of decorative *ersatz* purity (which resonates in his work as a "realistic" twinge of modernism's fading illusions) constitutes *Förg's bonus:* a throw-of-the-dice event – the Greeks called it *tyche* – that disrupts Förg's professionally treated, cheerfully cynical, art-effect immanence from the inside.

Förg's photographs *illuminate* the artist's ego at the moment of his abdication,[10] later ratified in the bronze reliefs and stelae. Through his formalization

of this ratification, he has recently introduced a not impure quality into the surrogate that then meets up with beauty, because it does not obscure the fundamental indifference that is the lot of all art effects. This is beautifully exemplified in the line of his large-format drawings and etchings, a line that does not play Twombly, that would not fall on its knees morning and night before Fautrier, that meanders past Marden and along Baselitz to arrive at the *nonsurrogate.*

Like Godard, Förg has no more use for art as enigma and ritual. He is no longer afraid. In fact, fearlessness is an expressive effect of his work, which in turn touches the viewer at a point where she or he would so love to be rid of fear. Those who fear naturally have a pre-ference (pre-lust) for fearlessness. And that is addictive – which explains why his collectors always want more and what we already have is never enough because (as art) it never turns out to be what we thought it promised. Art is the promise of happiness that is broken. Förg pushes this aspect of art today to its extreme, by turning consumer aesthetics against itself.

II

The same goes for Philip Taaffe, but in a quite different way. Taaffe works to continue abstract painting by (non)technical means in that he covers the art-historical primer with a layer of real, existing abstractions, thereby giving abstraction a semantic opening.

The primer in Taaffe's picture *We Are Not Afraid* consists, for instance, of a printed (re)construction of Barnett Newman's *Who's Afraid of Red, Yellow and Blue?* In a second step, Taaffe shifts the meaning of this construction of art history by substituting a braid for Newman's zip (the sign of pure presence). He spans a pictorial bridge all the way to Matisse's *Back IV,* that is, to a form of abstraction that does not relinquish the integrity of things even within abstraction. He thus liberates abstraction from the absolutism of pure form and from the norm of an aseptic skeleton of total nonreferentiality to which it has been degraded in the wake of standardization and academicism. Taaffe no longer fears contact with abstraction's history, nor does he have any problem with its taboos. But, unlike misconstrued appropriation, he does not think of history as a quarry out of which nostalgic arbitrariness can be mined, but, on the contrary, as a mission, namely, that of its construction as pictorial presence (of mind) on the way to a continuation of abstract painting.

Taaffe introduces the signifier ("the perceived thing, augmented by a certain thought")[11] to nonfiguration. Having freed it from the mysteries and rituals of its institutionalization, he takes real, existing abstraction, as it prevails in so-called life (architecture, ornament, semiotic realities) and integrates it into the picture,

thereby opening it up to evocations of real, existing emotions (love, sex, hate, intensities, and tensions of all kinds). Unlike Förg, who introduces a painterly view – substantially enlarged by his "Godard" experience – upon photography, Taaffe reverses the procedure and imposes the photographic as a layer of meaning upon the painting: "I want to apply a kind of barrage of photographic information to a painterly artifact."[12] He stages a multilayered scenario on the surface: modified reconstructions of the achievements of abstract painting, ornamental sequences of architectural signifiers, symbols (e.g., of bodily orifices), and cultural signs from diverse historical and geographical sources are all processed into a specific complexity. Taaffe shrouds this in a net of semantic layers, all of which are simultaneously present in the picture and engender a n≠onhermeticism that invites a reconstruction of the social implications of ornamentation. An overload of references fosters an experience of optical swindle that corresponds to semantic swindle. Taaffe approaches history from a pictorial distance that he pictorially stages, that is, from the future possibility implied by the interaction between pictorial and semantic layers. He approaches history from the future of its potential continuation.

The beauty of a Taaffe picture is that it does not ooze fake synthesis. The unity of the irreconcilable that it presents to the eye is none, although it does represent an unmistakable perceptual unit, but it also consists of superimposed layers of referential systems whose real disunion it does not obscure. Contradictory information remains dissociated. These contradictions are not simply aestheticized. Each layer can be seen in isolation and the import of the real acknowledged. Each individual text remains legible in the Taaffian intertext. On the other hand, Taaffe is not afraid to play out artistic perfection and extrovert beauty against the contradictions. It is, in fact, here that he sees a chance for the revival of the utopian function of art.

Taaffe romanticizes artificiality, for instance, by effecting a mutual confrontation of the most varied facial textures (as in calculatedly spontaneous configurations of lines, i.e., in a nondiagram, on linocut collages), whereby romanticizing is to be understood as a "qualitative potentiation"[13] of all the good old alienations. Taaffe thus draws on a (political) strategy of early German Romanticism. The objective of such potentiation is to produce pictures with anticipatory power: "The painting should say that there's another possible world. . . . It's a utopian position that I have, but I am actually trying to lay the groundwork for some kind of paradisiacal situation on earth. I think about what's going on in the world, and whether my painting can conceivably have any impact on the situation."[14]

Günther Förg. Installation Alsdorfer Straße, Cologne, 1990.
Maske (detail), 1990. Bronze. Photo: Wilfried Dickhoff.

By overdetermining his formalized layers of meaning in the consistent inconsistency of beauty, Taaffe reactivates Ernst Bloch's *"Ästhetik des Vor-Scheins,"*[15] which emphasizes the anticipatory quality of Schein (the artistic aspect of illusion, appearance, seemingness, radiance) as an essential factor whose questionability is articulated in individual pictorial elements – another paradox that once again serves the cause of beauty.

III

The longer and deeper (i.e., on the surface) one looks at (and listens to) Taaffe and Förg, the more obvious it becomes that all the popular clichés about America (surface, hard-core sales policy, formalism, pure presence, pragmatism) and about Germany (spiritual depth, content, mass of history, lost future, myth) won't stick. Comparison of the two artists' attitudes subverts the simple-minded fixation on American and German cultural identities and (art) mentalities. Taaffe and Förg build unhoped for abstract bridges across the ocean (and back again). In contrast to Taaffe, who maintains a deliberately anachronistic position in that he insists on the (counterfactually) utopian in painting, Förg insists on the facticity of the art product as such and responds with a plain and simple "no" to the question, "Do you want to have an effect outside the market?"[16]

Obviously, the roles cannot be reversed so neatly, even though Taaffe lived in Naples for a long time and Förg has been very successful in the United States. A Taaffe picture can be highly hermetic and formalistically sealed off; it may seem to make a fetish of complexity, just as much as a Förg installation may present a school of (alienated) perception. Once we examine just *how* Förg and Taaffe implement this mixture of surface and depth in their works that confuses cultural identities, then opposition and their respective origins are foregrounded again. It begins with their way of thinking, becomes blatantly obvious in their treatment of facial structures, and is far from conclusive in the import of sex in their work.

What is pleasing in both cases is, to repeat, their fearlessness. Taaffe has no qualms about placing the highly decorative elegance of his linocut collages, at times applied on the canvas like haute couture dress patterns (in the tradition of Paul Klee and Matisse's paper cut-outs), within the context of an *Ästhetik des Vor-Scheins*. And Förg, on the other hand, has no qualms about catering to the art service sector with his highly sensitive meditations on "visibility" (the state to which so many of his interpreters blithely reduce him). Thus, he gives the market what it deserves (has earned) – the naked, nothing-but-art product. From two opposite poles, which are not even complementary, Förg and Taaffe, by means of nondecorative decor, simultaneously serve and counter the fact that there is no possibility of being outside the prostitution contract. The awareness of this and

other paradoxes is inscribed into the lines and the compositions in Taaffe's and Förg's abstractions of difference.

At issue here is the coherent deformation in the nonsurrogate as a figuration of potential painting. Everything else deals with the questionability of an aesthetic theory of justice, situated somewhere between presence (a *Vernunftidee* à la Kant?) and cognition as art. But that's another story.

"Close your eyes! – Idiot! – You haven't read a thing!"
A. R. Penck

PHILIP TAAFFE: THE OTHER (AND THE) ORNAMENT

The first time I came upon Philip Taaffe's work was in the fall of 1984. I instantly felt that here a step never before seen in abstract painting was now being taken, without ignoring abstraction's endpoint (left behind after its peaks). Here was someone who started out at the sore point of abstract painting and the doubtfulness as to its purity by mimetically taking over representative examples of its history and transforming them from the inside out. Superficially, the changes made by Taaffe were minor, almost imperceptible. Many people – a good number of them highly vocal art critics – fell into the trap of believing that what they were seeing was only the Postmodern appropriation of works ranging from Barnett Newman to Bridget Riley. Actually, a second and somewhat closer look should have made it clear that something very different was operative.

During the early 1980s many painters chose the path of an "intensity program" and/or focused on a paradoxical "word to picture" literalness that threw all knowledge of modern painting overboard. Unlike them, Philip Taaffe started out from a reflective skepticism about the "eternal return of the new," on the one hand, and about the products from the painting of unrestrained or conceptually realized immediacy, on the other. Added to this came his experience of the way abstraction had been appropriated and tamed. Abstraction was now normal, powerless to irritate anyone at all, hardly even able to provoke tabloids into ridicule with cartoons and well adapted to a life of wall decoration in private homes. Even the Suprematist embodiment of pure (spiritual) emotion had long since been recognized and effectively exploited by ad men. Furthermore, during the process of its institutionalization by the academies, abstraction had become standardized to a germ-free skeleton of utter nonreferentiality and (seemingly) absolute autonomy. By this time, abstraction was no longer effective as a sign of freedom but, more and more, as an art-historical saga of a war of liberation from content, meaning, figuration, and realism.

Philip Taaffe. *Stewardess* (detail), 1990–1991. Mixed media on linen. 171 × 31 inches. © 1997 Max Hetzler Gallery, Berlin.

A serious challenge to a devitalized abstraction has to begin with the forms of its appropriation and utilization, as well as with those contexts that constitute its current social meaning. This is exactly what Taaffe did; on his way to the "semantic opening" of geometric forms, he worked at deconstructing the sublime. This required a painterly approach having little to do with methods that used to stand, in themselves, for a freedom that no longer exists as such. What was at issue was the possibility of "painterly distance." Taaffe's pictures are not "painted" in the conventional sense of the word. They are built up from linoleum cuts formed from his (ornament)drawings, printed with his serigraphs of "freehand" scribble drawings and/or "freehand" diagrams, and then collaged onto canvas, often in multiple layers. The result is a continuation of abstract painting by other means: technical, nonpainterly (housepainter-type application, diagrammatic quotations), painterly effects via print technology. The reflective distance (e.g., to the insincerity of blind expressivity or to the falsehood of so-called free abstraction) is turned into facial structure and – as materialized knowledge of the impossibility of "pure abstraction" – becomes an inherent component of painting itself. From the beginning, the quality of Taaffe's re-constructive paintings lay in the fact that abstraction's semantic opening was worked out from their surface.

The painterly distance realized within the medium of abstract painting orients the eye to the shift in the direction of possible meaning in abstraction and of abstraction. Thus, Taaffe was able to stage the deconstruction of the sublime and the rediscovery of abstract painting as a pictorial, parallel process, in order to act out a degrading of the sublime by reintroducing (social and existential) meaning to the realm of abstraction.

But in Taaffe's paintings, the sublime is latent in a deconstructive form. Deconstruction is here always de-construction – not only through the fact that there is a construction of (an)other surface but also a construction of possible meaning on this surface. Thus, for example, his (re)constructions of Bridget Riley's paintings (her originals were seen in the 1960s as an optical expansion of liberated perception) demonstrate, among other things, how constructive irony can be when it, first, is used as a strategy for a visual presence that confronts the memory of artistic inventions of forms with the possibilities of altered meanings that they (do not [yet]) have and could (not [yet]) have and when, second, irony is, in its formal reality, an inversion of an only pretended reproduction of historical abstraction. The painting *Brest* is not what it historically seems to mean but what the memory of Op Art could mean to us today in the course of a semantic opening towards abstraction. And it is not nostalgic mimesis. The mimetic element of *Brest* is a conceptual bluff in the form of a linocut collage. Thus, what appears obvious is that the social and art-specific situational context of a picture is what constitutes its meaning. This is only one example of the fact that, for Taaffe, history is not a quarry that can be arbitrarily mined for its nostalgic content but, on the contrary, a mission, one to construct history as pictorial present(minded)ness.

In the 1985 painting *We Are Not Afraid* (a reply to Barnett Newman's *Who's Afraid of Red, Yellow and Blue?*), Taaffe twists the meaning of his (re)construction of art history by replacing Newman's "zip" with a plaited braid, in other words, the sign of pure presence through a profane meaning and its associations (long hair, a back, a rope). He thereby builds a pictorial bridge back to a form of abstraction that never

gave up the integrity of things even when highly abstract: a return to Matisse's bronze relief *Back IV,* in which a reduced line of braid that, at the height of the vagina, passes into the gap made by two sculptural female legs but yet manages to depict both an abstraction and a nude back. Henri Matisse's painting, like few others in the first half of our century, embodies this standpoint, one whose traditional aspect now proves to be more future oriented than many examples of avant-garde compulsiveness. This also holds true for the way in which Matisse, in his cut-outs, transmutes plant and body forms into ornamental abstractions without giving up the link to human figuration. Here Matisse touched on the inversion of abstract devices, which Taaffe has taken up in *We Are Not Afraid.* However, Taaffe now applies it not to a representation of "reality" but to avoidance of the human "reality" in the historical key works of autonomous abstraction. With the title of the painting *We Are Not Afraid,* Taaffe announces almost programmatically the line his future work will take: fearlessness toward the social, political, cultural, sexual, and religious constraints of *Red-Blue-Yellow,* that is, the abstraction that a painting cannot not help being.

The following excerpt from a letter provides a small insight into Taaffe's pictures and the work behind their concept and perception.

The term "responsibility of form" kept flashing in and out of focus in my mind yesterday as I continue to attempt to define my position towards several issues – something of which we touched upon in our conversation the other day. I was struggling with the semantic variants of this expression "responsibility of form" and trying to make sense of them. On the one hand, in English, this expression takes on an autonomous, self-enclosed meaning, such as: "form determines the responsibilities inherent in it," or, "form engenders responsibility," also, "form is, a priori, a form of responsibility." Then, moving away from this more self-evident, somewhat solipsistic reading of this expression in the direction of broader, more inclusive implications, I would say that perhaps it can be stated in the following way: there is no such thing as responsible or irresponsible form (as raw material), one must bring a certain sense of responsibility, artistic responsibility, to bear upon the use of form for purposes of synthetic ordering. And it is in the nature of this artistic responsibility both to follow the dictates of a chosen form closely, to the deepest and furthest extent, and to meaningfully short-circuit those dictates. At this point we arrive at an expression like: the form that one is eventually artistically responsible for is that form which one has inevitably and irreversibly altered the autonomy of. It is that which has deliberately and with the deepest concern for its immediate and potential significance been introduced into a new scheme of things. Hence, there has been effected an intervalent process of a necessary denial and reaffirmation of form in order to locate or identify both what this form can be responsible for as well as what one's responsibilities are towards it. It is in light of this discussion that I chose to send to you a short collection of "music hall promotional icons" of culturally diverse origin. I feel they may represent one stage of this inspired attraction testimonial that I have just spoken about. When and how do we start to feel the responsibility of form in these instances? Remote experiences brought into alignment, blissful chords put in evidence and sent along. Where do we go from there? Setting aside responsibility for a moment just to see how things are, in assimilation.[1]

Philip Taaffe. *Arcade,* 1991. Mixed media on linen. 76 × 186 inches.
© 1997 Max Hetzler Gallery, Berlin.

What is so great about Taaffe's letter is that it is informed by artistic responsibility, which is the theme he writes about. Above all, the concluding observation once again concretizes Taaffe's criteria for selecting the forms that are meant to produce the semantic opening of abstract painting in the work: his awareness of assimilations of abstraction, as well as of the emotional values and meanings these forms of assimilation take in specific social situations. The "music hall promotional icons" (mostly from North Africa) that he sent me as a 3-meter-long fax are a good example. They demonstrate how something like ornamentation, borne by a sociocultural hope for identity, works as a signifying element of (illusory) self-representation.

In Taaffe's work, the real, existent abstractions (as they dominate so-called life in the guise of architecture, ornament, sign systems, etc.) and their meanings and social realities are subsumed in the picture. His work thus opens itself to an evocation of real, existing emotions like love, hate, sex, and intensities and tensions of all kinds. Like layers, Taaffe places them over the (art)historical priming. In this way, the pictorial surface is covered with multiple strata that formalize subtly devised double codes. The mise-en-scène becomes an intertextuality in which "pure" embellishment and quite concrete meanings interlock. Taaffe constructs complex and self-contradictory pictorial units that are only seemingly hermetic; they actually invite a reconstruction of social, cultural, art-historical, and other implications of ornamentation. The following five paintings demonstrate this quite impressively:

In *Arcade* (1991), we see alternating rows of decoration that look like the pattern in an oriental carpet. The tier of motifs grows smaller as they rise in height, so that they seem to be standing one behind the other, separated by rows of ornamentation like the decorative tops of fences and balustrades. But there are no fences. The whole picture exists insecurely in slightly blurred color planes. The color of the second row from the top reminds me of the artificial greenish-yellow video light over Baghdad in the TV coverage of the Gulf War. Viewed as such, the arabesques suddenly appear to be rockets and launching bases or chess figures that in sharply demarcated "black-white painting" face each other with animosity. Like figures in a shooting gallery waiting to be shot down, the ornaments, symbols, and signs of war and of the Orient confront the viewer. *Arcade* makes apparent a cultural divide and a communication gap between Christianity and Islam, a culture that has been stamped imperialistically by "our civilization." At the same time, this painting as a nonconceptual *[nicht-begrifflich]* communication of nonidentity calls for conditions that make understanding possible.

Conflagration (1991) is a picture of conflict, of a tussle between opposing energies, form and color dynamics, and contrary surface structures; this especially applies to the conflict between the smoldering pictorial movement in the back and the clear, orderly rhombic pattern in the foreground. *Conflagration* embodies what a painting with present(minded)ness does today: it presents contradictions. It is a good example of the way Taaffe deals with conflicting semantic layers. Although his theater is a union of incompatibles, he never cosmetically glosses over the real division between reference systems whose overlappings make up the painting. The con-

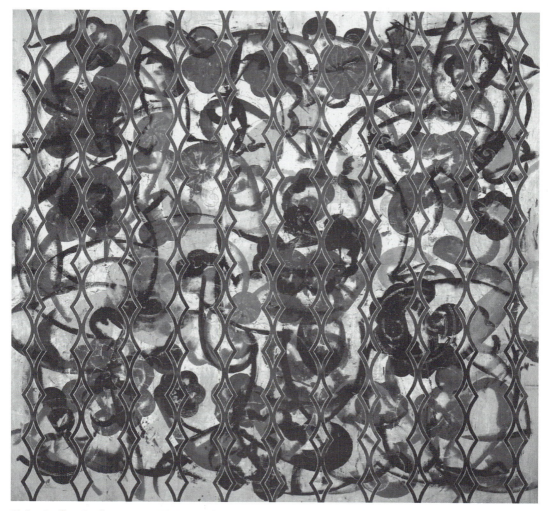

Philip Taaffe. *Conflagration*, 1991. Mixed media on canvas. 114 × 117 inches.
© 1997 Max Hetzler Gallery, Berlin.

tradictory bits of information remain unconnected. We can peer behind the scenes of complexity, see every semantic layer in isolation, and take note of the import of the real. Every individual text remains legible within Taaffe's intertext: the contradictions are not harmonized but artistically brought into play.

Celeste (1991), a meditation on the link between abstract painting and music, harks back to the 1920s and Paul Klee's investigations into this interrelationship. Taaffe's immediate point of departure is a playful orchestration of color tonalities painted by Myron Stout in 1950, a picture in obvious relationship to Klee's carpet-of-sound painting. Compared with the colors in the prototype, Taaffe's pigments are not so bright and optimistic. After applying them, he sanded them down, rubbing them into the canvas so that they appear reserved and pastel-like. *Celeste* is a pictorial meditation on the (im)possibility of "polyphone abstraction" and on its link to human reality, as a painting today, speaking from its form, could articulate it. This touches on the disputable and unresolved Klee question as to how the single individual could appear in all his structural complexity in the form of painting. *Celeste* articulates the openness (not only) of this question . . .

Reliquary (1990–91) is a kind of repository of signs and symbols, an archive of ornaments that Taaffe has already used in various other paintings, for example, *Stewardess* and *Arcade*. Shrouded in an atmosphere of Neopolitan fresco aesthetics, we see – side by side and of equal value – the relics of mutually alien cultures and eras, apparent in their availability for subtle intertextuality. In the end, the issue is the invention of a new ornamentation as sedimented history – neither more nor less . . .

The basic form in *Stewardess* (1990) is based on the trademark of a Bulgarian cigarette, which had already been manufactured at the time of coexistence between the super powers. The logo is an emphatically modernist-futurist, wing-like symbol of flight, travel, and freedom, one linked to our associations with a stewardess – particularly for people forbidden to leave their countries. Taaffe uses the symbol to construct a slender, upwardly striving abstract figure that is ready for takeoff (phallicized stewardess, rocket), and his ground consists of motifs that represented freedom in art during the 1950s: the paint-soaked "wipe sheets" (as Taaffe calls them) brushed across the canvas in the style of Abstract Expressionism. The Western artistic illusion meets the Eastern freedom illusion. *Stewardess* is comparable to an artfully designed memorial panel, on which aborted illusions of freedom are transformed into ornamentation. This and the phallic, vertical format are reminiscent of the architecture of old minarets in Iran, whose multilayered, ornamental decoration and inscriptions did have the original role of remembrance. Thus, an architectural motif of Islamic origin functions as a scaffold for the visual multiplicity of East–West cultural experience as it is manifest in ornaments of consumer-aesthetic and/or artistic abstraction . . .

This brings us to the specific quality of Philip Taaffe's "abstract" paintings. The complexity of reference systems, whose ornamental traces can be followed in his pictures, would be far less powerful, and certainly not of any interest, if they were not played out on the level of abstraction itself. The work would not succeed as it

does if the paintings lacked an autonomous abstract status that, as a constitutive condition, makes subject matter possible in the first place. Only because the meditations on abstractions that exist in reality (e.g., the cigarette named stewardess) are themselves unique abstract formulations, do they become subject matter. Therein lies the essential tension in Taaffe's continuation of abstract painting. He accelerates the tension by overloading the references and, above all, by driving the decorative to extremes. His paintings repeatedly surprise the viewer with their lavish elegance, detailed perfection, sophisticated composition, and refined color gradation. By means of his surface perfection, extrovert visual splendor, and luxurious ornamentation he copes with the genuine contradictions of "being (t)here" (Martin Heidegger) that he has made his theme. In a second step Taaffe simultaneously romanticizes his deconstruction of the sublime,[2] whereby romantization is understood as a "qualitative potentiation."[3] This potentiation is served by the exaggeration of the luxurious, the multiple layering of print technology-mediated painting styles and ornaments (in symbolic and decorative function), the multiple shift in what geometries mean in the history of abstract paintings, the high-strung formalistic semantic layers, and the perfect staging of elegant cut-outs, recycled fresco kitsch, an aesthetic of haute couture fabrics, a nostalgia for arabesques and wrought-iron Baroque, and much more.

In his pictures, Philip Taaffe is at work on a complex strategy of beauty and quality in which the following interlock very specifically: the pictorial analysis of socially mediated abstraction (in art, architecture, religion, decoration, ethnology, cultural history, and advertising), the gauging of the jurisdictions of abstraction within the framework of abstract painting itself, the possibilities of shifting these areas of jurisdiction, and an extravagantly intensified decorative elegance. The result of Taaffe's ornamentations is a paradoxical beauty that constantly draws nearer to what still is significant in art: "a possible model of freedom."[4]

In a conversation about such subjects as the problem of presence, Philip Taaffe once told me that his paintings want something they themselves are not, something that is not in them, and that they bear an inherent yearning for self-transcendence, for overstepping boundaries, or perhaps even a demand for change.

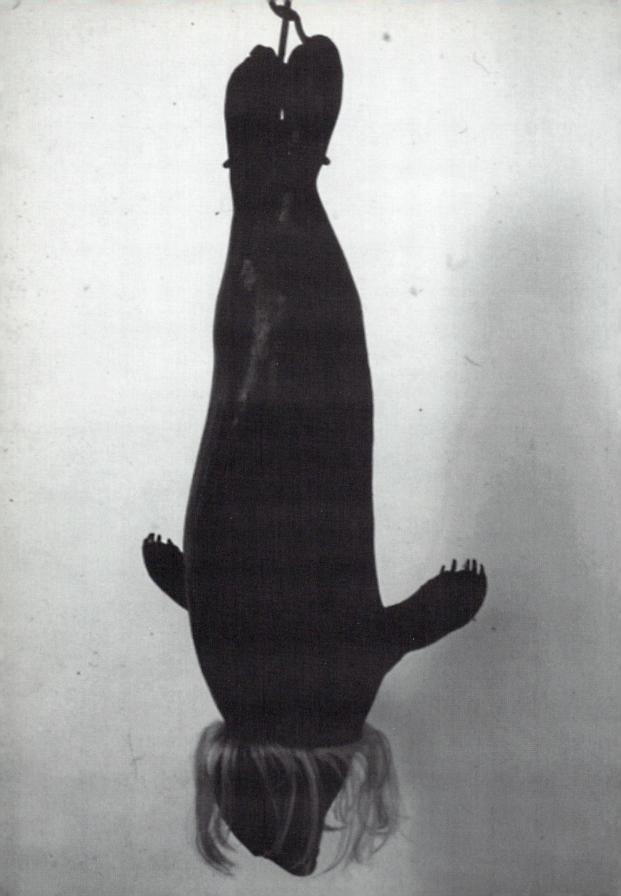

ROSEMARIE TROCKEL'S IRREDUCIBLE DIFFERENCE

When in the second half of the seventies Rosemarie Trockel began to work as an artist (in a context in which certain activities were considered as making art), art had once again reached one of its endpoints. A reason that was important for Trockel's decision to become an artist was the fact that the (political) utopias and hopes of the sixties with which art was associated were now being called into question, and it had also become apparent that many of the artistic activities tied in with these utopias and hopes had actually become reproductions of what they were directed against. Making art in this situation meant attempting to continue politics by other, artistic means. It meant working out new forms of altering affirmative identities and different means of artistic subversion. It meant for her also finding new paths of feminism while simultaneously avoiding feminism's "ism." This called for integrity, sincerity, and presence, qualities of resistance that seem to have been lost in what Sloterdijk called at the time cynical reason.

Rosemarie Trockel belongs to a generation of artists for whom it is self-evident that everything having to do with art is no longer self-evident. The questionable nature of one's own doings and a distance, not without humor, toward the imagined artistic identity/ies is inscribed into her work. But this is not all: a knowledge of the conditions under which art is possible today, of its dependence on context, and of the history of its means and ways always comes into play here. Her work, however, amounts to more than the conceptual formalization of thought about art-after-art.

Rosemarie Trockel started out on this path by placing the means of modernity, one that had left its own art-historical trail, in the service of personal and social contents. These contents – and they apply mainly to the social imaginary of woman and its feminist reflection – are visible in her works sublimated to form. In other words, not as illustrations of a theme but as a form of thought speaking from beauty, that is, as art. And art is rare.

This is why viewers – especially inexperienced ones – find themselves from their

Rosemarie Trockel. *Untitled* ("No one under the sun is more miserable than the man who has a fetish for a lady's shoe and must make do with the whole woman," Karl Krauss), 1991. Bronze, synthetic hair, 140 × 56 × cm.
© 1997 Monika Sprüth Gallery, Cologne.

first look at Rosemarie Trockel's *Strickbilder* (knitted pictures) confounded by a seemingly autonomous picture. Its hermeticism opens up only to the degree to which the viewer feels provoked into further eye contact with the picture, a contact that will in turn foster an opening of the viewer's perception to its critical aspect. When all this clicks, a possibility is accorded for the *Strickbild* to return the gaze of viewers and change their insight as to what is being viewed. I am talking here about the presence of a feminist gesture. But such a moment of presence is as rare as art itself.

At the center of the *Strickbilder* is the subtle inscription with social- and existential-political contents. A good example is the knitted picture in which she uses a stain – that small source of irritation we daily observe on our clothes – as a motif for a pattern that only appears to be abstract. In Trockel's knitted picture, the stain – a metaphor for soiling and impurity, something women for centuries have been, and still are, responsible for removing – becomes a computer-reproduced, abstract-figurative pattern on fabric. Rosemarie Trockel thus introduces into the domain of male art something that previously had no place in the discourse on art, especially – but not exclusively – as regards women, using the medium of a "feminine activity" traditionally assigned to the role of woman: knitting. What has been marginalized here appears in a (knitted) robe of pure abstraction, in other words, a kind of art that stands for the absolutism of pure form and the absence of the social imaginary. This introduction of the social in the knit dress is, at the same time, a de-construction of the various signs of the social that she chooses as her contents. Thus, for example, in her *Strickbilder* she (re)produces and (de)constructs selected examples of abstract painting (Toroni, Malevich), philosophical terms (such as *cogito ergo sum*), the Playboy bunny, and the wool sign as a diptych, mathematical equations, political logos such as the hammer and sickle, and so on.

Rosemarie Trockel is one of those female artists who have no problem with the contradictions that are bound up with any consistent, semantic opening of art. She has a certain reserve toward inflated art-society utopias. The fact that art confronts social and existential themes is for her – as noted – a matter of course. But she is fully aware in her work that art moves within the framework of the history of its self-referentiality (abstraction), self-reflection (Duchamp), and secular self-transcendence (Warhol, Beuys). All of which, however, does not hinder her from simply giving her works a soul without making them into a gospel. She once gave a sculpture – of a simple cardboard carton on which the outline of a face is seen, drawn by means of a white line and a (fake) necklace of pearls – the title *Die Seele ist ein dummer Hund (The Soul Is a Dumb Dog)*.

Rosemarie Trockel's art only seems hermetic. If one takes a closer look and thinks it over more carefully, the hermetic aspects are rendered obvious as a very specific compression of several layers of meaning that do not form a superficial unit but remain visible as parallel qualities. Above all, her sculptures, objects and drawings are characterized by an unmelodramatic playing out of irreconcilable contradictions at a formal level that combines complexity and lightness, seriousness and humor. She instead creates a higher ambiguity.

This is beautifully accomplished in her artistic treatment of animals, which appear as the incarnation of everything in human nature, whose effects we humans can do nothing about but for which we are nonetheless responsible (see the draw-

ing of the horned ape or the sculpture series Gewohnheitstier (Creature of Habit) – as metaphors for the object-character of living things, or concretely as helpless victims of the human practice of controlling life. In many of her works she addresses the theme of the animality of human *being (t)here* (Heidegger's *Dasein*), thereby insisting on an original equality of all minorities (women, children, animals, plants, and molecules). *Jedes Tier ist eine Künstlerin (Every animal is a female artist).*[1]

Another example of higher ambiguity is the double image *[Vexierbild] Woman-Vase*, which is often found as a form for form/content and interior/exterior in Rosemarie Trockel's drawings and sculptures of the early eighties. Not least of all the reflections on and the shifts in so-called sexual identities and in the meaning of sexuality are evidence of an intertextuality specific to her work. This involves levels of meaning that are mutually drawn to one another and/or disconcert each other: the interplay of presence and absence, simulation, appearance, illusion, deceit, and the wish projection inherent in women's social image and in the high pretensions to intellectual purity claimed by (male) art systems.

Starting from a general loss of a sincere voice in art and life, Rosemarie Trockel is at work on an art of setting signs, in which the all-too-human meets the political and poetic side of art in a way never seen in quite this way before. Her compressed symbols, as complex as they are simple, activate in equal parts a sculptural, intuitive, analytical, and moral way of thinking. Her object-constellations – which not infrequently reproduce figurations of possible paintings in a sculptural way – are part of the tradition that understands art as a possible model for freedom[2] but with the knowledge that perhaps art can no longer be such a model today.

In other words, Rosemarie Trockel's art – like that of many other serious artists of her generation – assumes that beauty is not an exception to what reigns as reality but the basis for (an)other order of freedom.[3] Playing out this paradox is central to her work, an art longing for more than what it is.

It is impossible to define Rosemarie Trockel's attitude or to reduce her concept of art to a generalization. Central to her work is a deconstruction, subversion, shift of any kind of fixed identity. It is a manifestation of difference, for example, in her constant, intuitive differentiation (even of her own artwork). For this reason, I would like to talk about her work in the particular. There follow four examples of her work from 1982 to 1996.

An object can arouse the greatest amount of attention not by being put on display but by a staging of its absence. This strategy is particularly well known among side-show entertainers, designers of underwear, and artists in order to create magical, sexual, and aesthetic magnetism. One famous example of this is the traditional magic trick of the woman without an abdomen. The particular fascination of this is based not only on a general interest in bodily abnormalities but also on an appeal to sexual fantasy. The absence of the woman's "central organ" has always been the greatest attraction for "centralized perspective" in art and life. Moreover, an empty space beneath the upper part of the body supplies an excellent *analogon* (an imagined ersatz object on which desire is projected) for all kinds of imaginative mud fights among the repressed near waterfalls. The success of the trick is built upon the social establishment of woman as a mystery and, in addition, relies on the fetishist gaze that moves forward to the same degree that the object of its desire withdraws. At this point we are confronted with the problem of psychoanalysis: "Psychoanalysis is the disease that it pretends to heal" (Karl Kraus).

With her sculpture *Ohne Titel (Falschspieler) (Untitled Cheaters)*, Rosemarie Trockel reverses the set-up of the woman without an abdomen. What we see in the magic trick, namely, the torso, we do not see here. The lower part of the body, however, which is invisible in the trick, is shown. It is as if, on a dissecting table, we were presented with that part of the body which is made to disappear in the trick by means of great acrobatic skill: you see a tightly compressed buttocks and even gooseflesh. The wax figure gives the impression of a dead body in a morgue that, because of its material, appears at the same time to be a body of light – a sign of illumination of that which lies in darkness: the realism of disenchantment in the form of half a woman made of wax.

At the seam line of the imaginary dismemberment of the woman's body, the basic operation on her object-character and the lecherousness that goes with it become apparent. *The layout of the sectioned woman, installed as an enigma by her beholders,* has never ceased to be a popular social event. The stretchered half of the wax figure confronts any fantasies about a woman's sexual triangle with its direct, nonerotic presence. Here the sculpture disappoints and disillusions whoever ventures this far. Instead of the projection space below the torso, the viewer is presented with a black rectangle painted on the floor. Thus, woman's image is synchronized to that of art: Malevich's absolute form of pure (spiritual) emotion overlaid with an *analogon* of vaginal fantasies. The discreet disclosure of both: of the seeming purity of form in art and of the sexualization of every vacuum by the social imagination.

This analogy between the foul magic trick inherent in our perception of women and the deception practiced in art is the theme around which this sculpture revolves. It is achieved by a constellation of negations: not only by the negation

Rosemarie Trockel. *Untitled (Cheaters)*, 1988. Wax, wood, glass, silkscreen. 160 × 90 × 180 cm. © 1997 Monika Sprüth Gallery, Cologne.

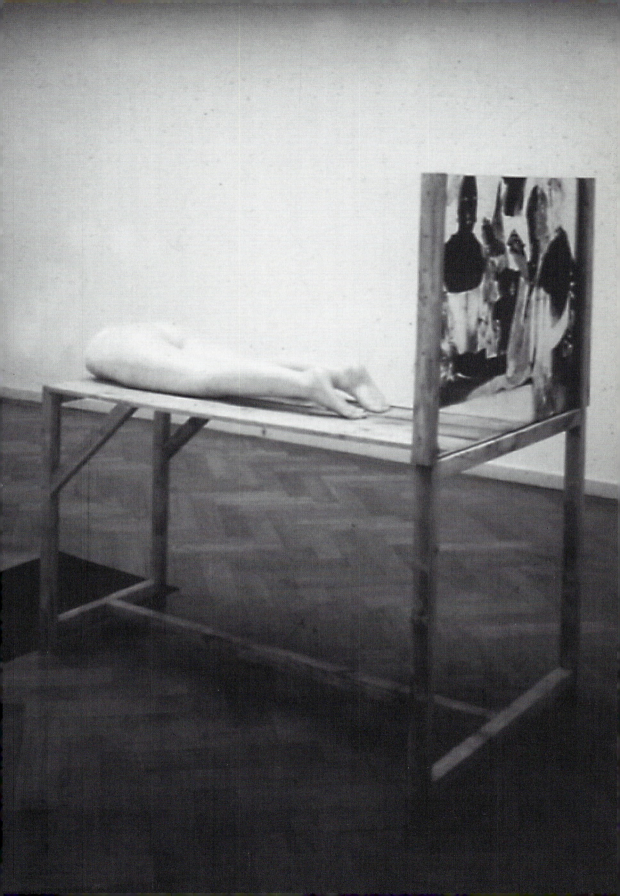

of the absence of the abdomen but also by a negative print of the painting *Cheat* by Georges de la Tour, which appears in place of the upper body. The *small glass* acts as a quasi-mathematical reproduction of the black rectangle on the floor. Here it mirrors the double exposure of woman's image and art's illusion in the photomechanical negation of a painting that is strongly normative. This is a subtle allusion to the fact that the appearance of truth in art can be achieved only through illusion, through deception. This, in turn, is a reference to a picture, the content of which, among other things, is the story from the New Testament of the prodigal son – who is seduced and deceived by a whore, the incarnation of gaming, wine, and women. This leads us back to the main point: the disharmonious unity between the deception in art and the reductionist image of woman.

The beauty of this sculpture is based on the fact that this synchronization of content through negative allusion is in turn deconstructed by the dispassionate loneliness of its components. Thus, the leeway the spectator thinks to have for a whole semantic field of interpretations is closed off. Beauty generally comes into play when disenchantment occurs through the medium of enchantment. From this perspective, *Ohne Titel (Falschspieler)*, as a sculpture and as a reversed trick show, functions as an allegory for the interaction between truth and lies in the (lost) speech of art. Art is not what is seen but occurs in the gaps, as Duchamp once said. Thus, art is the visualization of that which is absent and is as a consequence a structural accomplice of the woman without an abdomen. Also, as a serious work on the possibly visible behind the visible, it has its share in the deception, which it disappoints.

So why all this fuss about the reversal of the visible and the invisible in art? It is in order to see what remains of humanism when false appearances have been removed. This is certainly possible today only when art itself reflects on these false appearances and, above all, surmounts them through formal means. Otherwise, it will disappear as the artificial art of an abstract, sham society.

Art today cannot but help play out two things through the medium of form: the loss of true speech and its work on indecipherable signs "in order to make ever endangered truth light up fleetingly, a truth that everyone erects for everyone else according to his/her suffering and joy" (Albert Camus).

One example of this has been discussed here.

56 PINSELSTRICHE, 1990

> It is a question of eliminating the distance (the censorship) institutionally separating image and text. Something is about to emerge, something which will invalidate literature as much as painting (and their metalanguage correlations, criticism and aesthetics) and will substitute for these old cultural gods a generalized "ergography," the text as work, the work as text.
>
> Roland Barthes[4]

The *56 Pinselstriche* (*56 Brush Strokes*) are the products of a painting machine designed by Rosemarie Trockel expressly for their production. It functions as follows: seven rows of eight brushes each are attached to shafts outfitted with steel rollers, which are drawn along a track approximately 2 meters long by a spool driven by an electric motor. The brushes are manufactured by Da Vinci, a paintbrush factory in Nuremberg (Dürer's hometown), with the hair of real living artists. Of intentional characterological import, they are engraved with the names of the artists. For example, A. R. Penck's brush consists of a short and thick handle with a tangle of gray beard hair, held in the tin ferrule of the brush handle; Sophie Calle's brush is slim and elegant, the dark curl cut from her head held in place by a gold ferrule. Sigmar Polke, however, did not supply his real hair but several threads of real gold. All the eight different brushes in one row are first dipped in china ink by the machine and then drawn over Japanese paper, so that they leave behind eight different brush strokes running in multiply broken lines parallel to one another. The painting machine produced seven times seven sheets of eight different brushstrokes, representing altogether fifty-six artists. The finished product was *56 Pinselstriche*, 1990 (Japanese paper mounted on canvas, china ink, seven sheets, 140 × 70 cm each, edition of 1–7).

At the end of this production run, Rosemarie Trockel destroyed the mechanism of the painting machine in an ironic gesture that deconstructed to the second power the aura of originality. Along with the edition of *56 Pinselstriche*, a castrated machine remained behind: a(n) (abstract) sculpture exhibited in 1990 together with the copy number 1/1 of the edition as a self-contained work at the Michael Werner Gallery in Cologne.

This work unmistakably questions the constitutive process of what is taken today to be painting and revolves around the production of aesthetic experience in the institutional context and the structures of perception. Where does the boundary between authenticity and bluff lie, between charlatanism and the pictorial reflection of painting? What is the difference between painting monkeys, *Malerschwein* (painter swine) and a painting machine? How is visibility produced and staged in such a way that, via the eye, a magical experience is imagined? These are a few of the questions posed by the form that *56 Pinselstriche* takes. Its misleading similarity to the tradition of serious minimalist abstraction that had turned to the achievements of calligraphy as a means of maximizing graphic energy is also unmistakable. It practically invites you to

follow the byways (Heidegger's *Holzwege*) of a philosophy of visibility established by the line and a personal brush style. And from there it is not far at all to the folly inherent in the sort of art history that so fondly indulges in art-immanent comparisons. Barnett Newman, Brice Marden, Cy Twombly, Per Kirkeby, Philip Taaffe, and Günter Förg could be brought in here as examples of artists who have been (mis)treated in this way. I propose here to avoid any mystifying interpretations and, as a first step in this direction, would like to reflect on the preconditions of interpretation, which is in the end a construction of so-called meaning that reproduces its own paradigm. The work *56 Pinselstriche* suggests (and actually takes) a quite different path for painting. It will not have escaped the notice of anyone familiar with Trockel's work that deconstruction by means of intertextual composition is an important part of her art. Provoked by the multiple layers of discursive allusions, viewers can quickly feel themselves sent out on a discourse, which at the very first corner (of looking) turns out to be a narrative dead-end. The interpenetration of the conceptual levels and the multiplication of associative possibilities processed in this work do not make up its quality. They are part of a work process whose text it leaves behind. Its reconstruction might indeed be amusing and might provide viewers with a few interpretive crutches to move about with on the level of perception suited to them (that is, in the way the work functions on the viewer's perceptive level). But the (form) plateau of *56 Pinselstriche* does not begin to appear until the viewer sees it as reflection on painting sublimated to form, out of which the complexity of the allusions emerges like layers of glazes in painting.

The *56 Pinselstriche* is a calculatedly coincidental product. But are the criteria by which Rosemarie Trockel selects the single sheets for her edition not analogue to the criteria used in painting, whose enigmas and clichés have been negated by the mechanical production of her painting machine? By using brushes made from the hair of real artists, that is, by employing body parts cut off from real painters, Trockel, as the stand-in for the *Frau im Anschnitt* (the design of woman), the woman installed by her beholders as an enigma, gives back to painting what Duchamp had left to painting's bachelors, namely, the masturbation machine. "The bachelor grinds his chocolate himself," as Marcel Duchamp said. Rosemarie Trockel does not need to appear in the guise of an angel of castration and to cling to painting as a female ersatz identity. Trockel lets the painting machine grind its own brushes and thereby screws painting in a way we had not until now been privileged to see in just this way.

But that is not all. The *56 Pinselstriche* bear an unmistakable similarity to animal trails, that is, to the body traces of other creatures. They therefore illustrate not only the problems of painting but also that which the problems of painting illustrate, namely, the enigma of the body.[5] Roland Barthes was still certain – despite the fact that, along with his work, the body of the artist is also bought – that the irreducibility of the body always rises above the exchange in which the artist is implicated qua his or her contract of prostitution and that this singularity is manifest in the line, whose intelligence depends on whether the painter has succeeded in making it subversively awkward.[6] Trockel has her machine (seemingly) produce an awkward stroke and supplies a deconstruction of the so-called authentic line via the concept of the *56 Pinselstriche* and via her choice of its material manifestation.

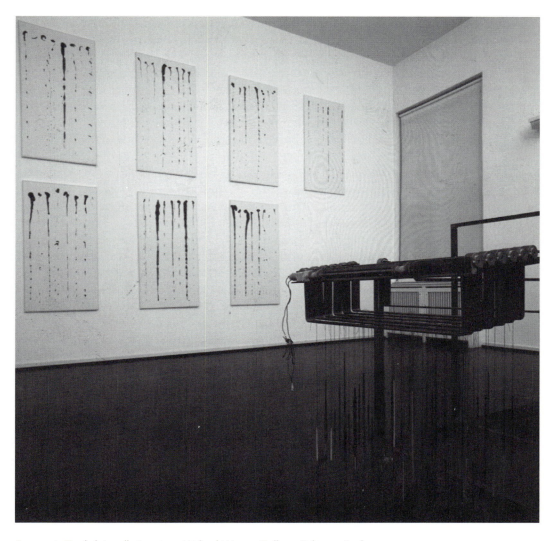

Rosemarie Trockel. Installation view, Michael Werner Gallery, Cologne. Background: *56 Pinselstriche*, 1990. Japanese paper and china ink on canvas. 140 × 70 cm each. Ed. 1–7. Foreground: untitled (painting machine), 1990. © 1997 Monika Sprüth Gallery, Cologne.

Thus, the enigma of the body in the perception of painting, to the degree that painting is a prostitute, remains the problem of its customer. In this way Trockel addresses the production of the subversive intelligence in the line (e.g., the brush stroke) within the visibility of the *56 Pinselstriche* by provoking a circular gaze between the perception of beauty and the thoughts on the conditions of its genesis. Could the *56 Pinselstriche* be precisely what it says? And if that is the case, then it calls painting in question and simultaneously calls this questioning into question.

Could we say that its ironic simulation of painting's authenticity, the conceptual humor of its disappointment, becomes a prefiguration of painting's (im)possibility?

In the painting effect of the *56 Pinselstriche* both aspects ultimately appear as one, thus abdicating the position that modernism imagined painting to be and posing the coquettish question: Am I not proof of painting's possibility after all? In this way Trockel brings two texts together: the text of the painting-surrogate, for example, the illustration of the reflection on painting's contextuality, and the text of beauty (of the surrogate itself) as the pictorial questioning of how painting's intensities (by which beauty materializes) are constituted. The transition that Marcel Duchamp accomplished in "Le passage de la vierge à la mariée" – the transition from Duchamp's "olfactory masturbation" to the "gray cells" – is here reversed.[7] The *56 Pinselstriche* feigns an "olfactory masturbation" (painting as work, manipulation, gesture, presence, thing), whose existence is thanks to the "gray cells" (concept). It no longer belongs to the established language of the conceptual (painting as discourse, thought, philosophical imagination, language). But neither does it serve sensuous consumption and/or purely aesthetic pleasure: a swing back and forth between two inter-texts. Is painting a speaking out or a making? Or could it be the enigma of an intertext that integrates speaking and making?

Derived from Duchamp, clarified by Warhol, the *56 Pinselstriche* leaves this question that points to Baselitz open. It is a sounding board of their creative conditions for formal magic and is yet more than merely a surrogate in the service of illustrating the social conditions that make possible the production and reproduction of painting effects (as in Sigmar Polke's painting "*Das war schon immer so [It Was Always Like This]*, 1982). And this *more* appears in *56 Pinselstriche* as the prefiguration of possible painting.

"Das haben wir noch nie so gemacht" [We Never Did It Like That Before].[8]

ICH HABE ANGST, 1993

The sentence *Ich habe Angst* (I am afraid – or, literally – I have angst) stands like a triptych in the altar room of Saint Peter's church in Cologne.[9] Rosemarie Trockel had it painted in this room by a calligrapher in capital letters (in Bodoni font) so that the three words create a sentence, as well as stand on their own: the *Ich* (the problem of identity and the related bourgeois illusion of the Ego), the verb *haben* (to have, in the capitalist imperative), and *Angst*. Of course, the word "angst" in the altar room immediately evokes existential, social, financial, ecological, political, economic, and spiritual anxieties, to name but a few. However, the sober object-character of the three words does not really allow it to take effect. The words turn back upon themselves: what is "I," what is "have," what is "angst"? And, above all, what does this mean in this particular place? And how does it, as art, relate to this place?

Angst is, in Jacques Lacan's sense, an affect that announces the subject's panic reaction when the object of desire gets too close.[10] In Rosemarie Trockel's installation in Saint Peter's, you repeatedly encounter the forms of presence and absence of these *object-causes of desire*. In particular, the small works that can be seen in the second-floor church gallery touch on such over closeness. For example, *Die Seele ist ein dummer Hund (The Soul Is a Dumb Dog)*: a cheap pearl necklace affixed to a cardboard carton, which constantly takes on different facial features. "Alone at night I read my Bible more and Euclid less": another cardboard carton on which a schematic drawing of numbered brain functions can be seen. *Ich kenne mich nicht aus (I Don't Know Anything About That)*: an unsuccessful proof of the existence of God springs out of a jack-in-the-box instead of the devil. *Das Intus legere durch die Sondergotik (Intus legere* [insight] by means of the Gothic) consists of photocopies of the wise and foolish virgins, a finger raised in moral indignation and a small box with a hole for the finger. *Geld stört nie (Money Never Hurts)*: a head as a piggybank/offertory box is adorned with small Band-Aids on which the names of psychophysical diseases are affixed. Finally, a series of six photogravures that show biblical motifs of seduction, rounded off with a pistol.

Rosemarie Trockel sets up a semantic field of unspecific allusions that, although they "make no sense," open up various possible meanings ("In the end to intimate, not only to know" [R.T.]). She avoids one-dimensionality and empowers a higher ambiguity in the name of difference. She composes a constellation of subverted references to racism outside and inside the Church, to the limits of (pseudo-) scientific knowledge, to the illusion *[Schein]* and mendacity of metaphysical glorifications of all kinds, but also references to what is not talked about in the institution "church": the preconditions on which discourse in the Church is based and the marginalized, whose voice in the Church cannot be heard, or only in exceptional cases, even if it is "talked up" in many sermons.

Rosemarie Trockel's installation in Saint Peter's is a deconstructive work. She shifts the preconditions, for example, by having a crucifix cast a second time, in other words, doubled, negating its meaning through its reproduction. The identical crucifixes are turned into a pattern on a beautiful old church wall.

Rosemarie Trockel provides a model for a different "reading" of the Church that brings to light what has been intentionally excluded. For example, the voice of ancient wishes and defeats, which still lack cultural blessing and political legitimacy.[11] This voice articulates, forms, and deflects the angst that arises when the empty self experiences itself as the emptiness, and the emptied Ego is merely the angst that gets stuck in the throat.

Rosemarie Trockel's deconstructions take the form of unobtrusive displacements that never try to blind us to the fact that the issue at hand is art, which plays out the limits of responsibility (of form) in order to posit itself as art.

It is the small encores and the staged gaps that help art stand on its own in the Church, not as a counter setting but as a parallel setting. Marcel Duchamp called this affirmative humor: "Money never hurts."

Rosemarie Trockel. Installation view, Kunst-Station St. Peter, Cologne, 1993. Photo: Wilfried Dickhoff.

. . . there seems to be a fine ship at anchor. Fear is the anchor, convention is the chain, ghosts stalk the decks, the sails are filled with Pride and the ship does not move. But there are moments for all of us in which the anchor is weighed. Moments in which we learn what it feels like to move freely, not held back by pride and fear. Moments that can be recalled with all their fine flavor. The recall of these moments can be stimulated by freeing experiences including the viewing of works of art. Artists try to maintain an atmosphere of freedom in order to represent the perfection of those moments.

Agnes Martin

L'arrhe de la peinture est du genre feminin.

Marcel Duchamp

Je crois à la jouissance de la femme en qu'elle est en plus, à condition que cet en plus, vous y mettiez un écran avant que je l'aie bien expliqué.

Jacques Lacan

What can be seen is a white square with two elegantly displaced black circular surfaces. But this is not a case of a geometric abstract picture. The white square is made of stove-enameled sheet steel, normally used to make cooking stoves, and the two black circles are hot plates. Instead of a geometric abstract picture, something quite different has taken its place. But it is neither an everyday object skewed to something artistic nor a picture overdistorted into a useful article. What you can see is neither an abstract picture nor a hearth as nonart in/as art(context). It represents nothing, but neither does it present nothing. It is all the same a picture, a hearth picture that refers to everything possible, which can be seen as geometric abstraction and understood as stove and hearth, but, at the same time, retracts this. The references *[Bezüge]* of the hearth picture are deconstructive. The self-retraction of the hearth picture is de-constructive. Both references/retraction simultaneously flow in different directions, their vectors analogue to each other. The language of the hearth picture is an analogical one; its basic components do not work as codes but as modulators of possible ways of seeing and of possible chains of signifiers. Two strands seem to dominate here: on the one hand, an imaginable chain of signifiers for the supposed "feminine," seemingly specific to the gender, which is (still) the object of identity assignment. For instance, the stove as a place for cooking where woman is at her home and hearth, the stove as the center of the family that is accredited and assigned to woman as home-body. On the other hand, in view of the hearth picture,

an imaginable picture chain of geometrical abstraction (modernism) and, as a consequence, painting's pretensions to purity as part and parcel of the masculine sublime. The hearth picture pretends to the presence of a purely optical image configuration and disappoints this pretense by profaning the material in such a way as to inscribe a potential social meaning onto pure painting, for example, assigning it female identity. Old-hat, masculine, metaphysical painting blended into a reduction of woman to the family hearth, the hearth picture places these two insupportables into one impossible relationship with another, an only seeming complementarity, an oscillation between two chains of signifiers that mutually irritate each other. In this way the hearth picture distracts from its immanent coherence and destabilizes the logic of its significance. The features *(Züge)* of the hearth picture, their relationships *(Bezüge),* removal *(Entzüge),* advantages *(Vorzüge),* retractions *(Abzüge)* run below the structure of the signifier. Thus, neither of the two strands nor their relationship to each other are readable as the meaning of the hearth picture. The relations that originate in pictorial fact take their subverted course and return to their origin, not, however, to a self-referentiality of the pictorial fact but to openness, for instance, to an openness toward other relationships. For example, to the following reading of *Ohne Titel (Junggesellen-Platten) (Untitled [Bachelor Hotplates])*: the two hot plates in this hearth picture are different in size; their size relationship corresponds to the electric hot plates called "bachelor plates," that minimal cooker of the single man on which he boils his coffee water and fries his egg. Bachelor plates as an image of the man as self-supporter, an image of the self-reference of the male without woman (center stage at the home stove), without woman as the center of his homestead. Bachelor plates, however, also as a picture of the self-referential image, whose supposed absolute form is perhaps not at all genderless but only the double image *[Vexierbild]* of the painter as a self-satisfier/self-performer, who imagines the absence of woman from the picture's lack of contents and references and onanistically brings it down to the hollow hole-form of metaphysical presence.

This way of reading is, of course, as suitable as it is far fetched, but it could easily be taken even further, for instance, in regard to Marcel Duchamp's *Large Glass (La mariée mise à nu par ses célibataires, même),* a work also creatively twisted and analogically and mentally continued in other Rosemarie Trockel works. Above all, the blend of woman and art in relationship to the bachelor (who grinds his chocolate himself) and the viewer (the viewpoint of the bachelor machine) in the *Large Glass* would, for this text, play right into my hands: a bachelor machine that vis-à-vis the hearth picture takes on lesbian features.

On Rosemarie Trockel's stove no coherent porridge of interpretation can be cooked up that would not need to be taken off the stove again, unless you (man) preferred to leave it to burn. The focal points of the bachelor plates, the nonidentical breasts and/or targets (as you like it), are red. The hearth picture is for laughs, to laugh off whatever ~~woman~~ represents. It first provokes a poly-logue of possible meanings and then retracts them. That's the source of its humor. And this process of retraction is, as noted, de-constructive. It is what in the hearth picture does not refer to anything, what constructively negates the critical deconstruction of the

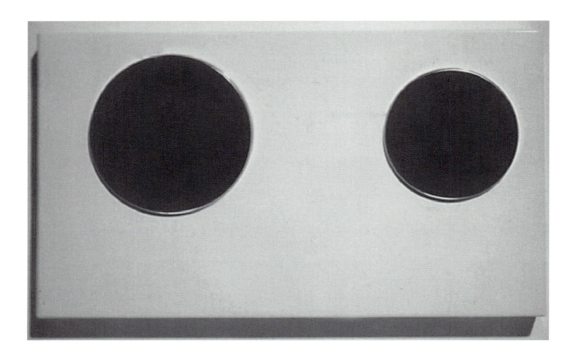

*Rosemarie Trockel. Untitled (Junggesellenplatten), 1991. 2 Hotplates. Ed. of 7.
60 × 35 × 50 cm each. © 1997 Monika Sprüth Gallery, Cologne.*

chains of signifiers: the analogical openness of the pictorial fact. Marcel Duchamp called this "affirmative humor," an ironic, poetic affirmation. A bonus *(même)* of the hearth picture is the elegant displacement of its optical composition, taking up and further spinning out the traces of other nongeometrical abstract painting as found in the paintings of Sophie Täuber-Arp, Agnes Martin, and Bridget Riley.

A parasite of itself,[13] of its nonpainterly quality, it appears as an awareness of what painting could have become, namely, a liberation of the body (from its cultural boundaries) within the flesh of painting. The hearth picture is more than a visual stage setting of disappointing the seemingly essential woman–man identities in art and family. As a replacement of painting, an Other *bloc* of sensation steps in, a nonpainterly visual association between "percepts and affects" (G. Deleuze) that, released from perceptions and affections (and those who have them), stands for itself. The hearth picture stands for itself, not as a picture identical with itself but as a platform for altering the images that it evokes. Confronted with the hearth picture, the images that govern our view of gender opposition stop making sense. From the hearth picture, an identity-destabilizing energy flows whose vectors function up to and including the non-identical, that is, anticipating nonidentity as a double-image *[Vexierbild]* of deconstruction. The hearth picture is an analogical conceit *[Denk-Bild]* that deflects and transposes its image-character to difference.

Its indifference vis-à-vis the identity assignment of the genders, its being-in-difference *[In-Differenz-Sein]* in relationship to the binary opposition of "woman" and "man" and to the logo-centric terminological oppositions that make a picture an art-picture, all this is the hearth picture's feminist gesture. Provided that the "masculine" designates the dualist position of opposition and the "feminine" its de-construction, this makes the opposition transparent as to what it abases and devaluates. The hearth picture is, insofar as it is in-difference, a moment of nonidentity. The nonidentical is (hopefully) not identical to the "feminine" *(qu'est ce-que c'est?)*, for if this were so, the "feminine" would not be nonidentical and could not represent the hope to which "it" more and more gives rise to. Where it lets the Other (in relation to all the representations of the "feminine") take place and be cooked up as a double image of a demand for freedom, the hearth picture is an occasion for hope that has, quite openly, more to do with *"la jouissance de ~~La~~femme"* (J. Lacan) insofar as this is *more* than one (man) wants to (make us) believe.

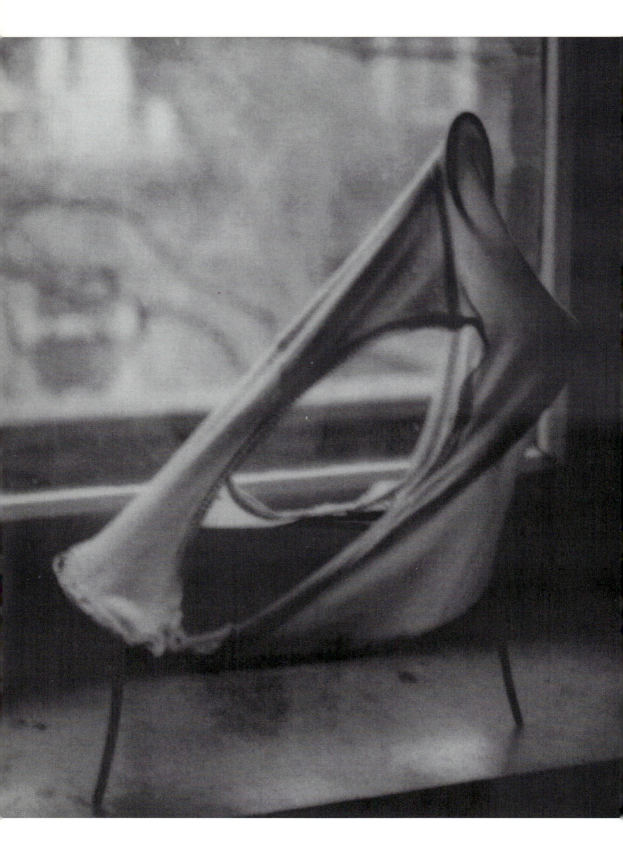

GEORG HEROLD: OVEREXPOSING AND
COUNTER-ILLUMINATING THE THEATER OF MEANING

> Wherever an unordered heap of trash can be found,
> there mankind is. The geological epochs have also left
> behind their trash and allow us to recognize an order.
>
> Jacques Lacan

> Man is the Being for whom questions come into the
> world that concern him but that he cannot solve.
>
> Jean-Paul Sartre

I

Georg Herold's works target viewers directly in that they make the question of meaning expressly a matter for themselves. They confront the viewer not with a pretense of unequivocalities and of univocal illusions but show up supposed unequivocalities and obvious illusions for what they are. For instance, by not semantically blurring and aesthetically befogging them but plainly and simply confronting them one with another. Herold does not synthesize. The single elements of his works remain individually readable and transparent as to their respective (social) context. He links them (as they "are," e.g., dumb and dim) in pseudoscientific test systemizations by means of which their inner perspective and the relativity of their meanings are made openly visible. The recourse to inert perspectives on seemingly objective sense-constructions of all kinds is at the center of the obviousness of Georg Herold's works. Here, obviously, things, pictures, and words are set into a relation in such a way that they allow their definitive boundaries, their syntactical identities,

Georg Herold. *Kleiner Bernhardiner, aus der Serie Deutschsprachige Gipfel* (German-Speaking Mountains), 1985. Iron wire, underwear. 30 × 30 × 30 cm. © 1997 Georg Herold.

and their semantic "contents" to be recognized as habits, silent agreements, inter-est- and perspective-guided meaning constructs, and ideological contracts that are based on a pretension to power, a "longing for meaning," and self-righteousness. The one-dimensionalities, limitations, impudence, and blind spots of absolutist per-spectives are trotted out before our eyes, assuming it is seen by the beholder who not seldom is stamped by the very perspective presented here. Herold liberates one's gaze, for instance, as to self-righteousness of every stripe or as to the claims to power that he digs up where someone claims "goodness" for himself:

The real nature of the good, its profound double character lies in the fact that it is not plain and simple a natural goodness, the answer to a need, but the potential power to satisfy power. That is why every human relationship is organized around the realities of the goods via the relationship to power, which is the power of the other (the imag-inary other) to rob him of power.[1]

Lacan even goes a step further and sees the angst of being robbed of power, which plays a major role in the need for goodness, as being based on – as he calls it – "the refinement of the human wound": the "envy of life."[2] This consists in the subject's

Georg Herold. *Nebenlatte,* 1984. Wood, pencil. 130 cm.
© 1997 Georg Herold.

always being oriented toward the Other as one who lives in equilibrium, in any case happier than himself, someone who asks no questions and knows how to remain at peace. From this delusion the subject constructs a (moral) transcendence: "Here's the good. Please don't touch."[3] In the subject's delusion of a transcendence, Lacan reads the text of our experience as such.

In Herold's works you can read a demonstration of goodness-pretensions and a reduction of these to the envy of life, insofar as the works are exposed to the laughter that comes about when this attitude of "Here's the good, please don't touch" is questioned about its envy of life and is caught with its pants down, namely, in *flagrante* with the language of its identity assurances. This is the theme of Herold's series of objects Deutschsprachige Gipfel (German-speaking Summits/Peaks/Climaxes), which are, in fact, made out of actual underpants hung over wire frames. With terms like deconstruction and subversion of referential systems, the offer that is made here is only inadequately addressed. Herold is at work on a Nietzschean gay science of pictures that makes an offer available to viewers to laugh off their self-identities. This present text understands itself as an essay to take up this offer to laugh off its own hypothetical construction of meaning.

II

On his object *Nebenlatte [Side/Minor Lath]* from 1984 is written: *"Gemeinsam sind wir Arschlöcher"* [Together we are assholes]. As clear as this sounds, the meaning is open and – as always with Herold – the thing (the semantic content) is the beholder's problem. It is, as noted, one of Herold's favorite occupations to make seemingly objective meanings trans(ap)parent down to their fundamentals and to pass this contingency on to the viewer. And even when you "look at" the written text in isolation – and, as noted, Herold always composes his works so that their single elements are readable as such – the text remains part of the image-object/object-image. Like each "building block" in Herold's works, this text/picture announces *pictorial difference,* that is, it counteracts the tendency toward aesthetic obfuscation and the syntactical blur by pointing to the difference between text, image, and object within the blended forms of text, image, and object. Herold provides his works with self-reflection in such a way that they always raise the question of their own conditions of possibility. If we – taking into account the pictorial difference – read the text "on its own," we would probably be able to agree that its meaning alternates between two poles. On the one hand, one could assume that the statement that what we (who is "we"?) have in common is the fact that we are all assholes. Our common ground consists, therefore, in our being assholes. On the other hand, one could read (into) the statement the fact that our asshole-being consists of a constant assumption of mutualities, by means of which one imagines a "we" that makes us into assholes. The "we" would therefore be the being (t)here (Heidegger's *Dasein*) that relates (wo)mankind as assholes to the world. If you subtract the Heidegger *sprachspiel* (which I have for the moment refrained from doing since it seems suitable to addressing Herold's humor), what remains as an imaginable minimal consensus is that the *Nebenlatte* points to the question of differences that only lead to wars because "we" are not capable of coping with differences in any other way than narrowing them down to "we" identities to serve our own angst-filled need for an identity assurance. Further, "we" absolutize them to objective truths that define themselves (truths and people) by means of deliberately excluding the other(s) and by specifying them biasedly as dumb, reactionary, mad, abnormal, or declaring them enemies who threaten "our" own "truth" and "identity." From this, "we" deduce "the right" to exclude the other(s) from the "we" in the name of defending "our" own identity, the final consequence of which leads to wars and systems of elimination of every kind (such as discursive, political, physical, and virtual practices).

Certainly this interpretation of the *Nebenlatte* is slightly overworked. "And interpretation here means also the availability of different parameters through manipulation" (G. H.). But the more works by Georg Herold I see (and this over fifteen years), the more clearly I see that the emphasis and insistence on difference are being addressed as an artistic position. And beyond this, the petitioning character of Herold's works articulates, among other things, the call to accept difference and to rethink our own mental patterns and referential systems (on which we rely for our thinking and our actions) in view of the horrifying everyday consequences of being

narrow-minded. This minimal demand I see being articulated in the *Nebenlatte* in reference to the "we," whereby the work *Nebenlatte,* as I said, is not to be confused with its name and what is written on the roof lath.

For which reason – after offering one way of reading the name *Nebenlatte* – I would like to place a variant reading next to it. "Just because of its, on the one hand, rational and, on the other hand, emotional prostitution of yielding to each and every purpose," (G.H.) the lath is, as (seemingly) neutral material (according to Herold), especially suitable for bearing the respective meanings that Herold would like it to interpose in its (and his) image-relationships: "in a short and clear form it demonstrates the confirmation of an intention (comportment of the lath to the thesis)" (G.H.). But independent of the fact that the *Nebenlatte* confirms the thesis that is written on it, it also functions as a sign (as a band between image and concept) for Herold's profanization of art. The lath articulates the profane short-circuit between so-called high art and low-status home workmanship and serves Herold as "pursuance" of a strategy that, since Novalis, has never ceased to "quicken" artists as well as poets: humbling the high and elevating the low.

III

What is art after you subtract its mystifications (like the cult of genius, artists' evangelism, sublimity, realism, surrealism, the expression of whatever, political effectiveness, or the myth of demystification)? For instance, the plain and simple act of tinkering, as in tinkering around with something you come across. But also tinkering in the sense of making oneself a picture of something. The emphasis here is on doing it yourself, executing (or imagining) it for yourself. The tinkerer is the amateur, the noninitiate, in relation to the expert who knows how one does it "right." The latter is associated in the context of the so-called art discussion more with the affirmative reproduction of uneven playing fields. The tinkerer is, in contrast, associated more with the artist as the producer of other (concept) images who undermines the status quo of the image worlds and (art) terms and/or alters them. This is done by reworking the given sociocultural material (signs of events and experiences or purposes [the signifiers] that have become the means [the signified], and vice versa) into more or less self-referential structures that in certain circumstances (e.g., that of art) are perceived as aesthetic. This artist-as-tinkerer's viewpoint goes back to Claude Lévi-Strauss,[4] who understood *bricolage* to be a "method" used by mythical thinking. Lévi-Strauss sees similar practices at work in art. The specifics of artistic tinkering, which according to him is at work halfway between scientific cognition and mythical or magical thinking, is pursued by him only sporadically. His pointer that art, play, and handiwork, still today, set the event and the structure into a relationship by their manner of treating the material (a treatment not dissimilar to magical tinkering) can only with difficulty be worked into a contemporary art theory that wants to find, in the supposed magic of form, the potential for a mythical counterweight in an age of technical realities and virtualities.

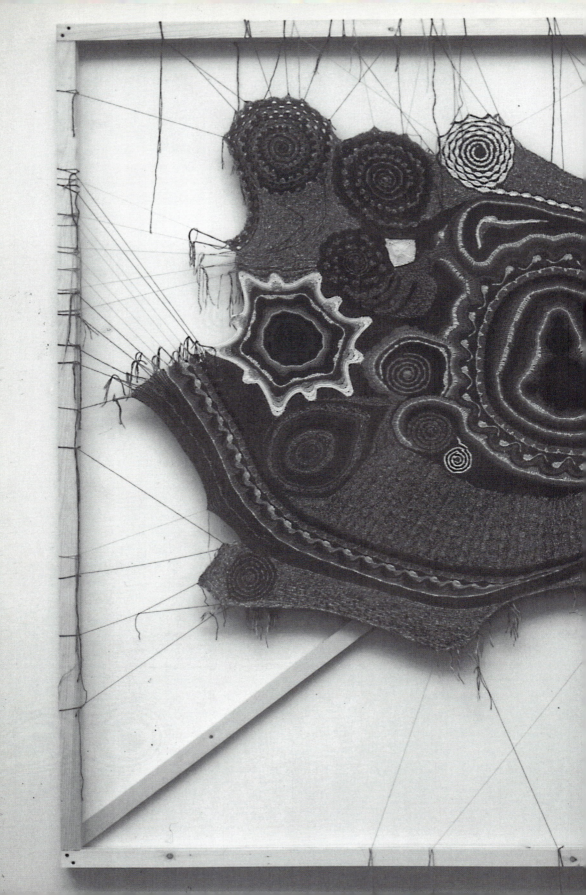

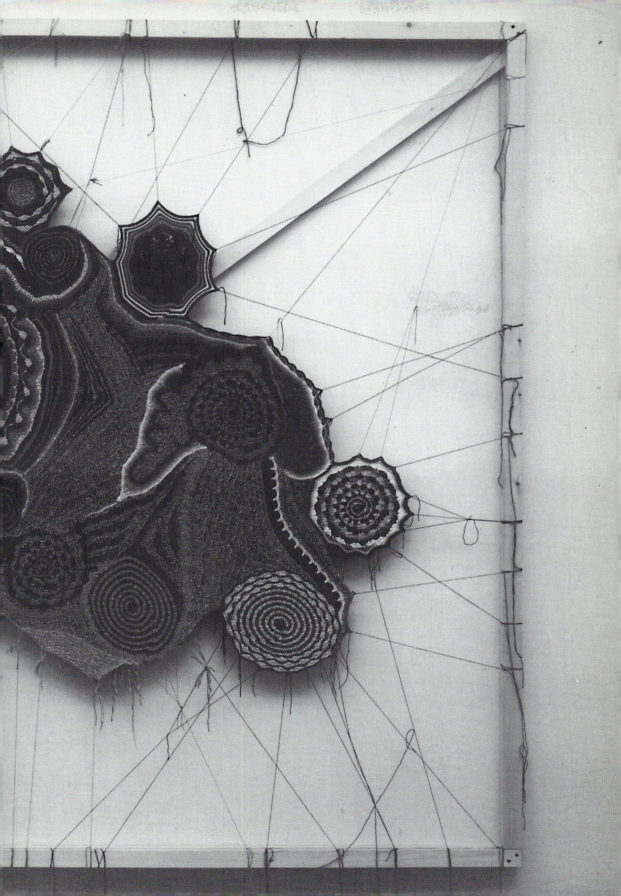

Herold also breaks the spell of this emphatic concept of art. He appears in the guise of the tinkerer and poses the question of interior decoration. How shall we fit ourselves out? In the home, in the world-of-images/images-of-the-world, in our emotional household, and in our thinking. This refers to the arrangement of our bedroom as well as to the scientific rationalization of experience, the (ersatz) ideological decoration of referential systems with a claim to universality as well as the visualization of fractals (e.g., *"Mandelbrot? Fragen Sie mal meine Mutter" / Mandelbrot? – Ask My Mother!*). Herold, by way of a pseudomythical re-organization of his "raw and cooked" materials, stages an underfulfillment of postmythic concepts of art simulations and exhibits these as signs of the ridiculousness of their desperate longing for meaning. Herold supplies mental pictures that are characterized by the absence of art: "Thus the question is: how do I make my ideas visible without disembodying them through artistic interventions, perhaps even going so far as to paint them in oils or carve them in stone" (G. H.).

IV

The art of avoidance, of omission, and of negligence in the sense of a purgation through emptiness was what stood at the center of Marcel Broodthaers's works. For Broodthaers, too, artistic activity was the height of inauthenticity. A possible answer for him was the authentic form of questioning art itself (in its and as its context). He saw his work as being grounded in the necessity to give "information on the material world of today through sculptural form"[5] and "to erode the falseness inherent in culture."[6] His art of determinate negation (e.g., the fabrication of fictions) was borne by the hope "that the viewer will be prepared to accept the risk, for a moment at least, not to feel so at ease with his own sense of things."[7]

Broodthaers also foresaw the eventual appropriation of this "authentic form of questioning art." And in his last installations (*Décor*) he reacted accordingly by presenting in image-form the subtle interlinking of the structures of fashion and power in art and culture. These images, by the artistic appropriateness with which they (dis)continued "art," set a still today unfulfilled artistic yardstick: "It still remains to be discovered whether art exists in another form and in another place than at the level of negation."[8]

A kinship with Herold's standpoint is obvious here, but with the decisive difference that the appropriative and fashion structures of art (e.g., the eternal return of the new), which Broodthaers in his time did not quite yet have to resign himself to, were for Herold a self-evident precondition from the very beginning. The art of determinate negation, which was inscribed with "the hope of a new alphabet"[9] as a double image, had at the end of the seventies and after Broodthaers's

death been debased to just one more illusion of goodness. However, what was overlooked here is that this art of supposedly critical distance had at the time reproduced exactly what it had vowed to combat. Correspondingly, Herold's profanization of inflated art simulations comes out harsher and more ruthless. Above all, he includes the questioning of his own production and possible reproduction of art illusions in the test structure of his picture science. Herold also relates the sentence written on the *Nebenlatte* to himself to the degree that reassurances of identity systems occur in his own work. It is not a paradox that this can even happen when identity is being subverted. As "we" saw with the *Nebenlatte*: "Together we are assholes!"

The strategy of a purgation by means of vacancy is one that is common to Broodthaers and Herold, with the difference that Herold puts it into quotation marks. He does not try to exclude what Broodthaers felt had to be avoided, but consciously brings it into the work and presents it as something drained of its meaning. One could even speak here of purgation by fatal embrace. The work *Void* thematizes vacancy in the form of a black-white painting on which the word "void" is written in the shape of bricks. By means of the mere evocation of all the possible meanings of seeing things in black and white and of the word "void," the purity of an art of vacancy is vacated, whereby the de-dogmatizing of a pure dogma (art ideology) hits you like a brick wall. Also a glance into a dictionary should be encouraged in view of this picture. There we find for the word "void," among others, the following possibilities:

Adj: 1. containing nothing. 2. idle, leisure. 3. a: not occupied, vacant. b: not inhabited, deserted. 4. a: being without, devoid (a nature devoid of all malice). b: having no members or examples, having no hands represented in a particular hand. 5. vain, useless. 6. a: of no legal force or effect, null. Noun: 1. a: empty space, emptiness, vacuum. b: opening, gap. 2. the quality or state of being without something, lack, absence. 3. a feeling of want or hollowness. 4. absence of cards of a particular suit in a hand as dealt. Verb: 1. to make empty or vacant, clear. b: archaic: vacate, leave. 2. discharge, emit excrement. 3. nullify, annul a contract. vi: to eliminate solid or liquid waste from the body.

V

Like every art (including all anti- and nonart variants and, of course, Georg Herold's) that makes it its business to discontinue and present illusions in art and life, it is resolved by the forms that it chooses and finds to express it. Also avoidance cannot get around the fact that it cannot avoid the art form of avoidance. When the issue for an artist – as in Georg Herold's case – is to find an adequate language for his mental models, the avoidance of aesthetics is one of the obstacles that he must take in his stride. "An unreflected regression to a reminiscent taste, only in order to serve some sentimentality or other, generates modernisms. A veneer on the

surface of insipid ideas" (G. H.). Herold sees aesthetics as, in the end, "an effort to put everything in order and to justify this with the pretty name of CULTURE." And he treats it as such in his works. His choice and treatment of materials deliberately underfulfill every imaginable aesthetic expectation. Herold counters the fact that art cannot not be aesthetic by indicating that he takes aesthetics back to where it came from, namely, to interior decoration.

"From all this clean-up, whole areas came into existence such as interior decorating, design, color arrangement. No furniture type was spared and no wall left out. Every niche in the house became worthy of treatment, and if there weren't enough niches, they were invented, e.g., on the flat wall, pictures" (G. H.). From the field of the design of a person's home, he takes his material, from which he has evolved an adequate language that is characterized by Herold's specific quality for approaching an absence of aesthetics. That is, his imagery supplies the necessary aesthetic for his mental models. Herold is one of the few artists of my generation who have given a form to the necessity of having an art after art, out of which speaks a (contemporary) presence of mind that is distinguished by an absence of self-righteousness. "I do not claim that art is dead, I try to produce 'dead art' so as later to revive it by means of the aid program, 'artistic medicine' " (G. H.).

Herold's art after art is realized not only in the form of underfulfillment. The opposite is also the case. The Kaviarbilder (caviar pictures), for instance, overfulfill the viewer's wish for a feast for the eyes, by painting a picture of pure luxury with the genuine article (Beluga caviar). This overfulfillment of our aesthetic expectations presents itself as an inedible enjoyment of the picture as a "luxury item." Here Herold's art is shown in its double character: as (self-made) dead art and as a way of raising dead art to the power of nondead art. "What vexes us in life, we willingly enjoy in a picture" (Goethe).

VI

Georg Herold's works point (the viewer) toward the complexity of the constitution of meaning in the world in between "art" and "life," assuming such an in-between world of art can even be targeted in view, for instance, of the progressive universalization of a multimedia iconoclasm and the resulting digital blur between text and picture, picture and reality. If it is the case, the viewer is asked to develop his perspective, that is, to make up a picture that meets the gaze of the Other (the gaze of ostracized desire), assuming the viewer is still in a position to expose himself to this gaze (his own unconscious desire), for example, in view of our changing knowledge of the brain. As it looks now, we will not be able to ignore the latest results in brain research. Researchers have established the fact that in the "middle-European brain" there is, for example, a change in the constellation of the hemispheres that causes a shift in lateralization, apparently in relation to the blur between text and picture, picture and reality (e.g., in TV ads). "Only a new art of 'enjoyment' can save us," as a cyber-culture ad slogan proclaims, a culture that not only seals the

victory of media information over "facts" and digital pictures over "things" but, even beyond this, produces the "paradox of a totalitarian individualism"[10] that suspends the language of desire and ratifies the defeat of the fact of making love, according to the virtuality commandment "Love your most distant as yourself."[11]

Why do I mention this? Because Georg Herold addresses the changed situation of pictorialism (e.g., the blurring of the boundary between text and picture) in the form of conceptual images that hit below the belt of the illusory worlds and passes it in all openness (of meaning) on to the viewer: "the return, via the associative, of illusory worlds to traditional image worlds. Real realism: reality as fiction and fiction as reality. The labyrinth as a spiral-shaped Möbius loop, as strange attractor" (G. H.).

VII

Herold proceeds according to the heuristic principle of a nonreductivist materialism, of a gay science (Nietzsche) of pictures that do not ignore the indifference, neither outmaneuvering nor harmonizing but playing it out. He makes readability available, a readability able to bear and pass on the hope that Herold used to create it. Herold opens and leaves open wherever he can in the hope of opening up possibilities. One thing is clear and repeatedly meets the eye when faced with Georg Herold's works; communication does not take place. But looking this fact in the eye could also be experienced as the necessity of attempts at communication that do not delude us about the bodily aspect of perception and about its rationalizations being dependent on the banal situation. Herold's deliberate under and overexposures of false (art) expectations effect here a (hopefully) conspicuous contribution. I wish that as many viewers as possible, when confronted with the works of Georg Herold, are able to witness an avoidance of the art of vacancy and an activation of the world in the artwork (*"einer Entlochung der Welt im Kunstwerk bei(zu)wohnen"* G. H.). Walter Benjamin called this "profane illumination," and Ernst Bloch called it the "counterillumination of things." I would like at this point to refrain from any further naming and, for the moment, leave it at this.

Cindy Sherman. *Untitled, No. 179.* Color photograph.
© 1997 Monika Sprüth Gallery, Cologne.

CINDY SHERMAN: PORTRAITS OF BECOMING ANO(R)MAL

At an AIDS auction in 1987, Cindy Sherman showed a photograph *(Untitled #179)* of a person in jeans and a sleeveless T-shirt sitting on a cruddy mattress, obviously making a great effort to master the art of using a condom. Not even on closer study of all the details can one determine whether it is a woman or a man. The person's posture (seen in partial view from behind) is calm and concentrated. The bent arm and slightly hunched torso suggest that the hands are busy experimenting between the legs. The mattress is strewn with a variety of new and used condoms in all shapes and colors, with packaging, instructions, a few carrots, and bananas. There are holes in the mattress – and a few unmistakable damp stains. A filled condom, conspicuously black, probably contains a peeled, overripe banana.

I am quite certain that the person is Cindy Sherman herself. But in her case, isn't this an utterly irrelevant and even secondary observation? Cindy Sherman does not use herself in her pictures for purposes of self-portrayal or self-distraction but plainly and simply as a model representing mock-ups of the Ego, illusions of identity, masks of authenticity, and other romantic monsters and postmodern zombies. Her body functions as an analogue of an image of perception that operates at first on the level of two subjects: the one on the scene and the one who watches, comprehends, and reflects on the former. Cindy Sherman provides both the scenario of a stereotypical or specific fictional ego and, far more important, a self-referential shift toward something different, even grotesque, an irreducible difference. Her photographs are baited with invitations to follow her on this latter subject level as well. She portrays the fake as fakes. Body parts and pictorial backgrounds are recognizably fake; cable releases are left casually unconcealed. But even this specifically Shermanesque mode of imposing distance, which even the most trivial of subject matters cannot do without, turns reflection on the scene into part of the scenario itself, whereby Sherman's manner of involving the camera as an independent partner, "a camera-self," also plays a vital role. This is very important because it manifestly reveals not only that Cindy Sherman has an unequivocal understanding of the conditions of photography but also that she has the ability to let the camera function as an equal partner, both on

the level of the photographic scene and on that of the photographic reflection of that scene. This would not be feasible were she not able to detach herself. Moreover, Sherman lets the camera take her place. And since she knows that the camera lies,[1] it follows that the hypocrisy of the camera (the mirroring of *camera lucida* and its chemical developers and fixatives) defines the character of the picture.

The photographic procedure of detaching her-self is so effective, however, precisely because Cindy Sherman puts her-selves directly in front of the lens with body and soul, a histrionic multiplication of identity. Without this authentically theatrical essence (which she says goes back to a delight in acting out transformative masquerades long before she transferred these acts to the context of art), the results of photographic reflection on the structures that she places before the camera lens would have no flesh and blood. Without the detached use of herself as model, without the quasi-conceptual use of the camera's intrinsic hypocrisy, and without the way Sherman raises artifice to the second power, we would be confronted with a dead-end product of travesty. Cindy Sherman successfully, productively avoids both of these potential pitfalls, the stupidity of the purely personal and its alter ego, the barrenness of the impersonal.

Let us return to #179. My opening description of it is a construct. It is impossible to read the content of the photograph at first sight. Its composition – basically determined by the lines and patterns of mattress, leg, pillow, upper arm, carrots, and bananas – has its own intensive and independent impact, which lends the picture a virtually irresistible measure of abstraction. Our gaze is forced to wade through a web of forms before it can distinguish the picture's subject matter. The viewer's first impression is defined by an almost classically abstract arrangement of the picture plane that disregards content and by lighting that transfigures and bathes the scene in the glossy warmth of a vacation postcard. The gap between abstraction and representation opens even wider the moment our gaze discovers the arranged display of rubbers and their manifest meaning. Cindy Sherman confronts the thematic portrayal with the simple fact that it is impossible for a color photograph not to be pretty and glossy and fake; she carries both poles, side by side, to the extremes that preclude both surface conciliation and conciliating surface. The content of the photograph is clear and unmistakable, and its form unmistakably communicates "photography as illusion," which contributes to photography's reality effect. But in Cindy Sherman's oeuvre, this tension is not characterized by an oscillation between these two poles but by photographically fixating the in-between zones of this contradiction and other dualities (e.g., man/woman, figuration/abstraction). This polyphony is the beauty of #179. Everything in this photograph can be read not only as "obvious meaning" but also as "obtuse meaning."[2] The printed instructions, thrust diagonally into the lower right of the picture, not only indicate at least a theoretical knowledge of how to use condoms (and, hence, of sexuality in the time of AIDS), they are also a formal counterpoint to the larger blue parallel line in the upper left of the picture. This emergence and disappearance of the signified can be seen in almost everything in the photograph. The upper arm, the flesh-colored bit of plastic above the bananas (probably fake tits), or the black banana in the condom appear as signifiers without signifieds. Every part is, on the one hand, an analogue of a real event

Cindy Sherman. *Untitled, No. 253*, 1992. Color photograph. 50 × 75 inches.
© 1997 Monika Sprüth Gallery, Cologne.

in the past – equivalent, in Cindy Sherman's photographs, to her studio fabrication of fictions of the self and its identity prostheses – with a corresponding semantic potential within the framework of the theme. On the other hand, it is a simple element of a unique photographic abstraction. The photograph is simultaneously the sign and the

thing itself, that is, respectively, a precisely deployed medium (preferably on the level of cheap, illusionist low-art targets such as B-film stills or *Playboy* centerfolds) and a suspended medium, the fixation of the in-between zones as the thing per se.

And this precisely is the art(work) here: Sherman deals with the profoundly serious problem of AIDS that affects every one of us in one way or another by focusing directly on the effort to combat it. But not for a second does she deviate from its unadulterated presentation in a glossy fixation whose strength lies only in the fact that it is condensed onto a surface that lets us forget its medium. #*179* is an artificial landscape analogous to presence in painting, but with a difference, because the photographic strategy of making a fake of a fake gives this abstract fixation its theme: the fixation's import of the real. The theme of AIDS remains inscribed as a co-presence in the picture's presence. In this form, Cindy Sherman has ruled out the hypocritical compassion typical of social art infected by the "Sting syndrome" and the modern cynicism of endpoint fetishists. The gravity of the nihilist situation is (t)here. The multiplied artificiality of truthful photographic reflection is (t)here. Nondeath is at least not absent. A curiously dissonant harmony by way of figurative abstraction is (t)here. Beauty is (t)here and the reverse side of beauty is (t)here. What more do you want?

But there is something else, something less tangible. The way the figure is sitting on the mattress reminds me of the faces lost in thought that characterize many of Cindy Sherman's women, especially in the centerfolds from 1981. In the film stills from 1977–1980, for instance, her face is masked so effectively that it aims at a generalized message: the stereotypical physical states structured by the social imagination, or the codes of identity based on clothing and physiognomy as imposed by society. The centerfolds, however, embody the most obvious photographic form of woman's availability to the male gaze. But the usual expectations – women as recumbent, passive, accessible, devoted, exploitable beings – are not fulfilled. These expectations are still formally evoked in Sherman's photographs but simultaneously disappointed. These women seem to be caught up in sensitively staged emotions that tend to unfold in the marginal zones and intermediate spaces of the role-playing procedure – for instance, before or after a disappointment or a fulfillment – or are simply dazed, lost in thought, bored, tear-stained, or sleepy-eyed. In any case, these self-contained, introspective gazes indicate an irreducible being-with-oneself that leaves the viewer alone with his own semantic constructions, projections, and associations. While in the film stills the masks face him with obvious, undisguised meaning, here the faces confront him with obtuse meaning, leave him stranded with no signified for the signifier.

But in contrast to the details of #*179*, the outcome is not photographic abstraction. Instead, our attention is directed toward that aspect of being which is not a product of the social machine, which is inaccessible and irreducible, which is not entirely contained within the structures of the signifier. Whatever that may be, it must, of course, remain completely open, especially since we are essentially concerned here with openness and a specific absence of the signified. In the centerfolds, the expressions on the faces contradict the other details, for example, body parts and clothing. These function as a semantic provocation of simultaneously different and contradictory interpretations (from a cold sweat that could simply be from a

Cindy Sherman. *Untitled, No. 89,* 1981. Color photograph. 24 × 48 inches.
© 1997 Monika Sprüth Gallery, Cologne.

fever or a heat wave to apparent traces of rape that could simply be household bruises). Whereas the facial expressions direct the gaze toward a simple dignity with no definable identity, a blind spot in the gaze of reception. Cindy Sherman's masks of inaccessibility are analogous to the profane irreducibility that Jean-Paul Sartre called the individual generalization that takes place in the act of personalization, which simultaneously is the alteration and the reproduction of the social constitution (of what we mean by personality). In other words, that which man makes of what has been made of him by making himself – in his own specific way – into what has been made of him. This is the trace of freedom alluded to in the beauty of the obtuse meaning in Cindy Sherman's photographs. And *#179* visibly demonstrates how narrow the paths of freedom[3] have become.

But what is this irreducible trace of freedom that these masks of inaccessibility speak of in her photography? The more of the *"jouissance de (La) femme"* (J. Lacan) definitely plays a major role here, but there is more "more" involved. The other side of beauty is not the ugly. It is not even the abnormal since this still exists in complementarity to the normal, the stereotypical, such as gender identities and the social order. The other side of beauty, for example, when it takes on the form of the grotesque, opens the door to what Deleuze and Guattari call the *anomal.*[4] The anomal is not being a-normal; it is not being at all. It is a becoming, a becoming something really (in contrast to imaginarily) different: "becoming-intense, becoming-animal, becoming-imperceptible."[5] This is exactly what is portrayed in Cindy Sherman's photography, for example, when, in her recent work, she extends her-selves into grotesque metamorphoses. Are, in the end, her photographs not becoming portraits of becoming ano(r)mal?

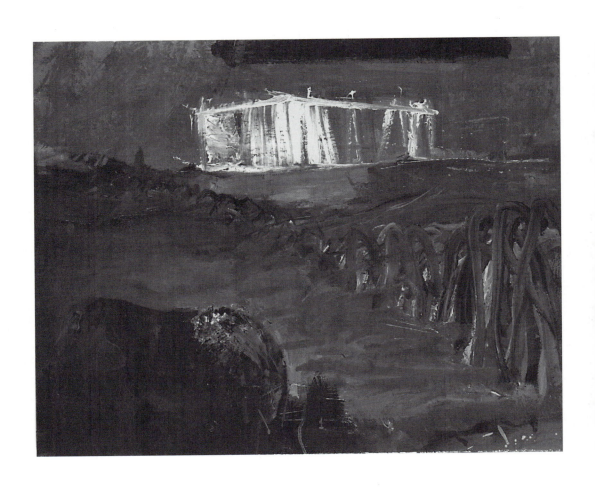

Siegfried Anzinger. *Tempelpferd,* 1987. Oil on canvas. 40 × 60 cm.
© 1997 Monika Sprüth Gallery, Cologne.

SIEGFRIED ANZINGER: PRE-FIGURES OF (POSSIBLE) PAINTING

> Surely "Olympia" is, among other things, also a miserable model on a bed sheet.
>
> André Malraux

> You have to speak your text through your instrument.
>
> Lester Young

It makes me sick just looking at all those ridiculously desperate efforts that tortuously spread themselves in the imaginary rectangle and mistake themselves for painting. Painting is rare. Not only at a time like the present, in which its impossibility once again seems to be obvious and in which talk of painting after the last painting is being rehashed, in a spacious, (post)modern fashion, in a desperate minimal illustration of supposed (in)visibilities.

Painting today is naturally possible only when the painter is aware of its impossibility. It no longer represents realities; the fetish of its presence has run dry and the bugbear of its sublimity stands, down-at-heel, in artistic space. It is a questionable, indeed, paradoxical medium. But Roland Barthes once wrote that to create art means to consider the desire for the impossible to be reasonable. This holds true especially for painting, perhaps now more than ever.

It's all the more pleasant, then, to come across painting, or more precisely "brushwork," that knows this, that inscribes its impossibility onto a painting, but – and here opinions differ – without exhausting itself in the pictorial illustration of this knowledge. Regardless of figuration or abstraction, a painting cannot not be abstract. Nevertheless, anyone who tries to eliminate completely the importance of reality produces a decorative substitute for purity. And anyone who confronts the importance of reality *in* painting naturally also produces a decorative substitute for art, for today's artist cannot also not do this. Each picture is decoration once it is on the identity prosthesis market. However, under certain circumstances *not only,*

but *only also*. And these circumstances are bound up with the risk, to which (no later than Kant) reasonable ideas are bound that are bound to the desire for the impossible.

In the focal point of painting activity stands the reconciliation of non-harmonizable contradictions. Dialectics are no help; nothing is synthesized, nothing glossed over; rather, a plausible paradox is simply painted: a pictorial statement that is inscribed, with a veto against itself. This inscription marks the difference *in* indifference (the interchangeability of exchangeable images), from which a picture can no longer free itself.

A good painting is therefore always also more than deconstruction. It is a deconstructive construction, even when deconstruction is part of the conditions of its possibility (anything else would be stupidly naive). Put another way: a beautiful painting is beauty without disguising its principled inadequacy and, as such, the request for an answer where there is none. In this questionable presumption lies one of the specific qualities of painting. Gottfried Benn spoke of art as the "inconsistency of the nihilist." And Michel Leiris called it a "yes without conviction." Maintaining this paradoxical balance is bound up with a high artistic risk, which is why most of what is daubed onto canvas drips of the well-intended, kitschy pseudosynthesis of transparent hopeful speculation, of embarrassing illustration, of a theater of mock souls, or of insincere fictitious responsibility.

Painting is rare. Because it is visible knowledge worked out of the painting gesture, it is not without the knowledge inscribed in it, not only of its conditions of possibility and of the contexts that give it its meaning but also of that which it is not, its relation to the world in the form of subliminal (social and/or existential-political) meaning in form.

Picasso once said that painting always has a theme, but an undetermined theme. "A theme that is not illustrated in its images because it can only take on form through them."[1] This was said by a painter whose works indicate that he had only one theme, namely, sexuality.[2] This, however, doesn't contradict Picasso's claim that the themes of painting take on shape only in painting. Figuration and abstraction are not simply two different possibilities in painting. Painting exists where both occur together without *really* becoming one, where, thus, neither figuration nor abstraction exists, but painting. And painting becomes painting when an undetermined theme is distilled out of it. Thus, painting exists when an undetermined theme takes on its determination in painting.

This can be approached from different angles. One side is the flagrant overtaxation of a painting as to its contents, as was practiced with a damn-the-cost attitude at the beginning of the eighties, especially in Germany, Austria, and Switzerland. Another side is the semantic opening of abstraction as it appeared in the course of the eighties, especially in the United States, as the deconstruction of the sublime.

Siegfried Anzinger belongs to those painters who allow only as much figuration in a painting as comes from painting, so that the content is and remains non-illustrative painting. This being the case, meaning becomes possible. And this is the issue, painting as the possibility of illustrationless meaning. The monks, the young girls, and the empty, imageless easels are derived from painting and are non-illustrative painting.

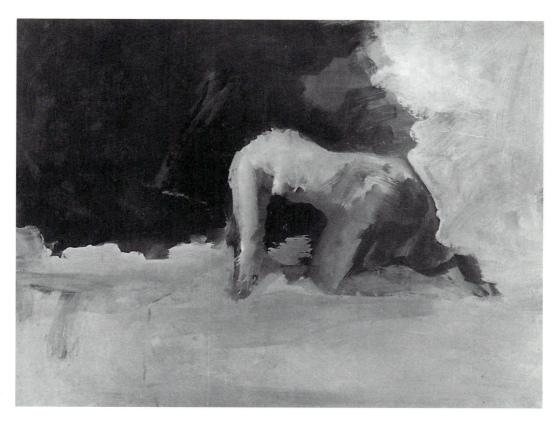

Siegfried Anzinger. *O.T.*, 1991. Oil on canvas. 53 × 69 cm.
© 1997 Monika Sprüth Gallery, Cologne.

André Malraux stated in his third volume of *"La métamorphose des dieux"* that the subject matter of painting doesn't arise from the painter's predilection for an apple, an ass, or asparagus but from a hatred of insincere idealism.[3] This is also what we find in Anzinger's new paintings. Their subjects come from a hatred of insincere sublimity in abstraction ("I don't want to sell my paintings as abstraction, that seems to me too spiritual" – Siegfried Anzinger), from a hatred of the sensationalism of so-called pictoriality that only feigns intensity, as well as a hatred of the insincere, upright artistic claim to avant-garde-isms that have long since become institutionalized.

Anzinger devotes himself consciously to a pictoriality (the risqué, the kitschy, the sweet, the unpleasant) that is, then as now, excluded by the academicism of long since incorporated radicalizations. He binds his daubings to an object, not really to a depiction, more to a depiction-analogue ("The image interests me, not the painterly as such" – Siegfried Anzinger). The object functions as an obstacle, a given

that stands at angles to the "personal brush style," which he uses to discipline painting, and to set free, grammatically, a motif from painting. Once the figure has been worked out clearly, it no longer needs backgrounds, or illusion or a diffuse spaciality; indeed, it no longer needs the seduction of the diagram *[Duktus]* and self-infatuated playfulness. The surface – of the individual components of the figuration – can now simply be coated with paint, confronting the beholder flatly, nailing color boards in front of his eyes.

Anzinger places color planes like blocks next to each other, illusionless in themselves but at the same time forming the motif. A figurative abstraction that simultaneously evokes an object, which, however, always remains transparent as an effect of pictorial figuration. It isn't realism that is indirectly being shown in the reality effect of "furriness," which the small painting of the shepherd dog produces, and neither is it painting as such, but the formulation of an image-thought that appears before one's eyes like an amulet. A pictorial thinking distilled from painting – that is the aim. And this presupposes an opposition to one's own conduct that offsets psychology and personality penetration and a purge of the brushwork by diluting the falsehoods inscribed on identity. Anzinger often paints standing sideways to the easel and at a minimal angle to the canvas, with his entire concentration focused on the formulation of the motif, while avoiding all aesthetic attempts at an aesthetic of breaks. The result is a beautiful abstract figuration of neutralized painting: a picture set free. This is painting. And painting is – to reiterate – rare.

When Anzinger says: "A pattern should be worked out by which you can paint on several images in primary colors and execute a prefabricated pattern; only in this way is painting bearable," this is not cynicism but rather the attempt – morally motivated – to formulate a sincere answer in the form of painting that is appropriate to the cynical situation of art.

Anzinger's pre-figures of possible painting are, in view of painting's impossibility, omens for pictures as possible models for freedom, no more and no less. And let's not forget: surely the figurative abstractions in these paintings are also monks, young girls, camels, and monochrome imageless canvases.

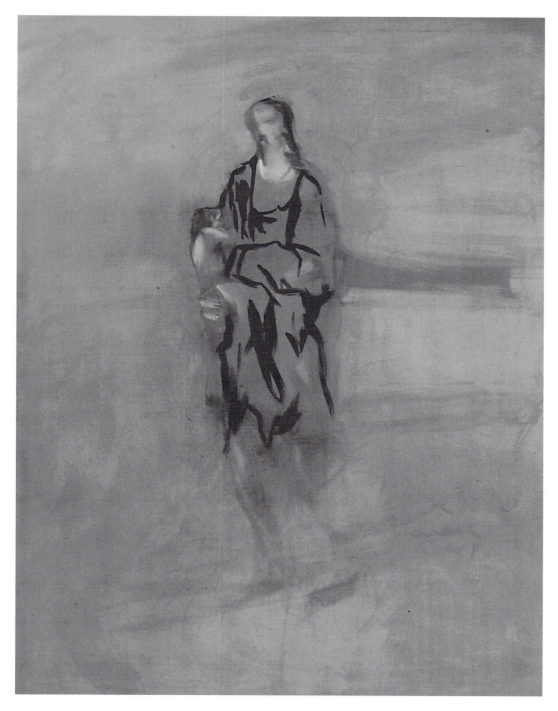

Siegfried Anzinger. *Madonna (Salamander),* 1997. Egg tempera on canvas.
170 × 130 cm. © 1997 Monika Sprüth Gallery, Cologne.

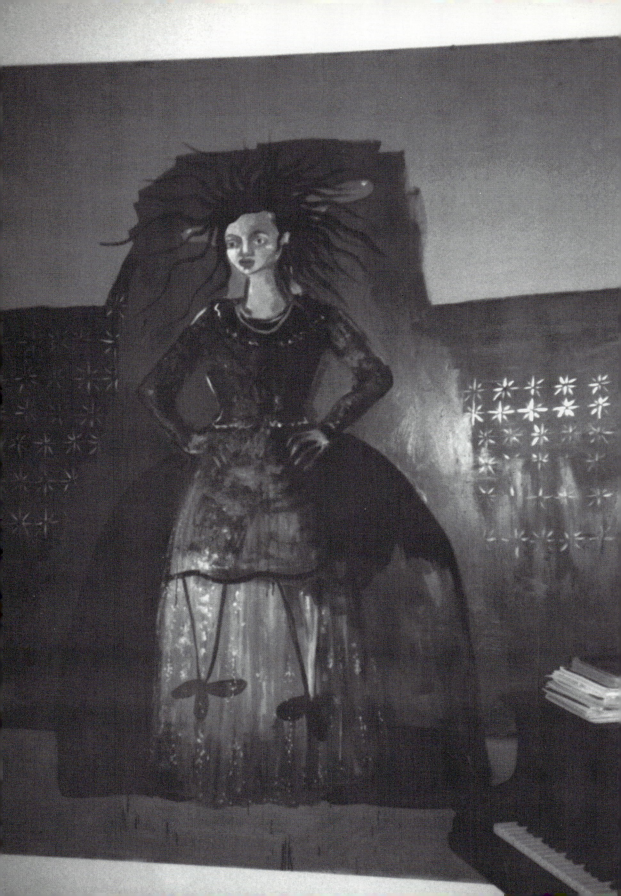

GEORGE CONDO: (IR)REAL PRESENCES

I. THE EXISTENTIAL ABSTRACTION

> . . . this useless passion – where one becomes a substi-
> tute creator, since one is not really a creation – is itself
> inexplicable without the remarkable challenge of that
> which is through that which is not. In the middle of util-
> itarianism – this transition from being to being which
> takes place in the middle of being – the artist's mandate
> is manifested by the presence of non-being as care.
>
> Jean-Paul Sartre

Depersonalized masks and Cubist dogs stare wildly around the illusionary corners of an ornamental orgy that spreads itself across the canvas like a schizophrenic kaleido-scope celebrating itself. Only the handle on the lid of a trash can offers the eye a hold in this hysterical rococo of instability and irreal mutations, which, propelled by a for-malistic obsession, proliferate in and out of one another but in the end are indeed rec-onciled in a closed composition of irreal abstraction: an architecture of its own equi-librium. The painting is called *Dancing to Miles*. And it was, indeed, a musical strand that the painter followed with his brush, a strand that the painter unwound from his own dissociated center. This inflating and deflating of forms and colors, this dynamic static of impossible pillar constructions, these multiplied masquerades of the frag-mented ego, this whirlpool of Spanish baroque ornamentation offer the eye an elabo-rately knotted musical tapestry, related not only to the improvisations of the Miles Davis group but, even more, to the late romantic tone painting of a Maurice Ravel. For example, his musical arrangement of three poems by Bertrand, which are notably dedicated to the memory of Rembrandt and Callot. The way Ravel *draws* the form of

George Condo. *Mrs. Death Lives,* 1993. Oil on canvas. 250 × 200 cm.
Photo: Wilfried Dickhoff.

a goblin hovering in the sky at midnight, smirking, laughing, and swiveling around on one foot, is similar to the way Condo *composes* a visible outline of echoes, which are perhaps not awakened solely by his own life and body.

No more and no less than the painter's internal correspondence to the sound of present existence is the subject matter here, which is why both the lie of pure abstraction and the lie of content-filled representation are out of the question. Condo carries out a figurative abstraction for which the interchangeable contents of hyperreality (passing for and reigning as so-called reality) serve only as material for the form of the irreal painting. He drives this material into the irreality of the painting until it resolves itself into a formal pattern that stands for itself, which simply is what it says and says what it is: the presence of the real irreality in a world of irreal realities.

In this way the painting of the irreal plays off the illusions against the real illusory worlds, which are organized along structural lines that have become more and more intangible. This way of painting introduces to the game the brilliant surface of non-sense to counter the pretension of so-called sense. Another painting from the year 1985, constructed according to the principle of the expanding canvas, is called *Nothing Is Important,* which, however, not only means that all values and contents are unimportant, arbitrary, and interchangeable. *Nothing* is important also means: Nothing is important, that is, the nothingness of being which we sense through the fatal structures of the everyday, history's circular structures of power, and the moments of fundamental loneliness. That is the existential theme the paranoic, obsessed Ego catapults onto the expanding canvas, where it creates, as an hysterical painting-Ego, positive irrealities that are able to transcend the initial existential impulse.

In one painting, two rigid objects face each other, *Separated by Life.* In a complementary structure they are shown like baroque furniture. Each is for the other an object of fetishism, a decorative sculpture. Their problem is that they are carved from the same wood and that both are green. Obsessed with one another, they repel and attract one another without ever being able to overcome their separation. This classic man/woman tragedy is performed against a blood-red brocaded backdrop that gives the scene an irreal atmosphere and envelops it into a painted dream world of mute meanings and dissimilar similarities. It has nothing to do with prosaic representations of the eternal relationship drama. On the contrary, the painting represents nothing at all, except perhaps nothingness. But nothingness is always nothingness of something, for example, an absence. In this same manner this picture is filled with the absence of a bodily and spiritual inseparableness. And precisely this absence is made visible and "nothing" else.

In other words: the nothingness of being is converted into an oil-painted being of nothingness. What results is not only expression but, in addition, animating sources of energy generated by paintings that determine the way they are looked at, thus making a fascination possible that radiates a moment of existential loneliness.

Condo's paintings articulate this moment just at the point where they appear to be farthest away from it: in the formalizing of nothingness, in the lewd illusory cult

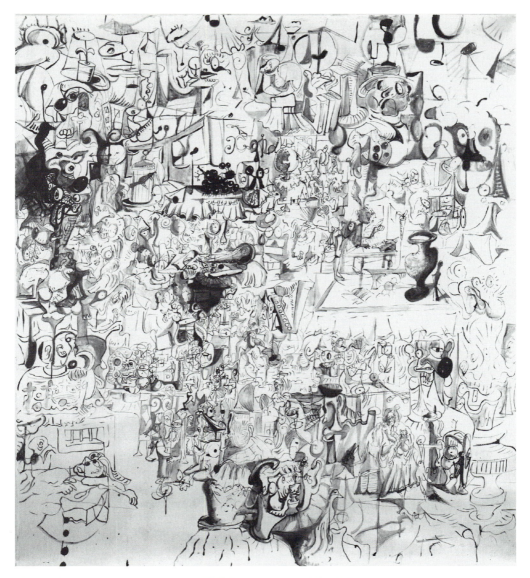

George Condo. *Nothing is Important,* 1985. Oil on canvas. 188 × 162 cm.
© 1997 Monika Sprüth Gallery, Cologne.

of the nonreferential, abstract figuration, in the hysterical baroque of an expression in quotation marks.

With the ease of a European-educated American, he has helped himself to the quarry of art history, in order to develop his blotting-paper paintings in the existential air of a Paris winter. What this blotting paper absorbs appears, however, not only in the form of figurative abstraction but also in the form of abstract figurations. The

former constitute the formally aesthetic background for the latter in his last paintings from Paris. The ways and means by which Condo produces here an intentionally awkward abstraction without surrendering resemblance has never been seen in quite this way. Paintings like *Seated Insect, Wooden Horse,* and *Melancholy Opposites,* have an *existential humor* that we, of course, constantly lose sight of in the fashionable cynicism of the everyday. The cult of incoherence, the aestheticization of the arbitrariness of all those "melancholy opposites" that usher in the irrealization, has nothing to do with aestheticizing affirmation. By involuting simulation, by potentiating imagination or by doubling the illusion *[Schein]*, would it not be possible to generate paintings that do not wither in the ghetto of fiction but, rather, conquer a place in so-called life as irreal spiritual facts of reality? Even the securement of art is ultimately subject to a very general law, the law of constructing being from the formal in the same way it works in organic growth. It has to do with one's own can-be *[Seinkön-nen]*, with the aesthetic proof of existence in the midst of today's aestheticized life, which none too rarely reveals itself as a living death. Our universal utilitarianism vegetates in dull factualities. In this passivity of the blind immanence of being, the painter attests to traces of freedom inasmuch as he makes nonbeing visible. For Albert Camus it was a matter of adapting art to the times by "tearing from death a lively picture of our passions and our miseries." And don't forget that, for Camus, Sisyphus was a happy man. In other words, I believe that this mandate of art could be taken up by a kind of painting that allows the fractures of existence to sparkle in an unscrupulously irreal positivity. In the new paintings by Condo there is this sparkle, especially where the baroque blending in and out of figurative abstractions becomes musical visibility.

All this sounds a bit over serious, but it is really quite simple. There is only naked existence and this rending of the heart, into which we are thrown after all the witty cynicisms of survival are exhausted and after all the self-ironical games have not improved the psychological, the intellectual, and the economic situation. It simply has to do with existence and its abstraction in a romantic-artistic potentiation. Which can then, for example, formulate itself as a *Green Love Poem*. This impressionistic tone painting operates like an infatuated swing between rhyming forms, a green craving for the one accord that brings everything to a head and is simply love. At the bottom of the painting's edge the love-dazed idiot crouches. Obsessed with the object of his craving, he gapes forlornly at a world that reveals to him only the absence of his beloved. The red ball allows the painting to compose its own clarified form. The way Condo furnishes the imaginary square articulates something artistically sentimental and impressionistically constructive with existential undertones. George Condo's existential abstraction (ir)realizes a meaningless, but sensefull, presence. If we were to name an "ism," it would be irrealism. The irrealist knows that what he does is deceptive *[Betrug]*. But he also knows that the deceptive images *[Trug-Bilder]* of art make perhaps the last allusions to our dissipated truths. Painting is a game about something (content, truth etc.) only to the extent that it is a game about nothing(ness).

Could it be that Condo's paintings herald a rebirth of authenticity in the form of (ir)real presences?

II. THE POST-NONDECONSTRUCTIVE PAINTINGS

> My work serves exclusively as the invention of new
> ornaments. Despite all, soul is necessary to combat
> technique. And so I, among many other things, have
> also made Richard Wagner a woman.
>
> Georg Baselitz

If you stick to the reference to reality, that is, to the function of the picture as an analogue (for something that transcends or suffuses it), knowing that a painting cannot not be abstract, then you paint in a twilight zone, there where the demonic is at home, which Klossowski says consists in the painter seeking to imitate, like an invisible model, "the demonic analogue to his own emotions."[1] The complicity of a demonic power would, accordingly, intervene at that sore point of painting where subjectivity[2] is blatantly unable "to create a soul" that could animate the picture. Of course, in order to give the painting a soul, the painter has to implement the demonic as a strategy, to allow what happens to him to happen. Thus, the demonic becomes fruitful only to the extent that the painter reproduces it, that is, exorcizes the obsessions that it involves. As a result of this calculatedly schizoid activity, which, in painting, used to be known as a reference to reality or "resemblance," could return via the demonic as a *reality-magnitude of form*.[3]

Today, of course, we are at a different stand of perceptibility. Our perception is structured by the simulacra of simulacra, imitations of imitations of stereotypes that survive in sensation, and other real irrealities of the imagination. When we open our eyes in the morning, we already find ourselves in a museum of senile modes of observing in which typologies of understanding have replaced seeing. Thus, anyone who today wishes to create a soul must begin by grappling with the soul of soul-lessness, exposing himself to the risks of deterritorializing the processes of thinking and seeing before he, following the demon of the fatally appropriated revolt of deviation.[4]

It was at this point in my reflections that in 1984 the painting of George Condo came on the scene. The first Condo works that I saw were pictures of clowns, who must have visually haunted him since the Carnival in Cologne, where the byways overflowed with drunken, singing, laughing idiots. From these sick paintings, the happy mask of depersonalization leaps out at the viewer. And the few people who were privileged to see those pictures back then instantly realized that here someone had set out to keep the promise of existential humor in an oeuvre of unrealistic figurations. But that was only the beginning.

Upon rereading the texts that I wrote about George Condo from 1984 to 1987,[5] I was amazed to see that I had tried to cram into my writing as much as Condo crammed into his *Expanding Canvas* – namely, more than the medium can bear. From the authentically paranoid structure of the individually univer-

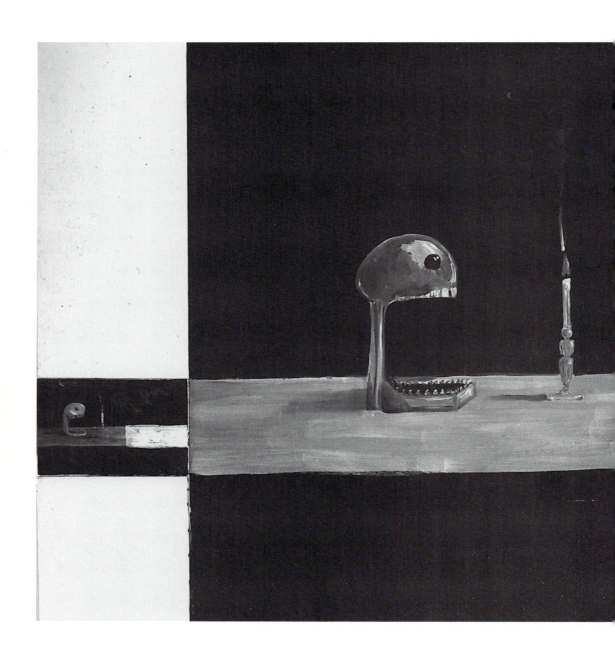

George Condo. *Vanité I,* 1991. Oil on canvas. 135 × 233 cm. © 1997
Monika Sprüth Gallery, Cologne.

sal person that he *is,* that is, from his convictions,[6] Condo had started to formulate a productively schizoid response to the artificial art of an abstract sham society. He staged (here a conscious act of painting is meant, quite the reverse of etiology and the lie of representation) an hysterical baroque scenery of interchangeable forms and contents, as they can hardly be seen anymore in the unreal reality of sign-mediated signifying structures – and this is crucial here – as they had been sublimated in modern painting in our century's process of abstraction. George Condo *lived* the death of painting in a painting of potentiated pictures. In so doing, he drew on the authentically inauthentic substance that the self, dissociated to loose fragments, offers when an artist, in the moment of painting, throws away his identity prostheses (an act involving a certain wholeheartedness, a certain risk that the nonart of post-Conceptualist design, for instance, cleverly avoids) and looks multiple Ego variations right in the eye. What Condo got from that substance was the figurative material of an *authentic irrealism* that had never before been seen in quite that way, and its blend of paranoically accelerated artificiality and existential humor made the broken planes sparkle. Condo offered in his paintings a commentary of shared emotion, and unlike cynical indifference or equal validity, especially trendy in the art of the second half of the eighties, they unscrupulously advanced the anachronism, "painting." This acceleration led to the post-Romantic strategy that I called the "potentiation of simulation."[7] Its – not only subjective – necessity was rooted in the agony of the real that became unbearably normal during the early eighties. Thus, by the mid-Eighties, Condo was already a giant step ahead of the products of post–Pop Conceptualism that adhered to hyperreality only as illustrations. For he achieved his first nonillustrative painterly result without falling for a mock soul.

Condo furnished the imaginary rectangle with the most contradictory contents, which, because his approach was so excessive, ended up as thematic patterns that looked like an endless riot of abstractions. He burdened the limited canvas with frame-transcending mutations that passed from the figurative to the abstract. This blatancy, which naturally overtaxed the unnatural boundary of painting, laid the foundations for George Condo's personal solution for the impossibility of painting by impossibly embracing the demise of painting's being once again propagated. By disorganizing and deforming, Condo made modern painting ridiculous; he lived its disappearance, and his paintings testified that "inside the living death of painting there's more life than in what they called life."[8] Which could be described as an energy source for the autonomy of his paintings. From the very outset, Condo's paintings, as if having to prove his existence, relied on a *grotesque displacement* that was already rooted in his psychosomatic constellation. This was the displacement of his tragicomical motifs: ruins, money, skull, clown, man as a paralyzed "bum head," the woman as the object of beautiful portraiture, art history as the material for a rebirth of the authentically natural artificial. And precisely because he considered his own abil-

ity to exist to be the point of his paintings, he managed to develop them into a *coherent deformation* that makes the death of painting ridiculous beyond the stale discourses on form and content.

When I met Condo in Paris last February (1991), I was delighted to see that all these concepts still applied to his paintings. His figurative abstraction had assumed various guises during the past few years. Nevertheless, from the over-crowded *Expanding Canvas* via the installations that made the individual picture disappear against a wall overloaded with pictures[9] to the canvases collaged with drawings, they were all consistently structured by a paradoxical parallel process: the deconstruction of the individual image, the individual meaning, the individual content, and the individual depiction[10] on the road to constructing an abstract pictorial architecture made up of those very images, meanings, contents, and depictions.

This not only causes the figurations to glide into the abstract, it also generates the unhoped-for return of content, which peers around the corner from every nook and cranny of the abstract construction. As in a double image *[Vexierbild]*, the figurations suddenly show their abstract face, or abstraction shows its heart-breaking, ridiculously existential face: "From total abstraction to concrete reality in the abstract way of looking at it."[11]

With his Combination Paintings, the first of which could be seen in 1990 in Paris, George Condo went one step further.

The Combinations consist of several individual pictures and white canvases – all arranged into a single picture. The most diverse landscapes, still lifes, portraits, and their abstract hybrids enter into a compositional unity of incompatibles. They become building blocks in a constructive pictorial structure, which, in the balance of its individual fields, recalls Mondrian without having anything to do with him. Condo's formal sublimations of grotesque displacement are given a fresh, up-to-date clarity by the aesthetic distancing inherent in these geometric pre-settings. The combination form lies like an imaginary composition over the individual pictures that turn into abstract form-color elements. Our attention becomes focused on the brush strokes, the brush style *[Duktus]*, the painting effects. The impression effected is like the one produced when Georg Baselitz turns his subjects upside down. Painting becomes openly visible as painting. The contents recede, and the viewer is forced to see painting per se and to yet again take up the threads of their reality-import from painting. Condo once again reactivates art's formal law, according to which the only things that count in artworks are the contents that speak from their formal structures.

Of special significance in this connection are the white canvases painted in very different tones of white. They look like window openings, the fall of light, restful zones, room dividers, or simply a board on the head. They are the white square from which painting comes and to which it keeps returning. Condo integrates them as forms for the impossibility of painting and as beginnings and end

points of the spiritual opening – at once ironic, melodramatic, and constructive. Condo's white tones communicate his "nothing is important" to Malevich's religious white.

As the care with which the white canvases are painted shows, the Combinations function only when each picture also functions individually. In this way, Condo devaluates the overevaluation of the individual picture as the surrogate fetish of a long-lost identity but simultaneously preserves the fetish by suspending it in the combination. Indeed, the Combinations allow him to formulate the fetish by throwing all caution to the winds; they also enable him to pursue the different and partly contradictory (painter-)Ego variations in the individual picture at all costs and at the same time have them in one picture: "All sides of the same head in different ways at the same time."[12]

The crux of the Combination Paintings is that Condo makes the constructive deconstruction undergo a further structuring, so that the figurative abstraction appears on a new level of abstraction, where representativeness, reality, and soul once again seem possible, precisely because they are visible in their painterly abstractness. Condo liberates the figuration in abstraction without for even one moment challenging the fact that painting cannot not be abstract. And that is how he rids himself of the problem.

He himself calls his abstracted figurative abstractions Tristructural Painting. And indeed, the Combination Paintings are third abstractions, which can shit on the third nature of our cultural indifference landscape by opening a rectangular hole in the visual catastrophe of so-called reality. Through this hole, "the light from the other side"[13] falls momentarily through a crack in the door of hyperreality, and the ass-end of the world becomes visible.

Condo's Tristructural Painting post-nondeconstructively catches up with modernism's erroneous ways, which, as is well known, abruptly ended in paths not taken.[14] Condo has thus created an existential ornamentation that drifts into harmonious disharmonies and, as paradoxical as it may sound, makes reality in painting possible again because this existential ornamentation is full to bursting with abstract figurations of possible paintings. George Condo is well on his way to rediscovering "the energy flowing through the current,"[15] an energy that does not dissolve into discourse and is inseparably bound up with the reality-import of form. And one of its preconditions is to be found in the demonic complicity that the painter must tap within himself if he wishes to "create a soul," knowing that it is only one if it contains the knowledge of soul-lessness.

In my opinion, George Condo is successfully reinventing an art of painting that is nothing less and nothing more than a model of freedom.

The end: In the post-nondeconstructive painting *Vanitas I*, we see, among other things, a death's head which both laughs and is frozen to a shriek and that eyelessly gapes at a candle that both burns and is dying out.

But I do not wish to bother you here with a description of a painting. In this

context, I merely want to tell you that the Spanish Baroque artist Valdes Leal went unrecognized in his era because his brush strokes were too crude and his pictures too "unfinished" for the prevailing taste of the time. In 1671 he did a painting for an old-age home in Seville: standing amid symbols of power, wealth, art, and science, Death snuffs out a candle, above which these words are written: "IN ICTU OCULI" – which more or less means "Open and close your eyes simultaneously."

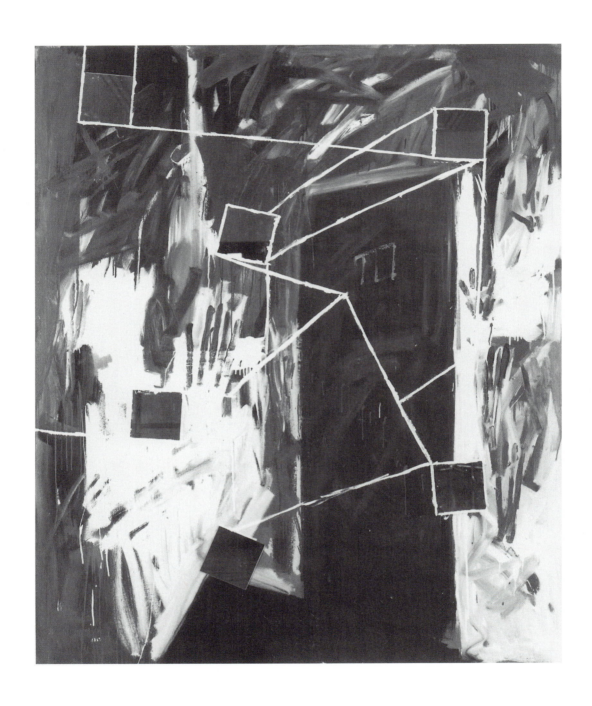

Albert Oehlen. *Kotzimmer,* 1982. Oil, varnish, mirrors on canvas. 190 × 160 cm.
© 1997 Max Hetzler Gallery, Berlin.

ALBERT OEHLEN: BEAUTY IS A RARE THING

Albert Oehlen, who was born in Krefeld in 1954, is one of those few painters who, due to a misunderstanding about *wilde Malerei* are famous at the beginning of the eighties but leave this cliché successfully behind them and show in their works that the critical name-calling assigned by provincial reviewers is not always as fortunate as the coining of "Impressionism" over one hundred years ago.

Albert Oehlen spent his childhood in the lower Rhineland. In 1972 he took part in transforming a UFO Club into a local KVJD (Communist Youth) in Krefeld. In the middle of the seventies he went to Düsseldorf, where he got a trainee's degree in bookselling and collaborated in setting up several Maoist factions. In 1976 he founded a League for Combating Contradictory Behavior together with Werner Büttner. In 1978 their joint painting came about: *(One day We Will Nail Their Windows Shut and Let in) The Light from the Other Side.* This picture marks Oehlen's venture into reinstating the art of painting, once again claimed to be in its death throes. In 1981 he, together with some friends, set up the "Church of Non-Differentiation." And in the same year he had his first solo exhibition in the Max Hetzler Gallery in Stuttgart, entitled "Before you paint, I prefer to do it."

At this point in time (1980–1981) you could already (if you wanted to) see that Oehlen's paintings had very little to do with the return of expressiveness, of a cheery, feel-good form of painting or an aesthetic of *Gleich-Gültigkeit* (indifference/equal validity). *Wahrheit erschlägt Kunst (Reality Slays Art)* is the title of an early painting, whereby it was already clear in 1981 that the aim was not to create a narcissist paintbrush eroticism in oil but to make painting possible again by letting it take on contents that painting per se is not able to express, for example, all the (im)possible (in)significancies of late-capitalist identity myths and the woe of all the discursively argued ideological assurances and welfare-state scenes. And because art – from the highlights of the ensouled line to the art-to-life transference illusions – had become so deflated through its takeover by society that what was seen as the most complete, most decorative, and seemingly most reactionary medium proved to be the most timely: oil on canvas.

At the beginning of the eighties, the use of oil on canvas as a means of communication sprang from the conviction that painting as a form had a necessity beyond any personal, expressive drive and today must not only be authentically but also tactically to the point. Oehlen dedicated himself to painting, fully aware that the gesture of taking up a paintbrush entails a certain worldview, including all its implied values. If you wanted to verify painting all over again from within and avoid a mere rerun of its already sufficiently old-hat cult of genius that vegetates nostalgically in its oily diarrhea (see neoexpressionism) or pallid whimsy, then this awareness must be brought to expression, that is, not only a worldview but, above all, a reflection on the conditions for the possibility of painting in relation to so-called worldviews. Thus, it was foreordained that Oehlen would tax art with an aggressive self-reflection. Painting was to re-create itself by catching up critically with the Conceptual Art of the seventies. *Indicate Right and Turn Left* was the name of one of his first catalogues, thereby formulating a strategy: that of reevaluating painting to an up-to-date means of questioning art today and, simultaneously, of further developing it.

A basic prerequisite for this is, as usual, the responsibility of form, a criterion that goes back to Sartre, Adorno, and Malraux. Which means that, on the one hand, no obsession exists in painting without an obligation. But, on the other hand, it also means that thematic radicalism in painting is not to be found directly in its thematic contents, discourse, or ideology but is a question of form. When I see a picture, I want to see what it has to say as a picture. What counts in painting is only what its facial structure voices. Everything else is something else, namely ideology, discourse, illustration, and other forms of currying favor with the world of the petty bourgeois. Form suspends ideology, but its substance exists only in that which voices its contents by way of formal structures. If painting cannot be satisfied with merely serving the system (which we are part of) with exchangeable picture cards (which it first made a must to radically challenge), then the sublimation of form becomes its mission. Only when it completely fulfills its own formal code can painting do justice to its (e.g., political, critical) responsibility.

Easily said and seemingly self-evident, but this was not at all the case in the eighties. Oehlen found himself confronted with a situation in painting in which private, fetishist formalisms were sold as sublimity, in which painters fell into the trap of their soul's own mock-up while, on the other hand, negation fetishists flattered the system with critical (i.e., glorifying) collages of cultural garbage and satirical-ironical (i.e., cosmetic) illustration, and conceptual design aesthetes made do with letting ersatz art signs circulate elegantly on phony installation sites.

Oehlen reacted to such phoniness and mindless dead-ends by placing the questionability of painting at the center of his art. For example, the questionability of the political effect of painting and of the variations of its failures: "Expand knowledge through failure" (A. Oehlen). Or, for example, the question whether painting could perhaps show the authentically nonauthentic in its theater of lies, the question as to the difference between painting as glorification and painting as criticism and the discursive and context-dependent procedure of naming, from which this difference arises.

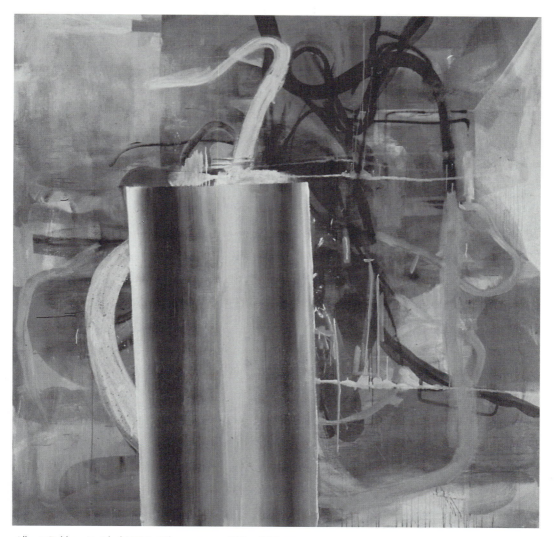

Albert Oehlen. *Untitled* 1994. Oil on canvas. 200 × 200 cm.
© 1997 Max Hetzler Gallery, Berlin.

From 1982 to 1984 Oehlen did the *Spiegelbilder* (Mirror Paintings). He pasted mirrors into paintings of rooms and thereby seemingly reflected the space behind by holding up a mirror to the surrounding room and, at the same time, fragmented the perspective of the picture plane. By drawing his own conclusions on the bottom line of illusionism, he raised painting's illusion to the second power. Picture-plane illusion and the deceit of social realism are thus swept away with the means painting has at hand. The paintings are called *Ofen I (Oven I), Im Museum I (In Museum I), Die Wahrheit liegt in der Wohnung (The Truth Lies in the Apartment), Teppichgeschäft I (Carpet Store I)*, and *Kotzimmer (Dung Room)*: painting as an execution of fictions that exist in dung cells and private homes. The example of the illusion of a prison cell smeared with excrement not only makes the decline and misery of public and intimate rooms visible. It is the dead-end of representation, in which the viewer, no later than when he catches a glimpse of his own face in the mirror in the picture, is confronted with the famous pairs of painting's contradictions (such as art/reality, presence/representation, beauty/ugliness, form/content) as they are ridiculed by the artist.

Oehlen's *Spiegelbilder* show that painting is always in the paradoxical situation of being, on the one hand, a deceptive luxury (especially today when it imagines itself to be critical) but, at the same time, has at least the possibility of being the stand-in for nonidentity and/or for what Ernst Bloch called *Vor-Schein* (the other side of art's negation insofar as the anticipation and longing for a "not-yet" [*Noch-Nicht*, E. Bloch], inherent in form as a *Vexierbild,* comes about), which seemingly anticipates its own repeal as art. Painting succeeds only where it plays out this paradox and where the form the paradox takes is kept under tension. Whenever the attempt is made to decide this contradiction unilaterally in order to evade it, naivety and/or cynicism take over.

Painting is neither complete rejection nor complete affirmation of that which is. It is simultaneous rejection and affirmation and, for that reason, can hardly avoid being forever torn between them. The painter wanders between two abysses (between anything goes and propaganda) and is spanned between rejection (questioning the whole) and affirmation. Painting possesses truth only by manifesting its contradictions, which is why it always pays the price of *Schein* (illusion/appearance) for its truth content, but a truth it first gains through *Schein* (appearance/illusion). Painting that copes with this paradox makes the part it plays in delusion visible as such. A painting should therefore consist of the so-called world and, at the same time, of its own delusion/illusion. No painting without enchantment, though its magic arises from disenchantment. No painting without beauty, but it triumphs only by casting beauty out in the knowledge that, for beauty's sake, no painting can be meant to be immediately beautiful.

"Art must be as ugly as the circumstances are," Oehlen says. This fittingness is only achievable, however, insofar as it radically structures (i.e., clarifies and resolves) its "aesthetics of resistance" (Peter Weiss). What the illusion and appearance *[Schein]* of sublimity once upon a time promised is the legacy of the sublime that art today has taken up, namely, the art of resistance as undiluted negativity,

naked and nonillusory. Thus far, contemporary art is in accord with Kant's understanding of the sublime as being the resistance of the mind *[Geist]* to prepotent nature. The aesthetic resistance to prepotency (of the second nature [culture] and the third nature [virtuality]) in the form of art is called on to develop and (de)construct a voice for the above-mentioned paradox. It is in this way that art today participates in the work that leads to an impossible beauty. An allergy to an art that is one of the hollowly sublime is more justified than ever. Adorno already knew that the sublime in art is only latent and always on the brink of the ridiculous. Could it be that art's latent sublimity is attainable only as a comedy on the tragic (individual)? If this is so, beauty (which is never achieved but always striven for, always a becoming never a being) could become the presence of this latency. Work on beauty understood in this way is what in the end might remain of contemporary art, from whatever varying or contradictory perspectives it might be seen in his-story of art.

There in the paradoxical quality of a beauty with no cosmetic beautification (which art can be only if it simultaneously copes with its programmed failure) lies the quality of Albert Oehlen's *Spiegelbilder* that he called "Procrustean," referring to a story in Greek mythology. As a form of punishment Procrustes had many offenders squeeze themselves onto a bed and let everything that protruded over the edge be cut off. That is how Oehlen treats content and illusion, using his canvas as a lethal bed. This is one of his strategies on the road he takes toward beauty as resistance, exemplarily (re)presented in the paintings *Abschaffung einer Militärdiktatur (Abolishment of a Military Dictatorship)* and *Raum für phantasievolle Aktionen (Space for Imaginative Actions)*.

Albert Oehlen is at work on a kind of painting for which art as the deconstruction of an art that deconstructs the deconstruction of meaning and representation is already the norm and is therefore a prerequisite that needs altering. The aim is impossible beauty, and with it the challenge to emerge from the one-way street of an art of (post)conceptual farewell parties (held to celebrate critical art's disappearance) by this attempt at post-nondeconstructive painting: "Beauty will remain, it is the only thing capable of following a strategy," as Albert Oehlen notes. And again: "Here you can see that beauty is not something static but constantly seeks to redefine itself by its longing for the end of art."

Together with his art works, Oehlen's writings (these are, along with his texts on the status of art today, publications in collaboration with the German writer Rainald Goetz), his work as an editor (for instance, of a publication on "situationism"), his readings and performances, and his publishing work (in 1985 he and Werner Büttner founded the *Meter Verlag*) show him to be a highly reflective artist, above all, one who reflects on the impossibility for political art and who despises in art any fear, loss of freedom, deception, or moralistic showing-off.

This becomes especially clear when Albert Oehlen speaks of the way the artist feels responsible for God and the (poor and repressed in this) world using the example of Picasso and Dali. He also speaks of what he calls the "Sting effect," the fatal cynicism of a standpoint that calls for Sting's dressing in Indian costume when

among Indians, gratified by the moral uplift from the aura of ethnosocial commitment but only, in the end, involuntarily reproducing the racism he sought to combat. The artist cannot speak for the Palestinian or the Bosnian. He can only make his work as good as possible. And since every car accident has something to do with the Gulf War, also art is a contribution to a change and/or a perpetuation of the system, like any other gesture that stands for itself and thereby at least articulates the conditions for the possibility of a voice that speaks for itself, its difference.

In March 1984 a catalogue was published to accompany the exhibition "Wahrheit ist Arbeit" (Truth Is Work) (together with Werner Büttner and Martin Kippenberger). It contains an extensive essay in which a pseudo-scientific triangle is constructed between behavioral science (K. Lorenz), analysis of social situations (E. Goffmann), and "The Logic of Scientific Discovery" (K. Popper). It is the attempt to get at the relationship between art and reality once again by means of their possible radicalness and responsibility. This is followed by several texts in which Oehlen deals theoretically with his painting of thematic resoluteness, that is, a type of painting that is thematically so overloaded with references to (wretched) reality that their contradictions as subjects of painting are depicted while, at the same time, its art becomes visible as art. This double strategy (the thematic overloading of art along with the simultaneous playing out of its contradictions) in Oehlen's painting during the eighties becomes manifest in the paintings as the tension between truth and falsehood.

On a painting from 1985, in which the detail of the antlers of a belling stag [a frequent motif in German kitsch art] can be seen, the words are inscribed: "money or culture?" The picture as image is naturally a part of culture, but the artist not only poses the question that "stands" in the picture but his artistic reaction provides the painting with a form of consciousness that expresses the (im)possibilities of any answers in the form of painting. The picture's title is *Kultur (Culture)*. Altogether it is "art-is-art-art" (A. Oehlen), but the process of its constitution touches on much nonart, the perception of which does not remain unaffected.

Kultur is not the only painting in which phrases appear. But these are not meant as statements and also not as abstract calligraphy (very often a colonial exploitation of, above all, Asian scripts for a specifically Western art effect that ignores the meaning). As painted terms, they become part of the painting itself. In Oehlen's pictures the painted word-concept has an abstract quality just as the non-figurative (conventionally perceived as abstract) components have a conceptual quality. Thus, Oehlen's work can best be described by the oxymoron "concept painting" (to be distinguished from conceptual painting). "I try to formulate certain terms in my pictures. I try to force the term, for example, 'smear' or 'shit' or 'blur' or 'fog' on the viewer. My goal is for him not to be able to get away from having the word 'smear' in his head" (A. Oehlen).

Concept painting appears as the presence of negations, painted in many coats of glaze. Reduction to the essential and the elimination of the false and the deceitful stand at the center of Albert Oehlen's painting, which can also occur by portraying and reproducing the superfluous, the false, and the deceitful or by "subjugation of

the same" (A. Oehlen) by means of "distancing through lies" (A. Oehlen). This is one of the art-ful strategies by which Oehlen rips apart the manneristically veiled horizon of painting. In his essay "The End Brings the Turning Point," he correspondingly cites the falsest colors as his favorites, because they are "the only antidote" (A. Oehlen).

In the mid-eighties Oehlen drove his concept painting to even further extremes. His goal, determinate negation expressed in the form of painting, has the consequence of bringing him to the point of abstraction, or, rather, of so-called abstraction. What is traditionally perceived as nonfigurative he uses as a "figure" for concept painting. This conceptual inversion of abstraction he calls "post-nonfigurative painting." He proceeds from the discernment, in the meantime taken for granted, that painting cannot *not* be abstract, even when it retains the figure. Something that Georg Baselitz realized in painting by inverting the figure. Stood on its head, the figure is negated and invalidated, but at the same time preserved in its figurative integrity.

Oehlen confronts Baselitz's concept of painting, which understands the image as not nonabstract, with the mental exploits of conceptual art. What interests him here is, above all, the political implications of the conceptual formalization of the constitutive process of what and why and under which conditions we consider something to be art. And here he strikes conceptual art at its sore point, which consists of formalizations that are often in themselves not the clarified form of what the conceptual artist wants (his) forms to express; that is, they remain external to the concept or idea and thus are merely illustrative. They are therefore as form not required, or in relation to the thinking invested in them, unnecessary and, in the end, superfluous. "Conceptual Art's Achilles' heel is the neatness of its presentation" (A. Oehlen).

Oehlen's post-nonfigurative painting is a painterly continuation of Conceptual Art. With it Oehlen goes a good step beyond the sufficiently rehashed debate on abstraction/figuration and form/content and justifies his place among today's few painters who paint at the peak of what is presently imaginable as social responsibility of form. Oehlen's painting is determinate negation in oils. It says nothing other than what the painted diagram itself expresses as thought. It is what it is. And it proves itself by the degree to which what has been thought through has been painted through and the degree to which it simply stands for itself. "I've been particularly concerned with evidence – with not seeing anything in the painting other than what's actually there. Nothing is codified – a mess is just a mess" (A. Oehlen).

Oehlen's concept painting should not be understood as materialized word analogies or as coded visibility. He knows that painting is only the drama of something insofar as it is the drama of nothing. It is a question of the unfolding of the specific world of painting with its carnal essences, its actualized resemblances, and its mute meanings. As always it is a question of evidence: thinking becoming itself (its difference) in painting, the conceivable aroused to paint: "to think in paint" (Cézanne).

Albert Oehlen takes up a thread that has often been interrupted since Cézanne,

but never quite broken off. But he did not take it up as regards apples, landscapes, nudes, and still lifes but as a necessary attempt to articulate the consequences that are the result of the critical self-reflection of art, not in the form of Conceptual Art clichés but in the form of painting: painting as diagrammatic thinking, painting as painting-as-concept, painting as a determinate negation of painting, painting as a formulation of the impossibility of painting. "As long as painting's refutation can still take the form of painting, painting has not been refuted" (A. Oehlen).

But where painting *is* this way – where it, for example, *is* the form of its own impossibility, that is, the impossibility of painting as purity, expression, political objection, original creation, as something new, as critical criticism or whatever – it could be that it simultaneously fixates a *Vexierbild* (double image), that of a demand for possibilities or, formulated with more pathos, of a demand for freedom. And this is the case here. Oehlen's paintings are the autofigurative painting of possibility, distilled from the visibility of its impossibility.

What in an interview he called autonomy is exactly that. The result of the elimination and negation of all conceivable mystifications and illusions is not pure negativity – a further illusion that is negated in Oehlen's painting – but clarified negation that also includes the negation of clichés about clarity (which is often confused with geometrical and other seemingly uncorrupted forms). Where this sore point of determinate negation is present in the painted diagram, you have what is meant by beauty as a voice of the latent sublime. "Beauty is a rare thing." (Ornette Coleman)

Albert Oehlen. *Traum,* 1997. Inkjet print. 202 × 151 cm.
© 1997 Gisela Capitain Gallery, Cologne.

Pragmatical Aprèslude

Michael Krebber. *Les bisch ja nich im Stich V*, 1992. Oil on canvas. 92 × 73 cm.
© 1997 Christian Nagel Gallery, Cologne.

"BLINDMEN, THROW AWAY YOUR CANES"[1]

A DISCUSSION WITH ART COLLECTORS ON "ARS PRO DOMO" AND SO-CALLED ART AFTER ART

Collector (C): Mr. Dickhoff, in "Ars Pro Domo"[2] you have put the artists' generation of the eighties on show, a generation to which you yourself belong. You have over the years accompanied these artists in exhibitions, catalogues, books, and other publications. You have very close contact with them and insight into their work. The unusual choice of title broaches many questions. Does it anticipate a definition of the exhibition?

Wilfried Dickhoff (D): The title is, first of all, meant to name the exhibition and not to identify its thematic content. It also is not intended to signify an overriding concept. The content of "Ars Pro Domo" can be found in the form/content of the artworks themselves. But in considering the possibilities of interpreting "Ars Pro Domo," one should keep in mind the felicitous correlation between this exhibition and the unusual constellation characteristic of the art scene in Cologne. *Ars pro domo* means "art for the house," one's own house and one's home and all one's homes with all their rooms – be they mental, intellectual, psychosomatic, museum rooms or everyday rooms – in which "you yourself" qua art search for a domicile. And, by way of a hint in another direction: there is one painting by Georg Herold entitled *Ars Pro Deo (Kölner Dom)*, which directs your attention to the simultaneous desire for transcendence and a *House and Garden*-type life in art. However, I would prefer not to dwell any longer on this point but would rather leave it up to each individual to wander on his own in the semantic field mapped out by the constellation of the artworks.

C: Where is the thematic emphasis of Ars Pro Domo to be found?

D: *Ars Pro Domo* is a small and concentrated portrait of my art generation, selected from the contents of art collections in Cologne. "Ars Pro Domo" is an attempt to show the specific qualities of this generation in a small condensed version. "Ars Pro Domo" is therefore not an exhibition on art collecting in Cologne but rather an exhibition essay with excellent pieces from private collections. With it, the active influence of the collectors in forming the signifi-

cance of the art scene in Cologne becomes part of it. But this, of course, also says something about the import of the art market as it influences exhibition making in general.

C: What do you mean by this?

D: Every museum exhibition today is to a great deal dependent on what is and what is not on loan. By limiting this exhibition to Cologne's private collections, I make this limitation part of the exhibition. The subtitle of "Ars Pro Domo" is a sign for the presence of the art market in the way art can be presented today.

C: You emphasize the extraordinary character of the art scene in Cologne. You were born in Cologne and claim to be a child of this scene.

D: Yes, that is correct. But I must add that it is not clear to many non-Cologners, and even to many Cologners that Cologne has grown in the past few decades to become perhaps the most important art scene next to New York. For artists, critics, collectors, gallerists, museum curators, and art book publishers, as well as for all others engaged in some way in the field of art, Cologne has taken on the role of a platform from which crucial impulses emanate concerning what counts today as art, as well as what will count as art tomorrow.

C: How did this come about?

D: There are many reasons, which I can't go into now. It began, so it is said, with the trade in relics during the Middle Ages, which was centered in Cologne. Apparently, enough "true" relics changed hands for the pope to impose a ban on further importation. This means that in Cologne art of the highest quality has always gone rather freely hand in hand with its trade.

C: Is the art that is created, shown, traded, and discussed in Cologne also represented in the private collections of Cologne?

D: Yes, in a quantity and of a quality that continually surprise me when I visit the collections.

C: The focal point of the exhibition "Köln Sammelt" ("Cologne Collects"), which the Cologne gallerist Rudolf Zwirner organized in 1988, was on the high-quality established art of the fifties and sixties. In your exhibition the emphasis is placed on the younger generation of the eighties. How would you describe the age of your generation?

D: It, of course, isn't determinable purely by the year of birth; quite apart from the fact that "generation" is, primarily, a question of attitude, although attitudes are not necessarily dependent upon a generation. The large majority of artists who are shown in "Ars Pro Domo" were born during the fifties, had their formative art experience in the sixties, and then went on to commit themselves in the course of the seventies to art. For more than fifteen years now their work has been hanging in many galleries and museums in Europe as well as in the United States, and they are at the very seat of discussion about contemporary art as it is documented in international art magazines. Their artistic development is

closely tied to the Cologne art scene, and many of the most renowned artists of this generation are leading personalities within it. For example: Rosemarie Trockel, Walter Dahn, Hubert Kiecol, Georg Dokoupil, Martin Kippenberger, Siegfried Anzinger, Andreas Schulze, and Georg Herold – all living in Cologne. But also international artists like Cindy Sherman, Philip Taaffe, Franz West, Mike Kelley, George Condo, Richard Prince, the pair of artists Peter Fischli and David Weiss, Robert Gober, Günther Förg, Jenny Holzer, and Albert Oehlen, all of whom, though not living in Cologne, have over the years been present here, not only through their works and their galleries but also personally.

C: With "Ars Pro Domo" comes *pars pro toto*, that is, Cologne as a city of art whose international prominence has been formed by its close connection with New York. How do you account for this aspect?

D: Cologne also has collector initiatives with Paris and Madrid as well as with London and Italy. For my generation of artists, with which "Ars Pro Domo" is primarily concerned, however, the transatlantic tie, with its priority for the German-speaking countries, is the dominant one. This can be seen in "Ars Pro Domo," but only insofar as it doesn't contradict my knowledge or convictions.

C: Are the activities of private collectors in Cologne tied closely to the most engaged gallerists in Cologne and to Art Cologne?

D: Yes, but to international galleries and fairs as well. I should add here that, for a long time now, collectors have been taking part not only passively but also actively and constructively in the discourse on art. The collectors' activities in Cologne are part of a lively interaction in which the artists, their supporters, and their opponents form a hub with supporting and adverse axes leading out of the city in all directions.

C: Exhibitions are often judged by their unifying concept. Could you say something about the concept underlying "Ars Pro Domo"?

D: I view overriding concepts for exhibitions rather critically because of the tendency for art works to be used in such cases as illustrations for preconceived ideas. I take the art pieces that I show seriously, and don't like to hide them behind ideas. "Ars Pro Domo" is a welcome opportunity for me to compile an exhibition on the basis of the quality of the individual pieces of art, and this could also be an opportunity to discuss the exhibition from this perspective. In other words, the selection and constellation of the works displayed here are the conception of this exhibition.

C: What criteria did you use in selecting the artists for "Ars Pro Domo"?

D: Gottfried Benn once said: "The opposite of art is not nature, but good intention." And this criterion sifts out quite a few. This means that "Ars Pro Domo" is an art-critical statement and not a balancing act between my convictions and the priorities of the Cologne collectors. I intend to exhibit in an exemplary way the most important attitudes and, with few exceptions, the most original artists of my generation in a small, condensed selection – no more and no less. The

fact that this is possible turns *Ars Pro Domo* into a compliment for the Cologne collections as well as for the entire Cologne art scene.

C: Could you name some exceptions?

D: The most significant Italian artist of my generation, Francesco Clemente, has not been collected – apart from a few beautiful small works on paper during the period when Paul Maenz showed him. Other exceptions are Julian Schnabel, Tim Rollins and K.O.S., Cady Noland, Haralampi Oroschakoff, and Michael Krebber.

C: What is your feeling for the reason these artists haven't been collected in Cologne?

D: Michael Krebber, who, by the way, lives in Cologne, has not yet been noticed and bought by the Cologne collectors. Perhaps the reason is that he allows his works to be sold as art only to the extent that they function as an extensive contemplation of that which, when, how, and why count as art. Tim Rollins and K.O.S. form a collective built upon a teacher-pupil relationship. In this case, it is difficult for the collector to impute to their work the still popular myth of the creative individual. This problem was also one that confronted the *Mülheimer Freiheit*, since they painted pictures of multiple Egos during the early eighties, thereby contributing to the disintegration of the bourgeois art Ego. What one indeed finds almost exclusively in the collections, however, are pictures attributable to the "individuals" Hans-Peter Adamski, Peter Bömmels, Walter Dahn, Georg Dokoupil, Gerhard Naschberger, and Gerhard Kever. Julian Schnabel, David Salle, and Francesco Clemente have always been too expensive for the younger collectors. And in the older collector echelons one can sense an aversion to the successful younger artists, which has made the quality of their work virtually invisible to many.

C: Have you noticed differences between younger and older collectors?

D: The Cologne collectors have tended to collect the art of their own generation. Almost all of them also have works by older or younger artists, but the priority is clear. Older collectors often have many pieces by a few artists, younger collectors prefer fewer works by proportionately more artists. This is a tendency that has been influenced by price developments, but also by different attitudes. Almost without exception, collectors under forty do not consider themselves collectors. Not because they don't possess enough art but because they feel that the notion "collector" is inappropriate for their way of living with their art. This, however, is a broad topic that *Ars Pro Domo* doesn't explicitly deal with.

C: Have you noticed any financial limitations on the acquisition of artwork with the Cologne collectors?

D: There aren't any. There are, however, limitations in consciousness, in perception, in devotion to art, in the need for compensation, in thinking. And there are those caused by fear and/or angst. However, there are also processes at work here that are normal. For example, a tendency to an aesthetic self-confirmation arises when you buy from young artists only what fits in with what you bought in your own generation. In other words, someone who is now fifty and col-

lected Cy Twombly finds himself attracted by works in the new generation that look like Twombly, often only watered-down versions of the original and far removed from the specific contribution of the younger art generation.

C: You haven't included in your exhibition artists like Georg Baselitz, Gerhard Richter, Sigmar Polke, and Anselm Kiefer, who were omnipresent in the eighties.

D: You have named some very good artists. I myself consider Georg Baselitz's latest paintings and sculptures to be especially very fine works. But in this connection you have forgotten A. R. Penck and Imi Knoebel, for example. First of all, these are not artists of my generation. Sigmar Polke, Georg Baselitz, and Gerhard Richter were even, in some cases, their teachers. Second, I believe that the time has slowly come to concentrate on the specifics of those artists who are approaching the threshold of their mature work, not as professed in theory but as can be seen in their works, as speaks from the form they use. And this remains – partly due to the unbearably indifferent matter-of-courseness of hypermodern art effects in the eighties – still largely unknown.

C: The artists of the eighties that you show are known for their large formats and their spacious installations. Can you do justice to them in the limited space at your disposal?

D: I can't do justice to them and don't choose to. In "Ars Pro Domo" I don't show large spacious installations but focus on the individual paintings, sculptures, objects, and photographs. As curator, I like to stand back behind a constellation of artworks that themselves allow you to see what they have to say – through the manner in which they attract or repel, confirm, elucidate, or question one another.

C: The special aspect of your exhibition is certainly its intimate character. We have become accustomed of late to megaexhibitions. What is the advantage of a smaller, more intimate exhibition?

D: I have nothing against large exhibitions. The criticism against them, which the art scene appears to agree upon, seems too fashionable for my taste. The advantage of a smaller exhibition is that one can't revert to the pseudoaura of over-staging or mood-creating bluffs, so that the specific quality of the individual works takes on more importance. It's not easier. In fact, it's an advantage that is coupled with more risks, especially when dealing with relatively unknown artists. But this is precisely what interests me.

C: We are in the *dokumenta* year of 1992. We have Jan Hoet's list of artists on hand. In looking through it we noticed that only ten of your artists are also participating in Kassel.

D: The majority of the most interesting and characteristic artists of my generation cannot be seen in Kassel. But that is normal.

C: You speak of what is characteristic for your generation. What is characteristic of these artists?

D: First of all, it is what the works have to say by virtue of their form, and I am not prepared to replace this – and this is what art is all about – by any theoretical standpoint. But I can say something about the changed political conditions from which we started out at the end of the seventies and the beginning of the eighties. It was a situation in which we were caught in a network of appropriation procedures and confronted with the growing immanence of a symbolic order. You found yourself incorporated into the establishment at the very moment you were revolting against it. Appropriation was no longer something that one could avoid but something that at every step you took had already taken place. Even art no longer stood outside society as the Other, as that which undermined the identity of the establishment, as the incarnation of deviation from all norms and normalities. On the contrary, much of what others (and even you yourself) had seen as rebellious subjectivity or as the authentic turned out to be an authenticity mock-up, and many well-intended efforts at critical or meta-artistic or political art revealed themselves to be a reproduction of that which they thought to have distanced themselves from or have overcome. And this applied as well to the intentions of a highly responsible Conceptual Art reduced to minimal signs of self-reflection that confronted young artists during the seventies as an academic status quo, as an institutionalized norm. The hopes for change that are linked with art turned out to be insincere and in many cases deceptive. A fog of postideological interchangeability and indifference had arisen in combination. And it was this situation that my generation had to face.

In this changed situation, the good old forms of provocation, opposition, resistance, protest, deviation from the norm, criticism, and subversion were no longer effective. New ways of artistic opposition had to be found. From the very beginning these new means of revolt had to have an in-built veto against itself, which was misunderstood as irony.

C: The precipitous development in the market often made the works of these artists appear fashionable, cynical, and affirmative. Aren't they just that?

D: In an atmosphere of indifference that tends to neutralize all the differences – which was in part brought on by a whirlwind development in the art market – art can no longer not be all this. But it is all the more important that art not just be this. For this reason, attitudes and strategies are necessary that don't just harmonize the contradictions under an avant-garde facade, but play them out. A behavior directed against the self that is not without humor and that systematically breaks down every longing for unity or identity, for example. Or formulations that carry their own negation but, at the same time, take the risk of an impossible artistic statement, which means the assertion of an answer where there is none. There is no outside to the system, including the "system" of simulation. Even the Other to the system turned out to be merely the reverse side. This even applies to the hope attached to madness and schizophrenia. Artistic resistance today probably depends on the level of humor adequate to the awareness of the impossibility of artistic resistance. As Gilles Deleuze once

said, "There is no understanding. There are only different levels of humor." In the end art exists either in this difference or not at all.

C: There was a time when, politically speaking, art was leftist. Where does it stand today?

D: Since the end of the seventies, at the latest, we have no longer been able to pretend that there is a clear concept of goodness which is subscribed to simply by deciding to dedicate your life to art. Any artist who believes he is sitting on the bough of authenticity, or in the cerebral convolution of pure negation that disappears somewhere between the brain's hemispheres, or in the pub of solidarity with all the underprivileged of the world (luckily dying in some far-off place), or in the crypt of spiritual subjectivity has been beguiled into stupid insincerity, mental deception, sentimental political self-adulation, or a spiritual mock-up. It might be a consolation to convince yourself that you are on the side of the good. And many critics and curators (not so often collectors) allow themselves to be gratuitously misled by conventional reassurances: in the name of what Jacques Lacan called "the good, please don't touch." This is, however, neither honest nor even moderately intelligent. On the contrary, it reinforces illusions that only weaken the contribution of art to the situation.

C: But what is the contribution then, if art is to be uncritically consumed and accepted by society as was the case in the eighties?

D: The acceptance that was in the eighties handed to my generation by the boom in the art market wasn't, in fact, acceptance. The artists who mistook the ringing of the cash register for acceptance quickly became cheap caterers to a cynical situation that the serious artists of my generation deliberately opposed. So-called acceptance is part of the more general indifference to forms, styles, and interchangeable images that these artists had to cope with in their own persons before they could even begin to operate with forms and colors.

As different as the works are that the individual artists in the end developed, what they have in common is, first of all, the knowledge that each and every one of them, no matter how resolute and contemplated, has a deceptive side, and second, the aim of articulating this knowledge. The point is, and always has been, to produce beauty as resistance, which doesn't harmonize the antinomies of art and life but shows them in their implacability and parallelism. And this requires, first, that you perceive, reflect on, and endure the fundamental irresolution of the situation. An artwork that smells of discursive reassurance – in other words, clings to a system of references that provides an illusion of harmony and a coherent identity – is an insult.

C: What new attitudes would, then, in your opinion, be more appropriate to the complexity of the situation?

D: What is at stake are new forms of artistic integrity, sincerity, and presentness. On the way here, within the course of the past ten to fifteen years, many double strategies, intentionally paradoxical attitudes and other productive "false

tracks," have been tested. The strategy of taking falseness, kitsch, embarrassment, mimicry, lies, and deceit in art to the second power is something that, above all, Georg Dokoupil and Martin Kippenberger have made unforgettable contributions to. The intensity-program of disdain for all worn-out styles and ideologies, the blatant overtaxed content of the picture, the semantic opening up of abstraction, and many intentional paradoxical strategies that one could superficially describe as nonaffirmative affirmation or non-negativist negation can be mentioned here. Art became a possibility for the very reason that one knew that art was no longer possible. Just because (post)modern art was at its end, its ways and means could be released for new forms and, above all, for new meanings.

C: Have political or moral pretensions played a role in this?

D: Because art was at its end, it became an at least possible continuation of that which was at one time termed political engagement. But before overhastily priding oneself on morality, one tried to exert a certain amount of intelligence in order to avoid naivety, imprudence, and cynicism with the intention of arriving at as true a formulation as possible. Artists like Walter Dahn, Albert Oehlen, Rosemarie Trockel, Philip Taaffe, and Axel Kasselböhmer, of course, follow moral or, if morally necessary, immoral impulses, but only to the extent that knowledge of the insincere imprudence of moral art is present in the artwork itself. And here opinions differ. For anyone can pride himself on being moralistic in content.

C: Why is an artist like Felix Droese, who represented Germany at the Banal in Venice, not represented in this exhibition? As far as I understand, he has been collected in Cologne.

D: Are you sure that you want to ask me this question in this context?

C: Yes, why not?

D: Do you remember Felix Droese's work *I too killed Anne Frank*?

C: Yes, I do.

D: Then I would like to answer your question in the following way. There is one drawing by Albert Oehlen that depicts two tubes of oil paint. The label of one reads *I helped Felix Droese kill Anne Frank* and the other *I, too.*

C: Doesn't this drawing express a cynical attitude?

D: Apropos of cynicism. If one understands it as a conscious reaction to a situation in which one cannot *not* reproduce that which one deems no good, then cynicism is a first step. It creates distance to the cynical reality of which one is not only a victim but also a producer on an everyday basis. But cynicism doesn't lead to any artistic result. A good drawing is necessarily more, namely, a rejection of defeat, dependency, and injustice. And this also applies to the drawing I described. It isn't cynical but a modest attempt in a cynical situation to contribute to its clarification, before materials that can't defend themselves are put into the service of notions they can't measure up to.

C: And when is that not the case, according to you?

D: For example, Walter Dahn, one of Joseph Beuys's youngest students, has always seen his own work within the framework of Beuys's concept of expanded art and viewed it with skepticism. But he has focused on his quality of an intense poetic concentration of images and after the death of Beuys has agreeably abstained from pseudomagical installations. Since the middle of the eighties he has been working on, among other things, small silkscreen paintings in which he reduces the image to a figurative skeleton and deconstructs the "authentic" line by means of its technical reproduction without giving up its existential aspect. Indeed, it is through this technical distance that it becomes believable. These pictorial operations on the boundaries of painting are some of the most beautiful that have been done these past years.

C: A painting by Albert Oehlen is depicted on the poster for the exhibition and a photograph by Cindy Sherman on the cover of the catalogue. Can one take these two motives as exemplary poles for your artists' generation?

D: The complementarity of both these works revolves around an attitude axis without defining it. But is it necessary to explain this? A woman and a man, America and Europe, photography and painting. And in both cases there is a distanced and reflective Ego portrayed in the picture. But not as a self that imagines a need for portrayal. With Cindy Sherman, it is – as always in her work – a deconstructed Ego used as a model for photographically staging a non-individual theme by means of her own body. It is a photograph that she took on the occasion of an AIDS auction in 1987 in New York.

In Albert Oehlen's painting *Krankenzeichnen (Sick[ness] Drawing)*, the self appears in the form of a worn-out model of the painter's Ego. A person is depicted who on his sickbed is holding the abstract result of his illness in his hands. A false cliché of the insane genius that even then didn't fit Van Gogh and doesn't even come close to touching the extreme acumen of an Artaud. Albert Oehlen paints it as a self-portrait and thus makes the authentic abstract-expressionist painter ridiculous, using himself as an example. He articulates the death of the artist as an autonomous subject but without ratifying it. He records it in the form of painting that probes its boundaries anew.

C: Do you believe in painting?

D: Roland Barthes once wrote, "To create art means to consider the desire for the impossible reasonable." This is especially true of painting. It is a very questionable, indeed paradoxical, medium. For me, on the other hand – not least of all also for this very reason – it is of very special interest. It no longer represents realities, and the fetish of its presence has also shifted into neutral gear. When one creates a painting today, one knows that it is impossible to create a painting any longer and that when one feels, for this very reason, incited to paint one, this can't be reason enough, which on the other hand also changes nothing about the simple human faculty and about the continually experienced

necessity "to paint" or "to play the piano." Therefore, when one paints a picture in which one's awareness about the impossibility of painting is apparent, that, on the other hand, doesn't exhaust itself in showing itself as such, but rather appears as a staging of a semantic opening – to so-called life and its constitutive structures – one does so without indirectly mistaking this appearance for realism, indeed knowing that a painting cannot *not* be abstract but that it is still possible in the act of painting to go against the grain of its own voice. In this way painting not only has something to say to art and, therefore, functions as concept painting that has been worked out of painting itself, it also does not give in to magical-political illusions and doesn't lose sight of the theme, a theme that Picasso said is an undefined one which can originate only in painting itself. Then one perhaps comes close to the conditions leading to the possibility of painting today.

But what I am rather modestly leading to here will become, I believe, clearer in view of good paintings like *FN Romantic* and *Der Baum* by Albert Oehlen, *Stilleben mit Krähen* by Axel Kasselböhmer, and *Ein zerbrochener Tag 1* by Siegfried Anzinger.

C: Is there not something like a *basso continuo* of a hidden theme in your selection that serves as a criterion?

D: A focus on content as the center of attraction regardless of aesthetic loss was what served in the beginning of the eighties as the initial spark for a liberation in art. Important impulses have resulted from the systematic overtaxation of content. As such, it was, however, in most cases more a matter of experience than of result. Content richness in art can be tolerated only if it is nonillustratively transformed into facial structure. If this is so, then it is a criterion. But then it is no longer a content, but art. And this is the criterion. Which touches on what I have called the nonsurrogate, for which Günther Förg and Philip Taaffe provide good examples.

C: What do you mean by nonsurrogate?

D: The artist today can expose himself, even going so far as to pull down his pants; it still remains a surrogate of expression. If he knows this, then he can include everything that goes under the name of subjectivity. And here it begins to get interesting. It is here that the idiotic comes into play, that is, the manner in which one turns oneself into that which one was turned into. Jean-Paul Sartre termed it individualized generality. But however he may begin, the artist, now more than ever, cannot get around the fact that everything he does is, in principle, stigmatized as inappropriate, because the object that he makes public in his name is, on the one hand, a "nothing-but-art product" that exists in the scenario of the market, yet at the same time already asserts, as such, an (im)possible beauty and lays claim to freedom. This is why most of the products of art are so embarrassing, because this – even with the best intentions – doesn't show.

C: Why is this impossible?

D: It is a possibility promised by its impossibility, and this goes back to Immanuel Kant, who attributed to human reason the ability to formulate questions it doesn't have the competence to answer. This is not a bad description of the mental situation in which (not only) Europe has found itself since the opening of the East, and also the transatlantic art world. I am convinced that an art that faces the instabilities of the present sincerely and copes with them through artistic form is working on the conditions for the possibility of new competencies that may someday be integrated into the answers to questions that mankind must answer. A good piece of art is a small presumption in this direction. This I assert with the fundamental inadequacy of an artistic statement. But art is rare.

C: Doesn't this also apply to the meaning of art at a time in which – due to the opening of the East, to AIDS, to insurmountable ecological problems – priorities have clearly shifted?

D: I choose not to add to the discussion, quite popular at present, about the time-fixated *Geist* of the West and the timeless spirit of the East. The art of the Eastern European and Asian countries will begin to speak out ever louder and I hope also ever more beautifully. But this will happen on its own. It doesn't need our art-colonizing efforts. This is an important subject, but not one that is relevant to "Ars Pro Domo."

As to the other problems that you have broached and that are not at all new: catastrophe as a permanent condition in which we find ourselves, indeed, of which we are a part, has caused many artists to play out the scope of art much more precisely and to avoid context-ignoring, mindless crossovers. Art is also always wall decoration – precisely "Ars Pro Domo" – or landscaping, and this leads to a more realistic intercourse with the sphere of art against the background of a constitutive context and its possible change. This also is a contradiction that will be played out in a good work of art.

C: But this dialectic in art is also not new.

D: But this is not a dialectic. Nothing is being synthesized. Art today is simply paradoxical. The attitudes are interesting that deal with a situation (not only) in art that can no longer be subsumed under a uniformity of thought without erroneously prettying it up and that develop corresponding strategies and adequate forms of reaction. This demands, among other things, an open approach to the surrogate character of contemporary art, such as Rosemarie Trockel, Julian Schnabel, Cindy Sherman, Albert Oehlen, and many others display.

C: But isn't a picture a unity in the end, even if it is a contradictory one?

D: No. It is a deconstructive construction, an artistic resistance that encompasses its own deconstruction. This can be seen in the combination paintings done by George Condo. A good painting is simply beauty that doesn't beautify its own impossibility. This isn't at all complicated, as the works of Rosemarie Trockel prove.

C: Can you illustrate this with other examples?

D: Just look at the painting *Hell (The People of the Art World in Monet's Pond of Water Lilies)* by Marlene Dumas, Rosemarie Trockel's knitted work *Matrazen-lager* or the photograph *Untitled #179* by Cindy Sherman that we have already talked about.

C: "Ars Pro Domo" hints as well at the contemplation of contexts that help determine the meaning of an artwork. A picture can mean something entirely different in a collector's living room from the meaning it has hanging in a museum. Does the exhibition make reference to this?

D: Indeed. In the title, in the installation of the exhibition, as well as in this discussion of ours. However, I don't use the artworks as didactic material for the explication of shifts in context or meaning. The fact that (self)contemplation of their so-called contextuality is inherent in them and the fact that they don't exhaust themselves in illustrating this have, indeed, been a criterion for their selection. In "Ars Pro Domo" there are works that fulfill this criterion and refer explicitly to the constitution of meaning. For example, three photographs by Louise Lawler are shown: one on buying, one on possessing, and one on the reselling of art. In the first one, a nice detailed study of selling strategies *(This Drawing Is for Sale)* can be seen; in the second, the private living room installation of an American collector couple, and, in the third, two of Schwitter's collages marked with the appropriate red dots at an auction where also pieces of the collection shown in the second photo are up for sale. This is – considering the quality of these photographs – a commentary on the journey of collecting that also many of the works to be seen in "Ars Pro Domo" have made and have yet to make.

C: What meaning does art have for the collector in Cologne? Don't social prestige and speculation also play a role here?

D: A residence full of art is naturally also a place where that self resides that is attempting to find its identity, having no home of its own. The buying of art for the purpose of acquiring psychosocial identity through the cultivation of art possessions always plays a role in collecting. But speculating on speculation is only very moderately present. I do not know of a single Cologne collector who in the eighties really went overboard and now goes into the auction houses shaking with fear. As for the meaning art has for the collector and gets from the collector, there are in the catalogue a number of photos that I took, along with the photographer Simon Vogel, at the collectors' homes. Here one sees how work vanishes in context, sets itself against the context for its own purpose, recovers its senses through private installation, takes on unexpected meaning, and so on. In these photographs you see a lot of art's life in the context of *House and Garden.*

C: Can making private collections public have any effect besides increasing the value of the collections?

D: Most of the works shown in "Ars Pro Domo" have already been seen in a number of exhibitions, catalogues, and journals and have already attained their value in every respect. But besides this, I have nothing against increasing the value of good artworks. Reflecting on the difference between value and price – even in the strict economical sense – is a useful exercise. "Ars Pro Domo" could be another chance to do so.

C: You talk of the specific quality of art and that it should become visible. How do you intend to set the scene for this? Even if you as curator step back behind the artworks, it still remains your stage production.

D: Even though every hanging may be a production, I would prefer to use the word "hanging." And for a hanging there are very concrete ideas and models. I am thinking of putting the work *Modell Interconti* by Martin Kippenberger – in which he used a monochrome gray painting of Gerhard Richter as the top of an end table – in a room together with paintings by Axel Kasselböhmer, a painter who sees his work as the continuation of a contemplated and intentionally distanced painting genre in the tradition of Gerhard Richter, who, on the other hand, also most likely feels closer to the humorous profanity of painting as a moral activity – as demonstrated by Kippenberger's works – than he does to the admiration of it. And if it works out, a piece by Reinhard Mucha will also be placed nearby. A pedestal that (as a sculpture) stands on a chair that also serves as a pedestal with a chair on it that again is a pedestal for the pedestal-sculpture and so on: the showing of showing as sculpture. This sculpture could enter into a not at all uninteresting dialogue with *Modell Interconti* and a painting that has been developed out of a responsibility to form. Whether and how this will work will, as always, be decided during the hanging. But this is the course that my thoughts on the constellation of the groups of pieces and individual works are taking.

C: Do you make reference in "Ars Pro Domo" to the different phases that your generation went through during the course of the eighties? There was neo-expressionism, post-Conceptualism, and so on.

D: I am not showing my generation of artists retrospectively but qualitatively from the vantage point of its results. They could also have been seen at the beginning of the eighties. Most of them have, however, originated in the last few years, let's say between 1986 and 1991.

Concerning their phases of development, I would like to say the following: viewed somewhat superficially, all styles of modern art were gone through in the form of neo and post "isms" in the eighties. It began with so-called neoexpressive painting, then ran through the comeback of the surreal, geometric, space-oriented sculpture, graffiti, installation art, and photography to the rediscovery of the conceptual endpoint. I say "superficial" because these so-called phases were displays of cyclic fashion accompanied by ecstasies of the market. The specific quality of the individual artists and their changed attitudes were

concealed in most cases by misunderstandings connected with these nostalgic recycled forms of art history, according to their success or failure – here they both meet – to the point of invisibility.

C: Do you think that this goes for artists like Julian Schnabel and Francesco Clemente as well as for those who have remained unknown?

D: This cycle of fashion suggested a chronology of neostyle phases and staged a pseudocontinuity of post-kitsch, while precisely those artists who didn't function or who couldn't not function within this circulation were productive in openly interacting parallel processes. The neostyles of the season played a role only insofar as they couldn't be gotten around. One had to accept them as a fact, in order to then – for example, by means of grotesque exaggeration, or pretended ignorance – inactivate them and protect one's own work, which began where the styles, the isms, the art ideologies, the progress and innovation fetishes, and their art-substitute ended.

Although within the modes of cyclic fashion, artists were still defined according to past styles and media, for the artists themselves openness had long been a matter of course – not at all in the sense of multimedia playfulness. The scope of the media was, on the contrary, defined very carefully. But even artists who concentrate on painting reflect, within painting itself, the increased complexity and dubiousness of painting gestures in the context of audiovisual realities. This almost moral identification of media and materials – like "painting is reactionary" or "painting becomes progressive precisely by being considered reactionary" or "the more technique, the more inhuman" and "the more burned wood, the more critical of myths" – this exaggerated ideological over-identification is no longer interesting. It obscures one's view for what a painting, a photograph, or a sculpture might have to say.

C: Could you name one misunderstanding that has come about by being ascribed to such nostalgic fashions?

D: From the places they have been assigned within the fashion market of the eighties, the American Richard Prince (who is considered the protagonist of rephotography) and the German Walter Dahn (who is thought of as belonging to *wilde Malerei*) should have nothing to say to one another. In reality, not only are they friends, but their work is also interrelated. Both work with photography and silkscreen technique as possible means of (re)presenting the sore points of cultural images. In the case of Richard Prince, these are often sexually overdetermined images of American culture; in the case of Walter Dahn, colonization images of the third world or pictures from childhood superimposed upon socialization. And both view critically blind expression and pseudointellectual conception, reality-lacking figuration and formalistic ornate abstraction, as do, by the way, all the artists that "Ars Pro Domo" shows. But this is only one example of the art of this postindifferent generation still to be discovered independently of the postmodern art logos.

C: What does that mean for the individual artwork? If I understand you correctly, you still presuppose an artwork to be free of its contextuality.

D: No, not at all. Art is the art of setting a gesture that makes a difference and/or a shift of context in the midst of the contextual complexity of which it is a part. And to the same degree to which it is simultaneously a belling stag, a recreation kick, state art, or an analogue of compensation for those who produce sensible questions needlessly, it is the paradoxical presumption of not being all this. There is no outside to indifference. There is only the art of being *in* difference.

C: Do the notions of presence, aura, difference, autonomy, beauty receive, in this way, new meaning?

D: "Yes, yes, yes, no, no, no," as Joseph Beuys and Johannes Stüttgen correctly stated in their famous dialogue of the same name. Presence yes, but one with dirty hands. That is to say, art searches for presence, where meanings dissolve by burdening themselves with social meaning, and then deconstructs it, thereby creating visual possibilities of meaning. Wherever art touches real wishes by virtue of its beauty, it is still possible that art is "a possible model of freedom," as John Berger says.

C: Do you believe in the aura of art?

D: As for aura, I wish to say – with Walter Benjamin – only so much: The moment exists in which a picture opens its gaze on us and conveys to the viewer the memory of a lost humanness. This auratic experience sends you home with the feeling of a genuine incongruity, that only art – in rare cases, it goes without saying – can impart. This is, of course, a platitude, but a continually reccurring one.

C: Is the art of your generation as serious and as deep as you have portrayed it?

D: In art there is only the depth of its facial structure. And it has more to do with the tragic-comic and serious humor that doesn't take the personal blatancy of the artist all too seriously. A personal example: Martin Kippenberger once was beaten up badly by youths when he was a business manager of the discotheque S.O. 36 in Berlin. He used a picture showing himself coming fresh from the doctor with a broken jaw and nose as the basis for a piece of work he entitled *Dialog mit der Jugend (Dialogue with Youth)*. In other words, an artwork that shows presentness "is a healthiness, a superior style, a good mood – but at the height of an inner despair." This was written by Albert Camus in 1954 in his diary, in a year in which many artists whose works can be seen here were born. "Ars Pro Domo" is an invitation to experience art as a good mood in this sense.

C: Mr. Dickhoff, I thank you for this discussion.

NOTES

PRE-SETTING

1. Theodor W. Adorno, *Aesthetic Theory* (London, Boston, Melbourne, and Henley: Routledge & Kegan Paul, 1984), p. 1.
2. See Gilles Deleuze and Félix Guattari, *What Is Philosophy?* (New York: Columbia University Press, 1994), p. 163ff.
3. Adorno, *Aesthetic Theory,* p. 196.
4. Following Baudelaire, Barnett Newman understood "Impassioned Criticism" as a trinity of being partial, passionate and political. See *Barnett Newman, Selected Writings and Interviews,* John P. O'Neill, ed. (New York, Alfred A. Knopf, 1990), p. 130 ff.
5. See Jacques Derrida, *The Truth in Painting* (Chicago and London: University of Chicago Press, 1987), p. 9 ff.
6. See Martin Heidegger, *The Question of Being (Zur Seinsfrage)* (Albany, N.Y.: NCUP, Inc., 1958).
7. See Gilles Deleuze and Félix Guattari, *A Thousand Plateaus,* (Minneapolis and London: University of Minnesota Press, 1987), p. 232 ff.
8. See Emmanuel Lévinas, *Humanisme de l'autre homme* (Montpellier, 1972).
9. Jacques Lacan, *The Four Fundamental Concepts of Psycho-analysis,* The Seminars, Vol. XI, Alan Sheridan, trans. (1978), p. 115.
10. Augen-Blick is a play on the German word *Augenblick*. Its meaning in English is "moment" or "instant," but the word is literally made up of *Augen*, eyes, and *Blick,* look/gaze. Thus, another meaning of the word as what the eyes look at or see (in an instant or at a given moment) comes about.
11. See George Steiner, *Real Presences* (London: Faber and Faber, 1989).

CHAPTER THREE. THE UNREDEEMED IN JOSEPH BEUYS'S EXPANDED ART

1. "Joseph Beuys – Zeichnungen, Skulpturen, Objekte," Customs Hall 3, Düsseldorf Harbor, September 25–October 28, 1988 (Curators: Wilfried Dickhoff, Johannes Stüttgen): A book of the same name was published to coincide with the exhibition: Wilfried Dickhoff and Charlotte Werhahn, eds. Düsseldorf: (Edition Achenbach, 1988).
2. Martin Heidegger, *Die Kunst und der Raum* (St. Gallen, 1969), pp. 11–13.
3. "In die Zeit hineingestülpte Zeit," Wilfried Dickhoff in conversation with

Johannes Stüttgen, *Wolkenkratzer Art Journal,* No. 2 (Frankfurt am Main, 1987), p. 32 ff.

CHAPTER FOUR. MARCEL BROODTHAERS'S DETERMINATE NEGATION

1. All quotations by Marcel Broodthaers are from Marcel Broodthaers, "Interviews und Dialoge 1946–1976," in *Kunst Heute,* No. 2, 1994, Wilfried Dickhoff, ed. (Cologne: Kiepenheuer & Witsch), and have been translated from the German.
2. René Magritte, *Sämtliche Schriften,* André Blavier, ed. (Hanser, Munich, and Vienna, 1981), p. 219.
3. Stéphane Mallarmé, excerpt from "Un coup de dés jamais n'abolira le hasard," *Mallarmé, Oeuvres complètes,* Henri Mondor and G. Jean-Aubry, eds. (Paris, 1945), p. 453 ff.
4. Magritte, p. 389.
5. Ibid., p. 388.
6. Mallarmé, "La musique et les lettres,"*Mallarmé,* p. 649.
7. Mallarmé, "Autobiographie," *Mallarmé,* p. 662.
8. Mallarmé, "Variations sur un sujet," *Mallarmé,* p. 368.
9. Jean-Paul Sartre, *The Family Idiot,* C. Cosman, trans. (Chicago: University of Chicago Press, 1993), pp. 174–175.
10. "Mallarmé, that conjurer of spaces, voids and absences, oddly enough had experimented, like Broodthaers, with eggs as integers (wholeness, however, was integral). The quatrains in Mallarmé's occasional Easter Egg poems were published after his death with the following note: 'Each verse was written in gold ink on a red egg and was preceded by a number in such a way as to reconstitute the quatrain. – Only once could the numbering be omitted, and, in transposing the eggs, the ensemble could be read many times in a different way.'" Cited from Dore Ashton, "Ten Entr'actes from the Tragedy of the Hotel du Grand Miroir," in *Marcel Broodthaers, "Le poids d'une oeuvre d'art,"* W. Dickhoff, ed. (Cologne, 1994), p. 193.
11. Mallarmé, "Proses diverses," *Mallarmé,* p. 869.
12. Sartre, p. 174.
13. Paul Celan, "Meine," *Zeitgehöft* (Frankfurt am Main: Suhrkamp, 1976), p. 28. Translated from the German by Jeanne Haunschild and Wilfried Dickhoff.

CHAPTER SIX. BRICE MARDEN: ENSOULED FORM

1. Barnett Newman, *Selected Writings and Interviews* (New York, 1990), p. 178. This is a statement he made in 1950 about his own work.
2. Brice Marden, "Interview with Robert Storr," October 24, 1986, *Abstract Painting of America and Europe,* Rosemarie Schwarzwälder, ed. (Klagenfurt, 1988), p. 71.
3. Ibid., p. 73
4. Ibid., p. 74.

CHAPTER SEVEN. HOWARD HODGKIN: THE CARNAL PRESENCE OF EMOTION

1. Howard Hodgkin interviewed by David Sylvester, in *Howard Hodgkin: Forty Paintings 1973–1984* (London, 1984), p. 97.
2. Ibid., p. 97.
3. Ibid.
4. Ibid.

5. Ibid., p. 105.
6. Ibid.
7. Maurice Merleau-Ponty, "Eye and Mind," in *The Merleau-Ponty Aesthetic Reader*, Galen A. Johnson, ed. (Evanston, Ill., 1993), pp. 125–6.

CHAPTER TWELVE. DONALD BAECHLER: ON LINE

1. November 1985.
2. Gertrude Stein, *What Are Masterpieces and Why Are There So Few of Them?* (Los Angeles, 1940).

CHAPTER THIRTEEN. JULIAN SCHNABEL'S INTENSITY PROGRAM

1. Georges Bataille, "L'art, exercice de cruauté," cited in Bernd Mattheus, *Georges Bataille, Eine Thanatographie*, Part I (Munich, 1984), p. 18.
2. Georges Bataille, "Die Maske," cited in Bernd Mattheus, *Georges Bataille, Eine Thanatographie*, Part I (Munich, 1984), p. 404.
3. Paul Valéry, "Autres rhumbs," cited from Walter Benjamin, "Über einige Motive bei Baudelaire," in *Walter Benjamin Gesammelte Schriften*, I.2, Rolf Tiedemann and Hermann Schweppenhäuser, eds. (Frankfurt am Main, 1974), p. 639.
4. Albert Camus, "Der Künstler und seine Zeit," in *Fragen der Zeit* (Reinbek, 1960), p. 216.
5. Friedrich Nietzsche, "Der Fall Wagner," in *Friedrich Nietzsche, Werke III* (Frankfurt am Main, Berlin, and Vienna, 1972), p. 352.
6. Ibid., p. 353.
7. Julian Schnabel, November 1981, Amsterdam.
8. Bataille, p. 16.
9. Joseph Beuys, "Wenn sich keiner meldet, zeichne ich nicht," Joseph Beuys in conversation with Heiner Bastian and Jeannot Simmen, in *Joseph Beuys, Zeichnungen* (Munich, 1980), p. 40.
10. Jean-Paul Sartre, *Was kann die Literatur?* (Reinbek, 1969).
11. Novalis, "Fragmente und Studien 1997–1998," in *Novalis Werke* (Munich, 1981), p. 384.
12. Maurice Merleau-Ponty, *Das Auge und der Geist* (Hamburg, 1984), p. 22.
13. Jean-François Lyotard, *Essays zu einer affirmativen Ästhetik* (Berlin, 1982), p. 7 ff.
14. Julian Schnabel, from the *Madrid Notebooks*, 1978, unpublished.

CHAPTER FOURTEEN. WALTER DAHN: BLOCS OF SENSATIONS

1. In the fall of 1988 in a German broadcast on Channel 1 (dressed in a PUBLIC ENEMY T-shirt before a wall hung with a Beuys poster: "Last warning to the Deutsche Bank/The next time names and terms will be quoted"), he read an "Open letter to the Deutsche Bank" in which he denounced its political, credit-banking involvement in maintaining the Apartheid regime in (then) South Africa and strictly forbade the sale (within the framework of his power) of any more of his works to the Deutsche Bank.

CHAPTER SEVENTEEN. MARTIN KIPPENBERGER: ART'S FILTHY LESSON

1. See Werner Büttner, Martin Kippenberger, and Albert Oehlen, *Wahrheit ist Arbeit* (Essen, 1984).

2. Ibid., p. 31.
3. Ibid.

CHAPTER EIGHTEEN. DAVID SALLE: ON STAGE

1. "An Interview with David Salle by Peter Schjeldahl," in *Vintage Contemporary Artists,* Elizabeth Avedon, ed. (New York, 1987), p. 40.
2. Ibid., p. 48.
3. Ibid., p. 74.
4. Ibid., p. 44.
5. See ibid., p. 40.
6. See Immanuel Kant, *Kritik der reinen Vernunft* (Hamburg, 1956), pp. 112–113.
7. Claude Lévi-Strauss, *Das wilde Denken* (Frankfurt am Main, 1973), pp. 29–43.
8. "An Interview with David Salle," p. 48.
9. Isn't the inhuman gesture of a formalism à la Salle a counterfactual human gesture, because it creates a difference that is subtracted from the "human" that our culture takes for granted as its basic supposition but which, in fact, is a(n) (in)human construction of conformity? Assuming that the answer is yes, David Salle's formalistic paintings might turn out to be memories of a lost childhood before (human) education.
10. "An Interview with David Salle," p. 74.

CHAPTER NINETEEN. ROSS BLECKNER: TRACES OF DEATHLESSNESS

1. Immanuel Kant, *Kritik der Urteilskraft* (Frankfurt, 1968); § 28.
2. Painting satisfies, for instance, a condition of the possibility for this precisely because it is up to its ears in the deceptive smut of illusion [*Schein*], and not just because it can again or still (re)present the indeterminate or the authentic.
3. Martin Heidegger, *The Question of Being* (Albany, N.Y.: NCUP, 1958), p. 103.
4. "The essence of nihilism, which finally is fulfilled in the dominance of the will to will, is based on the oblivion of Being. We seem to be related to it most easily when we forget it, and that means here, disregard it. But in so doing we do not pay attention to what oblivion as concealment of Being means. If we pay attention to it, then we experience the dismaying necessity that instead of wanting to overcome nihilism we must try first to enter into its essence." Ibid., p. 103.
5. See Gilles Deleuze, *Differenz und Wiederholung* (Munich, 1992), p. 281 ff.
6. From this vantage point, a different history of painting in the eighties could be inscribed. This, however, would be a different history of different vanishing lines.
7. See Lisa Dennison, "Ross Bleckner: Painter of Light," in *Ross Bleckner* (New York: The Solomon R. Guggenheim Foundation, 1995), p. 17 ff.
8. Jacques Lacan, *The Four Fundamental Concepts of Psycho-analysis,* Jacques-Alain Miller, ed., Alan Sheridan, trans. (London, 1977).
9. Ross Bleckner, "Transcendent Anti-Fetishism," *Artforum* (New York) 17:7, March 1979, pp. 50–55
10. Ibid.
11. "Reality" is understood in Lacan's sense as desire-informed complexity consisting of the real, symbolic and the imaginary. See Jacques Lacan, "Encore," Seminar No. 20 (Wertheim and Berlin, 1996), Chap. VIII, "Das Wesen und die Wahrheit," p. 97 ff.

12. From an interview with Ross Bleckner, in *Ross Bleckner* (Zürich: Kunsthalle, 1990).
13. Peter Halley, "Ross Bleckner: Painting at the End of History," in Peter Halley, *Essays 1981–87*, (Zürich: Édition Galerie Bruno Bischofberger, 1988), p. 58
14. See Jacques Derrida, *The Truth in Painting*, (Chicago: University of Chicago Press, 1987), p. 83 ff. In his reading of Kant's *Critique of Judgement*, Derrida points to what is useless, aimless, without end and "the sans of the pure cut," which (not only) according to Kant generates the sense of beauty. For Kant, the flower was an excellent example of this finality-without-end that constitutes beauty. I do not believe that it is simply coincidental that Ross Bleckner uses the flower as an approximative motive in his recent paintings.
15. Ibid., p. 129.

CHAPTER TWENTY. ANDREAS SCHULZE: THE FAMILY IDIOT

1. Jean-Paul Sartre, *L'idiot de la famille* (Paris, 1971).

CHAPTER TWENTY-ONE. GÜNTHER FÖRG AND PHILIP TAAFFE: WE ARE NOT AFRAID

1. Form is seen here, in contrast to Adorno, as the objective disorganization of whatever appears within an artwork to dissonant-harmonious expression.
2. See Jean-Luc Godard's discussion of the *caméra-stylo*, the painterly framing in films and the camera's two-directional focus in *Liebe Arbeit Kino* (Berlin, 1981).
3. Oswald Wiener, "Ein zum Teil imaginiertes Gespräch mit Günther Förg," *Fama & Fortune Bulletin* 2 (Vienna, 1990).
4. Gottfried Benn, "Der Ptolemäer," *Gesammelte Werke 5* (Wiesbaden, 1968).
5. Egon Friedell, "Die Krisis der europäischen Seele von der schwarzen Pest bis zum ersten Weltkrieg," in *Kulturgeschichte der Neuzeit* (Munich, 1984), p 1523.
6. See Jean-Paul Sartre, *Kritik der dialektischen Vernunft* (Hamburg, 1967), Book 2, Chap. A.
7. See Reiner Speck, "Köln, den 3. Dezember 1989," in *Günther Förg "Stations of the Cross"* (New York, 1990).
8. Godard, in *Liebe Arbeit Kino*, p. 80.
9. See Roland Barthes, *Cy Twombly* (Berlin, 1983).
10. See Paul Groot, "An der Oberfläche der Spiegel," *Günther Förg*, catalogue, Westfälischer Kunstverein (Münster, 1986).
11. Roland Barthes, "Die Kunst, diese alte Sache . . .," in *Der entgegenkommende und der stumpfe Sinn* (Frankfurt am Main, 1990), p. 211.
12. Philip Taaffe in *The Binational*, David A. Ross and Jürgen Harten, eds. (Boston and Düsseldorf, 1988–89), p. 200.
13. Novalis, "Fragmente und Studien 1997–98," No. 37.
14. Philip Taaffe, in *NY Art Now*, Dan Cameron, ed. (London: The Saatchi Collection, 1987), pp. 23 and 55.
15. See Ernst Bloch, *Ästhetik des Vor-Scheins* (Frankfurt am Main, 1974).
16. Wiener.

CHAPTER TWENTY-TWO. PHILIP TAAFFE: THE OTHER (AND THE) ORNAMENT

1. Letter from Philip Taaffe to Wilfried Dickhoff, Naples, September 30, 1990.
2. See Wilfried Dickhoff, Chapter 21 of this volume.

3. Novalis, "Fragmente und Studien 1997–98," No. 37. Novalis Werke (Munich, 1969).
4. John Berger, "The *Work* of Art," in *The Sense of Sight* (Lloyd Spencer, ed.) (New York, 1985), p. 203.

CHAPTER TWENTY-THREE. ROSEMARIE TROCKEL'S IRREDUCIBLE DIFFERENCE

1. See *Rosemarie Trockel: Jedes Tier ist eine Künstlerin,* Wilfried Dickhoff, ed. (Lund, Sweden, 1993).
2. See John Berger, "Was Kunst leistet," in *Das Sichtbare & das Verborgene* (Munich and Vienna, 1990), p. 217.
3. See John Berger, "Der weisse Vogel," in *Das Kunstwerk* (Berlin, 1992), p. 12.
4. See Roland Barthes, "Ist die Malerei eine Sprache," *Der entgegenkommende und der stumpfe Sinn* (Frankfurt, 1990), p. 159.
5. See Maurice Merleau-Ponty, *L'oeil et l'esprit* (Paris, 1964).
6. See Roland Barthes, "Non multa sed multum," *Catalogue raisonné des oeuvres sur papier de Cy Twombly,* Yvon Lambert, ed. (Milan, 1979), pp. 11–12.
7. Thierry de Duve, *Pikturaler Nominalismus, Marcel Duchamp: Die Malerei und die Moderne* (Munich, 1987), p. 58 ff.
8. Sigmar Polke, *Das haben wir noch nie so gemacht,* a painting of 1982.
9. Rosemarie Trockel's installation was set up in situ in the Kunst-Station St. Peter in Cologne, a Catholic church that is still used as such and in which contemporary art exhibits are regularly held.
10. Slavoj Žižek, *Grimassen des Realen* (Cologne, 1993), p. 151.
11. One example of this is the voice of Johnny Rotten, the singer of the Sex Pistols in *Anarchy in the U.K.* See Greil Marcus, *Lipstick Traces – A Secret History of the Twentieth Century* (Cambridge, Mass., 1989).
12. Strictly speaking, the *Herdbild* cannot be a parasite of itself. The non-painterly turn toward the body is not a genderless one. But does this not also apply to the strands and features *(Züge)* of the hearth picture? In other words, the hearth picture is a parasite of her-self.

CHAPTER TWENTY-FOUR. GEORG HEROLD: OVEREXPOSING AND COUNTER-ILLUMINATING THE THEATER OF MEANING

1. Jacques Lacan, "Die Ethik der Psychoanalyse," in *Das Seminar, Buch 7* (Weinheim and Berlin, 1996), p. 281.
2. Ibid., p. 285
3. Ibid.
4. See Claude Lévi-Strauss, *Das wilde Denken* (Frankfurt am Main, 1968), Chap. I, "Die Wissenschaft vom Konkreten."
5. Marcel Broodthaers, *Interviews und Dialoge 1946–1976,* Wilfried Dickhoff, ed. (Cologne, 1994), p. 76.
6. Ibid., p. 120.
7. Ibid., p. 124.
8. Ibid, p. 129.
9. Ibid, p. 149.
10. Paul Virilio, "Cybersex – von der abweichenden zur ausweichenden Sexualität," *Lettre International* no. 32, 1st quarter, 1996, p. 77.
11. Ibid.

CHAPTER TWENTY-FIVE. CINDY SHERMAN: PORTRAITS OF BECOMING ANO(R)MAL

1. "The image in the mirror becomes the character – the image the camera gets on the film, and the one thing I've always known is that the camera lies." Cindy Sherman, *Art News,* September 1983.
2. See Roland Barthes, "The Third Meaning," in *A Barthes Reader,* edited and with an introduction by Susan Sontag (London, 1982), p. 317 ff. Original edition *L'obvie et l'obtus – Essais critiques III* (Paris, 1982).
3. *Les chemins de la liberté,* a trilogy by Jean-Paul Sartre (Paris, 1945–1949).
4. "It has been noted that the origin of the word anomal ("anomalous"), an adjective that has fallen into disuse in French, is very different from that of *anormal: a-normal,* a Latin adjective lacking a noun in French, refers to that which is outside rules or goes against the rules, whereas *an-omalie,* a Greek noun that has lost its adjective, designates the unequal, the coarse, the rough, the cutting edge of deterritorialization." Gilles Deleuze and Félix Guattari, *A Thousand Plateaus* (Minneapolis, 1987), pp. 243–244.
5. Ibid., p. 232.

CHAPTER TWENTY-SIX. SIEGFRIED ANZINGER: PRE-FIGURES OF (POSSIBLE) PAINTING

1. André Malraux, *Der Geist der Kunst*, Vol. 3, *Das Zeitlose* (Frankfurt, Berlin, and Vienna, 1978), p. 68.
2. See John Berger, *Glanz und Elend des Malers Pablo Picasso* (Hamburg, 1973).
3. See Malraux, p. 357.

CHAPTER TWENTY-SEVEN. GEORGE CONDO: (IR)REAL PRESENCES

1. Pierre Klossowski, "Rückkehr zu Hermes Trismegistos," in *Die Ähnlichkeit* (Bern and Berlin 1986), p. 104.
2. Today one should really speak of rump individuality, of the personal cigar that is sucked on daily and is readily mistaken for the subject after his death.
3. I would construe the notion of form to be the organized disorganization of everything that appears within a painting toward a (dis)harmonious expression.
4. The standard here is still Antonin Artaud, "the suicide killed by society," in Antonin Artaud, *Van Gogh, der Selbstmörder durch die Gesellschaft* (München, 1977).
5. See Wilfried Dickhoff, "Le goût du Néant – in der Malerei des ausklingenden 20. Jahrhunderts," *Nouveau Bohème* (Cologne: Monika Sprüth Galerie, 1986). "The Being of Nothingness – Notes on the existential abstraction in George Condo's paintings" (New York, 1986).
6. His countless schoolday journals already contain texts and drawings that play on the processes of de-realizing that which is considered, and prevails as, reality.
7. Wilfried Dickhoff, "Schein des Scheins – oder was?," *Kunstforum International* 68, (12), 1983.
8. George Condo in a conversation with Wilfried Dickhoff, Paris, February 23, 1991.
9. For instance, "Petersburger Hängung" in the exhibition "Selected Major Works," Galerie Bruno Bischofberger, Zürich, 1985.
10. See Félix Guattari's discussion of George Condo's "structural deconstruction," Guattari, *George Condo* (Paris: Daniel Templon, 1990).
11. George Condo in a conversation with Wilfried Dickhoff, Paris, February 23, 1991.

12. Ibid.

13. Egon Friedell, "Epilog – Sturz der Wirklichkeit," in *Kulturgeschichte der Neuzeit* (Munich, 1984), p. 1523 ff.

14. See Martin Heidegger, "Der Ursprung des Kunstwerkes," in *Holzwege* (Frankfurt am Main, 1950), p. 1 ff.

15. John Berger, "The *Work of* Art," in *The Sense of Sight,* Lloyd Spencer, ed. (New York, 1985), p. 203.

CHAPTER TWENTY-NINE. "BLINDMEN, THROW AWAY YOUR CANES"

1. The title of this chapter is an English translation of a work by Georg Herold called *Blinde wehrt Euch!,* a title that Herold wrote on the canvas in Braille.

2. "Ars Pro Domo" was an exhibition curated by the author for the Ludwig Museum in Cologne from May to August 1992. The interview is a fictional text based on many actual discussions the author had with different collectors during his preparation of the exhibition.

PUBLICATION SOURCES

References are to chapter numbers.

1
Phase II, edited by Wilfried Dickhoff and Haralampi Oroschakoff. Akademische Verlagsanstalt, Graz, 1985 (German title: *Phase II*).

2
Jean Fautrier, "Sur les champs sur l'horizon j'écris ton nom, liberté," edited by Wilfried Dickhoff. Edition Achenbach, Düsseldorf, 1989 (German title: "Der Maßstab Fautrier").

3
Joseph Beuys, *Zeichnungen, Skulpturen, Objekte,* edited by Wilfried Dickhoff and Charlotte Werhahn. Edition Achenbach, Düsseldorf, 1988 (German title: *Voraus-Setzung*).

4
Marcel Broodthaers, *Le Poids d'une oeuvre d'art,* edited by Wilfried Dickhoff, Tinaia 9, Cologne/Florence, 1995.

5
Wolkenkratzer Art Journal, No. 7. Frankfurt am Main, 1985 (German title: *Malerei ist eine moralische Handlung*).

6
Brice Marden, *The Couplet Paintings,* edited by Wilfried Dickhoff. Galerie Michael Werner, Köln, 1989 (former title: *There is more than what there is*).

7
Howard Hodgkin, edited by Wilfried Dickhoff. Galerie Michael Werner, Köln, 1990 (former title: *Like an open book*).

8
A. R. Penck, *Kunst Heute* No. 6, edited by Wilfried Dickhoff, Kiepenheuer & Witsch, Köln, 1990 (German title: *Einleitung*).

9
Don Van Vliet: *Neun Bilder,* edited by Wilfried Dickhoff. Galerie Michael Werner, Köln, 1987.

10
Bilderstreit, edited by Siegfried Gohr and Johannes Gachnang. DuMont, Köln, 1988 (German title: *Nach dem Nihilismus*).

11
Francesco Clemente, *Kunst Heute,* No. 5, edited by Wilfried Dickhoff. Kiepenheuer & Witsch, Köln, 1989 (German title: *Vorwort*).

12
Donald Baechler, edited by Wilfried Dickhoff. Shafrazi Gallery, New York, 1985 (former title: *Getting closer*).

13
Julian Schnabel, *The Kabuki Paintings.* Pace Gallery Publications, New York, 1987 (former title: *Julian Schnabel*).

14
I: Walter Dahn, *Kunst Heute*, No. 8, edited by Wilfried Dickhoff. Kiepenheuer & Witsch, Köln, 1992 (German title: *Einleitung*).
II: *Walter Dahn,* edited by Wilfried Dickhoff. Kunsthalle Basel, Stedelijk Van Abbemuseum Eindhoven, 1985 (German title: *Einen Stiefelvoll Hirn*).
III: Walter Dahn, *Where Parallels Meet,* edited by Wilfried Dickhoff. Barbara Gladstone Gallery, New York, 1989 (former title: *Whole Lotta Love*).

15
I: *Kunstforum International,* Bd. 68,12/83. Köln, 1983.
II: *Wolkenkratzer Art Journal,* No. 7, 1983 (German title: *Das letzte Abenteuer der Menschheit*).
III: *Dokoupil,* edited by Wilfried Dickhoff. Verlag der Buchhandlung Walther König, Köln, 1984 (German title: *Auszug aus einem Brief an J. G. Dokoupil*).

16
Dahn & Dokoupil, *Die Afrika-Bilder.* Museum Groningen, 1984 (German title: *Masken der Verzauberung*).

17
Martin Kippenberger, *Die I.N.P.-Bilder,* edited by Wilfried Dickhoff. Galerie Hetzler, Köln, 1984 (German title: *I.N.P. oder Meinen sie es auch gut mit den Menschen?*).

18
David Salle, edited by Wilfried Dickhoff. Galerie Michael Werner, Köln, 1988.

19
I: *Ross Bleckner.* Galerie Max Hetzler, Köln, 1989 (title: *Degrading the sublime*).
II: *Ross Bleckner.* BAWAG Foundation, Wien, 1997 (title: *Traces of Deathlessness*).

20
Parkett, No. 8, Zürich, 1986.

21
Parkett, No. 26, Zürich, 1990.

22
Phillip Taaffe, edited by Wilfried Dickhoff. Galerie Max Hetzler, Köln, 1992 (title: *Introduction*).

23
I: "The Look of Loneliness": Rosemarie Trockel, *Skulpturen und Plastiken.* Magers/Sprüth, Köln, 1983 (German title: *Für Rosemarie Trockel*).
II: *Ohne Titel (Falschspieler): Rosemarie Trockel,* edited by Wilfried Dickhoff. Kunsthalle, Basel; ICA, London, 1987.
III: *56 Pinselstriche: Rosemarie Trockel,* edited by Sidra Stich. Prestel, New York, 1991.
IV: *Ich habe Angst: Rosemarie Trockel,* edited by Wilfried Dickhoff. KunstStation, St. Peter, Köln, 1993 (German title: *Voraus-Setzungen*).
V: *Rosemarie Trockel, Die Herd-Bilder.* Salon Verlag, Köln, 1997 (German title: *Die Herd-Bild*).

24
Georg Herold, ifa (Institut für Auslandsbeziehungen). Stuttgart, 1996 (German title: *Die Un-Art der Entlochung*).

25
Parkett, No. 29, Zürich, 1991 (German title: *Ohne Titel, Nr. 179*).

26
Siegfried Anzinger, edited by Wilfried Dickhoff. Edition Tanit, Köln/München, 1992 (German title: *Sicherlich ist "Olympia" unter anderem auch ein kümmerliches Modell auf einem Bettlaken*).

27
I: *George Condo,* edited by Wilfried Dickhoff. Barbara Gladstone Gallery, New York, 1985 (title: *The Being of Nothingness*).
II: *George Condo.* Pace Gallery Publications, New York 1989 (title: *In Ictu Oculi*).

29
Ars Pro Domo, edited by Wilfried Dickhoff. Museum Ludwig, Köln, 1992 (German title: *Matratzenlager*).